Africa in the American Imagination

Africa in the American Imagination

Popular Culture, Racialized Identities,
and African Visual Culture

Carol Magee

University Press of Mississippi / Jackson

www.upress.state.ms.us

Color reproductions made possible with a
grant from the University Research Council,
University of North Carolina at Chapel Hill.

The University Press of Mississippi is a member
of the Association of American University Presses.

First printing 2012

∞

Library of Congress Cataloging-in-Publication Data

Magee, Carol L.
Africa in the American imagination : popular culture,
racialized identities, and African visual culture / Carol
Magee.
p. cm.
Includes bibliographical references and index.
ISBN 978-1-61703-152-6 (cloth : alk. paper) —
ISBN 978-1-61703-153-3 (ebook) 1. Popular culture—
United States. 2. United States—Civilization—African
influences. 3. Africa—In popular culture. 4. Identity
(Philosophical concept) I. Title.

E169.Z83M33 2012

306.0973—dc22 2011016102

British Library Cataloging-in-Publication Data available

For Newt,
without whom everything would be less meaningful

Contents

Acknowledgments

Writing is, for the most part, a solitary act; in crafting my book I spent days and days in front of a computer alone with my thoughts. And yet I never wrote in isolation. This book exists because I had the cooperation and support of numerous individuals and their institutions, and I would like to recognize them here. Apologies in advance to those of you who feel you should find your name here and do not. My oversight was not intentional, and in no way diminishes your contribution.

There are those whose support had tangible impacts on the finished manuscript. Skip Cole deserves thanks for many things, not the least of which is his willingness to take students with him to Africa. Because of this, he and Michael Hamson were there at the start of the journey that began in South Africa in 1997, and their companionship and conversations enriched my time there. Their willingness to document photographically the Ndebele sites we visited and peoples with whom we spoke allowed me to focus my attention fully on the conversations I was having. The Friends of Ethnic Arts in Santa Barbara, California, provided this project's initial financial boost through a travel grant for this trip. Other financial support came from the Woodrow Wilson Foundation, providing me with a post-doctoral fellowship at Elon University, which gave me the time to think seriously through the material I'd gathered and begin the writing process. Jan Davis's generous donation funded my research at the Walt Disney World Resort through the University of North Carolina at Chapel Hill's Faculty Partner Program.

I am indebted to the people who generously made time for me, answering my questions and providing documents for analysis. At the Smithsonian's National Museum of African Art, Christine Mullin Kreamer, Janet Stanley, and Bryna Freyer gave me access to documents on the Walt Disney–Tishman collection, and helped me track down other valuable sources. My work on Disney's Animal Kingdom Lodge could not have been completed without Charles Davis, Mary Hannah, Skip Cole, and Doran Ross, who, having served as consultants on the project, answered my many questions, provided access to documents, and shared opinions,

allowing me to develop a more nuanced reading of that space. Heather Fonseca helped me understand the approaches and philosophies of Mattel with regard to its "Dolls of the World" collection. Martha Nomvula and Esther Mahlangu willingly gave of their time, responding to my questions about their participation in the *Sports Illustrated* swimsuit issue. Martha's thoughts on this topic were especially helpful in deepening my thinking about the cross-cultural interchanges and representations that occurred in that shoot. Corine Kratz, Carolee Kennedy, and Gary van Wyk graciously responded to my queries about the personal decoration of the Maasai and Okiek, Zulu, and Ndebele peoples, respectively.

Over the years I have had many research assistants; they deserve special thanks for taking care of the tedious double-checking of references, tracking down of sources and images, and taking of photographs: Ryan Johnson, Erica Longenbach, Yahaira Lorenzo, Elizabeth Magee, Ashleigh Raabe, Elizabeth Sanchez, Jeff Sekelsky, Shahrazad Shareef, Mara West, and Mona Young. Their work made mine much easier. Bettina Meier and Jako Olivier Services provided invaluable translation services, and I would like to thank Nicki Ridenour for proofreading my draft before I sent it off for the first time, and Alison Hafera Cox for the final read-through. I am indebted to Mary Sheriff, Dan Sherman, and Mary Sturgeon for their general guidance as I moved through this process.

Jennie Carlisle, Alison Hafera Cox, Rick Curtis, and Gina Sully offered comments that sent my thinking in new directions. The feedback provided by anonymous reviewers was vital for strengthening this manuscript, as was the guidance of my editor, Craig Gill, who accommodated my many questions and who changed how I think about writing in exciting ways. Additionally, there are many colleagues who read and commented on drafts or parts of chapters: Judith Bettelheim, John Bowles, Joanna Grabski, Sarah Watson Parsons, Stephanie Schrader, Debra Singer, Lyneise Williams, and the members of the Number One Ladies' Writing Group: Amanda Carlson, Andrea Frohne, and Shannen Hill. I am most especially grateful to Kristin Huffman Lanzoni, who went above and beyond the call of duty, reading the entire manuscript several times. Her contributions to this book are invaluable, her friendship even more so. These individuals are responsible for improvements in this text, and they share in its successes. They are in no way responsible for its faults; those remain solely my own.

The impact of family and friends is harder to define, and though less tangible, it is no less important. Their ongoing support deserves acknowledgment here, for I could not have accomplished this without them.

My heartfelt gratitude goes to Mom, Megg, Dad, Abby, Bern, Corbin, Chuck, Dickkers, Dick, Elaine, Fernando, Fran, Frank, Greg, John, Kathy, Kerry, Kinsey, Larysa, Laurie, Lindsay, Natalia, Pat, Patti, Rosann, Roya, Ruth, Sherrie, the Rhode Island gang, the Sekelsky clan, the Sekelsky lab, and Tom. Monique, Deanndria, Emily, Julie, Lauren, Mischa, and Toby helped to keep my body and, therefore, mind healthy during the writing process. Carolyn Allmendinger kept me laughing, and Cary Levine played a special role in keeping me sane. Thank you!

Finally, my thanks goes to my husband, who was a great sounding board, listening patiently as I struggled with articulating ideas, offering insights, and helping me find the paths the narrative needed to take. Thanks Newt, for your support, your sense of humor, and being keen on cereal for dinner. But most of all, thank you for helping me keep perspective. You made the setbacks more tolerable and the successes more exciting!

Africa in the American Imagination

1.

Introduction

Popular Culture, Racialized Identities,
and African Visual Culture

Objects are one means, then, by which humans shape their world,
and their actions have both intended and unintended consequences.
—KRIS L. HARDIN AND MARY JO ARNOLDI, *African Material Culture*

"I am African" declares the full-page, black-and-white advertisements fea-
turing David Bowie, Gwyneth Paltrow, Gisele Bündchen, Lucy Liu, Liv
Tyler, Alicia Keys, or any one of nine other celebrities from the worlds of
film, music, and fashion. Despite this declaration, the majority of viewers
know that most of these individuals are not African in any commonsense
understanding of what being "African" means: they were not born on the
continent, have not established citizenship in an African nation, and do
not live there now.[1] But the designers of this campaign want to stress that,
genetically, we are all from Africa; human life evolved in and moved out of
Africa to populate the world. We therefore share not only a biological her-
itage but also a general humanity. If we are all African, we all have a stake
in what happens there. Africa *means* something to us. Given this, the ads
urge us to give our money to the Keep A Child Alive organization. The
small print says, "Help us stop the dying. Pay for lifesaving AIDS drugs that
can help keep a child, a mother, a father, a family alive. Visit keepachild
alive.org to help." This 2006 campaign was created with the best of inten-
tions. It did not have the best of results.

 In a world where Africa is the focus of much charitable attention, skep-
tics see such moves as exploiting African crises to bring more visibility to
the celebrity. Counterimages soon circulated on the Internet. One in par-
ticular addresses the perceived superficiality of celebrity participation.[2] It is
a black-and-white photograph of a dark-skinned female (identified only as
"an African woman"); "I am Gwyneth Paltrow" is written across the bottom

of the image. Underneath this, the small print declares, "Help us stop the shameless famewhores from using the suffering of those dying of AIDS in Africa to help bolster their pathetic careers now that they're no longer dating Brad Pitt and no one gives a shit about them. Just kiss my black ass to help." Despite such critiques, the Keep A Child Alive organization kept using the campaign, and the images were still present on their Web site in 2008.[3] While the media have reported on the controversy surrounding these images, very little attention has been given to their visual elements, the emotional and social reactions they trigger, and what they say about how Africa is imagined for and by mass media consumers.

The imagining of Africa through popular culture is the subject of this study. Myriad American cultural products incorporate African visual culture, peoples, or landscapes. This book focuses on three case studies, each of which repackages African visual culture for American consumers: Mattel's world of Barbie, the 1996 *Sports Illustrated* (*SI*) swimsuit issue, and the Walt Disney World Resort. In particular, it analyzes the ways in which visual culture reinforces, challenges, and represents social relations, especially as they are articulated around racialized identities in the past twenty years. Two major threads run throughout this study. In the first, I analyze how these companies' uses of African visual culture generate ideological understandings of Africa for an American public. The second thread runs parallel to and, at times, is interwoven into the first; here I investigate the way that African visual culture, such as textiles, jewelry, architecture, and sculpture, focuses American self-understandings, particularly around black and white racialized identities. The time period for this study, the 1990s through the present, reflects an increased visibility of previously marginalized groups (women, homosexuals, blacks, and other people of color) within American society, a visibility that plays into what I suggest is a current crisis of identity for America. This crisis is mediated through popular culture forms, around racialized identities, and in relation to other cultures. In short, this set of case studies reveals not only the multiple ways that Africa functions in an American imagination, the multiple meanings it embodies, it also examines the conditions that gave rise to, and consequences of and implications for, such imaginings.

Although not the focus of this study, the "I am African" advertising campaign succinctly reveals many of the issues I engage, and demonstrates their presence and relevance beyond the material that is the core of this book. It therefore merits further consideration. "Painted" (digitally) on the face and/or head of each of the celebrities are broad strokes of color that

match the "I am African" text. Two horizontal lines (dark blue on top of light blue) cover the top of Paltrow's left cheekbone. Bright blue dots on Keys's forehead follow the lines of her eyebrows. An orange stripe runs the length of Bowie's nose. These color elements heighten the contrast with the black-and-white photograph of the celebrity. While these painted areas serve as color accents, creating a more visually interesting composition, they also evoke notions of difference. Facial painting (apart from makeup) is not part of everyday American cultural norms. It is not part of everyday African cultural norms either, nor are the patterns used in these advertisements direct replications of patterns used in African ceremonial contexts that might include some sort of facial painting. Yet imaginings of Africans with painted faces are commonplace. As such, in this context the facial painting positions these celebrities as African, thereby visually reinforcing the claim of the text. This association is further established through clothing and jewelry. The women appear to be wearing no clothes; viewers see their necks and bare shoulders.[4] This exposure suggests both naturalness and sexuality, while emphasizing the adornment of their bodies with the paint and drawing attention to the jewelry they wear. Indeed, the majority of the men and women wear beaded jewelry. Liu wears a flat-disc necklace, while Keys wears a beaded headdress.[5] Even if consumers can recognize those pieces as Maasai or Okiek, they were meant to read them simply as African, for in reading the celebrities as African, and at the same time recognizing and connecting with them as celebrities, viewers will, ideally, identify with Africans and willingly support the cause.[6]

Regardless of the intentions of the campaign, these various elements say much about the way Westerners frequently conceive of and understand Africa: it is primarily a place of nature, not culture; when cultural, it is exotic; Africa is a place of wildness that is frequently presented in terms of savagery and/or abundant sexuality; Africa is one cohesive entity—often referred to as a country not a continent, and cultural differences are subsumed under a general African identity. The face painting, unclothed bodies, jewelry, and the slogan "I am African" visually evoke these ideas and the associations they engender. In short, here Africa and Africans are positioned as representing those things that the West, in its view of itself, is not. Despite its intention to highlight European and American ties to Africa, the Keep A Child Alive advertising campaign's visual elements emphasize difference. In drawing on and reproducing reductive and stereotypical conceptions about Africa and Africans, these images do little to create nuanced and meaningful links to and ideas about Africa.

In this it is problematic. Simultaneously, I fully support both their overall goal—bringing everyone's attention to the AIDS crisis in Africa—and their underlying premise—we are all connected to Africa. These bonds may be genetical, but they are also emotional, political, and cultural. It is vital to comprehend these connections, for they shape American perceptions not only of Africa and Africans but also of themselves. This book highlights and disentangles these complexities.

As the title of this book suggests, I focus on *imaginings* of and *ideas* about Africa as they are manifest in an American context. This is not about presenting an African reality, though of course it will be necessary to refer to specific African contexts and cultural practices in presenting an analysis of their evocations in American cultural products. Nor is this meant to be a history of how such ideas came to circulate, as others have already compiled such histories.[7] Nevertheless, some discussion of the historical development of these ideas and images will be necessary in examining their contemporary use. The set of cultural products I consider here frequently present stereotypical and reductive ideas of Africa, as did the "I am African" advertisements. Yet my analysis suggests that, like the "I am African" advertisements that produce both negative and positive meanings about and associations for Africa, these cultural icons are complex representations that embody multiple perspectives and speak to various social-political-historical contexts: the Cold War, civil rights, and contemporary eras of the United States; the apartheid and postapartheid eras of South Africa; the European era of African colonization. At the same time, they are firmly embedded in their own historical moment. As occurred with the "I am African" advertisements, representations of Africa in these popular culture forms can be both problematic (stereotypical and reductive) and constructive (offering new ways to think about Africa).

I have regularly encountered misconceptions and stereotypes about Africa in casual conversations both inside and outside of an academic setting. I encounter surprise at photographs of African urban areas, for it is commonly thought that Africans live in grass houses in jungle villages. People refer to Africans as primitive, or propose their state of economic underdevelopment as a result of laziness that is inherently linked to their black skin. These latter ideas are particularly troubling for the way they imply that Africans, and at times African Americans, are inferior to (white) Westerners. These perspectives stem from ideas that, while not invented in the past 200 years, were solidified then. It was during the European colonial era, largely, that these ideas had mass dissemination and became part

of the popular imaginary, though they are no longer solely linked to that discourse. New discourses, such as those of globalization, likewise position Africa as inferior.[8] Significantly, these perspectives have been so integrated into an American worldview that they seem common sense (more on this later). To illustrate this, I offer the following small example. In 2005 the Exploris Museum in Raleigh, North Carolina, held an exhibition that highlighted the ancient kingdoms of western Africa: Ghana, Mali, and Songhai.[9] As part of an interactive experience, elementary school children who visited the museum were asked to draw pictures of Africa. Despite the fact that schools are integrating studies of Africa into their regular curricula, and despite the fact that the curators of this exhibition had taken great care to present factual views of these cultures' ways of life, the vast majority of the resulting drawings depicted elephants, giraffes, and monkeys as well as Africans dressed in grass skirts and holding spears, none of which pertained to the exhibition. Though regrettable, it is not surprising that such reductive images of Africa predominate, as this look at popular culture reveals. Indeed, that children have such images in their mind suggests both the prevalence of them throughout society and the early age at which children are socialized into them. The resulting misconceptions and partial knowledge affect not only an understanding of the past but also of the present, and thus future.

This is not a minor issue, for there is a strong presence of African culture—sometimes fully embodied, sometimes as a trace—in the American world. Along a similar vein, objects and images have lives that extend beyond the contexts in which they were first made and consumed.[10] These lives add meanings to those objects. African visual culture, whether in a museum, a private home, or a popular culture form, has meanings and values that pertain beyond local meanings and values (those relevant to the culture that produced it). While the value of African visual culture in these non-African locations and contexts is often celebratory, the celebration does not necessarily do enough to counter news media images of Africa as a place torn by civil war, famine, coups, and AIDS, or offered by popular culture of Africa as a place of jungles, animals, and "primitive" peoples (among other things). For example, thinking of Africa in terms of animals and the adventure of safari is not necessarily negative, especially in the way that images of political chaos can be. Neither is it necessarily constructive, however, in terms of how it positions Africa in the imagination.

As the "I am African" campaign reveals, cultural associations often conjure Africa as exotic and tribal. There are many instances in which

Americans encounter African culture that reinforce ideas about tribal Africa: an African drumming or dance performance or class; *National Geographic* or any of the coffee-table books offered by photographers Carol Beckwith and Angela Fisher; documentaries on the Discovery Channel; museums where the majority of objects are ceremonial or ritual, not paintings and other works that are more widely recognized as fine art. Such cultural representations that emphasize the tribal frequently position African culture as "traditional." This positioning often evokes ideas about simpler ways of life where one is more in tune with one's past and/or one's natural environments, and where cultural change is slow or nonexistent despite the fact that most people will acknowledge that traditions are invented and reinvented, adapting and changing over time.[11] It enables and engenders idealization and romanticization of the cultures depicted. In juxtaposition to American culture, which commonsense understandings see as modern (urban, industrialized, progressing), Africa as traditional, and therefore nonmodern, suggests a relative inferiority vis-à-vis American life.[12]

These tensions between nature/culture, traditional/modern, or negative/positive imagery are present in a majority of representations of Africa. This study examines ways these tensions exist in dialogue or contradiction with one another, often in the same popular culture form. In the remainder of this chapter, I explore the analytical components (popular culture, racialized identities, and African visual culture) that make up this study along with their various intersections, establishing the ground on which I build my arguments. Before turning to this, I want to comment briefly on some terminology.

Four terms in particular need attending to: *Africa, America*, the *West*, and *visual culture*. At the most basic level, the first three are simply shorthand ways for signifying in the text the complex locations I discuss. Yet because of their monolithic and homogenizing nature, they are also part of the problems against which I am writing, and against which I offer this analysis. Given this, I employ these in the tradition of Edward Said and his use of the term *Orientalism* to identify a body of knowledge that shapes how regions and peoples are understood and represented.[13] I am indebted also to those scholars whose critiques of Said's work have amplified and made more precise understandings about how such bodies of knowledge are produced and disseminated, and how they act upon the world.[14] In the course of researching and writing this book, I found much that I discuss is imagined through Africa, America, and the West; therefore I have chosen to retain use of these terms here, not to reproduce the problematics of the

concepts and implications of these terms, but to nuance their meanings and possibilities.

Despite the continent's enormous political, cultural, ecological, and historical diversity, Africa exists in the imaginary as a single entity. Each semester, for instance, I have students who refer to the *country* of Africa, even when they know better. Africans are seen as one homogenous group with a shared history or culture. The news media and even government policy perpetuate this.[15] For such reasons I use *Africa* here as shorthand to talk about its peoples, animals, and cultural products, and to signify the continent that is comprised of over fifty nations and hundreds of ethnic groups.

At the same time, I am using *America* as shorthand for the place, peoples, and cultural objects of the United States in much the same way I use *Africa*, recognizing, of course, that America can also refer to the rest of the countries comprising the North and South American continents. Yet the citizens of the United States refer to themselves as Americans, and I will therefore use America and the United States interchangeably. I explore the ways that this national identity, this sense of being American, is formulated through both ideas of commonality (what Americans share) and difference (both within and outside the geographic borders that define the nation).[16] Most Americans would argue, and rightly so, that there is no such thing as *an* American imagination; this country is too large, the peoples and beliefs too diverse, to be able to pinpoint and characterize such a thing, even when there might be shared understandings of concepts such as "the American Dream." And yet there are ways of perceiving and talking about the world that dominate within American culture. There are commonsense beliefs that are held, and there are hegemonic propositions that dominate ideas about American life and culture, even when there are groups that dissent and disagree with those characterizations or that work to undo those dominant representations. I reference all these things when speaking of America and the American imagination.

The *West* is also used as shorthand in this book. Here, the West is meant to signify those cultures that identify largely with a European cultural and political tradition, those cultures that are seen to have more in common with one another than they are seen to have in common with Africa (or Asia, for instance). America is one of those countries; its mainstream culture is understood to derive from and/or grow out of European culture. Sometimes in this text it is important to specify Europe as distinct from America because of the historical circumstances under discussion; at other times I refer to their shared traditions and approaches as "the West."

In those instances, the distinction between them is less relevant to the discussion at hand than their commonalities.[17]

Last, I have been using *visual culture* to refer to the objects from Africa (re)presented in these popular culture forms. These same objects are considered art in some contexts, and I refer to them as art in instances in which they are presented as such (museums, Disney's Animal Kingdom Lodge [DAKL]). However, in general I prefer, and thus use, the more encompassing term *visual culture* because of what it suggests. On the most basic level, characterizations of these objects as visual culture are appropriate as they visually embody the beliefs and values of, and are vital to the production of knowledge within, the culture that produces them.[18] Visual culture extends beyond the fine arts to include popular culture, media, architecture, and environments, among other things.[19] Given this, the popular culture forms offered by Mattel, *SI*, and the Walt Disney World Resort are as much visual culture as the African objects they use. The way one approaches images or objects, the way one sees, is culturally constructed, and the field of visual culture studies provides critical tools for understanding these processes. But visual culture as a field of inquiry considers more than just the ways one sees; it also examines the way seeing is implicated in creating social relations.[20] Part of chapter 3 explicitly explores these ideas, addressing the ways different cultures see the photographs of the *SI* swimsuit issue. In that discussion I demonstrate how, as with the "I am African" campaign, a single photograph can reinforce ideologies that position the West as superior to Africa at the same time it generates understandings that transcend such relations. This tension brings me back to the epigraph with which I opened this introduction: "Objects are one means, then, by which humans shape their world, and their actions have both intended and unintended consequences."[21] Indeed, the greatest interest for me is the way that images and objects mediate and shape social relations. Most specifically, I am concerned with how African visual culture and/or representations of it, through their appearance in American popular culture forms, help to structure social encounters, between Africans and Americans as well as among Americans.

2 Popular Pleasures, Guilty Pleasures

The vast majority of the American population has either access to or knowledge of Mattel's world of Barbie, *SI* swimsuit issues, and Disney

amusement parks (the subjects of my analysis). These are part of the main-stream and therefore are considered popular culture. Popular culture embodies mainstream values, beliefs, and mythologies, and may take the form of mass media, arts, music, rituals, events, objects, and so forth.[22] Given this, much of the African visual culture that these American popular culture forms use can also be thought of as popular culture, for it similarly conveys the beliefs and values of its makers, and engages with the specific sociohistoric conditions in which it is produced.[23]

Popular culture is important to consider because throughout the world a vast majority of significant education takes place in this realm.[24] This informal education occurs through engagement with the cultural products that fill our lives. The music that one listens to, the books one reads, the films one sees, can significantly impact and shape one's politics and worldview as much as, if not more than, one's formal education.[25] Popular culture teaches and contests ideas, passing them on and/or overturning them. I engage these socialization processes in looking at the popular culture forms of Barbie, the *SI* swimsuit issue, and the Walt Disney World Resort.

I chose these as the case studies because these cultural icons permeate American life and as such have a broad impact on U.S. culture. Consumers engage these icons in leisure activities, during moments when critical thinking is frequently relaxed, or in the case of child consumers, when critical thinking skills have yet to be developed. At such times the messages (explicit and implicit, text and subtext) are more readily absorbed subconsciously. They are encountered in moments of pleasure and evoke emotional reactions. We might marvel at the intricate details on a Barbie's clothes or enjoy the varying textures of different Barbie dolls' hair. Flipping through the pages of the swimsuit issue slows the pace of a busy day, the mind wandering, imagining liaisons in the far-off places depicted on its pages. Or the happy world presented in the "it's a small world" ride at the Walt Disney World Resort offers an escape from the constant bombardment of news about the wars in Iraq and Afghanistan. We might laugh in delight as a giraffe meanders past a window at DAKL. We should not underestimate the power of this pleasure, for it draws us into interaction with the cultural form. But in many instances the pleasure becomes both the point of entry and the stopping point in that interaction. This is what I mean when I suggest that critical thinking skills may be relaxed. I enjoy the reverie prompted by watching the animals wander past the windows at DAKL; why would I *want* to detract from that by thinking about critiques emphasizing the unrestrained capitalism of the Disney Corporation?

Why, in my moment of relaxation, would I want to think about whether I agree with those critiques, and since I do, what does it then say about my complicity in and perpetuation of—through my enjoyment of my Disney experience—that capitalist excess and exploitation? It is easier just to enjoy. Indeed, the expression "a guilty pleasure" recognizes that these sorts of conflicting engagements occur. To identify something as such is to acknowledge that one is aware that there is something problematic about it, but that one is choosing to ignore that problematic aspect and enjoy it anyway.

Cultural studies professor John Parham remarks on his students' disinclination to engage critically with their own "popular pleasures":

> The reluctance stemmed more . . . from an unwillingness to think about or at least talk about "identity" understood here as the locus and site of experience of social and cultural formations and ideologies. Instead, identity was interpreted as "individuality" or "personality" with little reference to either theoretical cultural studies concepts— systems of value, affective relationship, and so on—or formations of identity such as gender or class or sexuality, although one (interesting) exception here was race. This replacement of "identity" with "personality," I would suggest, is indicative of the broader cultural context that replaces social allegiances with individualized "choices."[26]

His reflection here touches on a couple of elements that have particular relevance for this study. First, popular culture is intricately linked to notions of identity, and, as importantly, identity is socially enacted.[27] Second, the call to engage critically with popular culture asks consumers to consider carefully the social construction of identity, the creation and dissemination of knowledge and ideologies, to engage in relationships with the individuals who are part of one's community *and* with those who are not, and to potentially endure a bit of discomfort. Doing so enables people to be more thoroughly connected with the world around them, to understand better both themselves and others. Such thoughtful engagement with the lives and cultures of others is vital in this time of increased globalization and increasing xenophobia.

Given the power that popular culture has in teaching social values, it seems logical to ask: does the world of popular culture have a responsibility to large social problems? Recent developments in the world of publishing suggest that more and more people might be answering yes. In July

2007 *Vanity Fair* published an issue dedicated to raising awareness about the myriad issues facing the peoples of Africa. A year later, in July 2008, Italian *Vogue* commented upon the relative absence of models of color in mainstream fashion by producing an issue that puts emphasis on black models.[28] Not only were those models emphasized, but the feature texts also turned their attention to accomplished blacks—Barack Obama in politics, Aretha Franklin and Tina Turner in music, Naomi Campbell and Tyra Banks in modeling—and touched on artists that deal with issues of race: Adrian Piper, Candice Breitz, Wangechi Mutu. Despite this, the majority of advertisements in this issue featured white models, and some of the stereotypes (animal print outfits, naked breasts) that I deal with in this book are present on the pages of this *Vogue*. Yet in both of these instances, the editors seem to have realized that it is in their power to explicitly engage their audiences in the discussions about larger social issues, issues that are not the usual subject of their endeavors.

Whether raising awareness of problems (such as racism—Italy's *Vogue*) or educating readers about particular issues (the difficulties Africans face—*Vanity Fair*), popular culture socializes its consumers into particular value systems. It does this explicitly and implicitly. As these examples demonstrate, popular culture is a site through which social concerns are negotiated. This mediation is always a complex act; both the texts themselves and consumers' responses to those products manifest competing ideas and values. This was evident in the Keep A Child Alive campaign, and is true also of the cultural forms I analyze. In their increasing and sustained popularity among adults and children, both in America and throughout the world, Barbie, the Walt Disney World Resort, and the *SI* swimsuit issue transcend time and place. Their staying power affords a profound influence on generations of consumers. This is, in part, why it is so critical to understand the multifaceted meanings they embody.

Not only are these cultural icons important because of their near ubiquity in American culture, they are important also in their differences from one another. Consumers engage them differently as they take diverse forms (a doll, a magazine, and amusement parks), and make use of African visual culture in distinct ways as well. Each brings something unique to understandings of Africa and America. Readers of the 1996 *SI* swimsuit issue see South African visual culture, appearing in the form of Ndebele and Zulu beaded jewelry, Ndebele painted murals, and the attire of two Ndebele women. These cultural objects, however, are not the focus of this photographic series. They are there to simply invoke Africa; the particulars

of the dress do not matter in this context. African dress, on the other hand, is the focus in Mattel's "Dolls of the World" Barbie collection and in the Walt Disney World Resort's "it's a small world" ride. For Mattel, the African significance of that dress is important for American understandings of the dolls. Despite this, neither Mattel nor Disney presents actual African clothing as the swimsuit issue did. Rather, they offer their audiences their own versions of African personal adornment. Where these two forms present dress as central to understanding Africa, the swimsuit issue positioned African dress as incidental, and, as I demonstrate in the following chapters, this distinction impacts the perceptions of Africans that these images foster.

Additionally, the Africa that Mattel and Disney present is part of a microcosmic representation of the world, whereas at DAKL, Africa south of the Sahara is given center stage. Rather than some nebulously defined Africa, the South African focus on the pages of *SI* theoretically enables engagements with the particulars of that country. Conceptualizing Africa in terms of continent or country, as an isolated entity or as part of the larger world, affects the meanings the representations convey. I am able to highlight and unpack these differences by looking at multiple popular culture forms.

DAKL, moreover, gives attention to Africa in part by presenting guests with African objects from myriad locations on the continent; visual culture is on display throughout the lodge. In this presentation of actual African visual culture, DAKL is more like the swimsuit issue than the "Dolls of the World." DAKL also presents real Africans. At the lodge, visitors can talk and interact with them in ways that readers of the swimsuit issue cannot. Associating Africa with real people, I argue, promotes more positive and comprehensive understandings of Africa than engaging those cultural products that lack such associations.

Finally, because these cultural icons treat African visual culture in different ways, they bring multiple discourses to the table. The "Dolls of the World" and the Walt Disney World Resort engage with issues (nationalism, imperialism, nostalgia, tourism) that span the second half of the twentieth century, even though the Barbie dolls and amusement centers I consider came into existence only in the last third of it. This suggests that these popular culture forms, though speaking to their particular historical contexts, engage ongoing discourses as well. My exploration of them reveals that these forms invoke, reproduce, and transform past ideologies for the present. The *SI* swimsuit issue, in contrast, is more firmly grounded in a

specific historical moment and place: South Africa in the mid-1990s. Shot in South Africa, the year following the official end of the National Party's apartheid regime, the swimsuit issue brings issues of race to the fore in a way that Barbie and the Walt Disney World Resort do not, even though they have race as a prominent subtext. As I argue throughout, racialized identities are central to the social relations being mediated with all these cultural forms. The varying ways in which these icons represent Africa, and the ways in which Americans engage these diverse popular culture forms, have great influence on the ways one comprehends those racialized identities.

Despite this strong subtext of race, the majority of critical attention to Barbie and the *SI* swimsuit issue focuses on issues of gender. In looking at the nonnaturalistic proportions of Barbie, or the sexualized objectification of the models in the swimsuit issue, one can understand how these critiques have gained prominence. And although critical attention to Disney explores broader issues, race is rarely given sustained attention in the critiques of any of these cultural icons.[29] For this reason, I thought it imperative to focus my attention on the way these popular culture forms construct and deploy race. Except where they intersect in highly relevant ways with discourses of race, I have chosen not to engage in an in-depth way with these other discourses. To do so would detract from the discussion of race and draw attention away from an issue that I believe is already underexplored in this context. My emphasis on race here will allow for a more sustained treatment of its construction as it relates to these cultural products, their generation of meanings about Africa and Africans, and their role in mediating racialized identities here in the United States.

Postcolonial Melancholia and Racialized Identities

The time frame of this study covers approximately twenty years, from the 1990s through the present. There are numerous examples from this era that speak to the racial tensions that exist in the United States. Some, such as the beating of Rodney King by Los Angeles police (1991) and the controversy that arose around comments made by the Reverend Jeremiah Wright during the 2008 presidential primaries, make the national news. Other examples never reach a larger public's awareness but are lived in daily experiences of discrimination and/or hatred. While the realms of dolls, theme parks, and popular magazines may seem worlds away from these

occurrences, I propose that they are not. Indeed, the discourses of racial tension that underlie the above examples inflect these cultural products as well. They exist as an often unspoken subtext, subtly informing the ways people think about the world through which they move. It is for this reason that they need to be addressed.

My thinking about these racial tensions and the racialized identities that are interwoven with them is largely informed by scholars such as Eduardo Bonilla-Silva, Michael Omi, Howard Winant, Paul Gilroy, Errol Lawrence, and Stuart Hall. These first three scholars theorize race in an American context, and I engage their work in depth in the next chapter. The last three scholars, working in cultural studies in the United Kingdom, are important because they consider race especially in relation to ideas of imperialism, which is relevant in an American context where the imperial nature of the United States is often ignored or denied. I address their work here to establish this broader context.

Gilroy posits the current social-political-cultural state of Britain as "postcolonial melancholia," a condition that I propose has relevance for and resonates with current conditions in the United States.[30] The onset of this melancholia is a post–World War II phenomenon (the beginning of the decline of the British Empire and its influence and importance throughout the world), and is a response "prompted by 'the loss of fantasy and omnipotence.'"[31] The decolonization processes that took place in the quarter century following World War II, and the resultant influx of former colonial subjects to Britain, visually marked this crisis of loss. This in turn threw into confusion ideas about what it meant and means to be British. I propose that a similar crisis of identity can be seen in contemporary U.S. culture, brought on not by physical loss of empire, but through changes in imperial status and population demographics, and through the increasing vocality and visibility of previously marginalized social groups. These changes frame my entire study.

The effects of this melancholia are profound, especially as they relate to race. By fixing on and entrenching racial categories, people are able to see their world as ordered and therefore more manageable.[32] The desire to control one's world, as it is expressed through ideas about racialized identities, is relevant particularly to my discussions of Barbie and Disney. Such dependency on race can be disturbing because of the material affects it has on peoples' lives, because it engenders racism.[33] As Gilroy observes, race may suggest essentialized identity, it may impose biologically associated characteristics, and it may be used politically to position one's own

group, or some other group, within society in ways that either offer or deny privilege. But none of these uses has been effective in treating the powerful impacts that racism has in society. Indeed, many people have a stake in ideas of race. People of the same race often have shared experiences that help them build a sense of community. Race can give a person a place to belong in a world that can seem alienating. Consequently, Gilroy offers, people hold on to race as an animating concept, even as they work against racism. Race, however, does not produce racism. Rather, the ideological discourses of racism produce the various racial categories by which people are grouped; race is the "complex, unstable product" of racism upon which racism depends.[34] Or, to phrase these ideas in another way, looking at race instead of racism is like looking at the symptom and not the cause; to cure the problem one needs to treat the cause. To accomplish this task, one needs to address the specific social-historical-political contexts from which racism arises. In particular, the colonial past offers insights into racism in contemporary society.[35] Hierarchical social divides (around ideas of race) established at that time have been carried forward and transformed into the present day.

For Lawrence, the fall of empire in Britain, to which Gilroy refers, amplified racist ideologies that had been applied toward former colonial subjects and brought about a crisis of identity. That this was an unconscious social response can be understood, he argues, through the lens of *common sense*. Although common sense presents certain knowledge as if it is a natural truth, common sense is, in fact, more complex.[36] Common sense is composite and contradictory, for it embodies both dominant ideologies and values and the contradictory positions that criticize them. Common sense, however, rearticulates these ideologies in such a way that those contradictions are not seen as separate, competing discourses, but as part and parcel of the dominant values.[37] Commonsense understandings of race prevail, in part, because contested ideas are taken in and reworked within these understandings.[38] One example of this is the success of blacks in sports and entertainment: "With common sense such roles are only fitting for blacks, since these roles provide an outlet for the expression of their 'natural' rhythmic and athletic qualities."[39] When such biological ideas about black bodies appear as common sense, they obscure the historical circumstances that offered sports or entertainment as one of the few career opportunities for blacks in segregated and/or racist societies. This creates a system in which the large numbers of blacks in these career areas seems like a natural occurrence rather than one that was socially

constructed. When such racial ideologies come to dominate social insti-
tutions, they affect all social relations. Indeed, race has effects for both
blacks and whites. It divides them from one another, and neither can real-
ize their full humanity.[40] To work against race, then, is a humanist proj-
ect, one that truly accepts the equal humanity of all individuals. It seeks to
expose and undo this racism. It acknowledges the problems of the past and
present, and their effect on the future. By engaging racism and the racial-
ized differences it promotes, one can move beyond race to a functional
multicultural society.[41]

Accordingly, I argue that playing with Barbie, reading the *SI* swimsuit
issue, or experiencing the Walt Disney World Resort socializes consum-
ers with regard to race, articulating and establishing sameness, difference,
and/or notions of cultural and national identity. And although these cul-
tural forms frequently evidence commonsense understandings of race,
they generate other meanings as well. Mattel, *SI*, and Disney give their
products explicit meanings; consumers decode those meanings. In this
process of decoding, meaning has power and effect, for during this pro-
cess individuals are socialized into those explicit meanings the producers
create.[42] At the same time, meanings rarely exist solely at that level of the
explicit. There are both denotative and connotative meanings, with the
connotative meanings picked up subtly. Indeed, nonovert meanings are
frequently naturalized, and as a result, their social and political implica-
tions for relations of power are not immediately, or necessarily, evident for
either producer or consumers. Attention to them is crucial, nevertheless,
because the way one thinks about the world affects the ways one acts in it.
Both levels of meanings, therefore, provide insights into the various ide-
ologies at work in any given context, as well as into counterdiscourses.[43]
For example, audiences throughout the world decode Disney's messages
similarly; they understand the denotative meaning.[44] Audiences read Dis-
ney's overt messages through these key terms: "romance, heroes and hero-
ines, beauty, evil villains, happy endings."[45] Yet reading Disney in this way
does not mean that audiences wholly accept these messages; the connota-
tive meanings (about the spread of American culture, Disney's global eco-
nomic and cultural dominance, issues of race and gender) may contradict
the denotative meanings and prompt resistance to Disney products as a
whole.[46] People may see the Walt Disney Company as racist or misogy-
nist, or in terms of corporate greediness, even as they identify the positive
denoted meanings in Disney's products.[47]

I address the interactions of the denotative and connotative meanings suggested in the Disney amusement parks, Barbie, and the swimsuit issue as they manifest, produce, and mediate racialized ideologies. I begin from the perspective that there is anxiety in American culture about who we are as a nation, and about what our position is in the contemporary world. These anxieties are frequently articulated around ideas of racial difference, and, moreover, negotiations of these anxieties and ideas of difference are evident in popular culture. This is not a new phenomenon. Nor is it new that these mediations find expression through ideas about Africa.[48] Turning now to African visual culture as the focal point for such representations, I explore this vital connection between Africa and America, especially as it relates to racialized thinking.

America's African Heritage: Visual Culture and Identity

With the "Dolls of the World" collection, the 1996 *SI* swimsuit issue, and the Walt Disney World Resort's "it's a small world" ride, American audiences come into contact with representations of African cultural products, though at DAKL, consumers encounter the objects themselves. Museums, too, are primary sites within the United States for Americans to engage with actual African visual culture, and not just images or representations of it, and although museums are not the focus of this study, the presence of African objects in museums has relevance for it. African visual culture appears in three main types of museums: ethnographic/cultural history, natural history, and art. The same visual culture forms may be found in each, though their treatment—the questions asked of the objects, their presentation, even what they are called—varies. An art museum may focus more on the form and aesthetics of an object (art), while a natural or cultural history museum may highlight its use or meaning (artifact). DAKL takes, for the most part, the approaches of an art museum. But more pertinent to this analysis than determining whether African visual culture is treated as art or artifact is the way museums, and the objects they present, serve as sites of social mediation.

The brochure providing general information about the Smithsonian Institution's National Museum of African Art (NMAfA) connects Africa and America. It informs readers that "more than 25 million Americans trace their heritage to the cultures and traditions of Africa."[49] This is a

simple, straightforward statement of fact. But it also says much more. By including this statement in its brochure, NMAfA suggests its role in representing Africa through the presentation and interpretation of African visual culture; its exhibitions provide foci for understanding Africa's rich and diverse traditions. The sentence also suggests a specific population (African Americans) that has a unique relationship to the objects in the collection because they trace their heritage to African cultures and traditions. And it proposes African heritage as a significant factor for *all* Americans' understandings of themselves; the sheer number—twenty-five million—for whom such heritage is important emphasizes the connection between Africa and the United States as part of one collective history.[50] In suggesting the importance of Africa to a general U.S. history, NMAfA acknowledges the shared history of Africa and America and the complexity of historical, political, social, and cultural interactions and identity formations. I elaborate on these ideas through a brief look at how this museum came to be.

Founded as a private institution in 1964 by American diplomat Warren Robbins, the Museum of African Art was an important site for educating Americans and others about African art. It was, not insignificantly, housed in the Frederick Douglass house in Washington, D.C. Nor is it insignificant that D.C. has a large population of African Americans and therefore a large potential audience who might have an interest or stake in African visual culture in this locale. In the 1970s it became impossible for Robbins to maintain the museum himself, so he offered it to the Smithsonian Institution. A racialized discourse is evident in the 1978 testimonies offered before the Senate Committee on Rules and Regulations, the committee whose power it was to authorize the Smithsonian Institution to acquire this museum. In a letter to Senator Claiborne Pell, Hubert Humphrey wrote:

The Museum is concerned not just with "art", but rather it is utilizing art as a tool for much broader social education in the realm of understanding traditional African values and the philosophical roots of Black culture. There are few educational areas that are more important today as we move into the second phase of interracial affairs in the United States. . . . Surely we cannot disappoint [African Americans] or suggest that their heritage is not deserving of appropriate presentation to the general public.[51]

And Robbins, then director of the Museum of African Art, submitted the following visitor responses as part of his testimony:

> . . . to preserve African art and culture is to preserve the heart of Africa here in America.
>
> Makes me even more happy to be alive and to be of African descent.
>
> Just lovely, develops my ego.
>
> I am delighted that time is given to young people to show them their heritage.
>
> I am pleased to know that our ancestors did something and that our heritage isn't completely forgotten.
>
> Needed for 100 years in the Nation's Capital . . . picks up what White history has left out.
>
> This may be as close to the Motherland as many Blacks will ever hope to see.
>
> . . . your museum adds validity to our noble past and traditions, the elements that sustain and equip us for the future. . . . Keep on so that we may heal wounds.[52]

These testimonies frame the museum and its importance for American culture in myriad ways. Like the Smithsonian Institution's brochure, they identify a portion of the population that has specific interests in and connections to African cultures. They highlight national recognition of African art/visual culture as essential; doing so could help raise senses of self-worth for both individuals and communities of African Americans. And, like the "I am African" campaign and the Smithsonian brochure, the testimonies posit African heritage as a general heritage, valuable to all Americans, not just one segment of the population. Perhaps most significant, these testimonies frame exhibitions of African art as a crucial element for revising American history, for helping to create racial unity among Americans, and for aiding antidiscrimination sentiments. These testimonies attest to the fact that more than simple presentations of African visual culture are at stake in exhibitions of African art; African art is central to how *ideas* about Africa are employed in establishing a sense both of African American identity and a collective American self, and for negotiating the racial tensions of the American social landscape.

Incorporation into the Smithsonian was approved, and in 1979 the museum was renamed the National Museum of African Art. Its inclusion

in the Smithsonian Institution, the national museum complex of the United States, promised possibilities for further bridging the racial divide in American society. Yet a look at the past thirty years of American history reveals racial divisiveness still exists. After Ronald Reagan came to power (1980), there was a backlash against the gains made in the civil rights era. This was due, in large part, to the economic policies of the Reagan era as whites (supported by official rhetoric) began to blame their declining economic status on minorities.[53] And yet as Barack Obama noted, "On almost every single socioeconomic indicator, from infant mortality to life expectancy to employment to home ownership, black and Latino Americans in particular continue to lag far behind their white counterparts."[54] The 2007 median household income, for example, was $54,920 for whites, $33,916 for blacks, and $38,679 for Hispanics.[55] In 2010 the per capita income of blacks remains 35 percent lower than that of whites.[56] With blacks, Latinos, and whites blaming each other for their economic woes, there is little hope or possibility for alleviating racial tensions. These problems, however, are not just bound up in politics or economics; they incorporate culture as well, for race is often spoken about in cultural terms in America. It is therefore important to look also at the discourses that promote racial equality through the celebration of cultural differences, to look at ideas of multiculturalism.

Multiculturalism is, in many ways, a double-edged sword.[57] On the one hand, it celebrates the particulars of a given culture, allowing that culture to find self-worth in those things that make it unique and mark it as different. It recognizes that difference as separate but equal. The recognition of these elements is critical, especially for people who have been marginalized in society, and who, through that marginalization, have been made to feel unimportant and insignificant, and/or who have been subordinated within the dominant culture. In this way multiculturalism challenges Eurocentric ideas of history and culture. In doing so, it often makes race a defining topic. Coming out of the civil rights era, and in the wake of strong feminist and gay rights movements, the cultural pluralism at the heart of multiculturalism was much touted in the early and mid-1980s. The multiculturalist perspectives in the realm of visual culture during this period are indicated, for instance, in the incorporation of a museum dedicated to African art and the opening of the Arthur M. Sackler Gallery of Asian art (1987) as parts of the Smithsonian Institution. This celebratory approach began to change, as people recognized the shortcomings of multiculturalism, including its inability to deliver the harmonious society it envisions. Multiculturalism, then, at times reinforces existing structures of

power, paying lip service to difference, but in the end, doing little to change institutions (schools, museums, churches, governments, and so forth) that privilege Eurocentric cultural conventions. Women and artists of color, for instance, who exhibit in shows with mostly white males may feel they are token nods to multiculturalism, indicating little has changed structurally. That many contemporary African artists are shown in exhibitions that highlight African art rather than being shown in exhibitions of contemporary art more generally may speak to similar practices. Multiculturalism's celebration and focus on culture elide the social inequalities that result from racist attitudes and policies. While the focus on culture may mask issues of race, it does not eliminate them. They exist there as a tension, just below the surface. This is not surprising, for it is within social interactions that cultural difference is constructed and meanings are generated around it.[58] It is critical, therefore, to address these interconnections.

The formation of NMAfA illustrates well the interconnectedness of Africa and America, and emphasizes the role that African visual culture plays both in that formulation and in creating a space for forging interconnections and mediating social relations. It demonstrates that African visual culture serves as foci for (mis)understandings of racial identities in the United States; those identities can be black or white, African or American. Although it may not have eased racial tensions, African visual culture still plays a vital role in how Americans think about racialized identities. In this study, I address the complexities of this role by considering when and how African visual culture comes to have value beyond its original, local meanings. The discussions around the formation of NMAfA, therefore, are instructive of the ways that objects' lives and meanings extend beyond their original contexts. Exploring these new contexts provides insights into the additional significance these objects have. The case studies in this book necessarily reference the local, indigenous importance of the African visual culture, but in examining its deployment in American popular culture forms, underscore the social life those objects have and the meanings those lives generate. Exhibitions of African visual culture may seek to illuminate the local, indigenous meanings of the objects for the museum-going public; they help us to know Africa. They are also sites for negotiating key issues of identity and mediating understandings of the world. The testimonies about NMAfA that were offered before Congress reveal this latter point. Thus not only will the study of African art/visual culture draw us into the world of its makers, but it will also ask us to reflect upon ourselves.[59]

One can, then, think of the use of African visual culture within popular culture as one might think about an exhibition. African visual culture carries with it the meanings of its producers, but its presence in the popular culture context adds meanings to it, just as presenting it in a museum exhibition adds meanings to it. My examination of the 1996 *SI* swimsuit issue, Mattel's world of Barbie, and the Walt Disney World Resort demonstrates that popular culture and African visual culture interface in ways that illuminate the interconnectedness of ideas about racialized identities, especially as they intersect with the discourses of tourism, imperialism, nationalism, multiculturalism, and nostalgia. My consideration of these cultural icons addresses both the benefits and problems in how Africa is imaged in and imagined through them.

Real World Implications: The Nexus of Africa and America

I have been arguing throughout this introduction that Africans and Americans are intricately intertwined, and that the effects of images of Africa in American popular culture can impact the world around us. In the example of the formation of NMAfA, many believed that presenting Africa in America would influence understandings of racial awareness and tensions in the United States. They believed such presentations would have a profound effect on how African Americans in particular might be viewed and might view themselves. The connection between Africa and America extends conceptually beyond the national boundaries of America, with representations of Africa having real implications for Africa as well.

Foreign aid to Africa comes in a variety of forms: direct aid through monetary contributions as part of the U.S. government's annual budget, aid through international organizations like the World Bank and the International Monetary Fund or nongovernmental organizations, aid through investment in or trade with African businesses, and aid through private investment, among others. Perceptions of Africa affect how much and what kind of aid (in kind or through development) is offered. This is especially true now that the Cold War is over, for Africa is no longer seen to have the same strategic value to the West.[60] In fiscal year 2004, for instance, foreign aid was only 0.9 percent of the entire U.S. budget. Of that 0.9 percent, African nations received 18.3 percent.[61] This means they received 0.162 percent of the U.S. foreign aid budget—less than one-fifth of 1 percent of the budget. For a continent with more than fifty nations, this is barely a drop in the bucket.

In general, many see lack of specific information on and knowledge about Africa as the biggest problem for promoting aid.[62] African countries that are economically and politically successful are often ignored because ideas about Africa's failures predominate. Additionally, few distinguish individual countries from one another; Africa is thought of as one entity.[63] Its problems are not deemed worthy of the time and effort addressing them might take, which results in less aid being supplied.[64] In short, Africa is seen as a "basket case."[65] Stereotypical ideas about Africa and Africans that resonate with some of the ideas I noted in the discussion of the "I am African" campaign feed this idea of Africa as a basket case. For example, Africa is seen as a dangerous place, and Africans are viewed as inferior (which, as it relates to foreign aid, frequently manifests as a perceived laziness).[66] In a study of private investment in Africa, the authors spoke directly with investors to better ascertain the perceptions that were informing their decisions about whether to invest, or how much to invest. One respondent offered, "Africans are perfectly happy falling asleep under a mango tree and leading a subsistence life."[67] As this statement indicates, it is not simply lack of information that influences perceptions but misconceptions as well. These, in turn, prevent full engagement with the material conditions of Africa and the lives of Africans.[68]

Still, some reflect on Africa as it relates to lives in America, citing the American jobs that are linked with Africa through trade.[69] Others analyze U.S.-Africa relations specifically in terms of African Americans or highlight African Americans as a special consideration when thinking about Africa.[70] The way African Americans might vote, for instance, influences U.S. policy toward Africa.[71] In their focus on the connection of African Americans and Africa, these approaches resonate with the way Africa was talked about in relation to NMAfA. Perceptions of Africa also affect Africans living in the United States. For example, Krista Thompson writes about Africans who served as community scholars/presenters for the Smithsonian Institution's African Immigrant Folklife Program in 1997.[72] As presenters, these individuals were responsible for explaining to the audiences the performances and events that were occurring around them; they were available to answer questions the audience might have. Thompson relates that these individuals were keenly aware of their role in mediating Africa for an American audience. One of their main concerns was countering stereotypes, stereotypes they themselves encounter while living in America. Whether in the realm of economics, politics, or culture,

the emotional, psychological, and material ways in which people experience their lives is at stake in representations of Africa.

Exploring African visual culture in American popular culture reveals the myriad imaginings (both positive and negative) of Africa in America, and exposes how America imagines itself through ideas of Africa. This unavoidably involves issues of race, for many contemporary ideas about Africans stem from perceived racial differences (both historic and contemporary) between Westerners and Africans. Moreover, because of the slave trade, and the large numbers of people of African descent who live in the United States, it is not only binary oppositions (Africa/the West; black/white) at work. Rather, cultural representations of Africa, Africans, and African visual culture are at the nexus of a triangulation of racialized identities: Euro-American, African American, and African. They intersect and interact in complicated and often convoluted ways.

Swimsuits, Barbie Dolls, and Amusement Parks: The Case Studies

The following chapter delves into the larger discussions of race that inform the entire study, doing so through an analysis of the 1996 *SI* swimsuit issue. Tyra Banks and Valeria Mazza appear on the cover. Banks is the first, and thus far only, African American model to appear on the swimsuit issue covers. The lens of race and celebration of this achievement framed most media discussions of Banks's presence. Yet because this swimsuit issue was shot in South Africa, and given the largely white readership of *SI*, I consider the interplay of ideas about black bodies as they relate to African Americans and Africans. Specifically, I focus on the photographs that feature black models Tyra Banks and Georgianna Robertson. Anchored in the conventions of various photographic traditions (fashion, advertising, and ethnography), these images map ideas (through costuming, poses, and setting) about Africa and Africans onto the bodies of these non-African black models. This conflation perpetuates and creates disparaging ideas about racialized identities both in Africa and America whereby black is seen as less than white.

My examination of this swimsuit issue continues in chapter 3, turning away from black diasporic bodies to consider the ways that African visual culture, in the form of Ndebele clothing, beadwork, and mural painting, highlight the South African locale. I analyze the two images that were

taken at Ndebele sites with regard to cultural tourism and travel photography, and through interviews I conducted with Ndebele participants. I argue that *SI* presents Africans as inferior to Westerners, at the same time positing the traditional/modern dichotomy as a means to mediate contemporary American identity. Yet a divergent narrative exists. Concurrently, I argue for an understanding of Ndebele participation in this project as one of self-representational agency. For these Ndebele women, their representation speaks to autonomy, pride, cultural cohesion, and economic power.

The armchair travel promoted by the swimsuit issue is also important to Mattel's "Dolls of the World" Barbie collection. In chapter 4, my analysis of the costuming in this collection reveals differences in ideas circulating around African Americans and Africans. Whereas the swimsuit issue conflates African Americans and Africans, Mattel treats them distinctly, though not equally. Here African Americans, aligned with Euro-Americans, are privileged over Africans. This is evident in the options that the clothing suggests for the dolls and, by extension (through play or collection), for the dolls' owners, as well as in the ways costuming evokes ethnicity and nationhood. I examine Mattel's use of dress and adornment in light of issues of nostalgia, imperialism, and identity in post–Cold War America. I focus specifically on kente, a strip-woven cloth, for dressing Asha (an African American Barbie) and Ghanaian Barbie.

In the last two chapters, I turn to the Walt Disney World Resort near Orlando, Florida, where many of the ideas I discuss throughout the book are manifest. Drawing on insights about the relations of power inherent in cultural representations, chapter 5 explores the role of narrative and history in Disney's presentation of Africa.[73] Although I touch upon Africa's many appearances, I focus on the "it's a small world" ride. The ride's story of multiculturalism suggests a breaking down of cultural boundaries; yet the representation of Africa actually reinscribes boundaries, creating and reinforcing an ideal of a small, *white, American* world.

Chapter 6 analyzes DAKL and its collection of African visual culture. To provide a safari experience, DAKL re-creates the African savanna in Florida. Visitors can eat African food, watch African animals roam past the windows, talk with African "hosts," and see African visual culture. Some visual culture is used simply as decor. As part of the lodge's (neo) colonial atmosphere, it contributes to the overall representations at DAKL that present Africa as more natural than cultural, Africa as black Africa, and Africans as subservient to white Westerners (a large Disney racial demographic). Such representations resonate with the other case studies,

and I draw out these connections throughout this chapter. African visual culture is also presented as art in didactic displays, where Disney explains the cultural use and context for the objects. Here Africa is constructed, through ideas of "traditional," as nonmodern. At the same time, these formal displays, along with the presence of actual Africans at DAKL, undermine the messages that the decor creates. The visual culture is presented in ways that focus on the human population, and hence the cultural, and not natural (like the animals that are the focus of the DAKL experience), aspects of the African world that emphasize similarities between Africans and Americans. I discuss the tension between these messages through the lens of museum scholarship that engages the collection and display of other cultures. In teasing out the complexities of racialized identities here, I return to ideas of exhibitions as mediations of key issues of social identity.[74]

The concluding chapter synthesizes these discussions about the various ways that Africa is imaged and imagined through American popular culture and their implications for conceptions of racialized identities in contemporary society. In addressing these imaginings, I demonstrate their relevance to understandings of both African and American culture. For those individuals who work closely with and think regularly about Africa, much of what I present here will not be new. One cannot help but see these things when immersed in the worlds of Africa. But these are not the individuals for whom I wrote this book. The principal audiences for whom I wrote are not specialists in African visual culture. Rather, I wrote this for those who engage Africa only in passing references, or through brief and/ or superficial encounters, and for those who have not given sustained consideration to the powerful effects that visual culture has in socializing us into perspectives about the world around us. I offer this book as a complement to the scholarship that focuses on specific knowledge and/or the particularities of African places and people. Though essential, as James Ferguson notes, that focus neglects the "Africa" that circulates in the mass media, and, in doing so, loses opportunities to investigate the ways local and global might provide insights into each other.[75] Engaging such issues enables a more comprehensive and responsible discussion of the visual and social relations that comprise this world. I offer this study as one small investment in such discussions.

2.

Race-ing Fantasy

The Sports Illustrated *Swimsuit Issue in South Africa*

In the U.S., race is present in every institution, every relationship,
every individual. This is the case not only for the way society is
organized—spatially, culturally, in terms of stratification, etc.—but
also for our perceptions and understandings of personal experience.
—MICHAEL OMI AND HOWARD WINANT,
Racial Formation in the United States

Valeria Mazza—a white woman—and Tyra Banks—a black woman—
appear back to back in leopard-print bikinis on the cover of the 1996
Sports Illustrated (*SI*) swimsuit issue (Figure 2.1). They are framed against
a blurred background of sand, water, and sky, and the bright yellow letters
of the *SI* logo are half hidden behind their heads. To the left of Mazza is
the white text that announces the year's theme, "South African Adventure,"
and the names of the two cover models. At first glance the South African
locale seems merely the background for this year's photographic shoot.
Shot one short year after the end of the apartheid era, this cover photo-
graph of black and white together in South Africa seems to celebrate this
African nation's new ideal for race relations. Yet the majority of *SI* con-
sumers are American, complicating its meaning, for Americans experi-
ence race differently than South Africans do.[1] This chapter explores the
complexities of the racialized discourses that surround this swimsuit issue
in the United States. In particular, I argue that the swimsuit photo essay
reveals complex issues of fantasy, desire, and race that perpetuate ideas
of white superiority over those with black skin. Because of the presence
of black models on the pages of this swimsuit issue, connections between

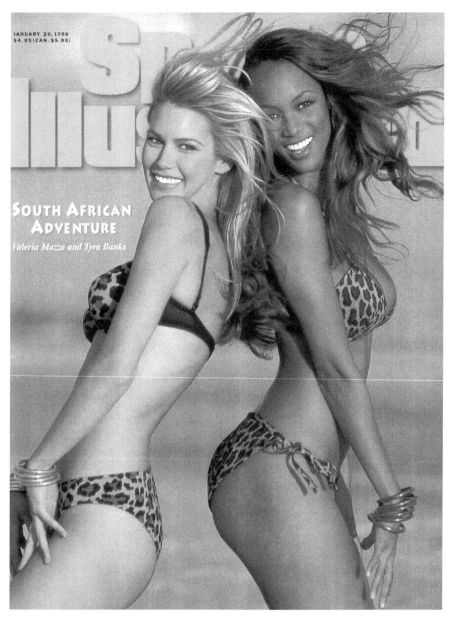

Figure 2.1. Valeria Mazza and Tyra Banks, *Sports Illustrated* swimsuit issue cover, 1996
Photograph: Walter Iooss Jr./Sports Illustrated/Contour by Getty Images

Africans and African Americans add to the racialized meanings these photographs generate. To demonstrate this, I analyze four photographs of Tyra Banks and Georgianna Robertson, the two black models appearing in this swimsuit issue. I do so in terms of the various photographic traditions (advertising, fashion, and ethnography) with which they engage.

A White Habitus

The American press has paid attention to the cover of the 1996 *SI* swimsuit issue in two ways. One is celebratory. Tyra Banks is the first African American woman to make the cover of the *SI* swimsuit issues; and although in 1996 she shares the prestige with Mazza, she alone graces the cover of the 1997 swimsuit edition. In the context of a magazine that presents statistically few women athletes (10 percent) and few women of color (athlete or not), an African American obtaining the cover photo (something all the models hope for) can be seen as an achievement in the face of double discrimination.[2] This achievement may not be all it seems. The models of color who have appeared in the swimsuit issues since the early 1980s tend to underscore the "racially-biased standards of beauty" promoted by contemporary media in general and *SI* in particular.[3] They have light-color skin and long, straight hair, standards of beauty that posit "white" characteristics as the ideal.[4] Those celebrating Banks's presence on the cover seem willing to overlook the potentially biased beauty she represents. They focus instead on skin color simply in terms of black or white. Such celebrations ignore the complexities of blackness and whiteness as they are socially constructed.

While the presence of Banks's black body next to Mazza's white body on the cover of the magazine signifies racially, the South Africa locale does so as well. South Africa was one of the most visible and overtly racist nations until the end of apartheid in the 1994 election gave black South Africans the right to vote for the first time. Throughout the last quarter of the twentieth century, the racist nature of South African society had the attention of the world community through events such as the student uprising in Soweto and the death of activist Stephen Biko (1946–1977) while in police custody in the 1970s, and the international protests and economic sanctions against the controlling white government of the 1980s. Therefore the locale itself is not neutral. It brings to mind, especially in 1996, this recent history. How are readers to understand this cover? Is *SI* celebrating the

new ideal race relations of this African nation? Is it presenting its version of the rainbow society the leaders of South Africa envision? One could see the cover as presenting progressive race relations. Or Banks's presence on the cover could be a strategy to avoid charges of racism had the cover depicted the usual white model.[5] (Significantly, to date, Banks is the only black model to appear on the cover of the swimsuit issues.) Indeed, although there was this obvious reference to race and thus potentially race relations, it is not, and was not, something that those involved in the production of the issue were willing to talk about. Editor Jule Campbell declined to speak with me at all, and photographer Walter Iooss Jr., who shot the cover image, agreed to an interview but only if race was *not* a topic of discussion. This silence about an issue that is so present in this swimsuit edition reveals tensions about issues of race, both in the context of production (South Africa) and in the context of circulation (the United States, primarily).

The political and social separation of races such as existed under the South African apartheid system was not unique to that nation. Racial separation and domination are an integral part of U.S. society as well. Indeed, the racial conditions within the United States posit American (national) identity as white.[6] Whiteness (and the characteristics and values associated with it) is the standard against which all other identities are engaged, processed, judged, and valued. Given this, it is not surprising that the first black model to make the cover of the swimsuit issue has physical characteristics that can be read as white. Those conforming to such standards are valued by the dominant culture. That Banks's presence on the cover of this issue is read solely in terms of skin color (black and white) suggests this divide is fundamental within U.S. society.[7] But this divide has consequences that reach beyond the context of the swimsuit issue. On the positive side, Banks's accomplishment provides an exemplar of success for African American women. She has translated her modeling achievements into a powerful television career and philanthropic activities.[8] On the negative side, the cover image perpetuates black and white as the paradigm for understanding the world. And this paradigm positions black as inferior.

The positioning of white as the established norm against which everything else is judged proposes a "white habitus."[9] Socialization within this habitus "*conditions* and *creates*" standards of white as positive.[10] In comparison, nonwhite is then viewed as deviant from the norm, and is thus seen to be negative and inferior.[11] This, in turn, affects how whites act toward nonwhite "Others."[12] Racial attitudes and their attendant categorizations

can have very serious consequences in employment, housing, school-
ing, and treatment by the media, among other things.[13] The paucity of
women of color in the *SI* swimsuit issues may be due to the fact that men
of color generally earn less than white men, and therefore do not have the
same appeal as a target audience to advertisers and therefore the mag-
azine itself.[14] Despite laws ensuring equal treatment, African Americans
do not always have the same access to loans for mortgages as whites. In
many instances, they do not even have the same access to neighborhoods
or apartments as whites, or they may be charged more money than whites
for the same living space. As the recent subprime mortgage crisis revealed,
minorities were the victims of policies that placed them at greater financial
risk than other portions of the population; African Americans and Latinos
were harder hit than other groups.[15] Blacks also often face discrimination
in the service they receive or through increased surveillance in stores, on
streets, and in cars.[16] These discriminations are the result of the natural-
ization of the perspectives of the white habitus. Moreover, these racialized
perspectives, as Eduardo Bonilla-Silva notes, "are the *collective represen-
tations* whites have developed to explain, and ultimately justify, contem-
porary racial inequality. Their views, then, are not simply a 'sense of group
position' but *symbolic expressions of whites' dominance*."[17]

In the realm of culture, such symbolic expressions of this dominance
appear in myriad ways. Mainstream representations have positioned black
as less than the middle-class ideal that is part of the ideological picture of
America.[18] In discussing this phenomenon in terms of her relationship to
the representation of blacks in Shirley Temple films, Ann duCille remarks,
"In the U.S., any black is every black. It's not just that we look alike, but
that we're all the same—guilty of the same sins, convicted of the same
crimes."[19] Despite significant changes in U.S. society with regard to images
of blacks, these observations still resonate. In the lived material world, a
specific black body may signify many different, complex, and contested
things; but in much mass media, it remains largely that any black body
will do, and its significations are simplified and often negative. The swim-
suit issue actively participates in this representational practice of equat-
ing all black bodies, and implicitly positing them as inferior. Thus, despite
the seeming equality of black and white offered by the 1996 *SI* swimsuit
issue cover, especially when read with the other photographs in the issue,
the 1996 swimsuit issue can be seen, instead, as a collective expression of
whites' dominance. Black bodies in the photographs are treated differently
than white ones. Although the models' bodies are all sexualized, the black

bodies are more so. And they are further associated with wildness in ways that white models are not. Banks and Robertson, moreover, are conflated with Africans whose colonized and sexualized bodies have been posited historically as inferior to whites' bodies. Such differences position them as implicitly inferior in the context of the white habitus of the United States. Given this, and given the various racialized discourses that inform these photographs, my analysis of these photos demonstrates these representations maintain racial inequality rather than challenging it.[20]

It should not be surprising that the cover photograph alone conveys messages of both racial inequality and racial equality, for a similar tension in representational messages (one that can be read positively, another less so) was evident in the Keep A Child Alive organization's advertising campaign. Furthermore, these representational tensions have foundations in the lived world. Whites generally do not notice that they live in a "white world," meaning that they are not regularly conscious of the racialized nature of their existence.[21] In the late 1990s surveys showed that fewer than 10 percent of white people had a black friend, and many were not even aware of this absence until they were asked about it.[22] This lack of awareness occurs, in part, because of the way whites are socialized. Institutions such as museums, schools, churches, and mass media create and frame the way people see themselves and others.[23] *SI*, in this sense, is like an institution; through image and word it represents specific views of the world and socializes its readers into these perspectives. As with whites who do not notice their lack of black friends, many readers of the swimsuit issues were not aware of the general absence of people of color.[24] It was not until the 1980s, for instance, a good fifteen years after the swimsuit issue was introduced, that readers started writing letters addressing the topic of race in these magazines.[25]

This lack of awareness about the absence of people of color, either in one's life or in media representations, is part of the disavowal of the significance and/or effects of the division of U.S. society along color lines. Such disavowal is especially evident in the rhetoric that proposes that the United States is today a "color-blind" society.[26] This dominant ideological discourse posits that race and racism are no longer issues and that the injustices of the past (slavery, segregation, discrimination, and so forth) have been addressed. Society, this position suggests, has achieved equal opportunity for all, and therefore race need no longer be considered. The power of this stance is evident in the increased battle against affirmative action programs seeking to redress past discrimination.[27] Though,

as indicated by the discussions around the 2008 U.S. presidential election, an election that resulted in a black man becoming president for the first time, race is still an issue, even when opportunities for blacks have increased. The sociopolitical conditions of the United States in the last quarter of the twentieth century were instrumental in this reimagining of a racialized America as color-blind.[28] With the civil rights, gay rights, and women's rights movements, there came an increased visibility of difference in American society, resulting in increased political fragmentation; a decrease in the United States' economic and military stance in the world was occurring at the same time.[29] This threw national and social identities into crisis, necessitating the repositioning, stabilizing, and rearticulating of identities and social positions. Ultimately, this prompted a backlash against those who were perceived to be at the heart of the changes. Ideas, common in the pre–civil rights era, of blacks as lazy and as less mentally capable than whites were/are recirculated and serve to further "explain" the social positions of blacks as an effect of their natural, biological qualities rather than as social occurrence.[30]

The rhetoric of a color-blind society has serious consequences for the material reality of people's lives. Among many, it denies a public space within which to discuss, explicitly, race as a social phenomenon. For instance, whether Iooss declined to discuss the cover photograph of the swimsuit issue because he had previous queries about the issue of race in it, or because he believes in a color-blind society, or for some other reason completely, the fact remains he closed down a discussion. This means not only that the realities of oppression and the structures of power at work around race are not fully dealt with, but also that racist ideologies (conscious or unconscious) can be reproduced in ways that employ language (verbal and/or visual) that masks their racist nature. The visual language of the 1996 issue helps to reproduce the racist nature of U.S. society but does so with the added layering of racial ideas as they are filtered through the lens of Africa.[31] While it begins with the juxtaposition of Mazza and Banks, white and black, on the cover, it does not end there. Throughout the rest of the photo essay, the seemingly different treatment of the models based on their skin color dampens celebrations of Banks's achievement. It also makes evident that significant social subtexts around race are at work.

Before turning to the racialized messages these photographs convey, however, it is necessary to consider the object of this analysis—a photographic essay in a popular magazine—more generally. Doing so will illuminate some of the compositional conventions at play within the images

themselves, and will provide also the contextual framework—advertising and fashion photography—that informs the production and consumption of these images.

Photographing Fantasy

A two-page photograph of Tyra Banks reclined on a beach opens the 1996 *SI* photo essay (Figure 2.2). In it she wears the same leopard-print suit in which she appears on the cover of the magazine. The caption for this photo states: "Tyra Banks, Sandown Bay, Kleinmond, OMO Norma Kamali, NYC ($200)." One can, quite literally, possess the Kamali-designed suit Banks wears. The photographic essay of the swimsuit issue is then, on one level, a series of advertisements. Yet apart from this obvious act of advertising, there are other ways in which these photographs participate in the conventions of the advertising genre. One is the role of fantasy in advertising (a topic to which I return shortly), and another is the physical way in which the models are posed and the meanings such postures suggest. Advertising photography, for instance, generally presents women as passive and sexual.[32] A recumbent position suggests a dependent one because it is not easily defensible, and one must trust the environment one is in; it also conveys "sexual availability."[33] Of the thirty images that make up the 1996 swimsuit issue essay, five depict models in recumbent positions. In this, the photograph of Banks is like the others; Banks and the other models submissively offer their bodies for the viewing pleasure of the readers of this magazine.[34]

Other conventionalized body positions include a tilt of the head or the body, further adding to the notion of submission and dependency. In advertisements, this tilt signals a willing subordination to the person in power, the person toward whom the head or body is inclined.[35] This posture is also evident on the pages of this swimsuit issue; fifteen exhibit some angling of the head or body. In advertising, the cant usually suggests subordination to another person that is present in the advertisement. In contrast, swimsuit issue models are almost always photographed alone; therefore they offer subordination to the consumer. Visually, the models appear accessible, available, and submissive. Even when the models are not alone in the image, the viewer is in the position of power. This is evident in the cover photo where both Mazza and Banks engage the viewer with their eyes, but offer submissive tilts of their heads, looking out playfully and suggestively over their shoulders.

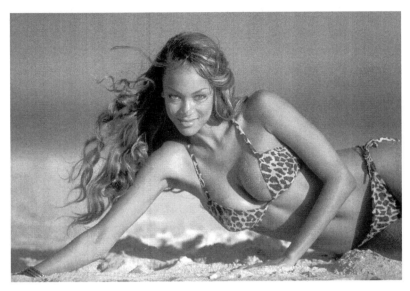

Figure 2.2. Tyra Banks, *Sports Illustrated* swimsuit issue, 1996
Photograph: Walter Iooss Jr./Sports Illustrated/Contour by Getty Images

The swimsuit photographs, moreover, share characteristics with a specific type of advertising, that of the fashion industry.[36] Advertisements, fashion spreads, and the swimsuit issues all use high-gloss images. The models and designers are from the fashion world.[37] The images are presented as a photo essay, a series highlighting the various models in an array of locales. Where the series of images in a fashion magazine might focus on one specific model or designer, the swimsuit issue emphasizes swimsuits in general. The first page of the photo essay for the 1996 edition identifies the hair and makeup artists (François Ilnseher, Pam Grier, and Tracy Y. Crystal). Fashion essays are frequently themed, as are the swimsuit editions:[38] "South African Adventure" (1996), "Nothing but Bikinis" (1997), "Islands in the Sun" (1980), and "City Life on the Water!" (1972). On-location shooting is the core of swimsuit issue photography. Fashion photographers Martin Munkacsi and Arthur Elgort developed this approach, moving fashion photography out of the studio and into the street, presenting models in real settings and in action.[39] And, in fashion, beginning in the 1980s an increased interest in internationalism resulted in the presence of models of color, and a trend toward the erotic.[40] *SI* followed fashion photography trends by increasing and/or emphasizing the

presence of models of color and offering more explicitly sexual poses during this same time period.

But as much as *SI* swimsuit photographs evidence compositional and structural similarities with fashion advertisements, they resonate much more significantly with the way these advertisements function. Advertisements do not sell reality as much as they sell an ideal of what might or can be, and/or ideals of what or who one might be.[41] When a consumer identifies with an advertisement, she or he is identifying with the "properties of the advertised product."[42] These properties are not the physical, material properties of the product, the type or texture of material from which clothes or shoes are made. Rather, the associated characteristics, the image-making ideals, sell these products: glamour, wealth, popularity, success, love, and so forth. The consuming public knows that advertising and fashion photographs construct idealized worlds even when seeming to present things as they are.[43] The power of advertisements, therefore, lies in their connoted messages: messages about lifestyle.[44] As such, they allow for the consumption of lifestyle through the (imagined/dreamed of) consumption of goods.[45] The swimsuit issues work in the same way.

The models appear playfully in swimsuits in locations around the globe, though not really to sell the swimsuits. Rather, they sell a glamorous life of leisure and world travel that one attains through visual consumption of the models. This takes place through the product of the swimsuit issue itself. After all, the swimsuits that are advertised are for women's use, yet the readership of *SI* is chiefly male.[46] Where advertisements offer pleasure through the purchase of a product, fashion offers pleasure through possession of the magazine itself.[47] Here a comparison to pornographic magazines is useful, as the commodity is also the magazine and not some product advertised within it.[48] Like pornographic and fashion magazines, the swimsuit issue does not necessitate an additional purchase to ensure it generates pleasure. Like those other magazines, the swimsuit issue photographs position the reader "as a satisfied (and satisfiable) consumer."[49] Through these mechanisms, the swimsuit issue offers erotic or aesthetic satisfaction to its readers; yet it offers larger social satisfactions as well. The viewer/consumer derives satisfaction from the positions of power occupied vis-à-vis ideological relationships with the photographic image. In the case of the 1996 swimsuit issue, that ideological relationship is especially racialized.

Here it is useful to understand ideology as "the representation of *imaginary relationships* between *real* things."[50] On the pages of the *SI* swimsuit

issue, images of real people (models, indigenous Africans) in real places (the Kalahari Desert, Cape Town beaches, a game reserve, and so forth) confront the viewer. Nonetheless, imaginary relationships are generated. The majority of the swimsuit models are sophisticated, idealized, and exaggerated versions of the girl next door.[51] As such, they are seemingly accessible, and this accessibility is important both for the ideological and fantasy elements of the imagery. Accessibility is also achieved through on-location shooting; one could travel to the specific locale pictured. In fact, the fantasy of place and model supersedes the reality of the fashion elements on the pages of a swimsuit issue, enabling fantasy to convey ideologies of power. The models, for instance, appear in locations that are not near water (in the 1996 issue these include the Kalahari Desert, an Ndebele village, and the Mala Mala Game Reserve, among others) and so beg the question of why one would be in a swimsuit in the first place. But practicality is not a necessary element in fantasy; rather, the necessary element is the imaginary relationship that is established between viewer and the subjects of these photographs. Whether one imagines oneself in (relation to) those locations, or imagines oneself with those people, or as those people, or as having that lifestyle, beauty, glamour, sex appeal, money, and so forth, it remains just that—an imagining, a fantasy. But it is a fantasy that positions the consumer in power over the bodies of the models who, as the subjects of the photographs, are the objects of desires. Like advertisements, fashion photographs, and erotic imagery, the photographs of the swimsuit issues sell interpersonal relationships.

Many argue the swimsuit edition images suggest interpersonal relationships that inscribe and reinforce male dominance over females.[52] I want to underscore the reinforcing of a *white* masculinity. Of the nine models that appear in the 1996 issue, only two are black (22 percent), and those two appear in only five of thirty photographs (17 percent).[53] Despite Tyra Banks's presence on the cover of this swimsuit issue, black models have a minimal presence. Occasionally, local people of color appear with the models. At these times the images can be seen to participate in symbolic colonialism.[54] The people who inhabit the locales where the issues are shot are subordinated to the models and therefore subordinate to the readers.[55] Exotic locales are made familiar through both the recognizable, predominantly white models and the context, the renowned swimsuit issue itself. At the same time, the presence of nonwhite bodies serves to create the exotic. This is certainly the case in the 1996 swimsuit issue photograph in which Kathy Ireland poses with two Ndebele women (I treat this image extensively in

the next chapter). Seated on either side of her standing figure, they visually reinforce the position of the West (signified by Ireland) as superior. This, and the differing presentations of the black and white models, combines to offer white as superior to black on the pages of this magazine.

This message is of course subtle, and is not, in all likelihood, intentional. Rather, advertisements are able to convey their messages through the use of familiar sign systems; because the consumer knows these systems, she or he can easily give meanings to the products.[56] The swimsuit images successfully create racialized meanings because they rely on and are born out of conventions of racial representation with which the photographers, editors, models, and viewers are already familiar. It is to these conventions I now turn. Most instances, however, reproduce these conventions unknowingly. Because they are internalized and naturalized, they go unquestioned. To be sure, I am in no way suggesting the producers of the swimsuit issue intentionally created images that can be read as racist. Rather, I am highlighting the ways in which images generate meanings that resonate beyond their explicit content and in which images are inflected with attitudes and biases that have been naturalized to the point of being unconscious.

Black Bodies, Wildness, and Sexuality

In a response to the 1996 *SI* swimsuit issue, Phalana Tiller critiques the fact that the two black models (Banks and Jamaican-born Georgianna Robertson) are shown in animal-print suits, or with animal motifs, and other exotic costumes.[57] Her problem is not with animal print per se, but rather the type of animals suggested. Robertson and Banks are shown in suits with leopard spots, with tiger stripes, or depicting lions. The European and Euro-American models, on the other hand, when associated with animals, are linked to seemingly more genteel animals such as zebras (Stacey Williams), penguins (Rebecca Romijn), butterflies (Manon von Gerkan), and elephants (Angie Everhart). The exception to this is the leopard-print suit that Mazza wears on the cover (I treat this shortly) and a tiger-print suit worn by Kathy Ireland.[58] The photo of Ireland in this suit, however, is tame. Her posture and setting counter any associations of wildness the suit might bring. The photographic perspective locates the viewer in a dominant position. Ireland, photographed from slightly above, stands, fully frontal, straight, and tall in a pool of water. Her left leg, positioned slightly

in front of her right as if the photographer caught her in midstep, barely disturbs the water's calm surface. Her arms and hands are fully extended and straight so that her fingers slightly touch the water because the water is relatively shallow (coming only to midthigh). The result is a somewhat stiffer pose than the sensuous curves emphasized in other photos in the essay. Additionally, behind her proper right shoulder appears to be a small fountain or waterfall (the out-of-focus background does not allow me to identify exactly what it is). Its surface is white (from sunlight on the water?) with dark stripes running throughout, suggesting, not a tiger, but a zebra when one also focuses on the suit.

Yet the black models appear *only* in suits that suggest wild and ferocious animals.[59] Tyra Banks wears the same leopard-print bikini in both images in which she appears. Georgianna Robertson appears in two images with outfits referencing wild animals; both images were taken at the Mala Mala Game Reserve. In one she wears a swimsuit that has both leopard- and tiger-print patterns (see Figure 2.8). In the other she wears a cover-up wrap depicting a lion roaring with its mouth agape and teeth showing. This photograph is a two-page spread; the left page is taken up by a brown wall on which the skull of a kudu is mounted. On the right page Robertson stands, wearing an Ndebele *dzilla* (a brass coiled ornament) around her neck and a semishear wrap by Gottex worn over her left shoulder. The game reserve location and the juxtaposition of lion and kudu evoke hunter and hunted. That Robertson is visually associated with the lion links her with the lion's ferocity and wildness, as well as linking her with the hunter. Her pose reinforces this, for while she is the passive object of the viewer's gaze (she looks off into the distance and does not confront the viewer), she is actively poised. Her right arm presses firmly against the building, her legs are taut, as she stands on tiptoes, ready to spring into action. In this photograph, multiple elements combine to bring to mind ideas about the African bush and safaris: suggestions of hunting, representations of wild animals, and the locale itself. Indeed, safari adventures (see chapter 6) are one of the most common things that come to mind when thinking about Africa.

This certainly seemed the case for the editors of the swimsuit issues. The 1998 issue, whose theme was locations on the equator, presents eight photographs that were taken in Kenya. Of these, three evoke safaris, and three depict animal prints in some form (on the suits or on props). There are an additional five photographs taken among the Maasai, who are one of the most well known African cultural groups, and who are a large tourist

draw. The Maasai frequently become the subject of photographic safaris. That Africa is largely associated with safaris is evident, too, in the 1996 issue. "South African Adventure" appears on the cover, with Mazza's and Banks's names below it. This automatically defines a specific type of South African experience. It promises that one will not just have fun there, but that one will have an *adventure*, an experience beyond the ordinary. Contrarily, past "teasers" are more innocuous and more generic, and often fail to specifically identify the locales: "What's New Under the Sun" (1974), "Splish Splash" (1987), "The Dream Team" (1994), "Beach Party" (2006). There is, on some level, a need, a desire, even a habit, of associating (South) Africa in a specifically defined manner, one that evokes wildness. Along with the photo essay, each swimsuit issue also has articles about the places, people, or sports of the locations. The 1996 South Africa section opens with an essay, "Wild Things," about a "daring" safari in a private game park. Written by E. M. Swift, it begins, "I had a hunch that given the choice between shooting the black rhino and holding fire as the beast charged and tried to impale me, Joseph, our armed tracker, would not shoot the rhino."[60] That one sentence transports the reader to the dangerous wilderness of the African land—there is an armed escort, and a charging animal that reinforces the necessity of that escort. The adventuresome author is the heroic explorer, facing fierce animals, and Swift takes the reader along on this adventure into the heart of Africa.[61]

The magazine constructs more than the animals of Africa as wild, however. It also maps such associations onto human bodies. Placing the black models in suits that evoke ferocious animals implies wildness in the models themselves, and the blackness of their skin associates them with the African locale, and thus Africans, in ways the white models are not. That Robertson is wearing an Ndebele *dzilla* in the above-mentioned photograph further Africanizes her. The association of black models with an African context has a history in the swimsuit issues, for Charissa Craig appeared in four of the nineteen images in the 1982 issue that was shot in Kenya. It is not surprising that portions of the 1998 issue were shot in Kenya as well, given that Kenya and its animal safaris are quintessentially African, at least in an American context. Craig's appearance in 1982 is particularly notable because it was a full eleven years earlier, in 1971, that an African American model had last appeared in the swimsuit issue and then not again for another four years after Craig.[62] While the 1982 issue does not present animal prints, Craig appears in two of the four images that include local peoples, further associating her with Africa. Even one of the

photos in which she is alone associates her black body with Africa, for in it she holds a local gourd on her head. Unlike the 1996 and 1998 issues that depict Ndebele or Maasai individuals, the locals depicted in the 1982 issue are in deep shadow. Because one cannot see their faces, one cannot get a sense of their individuality. These examples demonstrate that *SI* aligns the bodies of the black models with Africa through context, costuming, and props. They portray an Africa that is conveyed as largely black, natural, and/or wild.

Discourses that produce the black body as wild are centuries old, though they became increasingly solidified in the nineteenth and twentieth centuries. They are prevalent in European discourses about imperial cultures' relations to the indigenous peoples of the lands they were colonizing, and they occurred in literature, science, and popular media, among other contexts. They prevail in the United States as well. Social Darwinism, a particularly influential line of thinking in late-nineteenth- and early-twentieth-century America, posited a hierarchy of evolutionary development among human beings and their social institutions. American (European/white) males were at the top of this list, followed by white women and children, and then people of color (with Asians above Africans), who were seen to represent humankind at earlier stages of development. Scientific studies measuring brain size were said to prove the superior intelligence of the white race.[63] In the United States, the belief in race as biologically determined was an integral component of the ideological rhetoric of the Jim Crow era, when degrading attitudes toward black bodies continued to develop, even after the abolition of slavery, as a way to indicate the failure of ex-slaves to "cope" with their newfound freedom.[64]

Ideas that posited blacks as inferior to whites were reinforced, focusing not only on black bodies in America but also on the original location of these black bodies—Africa. Henry Stanley's 1871 search for and encounter with Dr. David Livingstone was commissioned by the *New York Herald*, and Stanley's dispatches to the *Herald* about the expedition solidified such associations, as he frequently referred to "Darkest Africa"; *Through the Dark Continent* was the name of his 1879 publication.[65] Stanley was not alone in conjuring Africa in this manner. Many writers of the time juxtaposed the "rationality" of Europe with the strange wildness colonials were encountering around the world.[66] Westerners imagined Africa as the "Dark Continent," a place void of reason, a place full of danger—from animals, disease, cannibals—and a place in need of the civilizing presence of Europeans.[67] Additionally, in much literature, including Stanley's accounts,

Africa was anthropomorphized. It was racialized through the designation *dark*, and it was feminized, and in this feminization, sexualized.[68] European explorers were talked about as the penetrators and conquerors of virgin territories; Africa was lying in wait for the decisive actions of Europe.[69] Moreover, attitudes toward and ideas about the African land were mapped onto the bodies of African peoples. Africa and Africans as Other to the West's males were attributed characteristics that were associated with females: childlike, needing guidance, closer to nature.[70] At the same time, they implied a threat to Western men, who perceived them as "dangerous, treacherous, emotional, inconstant, wild, threatening, fickle, sexually aberrant, irrational, near animal, lascivious, disruptive, evil, unpredictable."[71] Thus Africans were thought of as either submitting to or unsettling the white male norm. I suggest that such attitudes, though slightly varied, hold currency today.[72] But the feminization of Africa and ambivalence toward Africans also meant that African women, in particular, carried with them the corresponding associations of wildness and danger in a Western imagination. In Rider Haggard's late-nineteenth-century novels set in Africa, for instance, "white/male/civilized" was juxtaposed with "black/female/primitive."[73] With the feminization and racialization of the continent, African women symbolized the possible meanings of Africa; they came to signify especially a primitive sexuality.

One can see an emphasis on the sexual nature of blacks in many arenas. Art, literature, and medical writings of the late nineteenth century produced and reinforced the association of African women with the prostitute—the lowest sexualized European body of the times.[74] Eighteenth- and nineteenth-century treatises on health, physiology, and psychology align with artistic practices and conventions of representation to present a picture of blacks as sexual. The sexual nature was perceived to manifest externally.[75] This explains the profound interest in Saartje Baartman, the so-called Hottentot Venus. Her body, particularly the buttocks and genitals, were the fascination of much of Europe in the early nineteenth century (1810–1815).[76] Sigmund Freud also connected female sexuality, black bodies, and "the Other's exoticism and pathology" with the phrase "the dark continent" to describe female sexuality.[77]

Such associations are evident still in the early twentieth century. African American performer Josephine Baker offered exoticized and eroticized performances in "La Revue Negre" in Paris in the 1920s. The banana skirt in which Baker notoriously performed (Figure 2.3) evokes the clothing frequently worn by African women in colonial postcards.[78] But, more

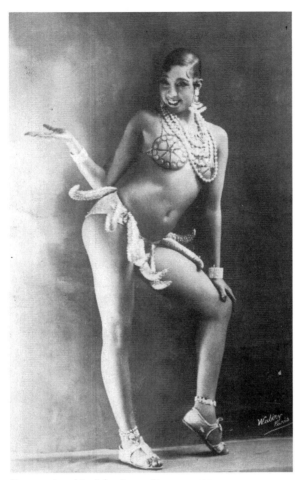

Figure 2.3. Josephine Baker, Banana Dance, ca. 1925
Photograph: Stanislaus Walery/Hulton Archive/Getty Images

important, in presenting herself as savage/sexual, Baker firmly placed her-
self in the realm of being "an 'authentic' *African* body."[79] Slightly earlier,
one need look only to Picasso's *Demoiselles d'Avignon* of 1907 for a connec-
tion between Africa and sexualized female bodies. Here he used African
masks as models for the faces for at least one of the prostitutes depicted.
In colonial thought, the white sexualized female, especially the prostitute,
was linked with the black female.[80] Although I am not in any way suggest-
ing the models in the swimsuit issue are prostitutes, their presentation is
highly sexualized. In that sense, there is no difference between the white

and black models in the photo essay. All are presented for an eroticized viewing pleasure.[81] However, the extent to which they are sexualized differs, and it is to this that I now turn.

On the cover, Mazza and Banks are in profile (see Figure 2.1); Mazza smiles over her left shoulder at the camera, Banks smiles over her right. They lean back against one another, their heads and upper backs touching, their hair blowing in the wind. Yet Banks turns her upper torso slightly toward the viewer, which results in visible cleavage; the view of her left breast is almost entirely one of skin as it is outlined with a thin strip of the leopard-print suit. Mazza looks flirtatiously over her right shoulder at the viewer, but the viewer is visually blocked from access to the skin of her breasts because she turns slightly away, raising her shoulder toward her chin. This turn shows more of her upper back than the front side of her body. This suggests Banks is more sexually available to the viewer than Mazza, whose bathing suit does not reveal the skin of her breasts and whose posture denies access. The formal composition of the image reinforces a racially sexualized reading, while the leopard-print bathing suits posit this sexuality as wild. Additionally, the women, leaning against one another, form a triangle. Their touching heads are the peak and their legs, separated from one another, are the base. Mazza forms more of a straight diagonal (from lower left to upper center) in the pictorial plane. Banks's pose is more serpentine. Her legs angle from the bottom right upward to the left; her lower torso moves in the opposite direction (upward to the right). She arches her back in order to make contact with Mazza, which sends her upper torso back to the right. This also has the effect of emphasizing her breasts, which move forward with the arch of her back, and her buttocks, which end up sticking out in the opposite direction of her breasts. Banks's protruding buttocks visually demands attention; it contrasts to the relative flatness of Mazza's buttocks, and is positioned at the vertical axis of the page. This emphasis on the breasts and buttocks of black women is common in visual culture.[82] Moreover, Banks's posture brings to mind the silhouette of the protruding buttocks of Josephine Baker (see Figure 2.3). Baker's poses in many publicity posters and photographs recalled the body structure of Baartman and other Khoisan women (Figure 2.4).[83] The visual markers of Banks's pose evoke these past images and discourses, perpetuating the associations of blackness with overt and wild sexuality, a sexuality that was linked to Africa through both the figures of Baker and Baartman.

As the promotional photograph of Baker and the ethnographic photograph of the Khoisan woman demonstrate, associations of black skin,

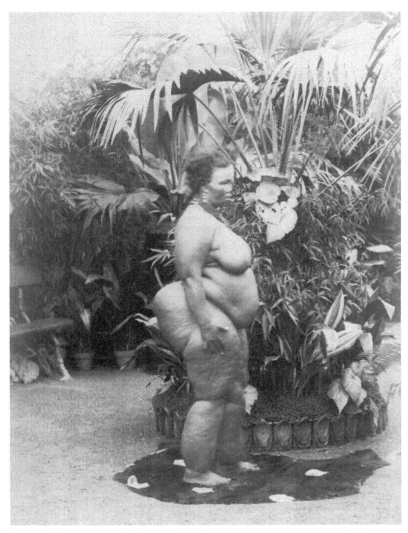

Figure 2.4. [African woman.] Boschimans et Hottentots (Bushmen and Hottentots), ca. 1890
Photograph: Prince Roland Napoleon Bonaparte (French, 1858–1924). J. Paul Getty Museum,
Los Angeles. Albumen silver, 16.8 x 12.1 cm (6⅝ x 4¾ in.)

wildness, sexuality, and Africa were solidified visually as well as in writings. These earlier textual and visual discourses of blackness continue to resonate today. Whether or not the *SI* photographers were aware of these specific photographs, the conventions of photography they represent have been naturalized so as to be common.[84] Furthermore, the *SI* images of

black women in animal prints recall early photographs of African women. Anthropology and ethnography were the most common colonial-era context for such photographs.

Colonial-era photos document the experiences and studies of the explorer, scientist, colonist, and missionary as well as the lives of the peoples they encountered in their work and travels.[85] Right from the start, then, cameras were an important tool in Africa and for anthropologists. And anthropology was an important tool for colonial governments, where knowledge of the indigenous peoples was translated into the power to control them. In the service of empire, cameras could send home images of the labor and resources of the colonies or of the successful work of the missionaries, validating the need for further funding to continue these endeavors. Although often presented as such, photography was not simply neutral or objective documentation. Early photography helped to disseminate stereotypes of the peoples Europeans were encountering around the world, and conventions for depiction reinforced rather than challenged stereotypical and derogatory perceptions.[86] As such, photography was a critical component for anthropological engagement with ideas about race and racialized bodies.[87] Anthropologists could collect photographs of the people they were studying, and these photos provided evidence of cultural and racial difference.

But in the guise of anthropology, photographs of African women also served the dual purpose of erotic voyeurism. Photographs of nonclothed African women were not uncommon. The women in these often held similar stances to the poses of European women in erotic photographs from the same time period. In these images, European women appear in shallow interior spaces. Few objects or furniture share their space, focusing the viewers' eyes on their bodies. The woman is often reclined on a settee, supporting or touching her head with one arm or hand. Still others present women together, leaning against one another, softly touching, or leaning against a draped wall, arms stretched behind the head, emphasizing the curve of the body and the prominence of the breasts. By placing African women in similar positions, the European male photographer bypasses his own society's prohibitions against the enjoyment of such images. Because these African women were already colonized and dehumanized as exotic Others, the social standards that applied to European women were absent. In claiming anthropological interest for the examination of such imagery, study of these images could be scientific and not prurient.

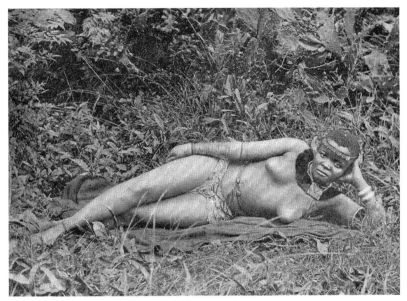

Figure 2.5. Xhosa woman, late nineteenth–early twentieth centuries
Reproduced from Albert Friedenthal, *Das Weib im Leben der Völker* (1910)

In 1910, for example, Albert Friedenthal published a book that pres-
ents women of the world dressed in "traditional" outfits. In it, there is
an image of a Xhosa woman (Figure 2.5), bare-breasted and adorned in
beads: a loin covering, bracelets, necklace, anklets, and waistband. She is
reclined, her head propped in her right hand, on a blanket surrounded by
vegetation. This minimal background ensures the viewer is not distracted
from study of this woman while also serving to associate her with nature
(and thus wildness and not culture). The coy and seductive expressions
of women in European erotic images is absent from this Xhosa woman's
face, as well as from the faces of many of her African counterparts. There
are multiple explanations for why this might be so. The technical condi-
tions of production necessitated long exposure times requiring sustained
nonmovement of the subject. The subject may have been uncomfortable
with being photographed this way. Or it may be because the photographs
were aligned with anthropologic or ethnographic purposes. The absence
of such a look, however, does not preclude its consumption as an erotic
image. Indeed, the caption for the photograph promotes appreciation
of the body on a physical and not a cultural level; it notes the "flawless

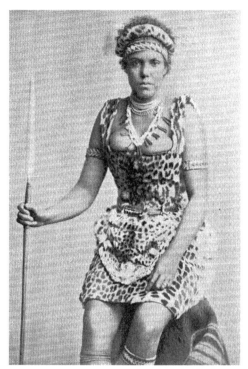

Figure 2.6. Zulu princess in leopard outfit
Photograph: C. Günther, ca. 1902
Reproduced from C. H. Stratz, *Die Rassenschönheit
des Weibes* (1903).

beautiful body-shape."[88] A similar image of a Sotho woman appears in
Carl-Heinrich Stratz's *Die Rassenschönheit des Weibes* (The Racial Beauty
of the Female), published several years (1903) before Friedenthal's. Rather
than reclining, this woman stands, her right leg crossed in front of her left,
her arms raised, her hands behind her head, and her elbows open to the
sides, emphasizing her breasts. Her head, turned toward her left and pre-
venting her from engaging the viewer's gaze directly, invites unchallenged
looking. (This convention is readily visible in the swimsuit issue photo-
graphs; see, for instance, Figure 3.2.)

Additionally, Stratz's book, through its title, acknowledges the racialized
body as the focus of its attention.[89] Two other photographs from this text
present the viewer with studio portraits (the background is a neutral cloth)
of a "Zulu princess." In one, the woman sits, holding a spear in her right
hand; her left rests on her lap. Her costume is a tailored leopard skin—it is

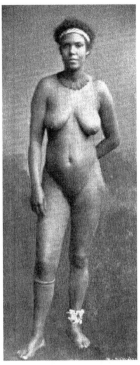

Figure 2.7. Zulu princess standing
Photograph: C. Günther, ca. 1902.
Reproduced from C. H. Stratz, *Die
Rassenschönheit des Weibes* (1903).

tight around the waist. Her breasts are lifted as if in a bustier, and the head of the leopard is positioned in front of her pubic region as an apron would be (Figure 2.6). (This outfit reminds me very much of a French maid's costume.) There are clues that suggest this image is about fantasy as well, and here the voyeuristic possibilities for the photo seem more explicit. For one, hunting is not a woman's activity within Zulu society. Here, instead, the spear and animal skin outfit signal wildness and danger. And while Zulu women did sew their clothes, none were tailored in such a fashion. Nor did Zulu women wear leopard skins, for that was the prerogative of royal men.[90] The ample cleavage created by her outfit emphasizes the sexual nature of this fantasy. So, too, does another photograph of this same woman (Figure 2.7), taken by the same photographer. Here she stands in a full-length portrait wearing nothing but a necklace, headband, and two anklets. Significantly, this is more in alignment with the cultured presentation of Zulu

women at the time, though girls would wear a beaded skirt, or, at min-
imum, a beaded band around the waist. Along with technical measure-
ments of the woman's body, Stratz provides the following description: "The
entire body is well fed and of round forms, the breasts well rounded and
therefore the chest measurement is large ... the width of the pelvis is espe-
cially eye-catching in the picture [with the leopard costume]."[91] Whereas
exact measurements were given for her feet and the space between her
eyes, the above language suggests a nonscientific interest in and apprecia-
tion of this woman's body.

On the pages of the *SI* swimsuit issue, we see remnants of these pho-
tographic conventions: the animal costuming, the sexualized presentation
of the models, their association with nature, minimal background, and the
way Banks and Mazza softly touch each other on the cover of this issue.
All recall both early Western erotic photographs and ethnographic pho-
tographs of African women. One can read the other photograph in which
Banks appears through these conventions and discourses (see Figure 2.2).
In it, she reclines in the sand on her right side, propped up on her arms.
The image is cropped just below her pelvic region on the right side of the
page. There is minimal background to distract attention from the body,
though there is enough detail to know she is on a beach, and therefore to
associate her with nature. In this way, both her pose and setting resonate
with that of the woman in Figure 2.5. The photographic subject (Banks or
the Xhosa woman) is stripped from a specifically identifiable locale so as
to more easily place her in the fantasy context of the (male) viewer. Banks
is in the same leopard-print suit as in the cover photograph, her long hair
blowing in the wind. She smiles engagingly at the viewer, inviting his look.
Indeed, where the photographic subject looks has a large impact on how
the image is interpreted.[92] The acceptance of the viewer's gaze (signaled by
the photographed subject "looking back") is a key way in which subjects
are positioned as submissive, especially when facial expressions (such as
a smile) reinforce the (potential) friendliness of a returned gaze. This is
especially so for photographs of non-Western people.[93] Although not tech-
nically a non-Westerner, Banks functions as one on the pages of the swim-
suit issue. Her black skin reinforces this reading. Given this, and though
taken almost 100 years apart, the photo of Banks in a leopard-print suit
and the photo of the Zulu princess in a leopard-skin outfit are part of the
same discourses associating black bodies with wildness and sexuality. In
both instances, these women were/are presented for the viewing pleasure
of a (predominantly) white audience. Then and now, in the privacy of one's

home, one can construct a fantasy around and through such images. To viewers of today, the Banks image is perhaps more easily read as sexual. Her posture and gaze, like those of the other swimsuit models, have been conventionalized to suggest allure. Nevertheless, the wildness evoked through the suit and its associated sexuality still come together and are framed through the locale: (South) Africa. Africa and its attendant associations reinforce the racialized subtext of this photo essay.

Connections and Conflations: African Americans and Africans

Another example from the 1996 *SI* swimsuit issue will further demonstrate the way Africa frames wildness and/or sexuality for black bodies (Figure 2.8). Wearing a combination leopard- and tiger-print suit, Georgianna Robertson appears in a photo taken at the Mala Mala Game Reserve. Both the suit and the setting connect her with nature and wild animals. She arches against a tree trunk, her left arm raised above her head and framing her face, her right arm reaching behind her to hold the trunk. Adding to the exoticizing nature of this outfit is the wig Robertson wears. It consists of chin-length braids ending in beads that pick up and highlight the shape of the leopard spots in the bodice of the suit. This imparts an ethnic flair, and the wig associates exoticism with ethnicity. This has particular resonance in the context of the United States, where the swimsuit issue is primarily circulated. A broad understanding of *ethnic* might suggest that Americans have a shared ethnicity, through common national, cultural, and/or linguistic heritage. In practice, however, ethnicity is reserved as a way of identifying the many subgroups (Italians, Greeks, Mexicans, and so forth) that make up the American people. Ethnic does not describe the dominant, mainstream culture of the United States, and therefore, in its commonsense usage, references difference, Otherness. At the same time, ethnicity suggests cohesion within a group. Ethnicity, therefore, allows for markers that suggest "being-the-same-as *and* being-different-from."[94]

In this instance, the ethnic hairstyle of the wig marks Robertson as being different from U.S. hegemonic (white) culture *and* being the same as African American culture. The wig associates Robertson not only with African American culture but also African cultures; such hairstyles and ornaments were derived from and inspired by those of African people. They still carry these associations with them today. For instance, visual material connecting African American hairstyles and African hairstyles

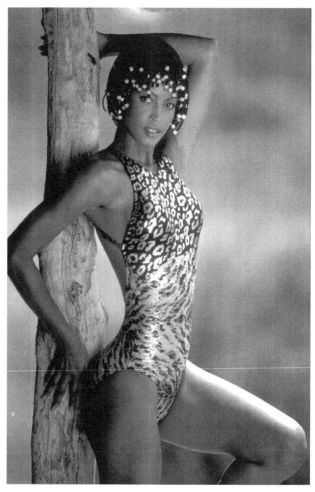

Figure 2.8. Georgiana Robertson, *Sports Illustrated* swimsuit issue, 1996
Photograph: Robert Huntzinger/Sports Illustrated/Contour by Getty Images

is presented in Ima Ebong's book, *Black Hair: Art, Style and Culture*. Lisa Jones writes about the use of *Africa* in the names of hair-care products for the African American community.[95] Bill Gaskins, in the preface to a collection of his photographs documenting and celebrating African American hair, offers that "while many African Americans who wear these styles personally reject any cultural connections between themselves and Africa, their hairstyles amount to an unconscious adaptation of African hair adornment—expressing what I refer to as ancestral recall."[96] And Kobena

Mercer, in his discussion of the politics of black hair, comments on the adoption of clothing and styles of adornment by blacks in the last quarter of the twentieth century. He posits this adoption as a means of recuperating beauty for blacks on their own terms. It rejects European standards of beauty and identity, and invokes Africa as a positive alternative to those conventions.[97] Yet what began as a counternarrative often gets incorporated into mainstream culture. The costumes' specific references are lost, and they become signs simply of ethnic Otherness and exoticism. Mercer argues,

> Like the Afghan coats and Kashmiri caftans worn by the hippy, the dashiki was reframed by dominant definitions of ethnic otherness as "exotica": its connotations of cultural nationalism were clawed back as just another item of freakish exoticism for mass consumption. . . . To make the point from another point of view would amount to saying that the Afro engaged in a critical "dialogue" between black and white Americans, not one between black Americans and Africans. Even more so than Dreadlocks, there was nothing particularly African about the Afro at all.[98]

To the above I would add that Robertson's ethnic hairstyle in this photograph engages more than a dialogue among black Americans, for although the meanings of such hairstyles change depending upon their historical context, the connection of black hairstyles with Africa remains strong. The braids signify Africa and Otherness, not the cultural pride of Robertson. This hairstyle is not a personal statement on Robertson's part; she appears in all the other photographs with hair cropped closely to her head. The hair in this photo helps position Robertson as a submissive (her head is tilted) and therefore nonthreatening Other.

In such images Africa and diasporic Africans are conflated, and this stems from historical connections between these groups. African Americans have been instrumental in making connections between themselves and Africans. For example, Frederick Douglass, Alain Locke, Marcus Garvey, and W. E. B. DuBois promoted, in their own distinct ways, an African American relationship with Africa. Culturally, African Americans have turned to African art and culture as sources of inspiration, as evident in the paintings of Aaron Douglas or the sculptural works of Alison Saar and Renee Stout, to name but three artists. The cross-Atlantic dialogue between anticolonial movements and those fighting for civil rights

prompted, among other things, the adoption of African clothing (such as kente), personal decoration (hairstyles, beads), and beliefs (Kwanzaa) on the part of many African Americans seeking to celebrate and visually express their African heritage. All this serves to connect, broadly and publicly, Africans and African Americans in the minds of Americans.

The political climate surrounding race relations in America impacted the ways that Africa was represented in American popular culture historically as well. Cultural institutions such as zoos, world's fairs, and natural history museums, as well as the American press, reflected ideas about Africa as the Dark Continent, a wild frontier, or bright open spaces and controllable wilderness.[99] The discussion of the National Museum of African Art in the introduction makes clear these are ongoing occurrences. The community support group for African American art in museums is frequently the same for African art. But it is when these connections conflate that problems can arise. Euro-Americans at times projected anxieties they were feeling about Africa and Africans (and all they represented in the American imagination) onto African Americans.[100] At other times, tension around race relations with African Americans in the United States were projected onto Africans, even when those tensions or anxieties had nothing to do with the actual conditions of the other group. In these examples, these groups are linked conceptually rather than historically or biologically. While there are some obvious and important artistic and cultural connections between Africans and African Americans, grouping them together often prevents their distinct cultural and historical backgrounds from being explored as fully as they might be.[101] Moreover, such conflation does not allow space to address adequately the material issues of race these groups experience.

All this is to say, then, quite briefly, that there is a well-established history in the United States of connecting African Americans and Africans via ideas of race and culture. Such conflation occurs on the parts of whites and blacks. The meanings associated with each group can be applied to the other. When these meanings are reductive and stereotypical, they are problematic. Such associations occur, in part, because they rely on sign systems that are familiar to the viewer. They do not challenge meanings. As I have shown, ethnographic photographs, and their representation of Others, are steeped in discourses that posit black/African females as overly sexual, wild, and natural. The animal-print suits and the African locale of the 1996 *SI* swimsuit issue evoke these associations. They map them onto the bodies of the black models, thus perpetuating them

as viable in contemporary times. The treatment of women in fashion and advertising photography as passive, subordinate, sexualized, and objectified also serves to reinforce these ideas. Nonetheless, on the surface, these images can be read as positive. The ideals they present are worthy of celebration: black and white together in South Africa—apartheid dismantled; an African American woman on the cover of the swimsuit issue—social recognition and racial equality in America. That *SI* includes black models in general suggests that, in many ways, racism has been overcome.[102]

In fact, the sociohistorical context that frames these photographs allows for such positive readings upon first glance at the photographs. The predominant view of U.S. society as color-blind enables the continued representation of racist views without their explicitly being understood as such. And yet, as the foregoing has demonstrated, a less positive read of these photographs is also possible. These various messages are conveyed simultaneously. I am, therefore, arguing that there is a racialized subtext of this *SI* swimsuit issue that is manifest through the perpetuation of images that socialize people into ideologies that posit white bodies as superior to black bodies and that present black bodies as more sexually available, wild, and exotic than their white counterparts. The *SI* swimsuit issue leaves little room for an understanding or dialogue that would undo these stereotypes. Without the changing of stereotypes, other negative associations can and will also be reinforced. Indeed, because these photographs deal with race on a representational and discursive level, they are instrumental in giving meaning to race. The fact that such images circulate and give meaning to race without much commentary on their racial nature indicates the levels to which a racial hierarchy is still in place in the United States. They therefore deserve critical attention. Unpacking the racist subtexts, and demonstrating how images might be read with an eye toward their presence, works to prevent passive consumption and the reinscription of those subtexts.

The various photographic conventions (ethnographic, fashion, advertising) that come together on the pages of this issue that reaches millions of viewers each year help to deny race as a problem or a topic worthy of continued consideration. This has detrimental effects. It is problematic for blacks in that it perpetuates negative stereotypes that have psychological, emotional, and material effects on their lives in the United States. It is problematic for whites as well, for all people suffer in racist societies where some humans are thought to be better than others. It has repercussions for Africa. Conflating black bodies with negative representations of

Africa reinforces ideas about Africa and Africans as inferior. This, as I discussed in the introduction, in turn often prevents a willingness to engage with their cultures, politics, economies, and histories in meaningful or helpful ways.[103] Limited meaningful engagement with South Africans, and the positing of Africans as inferior, is manifest also in the swimsuit issue photographs that make use of Ndebele people and visual culture. Those engagements are entangled in issues of tourism, cultural heritage, and economic well-being, entanglements whose complexities demand more than superficial engagement. It is to that story that I now turn.

3.

"It's Sort of Like *National Geographic* Meets *Sports Illustrated*"

The photograph and the non-Western person share two fundamental attributes in the culturally tutored experience of most Americans; they are objects at which we look. The photograph has this quality because it is usually intended as a thing of either beauty or documentary interest and surveillance. Non-Westerners draw a look, rather than inattention or interaction, to the extent that their difference or foreignness defines them as noteworthy yet distant.
—CATHERINE LUTZ AND JANE COLLINS,
Reading National Geographic

Every year the editors of *Sports Illustrated* (*SI*) load models and photographers onto planes and set off for tropical locales with gorgeous beaches and sparkling waters to produce the much anticipated swimsuit issue. The swimsuit issues are therefore framed by travel: the travel of the models to the sites, the "armchair" travel evoked in reading the magazine, and, in this particular instance, my own travel to investigate the 1996 issue. Although these moments of travel are temporally unrelated, they have in common the discourses, spectacles, and commodifications of tourist culture. To elucidate this, I focus on two images in the photo essay that use Ndebele people and visual culture to evoke the South African locale. I touch also upon other images from this same photo shoot that were in the 1997 *SI* swimsuit desk calendar, but did not make it into the swimsuit issue itself. I argue two things. The first is that touristic travel, in the context of this swimsuit issue,

reflects racial conceptions that posit Africans as inferior to Westerners. It is accomplished through representational practices that perpetuate colonial relations, but also by implying the traditional/modern dichotomy as a means to mediate contemporary American identities in relation to the rest of the world. At the same time, as was evident with the other photographs of this swimsuit issue and the Keep A Child Alive advertisements, divergent narratives exist. These images suggest the above meanings for a U.S. audience, but for an Ndebele audience, and certainly for the Ndebele participants in this photographic shoot, they convey different meanings. My second argument is, then, that these photographs speak to autonomy, cultural pride, and economic power, especially as they relate to the postapartheid moment in which the photo shoot took place. This chapter explores these contrasting meanings as well as the intersections of various localities in these representations.[1]

As I delineated in the previous chapter, the discourses of darkest Africa, social Darwinism, and other racial theories that were solidified in the late nineteenth and early twentieth centuries posited Africans as wild, sexual, natural, and uncivilized—all things Westerners were not—and these perceptions emerge in the images in the *SI* swimsuit issue. Such understandings of Africans reduced them to these few characteristics and discouraged meaningful engagement. Photography, then and now, helps to produce, perpetuate, and/or disseminate these ideas. In this chapter, I expand this discussion to consider the presence of indigenous South Africans and their visual culture on the pages of the 1996 swimsuit issue. Where in the preceding chapter I looked at the traditions of ethnographic, advertising, and fashion photography as they informed the swimsuit issue photographs, in this chapter I add tourism and tourist photography to the analysis. Before doing so, however, I discuss Ndebele visual culture and its appearance on the pages of this swimsuit issue.

In the first photo I consider (Figure 3.1), Kathy Ireland stands in the doorway of an Ndebele building, with two Ndebele women in ceremonial attire seated on either side. Ireland's swimsuit, designed by American Norma Kamali, echoes the geometric patterns and colors of the building's painted walls.[2] She wears a felt cap, common to women in Ndebele society, as well as two beaded bracelets. In the second photograph (Figure 3.2), Georgianna Robertson also stands in front of an Ndebele building. Rather than placing her in a suit that evokes the patterning of the murals, she wears only a thong, and has geometric designs painted on her bare breasts. What role did Ndebele women have in this body painting? What

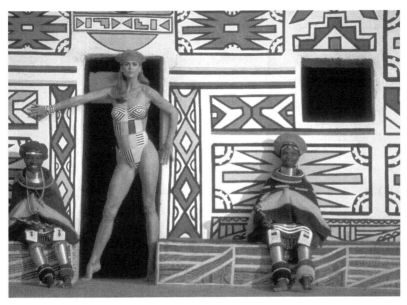

Figure 3.1. Kathy Ireland at Ndebele Village, *Sports Illustrated* swimsuit issue, 1996
Photograph: Robert Huntzinger/Sports Illustrated/Contour by Getty Images

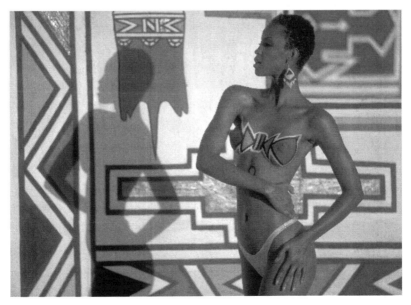

Figure 3.2. Georgianna Robertson, *Sports Illustrated* swimsuit issue, 1996
Photograph: Robert Huntzinger/Sports Illustrated/Contour by Getty Images

were Ndebele understandings of these images? I had to find out. Off to South Africa I went with color copies of these images and the knowledge, garnered from their captions, that these photographs had been taken in a traditional Ndebele village somewhere east of Pretoria.[3] My hope was the distinctive designs painted on the building by which Ireland stood would help me find it and the women posed with her.

On Being Ndebele

The Ndebele people of South Africa paint the walls of their homes and construct their beaded jewelry with stunning geometric patterns. These patterns emphasize white or black outlining of rectilinear areas of solid, contrasting colors. Motifs repeat symmetrically. These motifs are usually abstract, though some murals may incorporate stylized figurative elements. While designs were originally rendered in earth tones derived from natural pigments, the development of synthetic paints allowed for a brighter, more colorful palette to be taken up beginning in the early to mid-1940s. In fact, the decoration of their home walls was something that developed over a great period of time. The Ndebele people entered the South African Transvaal region sometime between the fifteenth and seventeenth centuries. The feuding that caused this migration in the first place divided the Ndebele peoples into three distinct groups: the Matabele of Zimbabwe and the Ndebele groups of the Northern and Southern Transvaal; the Ndzundza is the Southern Ndebele group with whom this project deals. These Ndebele settled mostly among the Sotho, who, like the Ndebele, are part of the Nguni language group. Living among the Sotho peoples, the Ndebele adopted and adapted many aspects of their culture, including wall painting, making it their own. Conflicts with Afrikaners at the end of the nineteenth century resulted in the indentured servitude of Ndebele families on the farms of white landowners, further separating the Ndebele peoples. In fact, these dispersed families often were able to reunite only for ceremonies. Ceremonies, and the decoration around them, thus took on even greater significance for these groups. The ornate decoration of compounds with murals enabled Ndebele individuals to assert a distinct identity from their indigenous neighbors, the British, and the Afrikaners. It also established a means of maintaining cultural identity despite the distances that separated them. Because migratory labor removed men from

the homesteads for long periods of time, and despite the patriarchal nature of Ndebele society, the compounds became the domains of women.[4]

Indeed, the practice of mural painting is intimately linked with the women of this culture. Mural paintings are often associated with ceremonial occasions: *wela* (the time during which boys are in circumcision schools), weddings, and other communal celebrations.[5] At these times women replaster the walls of their compounds and paint and repaint the murals, opening their homes to visiting relatives and neighbors. Their attention to their homes proclaims their pride and honors those individuals being celebrated. Some women repaint seasonally, or as the environmental wear on their homes requires. Still others, such as Francina Ndimande, a successful Ndebele artist, maintain constant attention to their compounds, not waiting for special occasions to repaint.[6] Historically, when young women reached puberty, around the age of twelve, they were secluded and taught painting techniques.[7] While the demands of modern life require boys and girls to attend school, time is still set aside to learn these traditions, even if fewer and fewer individuals are choosing to participate in them.[8] During moments of social transformation, women adorn not just their homes, but themselves; they wear elaborately beaded clothing whose geometric patterns resonate with those found on the walls. It is just this type of outfit that is visible on the two Ndebele women who posed with Ireland.

Driving around the Ndebele region of South Africa I would occasionally stop, hop out of the car, show the image of Kathy Ireland, and ask if anyone could tell me where I could find that particular building. Remarkably (and luckily!), someone could. Before arriving in South Africa I had contacted *SI* to find out where the photo shoot had taken place. Their public relations department could not provide the information, but gave me the name of the tour agency that had arranged the trip. When I contacted this agency, they wanted money for that information—or rather, that I hire a guide to take me there. As I was on a graduate student budget at the time I opted to search for it myself. As I set off on my travels, I envisioned the difficulty I might have in finding this building. I imagined it would easily be hidden from my untrained eyes among all the other painted homes. However, I had just the opposite problem—finding painted homes at all; most buildings in this region just north of Pretoria are plain and unadorned. This is in part due to the decrease in tourism to this area during the 1970s and 1980s.[9]

Interest by the white South African population in Ndebele painting practices had grown in the 1940s when architect A. L. Meiring published photographs of their homes.[10] Tourists began to visit the Transvaal region regularly to see such homes, and the first official Ndebele tourist village, KwaMsiza, was established. There, tourists paid to photograph the people and their homes, and women began selling beadwork to visitors. With the Bantu Homeland Citizens Act of 1970, indigenous peoples were forced into citizenship of the various homelands.[11] As homeland authority and populations grew, population movement was restricted, and income from tourism declined.[12] Women, employed as domestic help in cities, then had long hours of travel to work. The relocation of large groups of people to Kwa-Ndebele (the Ndebele Homeland) also solidified notions of what it meant to be Ndebele, ideas that are still in play today. Following the collapse of the apartheid system, these areas were once again opened up to tourists, and there has been a revitalization of cultural heritage museums. It turns out that *SI*'s "traditional Ndebele village" is in fact one such tourist destination, the Kgodwana Ndebele Village and Museum.[13] It is designed to show the development of Ndebele homes and mural painting as they evolved, over 100 years, from monochromatic designs done in cow manure on circular buildings, to polychromatic designs in synthetic paints on rectangular ones.

When I arrived at the museum on September 3, 1997, I asked if either of the women in the picture with Ireland was present. Luck was on my side; Martha Nomvula, seated to the proper right of Ireland, was there. I showed her the picture. Her excitement and pride in viewing this image were quite noticeable (Figure 3.3). It turns out she had never seen it; *SI* had never sent any of the photos. That these Ndebele participants were not shown the photos suggests that *SI* had thought of them as visual props, as part of the background, and/or as a commodity to be paid for, and not as individuals who may have had an interest in their participation in the project.[14]

I interviewed Nomvula and other Ndebele women who were at the museum about what they thought of the image (Figure 3.4; Martha Nomvula is seated on the far right; Sarah Mbonani is seated next to her; Sarah Masombuka is wearing the straw hat; and Lettie Jiyani is seated to her proper right.)[15] Their critiques focused almost exclusively on clothing, jewelry, and personal decoration. They said that they would never dress like Ireland (they thought she showed too much leg). But they thought the image was okay because they knew that this was how Americans dressed.[16] Figure 3.4 shows these women's dress regularly covers more of their body.

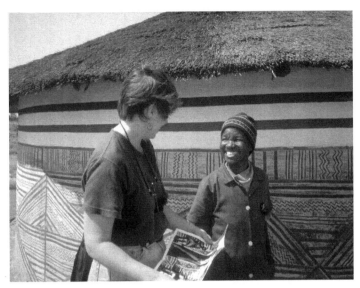

Figure 3.3. Carol Magee and Martha Nomvula at the Kgodwana Ndebele Village and Museum, South Africa
Photograph: Herbert M. Cole, 1997

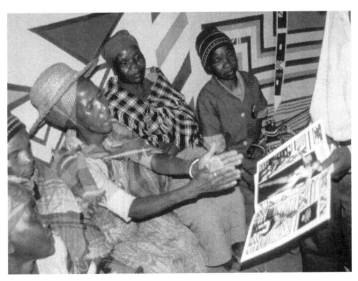

Figure 3.4. Interview with Martha Nomvula (far right), Sarah Mbonani, Sarah Masombuka, and Lettie Jiyani at the Kgodwana Ndebele Village and Museum, South Africa
Photograph: Michael Hamson, 1997

All the women at the museum that day wore skirts or dresses that hung below their knees, T-shirts or blouses, blankets or jackets, and head-coverings of some sort—knit or straw hats or cloth wraps. "Western" dress has been the norm for Ndebele people for decades. Traditional dress such as one sees in the swimsuit issue (and in tourist villages) was out of style for everyday contexts prior to the embellishment of mural painting in the 1940s.[17] Such clothing is now generally reserved for ceremonial occasions, and even then this clothing has been transformed; aprons, for instance, are often "beaded" with plastic strips rather than actual beads.[18] And large plastic beads are coming into use rather than the small glass beads used historically.[19] Only in the Nebo region and areas with lots of tourists do women wear, with any regularity, the *dzilla*—the coiled bands of brass that circle the neck, wrists, and legs (see Figure 3.1).[20] Nonetheless, that these women focused on dress is significant because dress, like the wall murals, marks the person and building as Ndebele. (I discuss the importance of dress in the context of ethnic identity and cultural heritage more fully in the next chapter in relation to Mattel's "Dolls of the World" collection.) As the repositories and conveyors of culture, these women present "Ndebele" to the (visiting) world. The women in the image with Kathy Ireland, Martha and Rose,[21] for instance, wear *liphotu* (beaded skirts), which identify them as married women. The blankets around their shoulders connote authority, connect them with ancestors, and honor their husbands. In the *SI* photograph, as in ceremonial occasions, women wear the colorful Middleburg blankets for which the Ndebele are known. Even if they were not the formal Middleburg blankets that Rose and Martha sport in the Ireland photograph, the majority of women at the museum were wearing blankets around their shoulders. The symbolism of the blanket, and its importance in conveying cultural values, is maintained even when the form changes from Middleburg, say, to any blanket.[22] The plain blankets still speak to those meanings of husband, ancestor, and authority even without a ceremonial context or support of other ceremonial adornment.[23] Knowing the ways the dress and mural designs indicate the maturity and stature of women, I was even more curious to speak to them about their views of the Robertson photograph.

The women's reactions to the photo of Robertson with her painted breasts were much more animated than their responses to the photo of Ireland. They felt uncomfortable with this use of Ndebele designs, but they did not approve of this photo primarily because of the bare breasts, despite the fact that Ndebele women historically did not cover their breasts when

dressed for ceremonial occasions; beaded skirts and jewelry, not tops, were the focus of age-grade clothing.[24] While the women at the museum were primarily concerned that Robertson's pubic area was covered, their remarks focused on her state of undress. Mrs. Masombuka remarked: "We come from our ancestors naked to earth. As we grow on earth we start covering ourselves for public decency, we can't just expose our private parts." Referencing the larger sociopolitical context, Nomvula commented, "Because of democracy, this one [Robertson] liked it but I wouldn't like it to happen in my daughter. Taking democracy into consideration it's her right [to dress that way], but I just don't like it for my daughter." And the interpreter noted that "I guess as far as I [am] concerned, the way I look at it . . . to them [the married women I was interviewing] it looks like more in a prostitute line, you know." I asked how they felt about millions of readers seeing these images; they were thrilled that so many people would see Ndebele culture. They were also excited because Robertson is black, though this was not without its drawbacks; they were concerned people might mistake her for an Ndebele woman, and thus their culture would be misrepresented to the viewing audience. Here the women expressed their understanding of the power of images to convey information *and* misinformation. Their concern thus speaks to their understanding of how they want their cultural heritage to be represented and/or circulated. At the same time, it potentially comments on and reflects their contemporary and historical sociopolitical circumstances. Tourism provides an alternative occupation to domestic service, the primary job Ndebele (and other black South African) women held in the last half of the twentieth century.[25] With mural painting and beadwork as the domain of women, the women became the culture brokers for the Ndebele peoples more broadly. The complexity of this cultural brokerage is beyond the purview of this study. It is important to note, however, that the women at the Kgodwana Ndebele Village and Museum present a picture of Ndebele-ness through beadwork and the decorative murals.

Similar understandings about culture representations were evident with Esther Mahlangu, an Ndebele artist who lives near the museum. She supervised the painting of the designs on Robertson by a *SI* makeup artist. Mahlangu did not share the concerns about the appropriateness of Robertson's clothing. She did not have any problems with the picture and had painted designs herself on the model Iman when Margaret Courtney-Clarke photographed this region and its peoples for *Town & Country* (1992).[26] It is my guess that the differences in reactions are in part due to the social roles

these various women play. The women I interviewed at the museum were there to preserve and present traditional Ndebele culture. Mahlangu, on the other hand, whose art is based in traditional Ndebele visual expression, is an internationally known artist and savvy businesswoman. Indeed, Ndebele women have been recognized increasingly as artists, and their individual success has increased their standing in their own communities, as well as increased knowledge of their art around the world. Museums collect canvases painted with Ndebele motifs.[27] Mahlangu is perhaps the most famous Ndebele artist, and visitors to her compound are made aware of this in many ways. The sign on the way to her compound identifies her as an "art woman" and "the 1st woman who visited overseas." On the wall of the shop at her compound one sees posters from exhibitions of her work. One poster depicts the BMW Mahlangu painted in 1991. Over the years, BMW has commissioned artists to paint a car in their signature style. Among them are American artists Alexander Calder (1975) and Robert Rauschenberg (1986), and Australian artist Michael Nelson Tjakamarra (1989); Mahlangu is in prestigious company.[28]

Significantly, there seems to have been a lack of awareness of or disregard for Mahlangu's artistic status by the *SI* team. For example, Kathy Ireland kept a diary of her trip, and it, or parts of it, were available at the *SI* Web site.[29] In it she states:

Today we shot at a different location. We went to this woman named Ester's [*sic*] house. Ester is a beautiful Ndebele woman, and her home is magnificent. She painted it herself in the traditional Ndebele style. She's a good business person. Sometimes tourists will stop and look at the house, and she charges them 700 Rand to take pictures and look around. I still haven't figured out the exchange rate, but I think that's a couple hundred dollars.

When I was there almost two years after Ireland, 700 rand was about $117, and I paid only $5, or 30 rand, to photograph Mahlangu's compound. This difference could speak to Mahlangu's shrewd business sense in that she recognized she could get more from a corporate entity such as *SI* than the individual tourists who visit her. Additionally, Ireland's comments highlight two elements that relate to the overall themes I am addressing. First, she mentions the relationship that Mahlangu has with tourists; I return to this in a moment. Second, she refers to Mahlangu as "this woman named Ester." That she does not elaborate suggests that she did not know this

woman is a celebrated international artist or a member of a royal family in this region. Nor does it recognize her as an important community member and well-recognized mural painter.

That Ireland fails to elaborate on who Esther Mahlangu is suggests this information is not important to the *SI* team that mediated Ireland's South African experience. Because a tour agency facilitated the *SI* team's time in South Africa, presumably the information was available, or could have been easily found out if it had been desired. What is important, and what Ireland seemingly took away from the encounter, is Mahlangu's Ndebele-ness. Mahlangu was simply one of the many Ndebele women with whom the *SI* team had contact. The team did not, it seems, interact with these women as individuals with interesting or important information to share about their culture, heritage, or lives. Rather, these women were there to create a certain vision of traditional and exotic Africa or as individuals whose role is to facilitate an (Euro)American's experience.

Yet at the same time that I critique this situation, I cannot deny that Ndebele-ness is being sold. The context of tourism is part of the complex process in the visual solidification of what it means to be Ndebele. For example, Meiring's interest in and promotion of the murals and the KwaMsiza village stemmed in part from his support of the Afrikaner National Party and its apartheid system, which promoted racial and ethnic separatism. The Ndebele murals were exactly the kind of ethnic flourishing the apartheid social system desired: separate and contained.[30] On the one hand, this representation of Ndebele-ness served the purposes of the oppressive government, whose policies placed the Ndebele people in situations where the strong maintenance of communal identity was necessary. The Ndebele were not among the indigenous groups originally assigned space in the self-governing homeland system. There were many Ndebele who resisted accepting the independence doctrine of KwaNdebele.[31] The relocation of large groups of people to this area and their living among neighboring peoples nonetheless served to solidify cultural notions of what it meant (and means) to be Ndebele. On the other hand, representation of Ndebele-ness kept cultural values and practices intact in the face of circumstances that worked to undermine them. Additionally, the international renown of Mahlangu and other Ndebele artists solidifies the cultural identity of the Ndebele peoples as marked by the motifs and patterns that decorate their homes and clothing. It brings artists as individuals, *and* as Ndebele, to the attention of people who might not otherwise know about them and their stunning designs. In many contexts, local and global then,

the distinctness of the designs signifies Ndebele. That these designs are important to an understanding and experience of Ndebele culture is evident in Mahlangu's shop. It is filled with dolls, paintings, and jewelry, all of which are covered with bright, geometric patterning.

But these items are all for an external experience of Ndebele culture; these souvenirs are ways of remembering one's experiences in South Africa. Local Ndebele women do not buy these items for their own use. And although Mahlangu's shop is not explicitly present on the pages of *SI*, a touristic experience of Ndebele culture is in several ways. Mahlangu made some of the jewelry the models wear. The Ireland photo was taken at a tourist museum highlighting the development of Ndebele architecture and its decorative embellishment; and, most explicitly, the models fly into the region, spend a few days, and then are off to a new location or home. It is necessary, therefore, to address the touristic nature of the production and consumption of this photo essay.

Touring Cultures

Most of the world's tourists are from industrialized countries. For instance, in 2006 (the most recent year for which I have figures) 615 million people traveled from Europe and the Americas, whereas only 24.5 million traveled from Africa.[32] When traveling in nonindustrialized countries, where the majority of the *SI* swimsuit issues are shot, a tourist has a tremendous amount of economic and social power. For example, one can stay in accommodations that are more luxurious than one might be able or willing to pay for in the United States or Europe. But the power comes not only from what money can buy but also from the privilege that is often afforded visitors to these countries. In my travels in Africa, for instance, I have been given seats in the front of buses and taxis and moved to the front of long queues at banks, despite the fact that I had not requested such things.

Indeed, such relations of power lead many to suggest that tourism is another form of colonialism.[33] The World Bank and the World Tourism Organization encouraged nonindustrialized nations to develop tourism as a means of economic growth in the post–World War II period, as tourism can generate substantial income. This was especially true for tourism that focused on animals. In Kenya, this income ranges from $7,000 a year (per lion) to $610,000 (a herd of elephants).[34] Animal reserves also employ a great number of people. The lodges at the Phinda Resource Reserve

in South Africa, for example, employ over 300 people; some see this as being of greater benefit to the local economy than the farming that took place on those same lands.[35] Yet the effects of tourism on these nations are not as beneficial as they may at first glance appear. Tourism causes numerous economic and environmental problems (overuse of water supplies, damage to ecosystems, forced removal of individuals from lands that then become tourist sites).[36] The local peoples who make their living in the tourist industry earn low wages, and often official tours and hotels are run by transnational corporations, which prevents the in-flow of cash from reaching the local populations. Rather, as much as ninety cents for every dollar may move out of the local economy.[37] This can be seen as a form of economic, not political, colonialism.[38] Yet it involves culture as well, for culture is turned into a marketable commodity. A people's heritage and traditions are presented for tourists' pleasure as consumable authentic experiences.[39] Such experiences are a form of symbolic colonialism.

> Symbolic colonialism by tourists resembles colonialism of the past in three respects. First, colonizers during both periods claim that they have "discovered" new lands and/or people. . . . Second, both bygone colonialism and symbolic colonialism are justified through discourse that maintains that the (post)colonialized regions are uninhabited or uncivilized. . . . Third, colonizers during both periods "capture" people and lands. During past colonialism, the colonizers literally captured the land and/or people of a region, while during the contemporary period of symbolic colonialism the tourist "captures" this land and people in photographs.[40]

Significantly, symbolic colonialism can take the form of traditional tourism with actual, physical travel to a site, or through media representations such as the *SI* swimsuit issues.[41] Whereas one can understand the photos through the framework of symbolic colonialism, at the same time they push against and counter such understandings.

Demographics show that half of *SI* readers travel internationally for pleasure.[42] In one sense, then, it is the privilege of travel, the right to go wherever one wants in the world, to consume new lands and new experiences, that one finds on the pages of the swimsuit issues.[43] Historically the swimsuit issues were framed in terms of tourism and leisure, as Laurel Davis's study of them demonstrates.[44] She argues that in the context of *SI*, men define their masculinity through sports, and in such instances sports

are taken very seriously. The producers of the magazine recognized that their readers might need a lighter way to relax as well. Building on the connection of sports and leisure, *SI* offered the swimsuit issue. Yet many producers of the swimsuit issue do not see tourism as the major framework for it.[45] One producer nevertheless commented that an ideal site for the photo shoot was "an 'up and coming new place for tourists to go.'"[46] That tourism is a motivating concern is evident also in the lead essay in the 1996 issue, "Wild Things," detailing the author's experiences at a South African game reserve. And tourism's primacy is evident in the fact that each image in the swimsuit photo essay identifies the location in the caption.[47]

That this locale be desirable is only part of the equation. The other part is its exoticism, which is also seen as a draw for consumers.[48] The models are all presented in exotic, relaxing settings. When the background is visible in any detailed way, it promotes vacation. The most obvious setting is, of course, the beach, or water, and is the most appropriate for the marketing of swimsuits. Twelve of the thirty images in the 1996 issue depict images of water and beach or water alone. Six more show models on the sand; while four of these are on wide stretches of dunes along the Western Cape, two, in fact, are taken in the Kalahari Desert. One other shows a rocky area that looks as if it could be a beach. The remaining eleven images are near buildings or present the models in ambiguous spaces; two present the models on or near boats. With the exception of the Ndebele walls (and possibly the red sands of the Kalahari), there is an absence of any identifiable visual markers to situate the specific site. Despite the information in the captions, visually the location could be any place. And the implications of this are twofold. One, the (male) viewer can more freely project his own fantastic relationship with the model on an unspecified place: it can be anywhere and anytime. The images are dehistoricized, which leads to the second and more serious implication: the particularities of the place, the lived conditions that the local peoples experience there, are totally denied.[49]

At the same time, the South African locale is ever present as South Africa. But it is a very specific, very idyllic, and exotic view of South Africa that is presented. The viewer does not know if South Africans inhabit or simply visit these areas. Looking at the swimsuit photos, the viewer does not know if South Africans are wealthy, are poor, are suffering still from the effects of the apartheid system, or are celebrating its end. In fact, because visible markers of poverty are absent in many tourist sites, it is not surprising that poverty is not represented in the swimsuit issues.[50] One

cannot escape from one's own workaday world if constantly reminded of others' labors, or, more significantly, the lack of resources and comforts that those labors bring to those people. Constantly engaging with poverty would make it more difficult to spend one's own money on what could very well seem frivolous or extravagant to the people who are catering to and providing these services for travelers. Poverty reminds those with money, those who can afford to travel, that they are privileged. The number of scholars who make note of this phenomenon suggests that for most tourists, a reminder of privilege is uncomfortable in the face of poverty.[51]

The townships that are home to the majority of blacks are sites of much of South Africa's poverty. Only once does one encounter them visually on the pages of this swimsuit issue, even though Rick Reilly's accompanying article, "Swinging for the Fences," details the hardships that arise around sports in Soweto, South Africa's largest black township. If one takes the time to read Reilly's piece, rather than simply looking at the swimsuit photo essay, one is made aware of the economic struggles facing Sowetans. But if one looks at the photographs that accompany the article, only the one that presents a view of boys playing soccer in the Kliptown section of Soweto visually suggests the harsh living conditions characteristic of townships throughout the nation. Here one sees the pieced-together corrugated metal homes and the rows of port-o-pots that serve as toilets for the community. The other photographs that accompany the article show children in some sport activity, with little that provides a sense of their physical context or the lack of equipment about which Reilly writes. Ireland's commentary in her online diary, however, thoughtfully reminds swimsuit fans of the history of this nation. She writes:

> I spent most of the day with my family taking a walk near the hotel. It was sad to see this charming suburban neighborhood with barbed wire fences, guard dogs and huge signs posting the names of security systems. People here seem optimistic about the new government, but it will take many years to reverse the damage. I have great hope for this country but seeing the scars of oppression makes me sad, and makes me think of the oppression that takes place in the U.S. These thoughts stayed with me throughout the day.[52]

Although Ireland was aware of a different story, she was exposed to a predominantly white neighborhood and homes with their security systems and high walls designed to keep blacks out. I, too, stayed in such a

Figure 3.5. A house in the region northeast of Pretoria, South Africa, where a large number of
Ndebele people live
Photograph: Michael Hamson, 1997

neighborhood on my trip. Absent in these instances are the black neigh-
borhoods, where many black South Africans are living in homes without
electricity or running water. All these elements combine in such a way
that *SI* presents a whitewashed view of a postapartheid South Africa. This
view obscures the struggles of the majority population both historically
and contemporaneously. This erasure is even more noticeable when the
location is identifiable, as in the instances with the Ndebele homes. The
way these are presented suggests that the buildings in the Ireland and Rob-
ertson photographs are what typical Ndebele compounds look like, when
in actuality this is not the case. The majority of homes in this region look
like the one in Figure 3.5. In fact, the existence of "specialized places" (in
this instance the Kgodwana Ndebele Village and Museum) allows for pov-
erty to be covered up.[53] In looking at this swimsuit issue, readers can for-
get about the economic, political, and historical hardships of black South
Africans as they marvel at their visual creativity.

 Indeed, it is not just the locations that speak of tourism, travel, and
exoticism. It is also the incorporation of things and people Ndebele. And
these speak of cultural tourism, where the peoples of the places visited

are objectified as part of the spectacle and are part of what is consumed, both experientially and photographically. One can relate the appearance of local peoples in the *SI* swimsuit issues to tourism advertising and promotional images that often feature locals, especially sexualized women.[54] When local peoples appear in this magazine, they are generally nonwhites: boys playfully engaging with the models; men working or in some action of service related to the models; girls and women performing.[55] Such use of local peoples is found in the 1982 and 1998 swimsuit issues that were shot in Kenya. In the former, for instance, Charissa Craig appears echoing the stance of the local fishermen who are silhouetted in the background carrying their fishing baskets on their heads. In the late 1980s local women of color appear in three of the swimsuit issues.[56] They are depicted in the same manner as the Ndebele women in 1996—dressed in "traditional" outfits and thus presenting a striking contrast to the scantily clad models. This costuming adds local flavor, but positions the locals (people of color) as inferior. They are background elements, in positions of servitude, and/or decorative elements.[57] As in the colonial period, these juxtapositions present people of color as culturally different from whites and associate negative ideas (overt sexuality, naturalness, being childlike) with these peoples.[58] This positions whites as superior.

Cultural difference is an important element in the swimsuit issues. As Davis reports, one producer commented, "I think that doing the swimsuit issue in an exotic place gives us an opportunity to discover something about a culture, . . . and appreciate and examine it."[59] Yet with the 1996 swimsuit issue, one does not learn much about South Africa (beyond safari and township sports). This is especially true for the cultures represented through the presence of their visual culture. In contrast, the 1992 *Town & Country* spread presenting Ndebele visual culture provided didactic information about it, and provided the names of the Ndebele women who were pictured. The 1996 swimsuit issue depicts two indigenous South African cultures. Valeria Mazza wears a Zulu beadwork necklace in a photograph taken at Sandown Bay. Beadwork, murals, and people manifest Ndebele culture. Ndebele, however, is the only one identified. This happens in the caption that locates the Ireland and Robertson photographs and suggests that all black South Africans are homogenous. Trained experts in the beadwork of South Africans can identify the cultural specificities, but for the average viewer, such differentiation is nonexistent.

Six photos show models wearing Zulu and Ndebele jewelry. If one also considers the desk calendar that was marketed with this swimsuit issue,

there are four more. One of these is of Georgianna Robertson wearing earrings, four beaded bracelets, and a beaded piece around her neck. I showed Nomvula and the other women at the museum this photo in which Robertson stands holding an umbrella to shade her from the sun at the Mala Mala Game Reserve. The light brown grasses behind her are blurred, as are the wooden sticks that make up a fence in the middle ground of the image. She is dressed in a black, brown, and white sarong by SwimNY Ltd. and a cropped short-sleeve black top. The patterning on the sarong evokes the designs one might see on *bogolanfini* and serves to Africanize her in a manner similar to the *dzilla* and the animal-print suits I discussed in the previous chapter.[60] So, too, does the circle of white dots painted around her right eye, an approach that was echoed in the face painting offered by the "I am African" advertising campaign nearly a decade later. Although the women at the museum use makeup and facial painting to enhance their beauty for special ceremonies, they noted their faces are not painted in this manner. They all believed the circular dots were an element Robertson added for the sole reason that she liked the way it looked; they also liked it.[61] In this South African context, then, the painting suggested aesthetic choices in personal adornment. From a perspective here in the United States, the paint recalls ceremonial performances that include body painting as part of their transformative nature. Consequently, this further aligns Robertson with nonwhite, non-Western bodies, highlighting their exotic nature. The indigenous jewelry adds to that exoticism for *SI* readers, as it does for viewers of the Keep A Child Alive advertisements. The use of ethnic jewelry also serves to transfer the assumed sexuality of indigenous people to the models, who become/are the objects of desire and fantasy.[62] The eroticism and exoticism associated with the model is doubled when the model is not white, as with Robertson (and Tyra Banks in other photos in this edition).

The *SI* team visited the museum several days prior to the shoot and commissioned women to make the jewelry that the models wear. The women were able to identify which of them had made what pieces (Esther Mahlangu made the earrings that Robertson wears in Figure 3.2) and which pieces were made at a different location (as in the case of the Zulu necklace worn by Mazza). Perhaps the most interesting and telling comment about the jewelry came from Nomvula. "Look," she giggled, "she's wearing a jewelry that was supposed to be on the waist, on the neck." The beaded panel that Robertson wears around her neck is a *pepetu*, a young girl's beaded apron.[63] While her giggling may have indicated amusement, it may also

have been a result of nervousness suggesting a level of discomfort at the current use of the beadwork, or a combination of the two. Given Nomvula's other comments, and her role at the museum, I tend to favor the latter two possibilities. In any case, it seems the designers at *SI* had not bothered to find out exactly how the pieces are conventionally worn, though perhaps they had misunderstood. Or perhaps they did not care, choosing to focus instead on their own aesthetic interests. In any case, this misplacement suggests the *SI* team regarded these Ndebele women and their visual culture as commodities to be used as they pleased. As I mentioned briefly earlier, beaded aprons are used to mark the age and social position of Ndebele girls and women, and if *SI* cared about Ndebele uses, cared about "discover[ing] something about a culture," it surely would not have had the models wear the beadwork in such a manner. It also speaks to the superficial engagement that occurred with these Ndebele women, in that a meaningful discussion about the beadwork evidently did not take place. At the museum, then, *SI* found immediately available all it needed to craft *its* picture of an exotic, peaceful, authentic, indigenous South Africa—women to dress in formal attire, painted walls, and women who could make the ethnic jewelry the models wear.

Many Ndebele people, in fact, play into this desire for an authentic experience of the ethnic Other. As Kathy Ireland noted in her diary, while at this museum, local men performed for them. I, too, experienced such a performance of culture there. When our interview concluded, the women, with one man, sang songs and danced. Such performances are the standard tourist fare. I did not ask these individuals to perform, but they *expected* that, as a visitor to the museum, I would want them to, and/or they *wanted* me to see it. Travelers to Africa, in fact, do have expectations, and these are often based on reductive notions of what indigenous cultures and lifestyles are (just as the belief that Americans dress in the manner of Ireland is based on reductive notions of what American culture and lifestyle are). The travel encounters that the models and I had with the Ndebele individuals who worked at the museum were organized around and manifest these expectations. In turn, *SI* creates and re-creates these expectations as virtual travel for its readers.

One can understand such performances as "reconstructed ethnicity" whereby a group may conserve cultural elements such as the ceremonial dress I discuss here, so that they might use it to entertain another.[64] One of the implications of reconstructed ethnicity is that productive interactions are deterred. Each group involved in the exchange around ethnicity

is already solidified into notions of what that ethnicity should be, or what it expects from the exchange. Therefore neither tourists nor performers fully question what their own ethnicity might say or mean or be. Nor do they question their experience of the Other's ethnicity. This was evident and reinforced in my experiences at the museum and around discussions of dress. Power relations in such interactions between the tourist and the indigene reinforce the colonizing subject, for as Dean MacCannell proposes, "if the tourist simply collects experiences of difference (different people, different places, etc.), he will emerge as a miniature clone of the old Western philosophical Subject, thinking itself unified, central, in control, universal, etc., mastering otherness and profiting from it."[65] Many tourist encounters do serve to reinforce such senses of self and the world as well as serving as a means by which an individual can make sense of the world.[66] The superficial presentation of Ndebele culture that *SI* presents allows its readers to "collect" yet another culture (adding it to the cultures from previous swimsuit issues), doing little to challenge the way the reader may perceive the world or the myriad peoples that inhabit it. Reductive or essentialized notions of authenticity and ethnicity provide a way to see the world in easily fillable categories. Yet these performances are not totalizing, and there is need for a nuanced reading of their possible meanings.

The producers, and thus one can assume also the readers, of this popular magazine expect to see indicators of exotic locales in the same way that the Ndebele women had come to expect the liberal exposure of skin as what Americans do. Such expectations may derive from experiences with the models, other tourists, or even American television shows such as *Baywatch*.[67] The constructed nature of the Other's performance did not enter into play in the generation of meanings in these exchanges. Cultural presentations were accepted at face value in terms of experiencing one another's culture. I would argue, however, that the Ndebele men and women who work at the museum are, nevertheless, aware of the construction of their own ethnicity in these instances of tourist encounters. People have their own theories of self-representation, and therefore we must consider their agency in the tourist experience.[68] They are not powerless players in a scene staged and directed by someone else. My own touristic experiences at the Kgodwana Museum confirm this.

Upon conclusion of the interview, the women seated themselves and began to clap an accompaniment to three performers, one man and two women (Figures 3.6, 3.7). The man and one of the women were in full costuming, rather than their everyday clothes. The woman wore an outfit

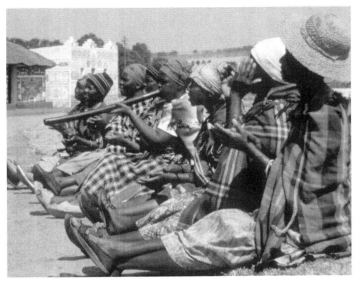

Figure 3.6. Women providing rhythmic and vocal accompaniment to performers at the Kgodwana Ndebele Village and Museum, South Africa
Photograph: Michael Hamson, 1997

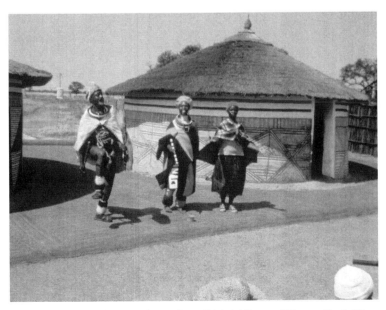

Figure 3.7. Ndebele performers at the Kgodwana Ndebele Village and Museum, South Africa
Photograph: Michael Hamson, 1997

much like the one Nomvula wore in the photo with Ireland: a beaded skirt, neck and arm rings, brass bracelets, a colorful cloth around her shoulders, and a felt hat. The man wore animal fur on his hat and ankles, an animal skin cape and loincloth, beaded rings around his neck, and a beaded panel, with characteristic geometric patterns, suspended from his neck; he also carried a round leather shield. They were dressing to perform their songs *and* their culture for the visitors to the museum that day. It was a conscious decision to present themselves in the manner that they did; the women who accompanied them with singing and clapping and one of the main dancers, for instance, were in their everyday clothes for this performance. Yet it was vital that at least some dress as Ndebele, for the outfits were important for us, as visitors, to see in this context.[69]

When I arrived at Mahlangu's compound, her colleague, Francina, stated that Mahlangu was not there.[70] Not five minutes later, however, Mahlangu arrived, dressed in a complete married woman's outfit like the one Martha and Rose wear in the image with Ireland. I have no way to confirm this, because I did not ask her directly, but I feel confident in asserting that she "was not there" because she was quickly changing clothes for her newly arrived visitors.[71] Mahlangu had a certain image of Ndebeleness that she wanted to portray. This image put the visual arts, the lovely geometric patterning of her compound walls, and beaded clothing at the forefront. I am sure visitors are more inclined to buy souvenir items from someone who looks the part. Dress, as in this instance, can be a smart business move. Ndebele-ness was being sold at Mahlangu's in the form of an idea, but also in terms of objects. While there, I watched as Mahlangu's colleague made the jewelry that was on sale in the shop. Both women, then, guaranteed the authenticity of my Ndebele experience.

It is not uncommon for tourists to see indigenous peoples in traditional garb when traveling to other destinations in Africa. Edward Bruner and Barbara Kirshenblatt-Gimblett have written about the Maasai who perform for tourists visiting Mayers Ranch outside Nairobi, Kenya. There, Jane Mayers "does not permit the Maasai to wear their digital watches, T-shirts, or football socks, and all radios, Walkmen, metal containers, plastics, aluminum cans, mass-produced kitchen equipment must be locked away and hidden from the tourist view."[72] Views of such things would interfere with the picture that is being presented. These Maasai performers, when asked about these restrictions, commented that visitors wanted to see things Maasai, not things European.[73] While this is certainly true, at issue is the fact that digital watches, metal containers, radios, and T-shirts

are, at this point in history, every bit a part of everyday wear for the Maasai as are beaded necklaces, ochre-covered braids, and red cloth wrappers. But these nontraditional items are not what tourists expect and therefore would disrupt greatly their desired experiences. In such instances, because the "primitive" does not exist, it is created for tourists. The hiding of these cultures' participation in "modern" life illustrates this.[74] There are very little means by which tourists can understand an experience of modern Others; too much of the popular imagery and information presented about them denies such modernity. The literature tourists are given for their tours and photographs from such popular culture forms as *National Geographic* (*NG*) construct their experiences prior to their travels. All present the same Africa that tourists encounter in performances of culture such as those by the Maasai at Mayers Ranch and the Ndebele at the Kgodwana Museum. Ultimately this is all right with a great many tourists, for they want (consciously or not) recognizable "spectacles and performances."[75]

The spectacle at Mayers Ranch is one of wildness.[76] In that instance, it is juxtaposed and contrasted with the civility of afternoon tea served on the lawn with the Mayers after the Maasai dances. The juxtaposition of wildness and civility reiterates the colonizer/colonized paradigm at work. Here the "wild" is experienced in a controlled and "civilized" manner. A similar reiteration is evident in the swimsuit issue as well. The photograph of Robertson with designs painted on her bare breasts implies wildness, as do the animal-print swimsuits she and Banks wear. The women in their costuming present a spectacle of Otherness at the Ndebele museum. But when presented with little more than the brightly colored walls of the buildings, the Other can never threaten, only delight. This is in line with the other images of idyllic South Africa that *SI* presents—abandoned beaches, vast desert landscapes, and cool, refreshing waters.

That these images convey a safely consumable wildness is of concern here. Tourism is "safe for contested practices" (such as colonial relations of power and discourses) because tourism operates as a "representational economy."[77] The tourist experience represents the ideas, peoples, and locales to visitors. This experience is generally not an unmediated one. It is important to think, therefore, about how things get represented to visitors, and what these representations might mean. Cultural performances and dress are two forms of representation. Another form that is highly significant for understanding how the swimsuit issue might create meaning for its viewers is that of tourist photography. By this I mean any photograph promoting tourism, postcards, and/or photographs taken by

tourists themselves. Although the *SI* swimsuit issue images are not conventional tourist photographs, they can be seen as touristic images nonetheless. The models and photographers, for example, are tourists (in the majority of instances) in whatever country happens to be the locale for the photo shoot.[78]

Picturing Others: Ethnographic and Tourist Photography

Ethnographic photographic conventions again come into play in this analysis, for the vast majority of late-nineteenth- and early-twentieth-century ethnographic photographs were taken by tourists of one form or another. Certainly these travelers are not the types of tourists one encounters today since leisure travel is not only quite different now than it was 100 to 150 years ago but also leisure, at that time, was not the primary purpose for travel to places such as Africa. In many cases, the tourists then were more permanent or long-term visitors to their locations (missionaries, colonial administrators, anthropologists), but they were visitors nonetheless. Ethnographic photography established their subjects as different, in sexuality and wildness, for example. The ideas such photographs conveyed were often stereotypical, and stereotypes became associated with particular social types. It is this relationship of photography to social types to which I now turn. Scientific inquiry is again significant, for it frames discourses of black bodies.

In the late nineteenth and early twentieth centuries, phrenology and physiognomy were being used to determine individuals' characters; photographs provided visual evidence for these studies. Scientific theory and photographic recording aligned in both Alphonse Bertillon's documentation of criminals and Francis Galton's categorization of social types in the development of the theory of eugenics.[79] Similarly, Louis Agassiz classified American slaves with the aid of photography.[80] In each case, the individuality of the photographic subject is suppressed in favor of his or her social type. These archives provided a body of knowledge against which to formulate understandings of the world. Early photographic records gave the viewing audience "a language for understanding themselves and the limits they must observe to avoid being classed with those on the outside," for it was largely society's margins that were the subject of these classificatory exercises.[81]

The pseudo-scientific approach of French photographer Désiré Charnay, as just one example, shows the influence of such scientific theories.

Charnay went to Madagascar at the request of the French government in 1863 as part of an imperial mission to solidify the French position in Indian Ocean trade. While there, he made photographic studies of the peoples he encountered. In these photographs, the people are largely presented as types rather than as individuals. The dominance of scientific influence on Charnay's photography is evident in "Three Women, Madagascar" (1863).[82] It presents a photograph of three unclothed women. Unlike the photographs of African women that I discussed in the previous chapter, the lack of clothing in this image was not intended to titillate, as is indicated by the poses in which the women are depicted. The woman on the right stands facing the photographer; next to her is a woman whose back is turned to the camera; the third stands facing the other women so the viewer sees the right side of her body in profile. Thus we have in three separate women the poses that scientists were using to document *one* individual in terms of body characteristics. Scientific studies took photographs of people from the front, rear, and side as a way of measuring and recording body types and sizes and other telling physical characteristics. In such treatment, it is obvious also that Charnay was not thinking of these women as individuals whose personality he wanted to represent.[83] Rather, these three women represent an ethnographic type: Madagascar women. This same presentation of types was evident in the photographs of the Khoisan and Xhosa women and that of the Zulu princess discussed in the preceding chapter (see Figures 2.4–2.7). In each of these instances the woman was identified solely by ethnicity, not by her individual name. Charnay's photographs also reveal the way nonwhites were placed within hierarchies in the imagination of Europeans; his treatment of the coastal Malagasy peoples whom he photographed in their (European) clothing was more respectful than his treatment of the Hova peoples depicted in "Three Women, Madagascar."[84]

While not posing the models in pseudo-scientific postures, the 1996 *SI* swimsuit issue photographs evidence this photographic tradition nonetheless. In the picture with Ireland, the Ndebele women are presented as types. They could be any Ndebele women; the costuming and wall painting identify the culture for us. The models, too, can be seen as a type (variations on the wholesome, girl-next-door theme).[85] While certain models have recognition and thus push against typing, they are replaceable—one model could be as good as another model (not in terms of skill in modeling but in the cultural role that a model in a bathing suit plays in the swimsuit issue). The implications of such typing, then and now, are great, for as Brian Wallis notes, "the emphasis on the body occurs at the expense of

speech; the subject is already positioned, known, owned, represented, spoken for, or constructed as silent; in short, it is ignored. In other words, the typological photograph is a form of representational colonialism."[86] In this representational act, the photographer has power over the silenced subject. If the photographic subject has any voice, it is the one the photographer establishes and defines. Such relations of power and representational colonialism are obvious in both tourist photographs and the swimsuit issue images.

These relations of power play out in many tourist contexts, and the camera mediates these. One can see, for example, "the dominance of the camera- and money-wielding foreigner over the spear-carrying native" in tourist images of Kenya's Samburu warriors.[87] Or one can liken the tourist photographer to a hunter on safari; the tourist shoots, thus capturing the subject, and then presents the photograph as if tendering a trophy.[88] In these instances, the African subject is positioned, represented, and thus spoken for as so many colonial subjects were.[89] The tourist/photographer has control over how the subject is framed and given meaning. In the 1996 magazine, the models and Ndebele women are silenced. The viewer comes to know their bodies, visually, but not the women themselves. Yet with the models there is still some sense of individuality, even if they can be read as the-girl-next-door type; their names are known, their faces recognizable.[90] On the other hand, the Ndebele women, *as individuals*, are silenced due to their Otherness. The viewer can know them in no other way than in this superficial, reductive representation of Ndebele-ness. Martha and Rose are positioned, owned, represented, and further spoken for as ethnic types, as Ndebele, as Africans.

Presenting Martha and Rose only as ethnic types serves to establish the authenticity of the tourist experience. Many travelers in Africa feel that if they do not have an experience of animals or indigenous peoples, they have not had a true experience of Africa. Thus tourists seek out such experiences and photograph them, thereby proving they had an authentic experience. Moreover, photographs used to promote tourism socialize the tourist to these expectations.[91] The archive of tourist photographs helps define tourists' visual experiences, just as the archives of ethnographic photographs constructed ethnic types. There are brochures and posters that advertise locales to visit and spectacles to experience. Once at these locales there are postcards as souvenirs for the traveler's friends and family. Almost all these images center on the spectacular, the extraordinary, and/or the exotic. The conventions of these images send the traveler into

the world with preconceived ideas of what to see, how to see it, and how to understand what they see.

Although not a tourist publication per se, *NG* has been a vital source for Americans' visual understanding of other peoples around the world for over a century, and *SI* shares characteristics and approaches with *NG*.[92] This is true in terms of structure—*NG* offers images in photo essays as does *SI*—as well as in terms of content. *NG* represents non-Western peoples in four basic ways: exotic, idealized, naturalized, and sexualized.[93] These are all elements that the swimsuit issue photographs include in their portrayal of non-Westerners and/or the black models.

There are also, as Catherine Lutz and Jane Collins note, particular conventions of *NG* photographic representations of non-Westerners that inform the way Americans understand the peoples with whom they share the world.[94] While not all these conventions of photography are present in the swimsuit issue, the majority are. Those that are not are absent largely because they are irrelevant to the content of the swimsuit issue. One of the most prevalent shared conventions is the use of ethnic clothing to mark difference and distance, and the ethnic photographic subject is idealized, often in the guise of the noble savage. Notions of youth and beauty predominate and frame visions of the peoples of the world. Color photography creates slick and spectacular objects for viewing, emphasizing these idealizing tendencies. It also gives viewers the sense that they can touch, and thus possess, the photographic subject; she is real.[95] *NG* presents a middle-class world. No poverty is present, and therefore the viewers do not have to contemplate topics that may make them uncomfortable or lessen their reading pleasure. Societies are presented as being without history; change is denied, and this results in the photographs in *NG* positing "two worlds—the traditional [the non-West] and the modern [America]."[96] Finally, Lutz and Collins note, *NG* has conditioned viewers to the representation of naked black women.

I have already discussed how clothing and jewelry have been used to mark the South African landscape and people as different and, in that difference, distant. Moreover, this distance references both space and time. The difference signifies not just a place that is far away from the viewer but also a time. Whereas the viewer's time is modern time, the non-Westerner's time is the nonmodern, the traditional. The Ndebele women appear in ethnic clothes. This suggests that they wear such clothing on an everyday basis, even though this is not the case. There is nothing in the photo essay showing cities or cars or other commonsense signs of modern life or the

economic plight facing the majority of black South Africans. The Ndebele women in the *SI* photograph, while mature members of their society, are not old; certainly the models themselves are epitomes of beautiful youth. And despite the problematic subtexts the photographs in this swimsuit issue present, in the photo with Ireland, Martha and Rose appear dignified, a representation appropriate to their status within their own communities. Their difference is not wild but contained. In fact, the wildness and sexuality commonly associated with African bodies have been transferred to the bodies of Robertson and Banks. The photo of Robertson against the Ndebele wall even provides the bare-breasted black woman.

Indeed, tourists subconsciously learn to frame their images of Africa from professional images of Africa such as those found in *NG* and the *SI* swimsuit issues, ensuring that the difference they encounter is familiar and manageable.[97] And most of this goes on without the photographer (professional or amateur) knowing the extent to which he or she has been socialized into the underlying conventions and themes that frame popular views of Africa and Africans. *SI* photographers, for example, are not consciously incorporating the standards of representation found in *NG*. Nor are tourists intentionally mimicking these professional depictions. Rather, all are participating and communicating in what has become a culturally common visual language to represent the non-American world. It is crucial to remember, too, that at the same time these images construct understandings of Africa, they are constructed by them as well. In using the term "constructed" I want to call attention to the fact that many social meanings are generated through these photographic representations, and that these representations are composed based on a priori social ideas. They are manipulated presentations, not straightforward recordings of peoples and places. This constructed/manipulated imagery makes evident the fantasies and desires that inform these photos.[98]

A viewer of tourist photography can fantasize about the locale in numerous ways. Maybe it is a place one wants to visit, or maybe one reminisces about one's actual experiences of it. In either case, the image serves as a site around which one imagines. The fantasy of the tourist image is, therefore, similar to the fantasy that fashion and advertising photography offer. All three photographic genres work to generate desire, and they offer lives (or portions of lives) other than what an individual is currently living. All offer the possibility of constructing oneself in new ways. Wearing certain clothes, driving certain cars, visiting certain locales, or partaking in certain activities promises transformation: to be more beautiful, more

sophisticated, more adventuresome, more whatever it is that seems to be missing from the workaday life. And, as in advertising and fashion photography, the desires evident in tourist photography are articulated subtly and implicitly. These desires seem natural. Viewers are not consciously aware that the images have powerful subtexts that manipulate them into desiring the products or experiences. The realism of the photograph in these genres enables the successful generation of these desires.[99] The technical aspects of the photographic process present the viewer with a representation of something that exists in the material world.[100] The camera lens is pointed at a subject, and that image is recorded. The viewer knows that an actual human would have taken a photograph of a spectacular vista, and this knowledge promises that the viewer, too, can stand at that spot and take the "same" photograph. The desire for a dress, car, or experience seen in a magazine can be fulfilled: one need only to shop or travel.

But it is important to look beyond the mechanistic recording afforded by photography to the generation of meaning as well. In scientific photo-documentation, the photo is metonymic—it represents something that "stands for itself," whereas in art and advertising, photos are more often metaphoric "allud[ing] to meanings and understandings outside the picture."[101] Travel photos are both metonymic and metaphoric as the content is often documentary (a photograph of a South African beach stands for that beach), but the context of their circulation creates metaphoric meaning (the South African beach has meanings, for instance, because of ideas of South Africa, ideas of beaches, and how these intersect). In the *SI* photograph with Ireland, Martha and Rose are Martha and Rose, but they stand for Ndebele women and mean Other. They mean more than just this. Because of the leisure of travel, their presence on the pages of *SI* represents the economic power of the reader. This economic power may be virtual or actual; the models and photographer (during the shoot) and viewer (when looking at the magazine, when imagining) are away from home; Rose and Martha are at home. Too, because the legacies of colonialism permeate contemporary culture, Martha and Rose represent ideas about white superiority, domination, and subordination. This is underscored in the composition of the photograph. Rose and Martha are seated on either side of Ireland, who stands in the doorway of a building covered with the bright geometric patterns of Ndebele wall painting. Ireland, *standing on her tiptoes*, towers over these women. Raised on her feet, she dominates their space, too big to fit comfortably in their doorway. This photo demonstrates a classic hierarchical composition, implying the (white) figure

in the middle, as the largest and highest in the pictorial space, is the most important. In contrast to the individuality of the model, which is emphasized in part through the caption and in part through her fame, the individuality of these two African women is seemingly not important; their presence is not even mentioned in the caption. Compositionally, then, the Ndebele women function here as props, and as such they are silenced in this (neo)colonial representation.

In a similar manner, the designs painted on Georgianna Robertson's breasts serve the same purpose as Martha and Rose: to evoke the ethnic, exotic Other, thereby locating the viewer in a position of power: as a traveler, voyeur, and, most often, as (a) white (male). On many levels, then, in this second photograph the viewer takes the position held by Ireland in Figure 3.1. Where Ireland's presence and juxtaposition with the Ndebele women make those ideas explicit, the Robertson photo is less overt. Although I assured the women at the museum that American viewers would not mistake Robertson for an Ndebele woman, the subtext of her representation elicits just such a conflation.[102] Her black body is sexualized in a way that none of the other models' bodies in this photo essay are. And because she has a black body, notions of sexual abandon are mapped onto it, just as they were in the images of Tyra Banks discussed in the preceding chapter. While the viewer does not, in all likelihood, mistake Robertson for African, this image, through its conflation of black bodies, does nothing to counter notions of Africans as sexual and exotic. Meanings are thus generated through social baggage, the knowledge and attitudes through which we filter these images and categorize their subject matters.

Meaning is also generated in tourist photographs in that they are mnemonic; they are reminders and evocations of the experiences one had when traveling.[103] Looking at the photo of Martha Nomvula and me (see Figure 3.3), for example, brings to life a variety of emotions. I remember, and can relive, the joy on her face at seeing herself in the photograph. I can remember and relive my own relief at having found her, of being able to do the research that I had wanted to do on my trip to South Africa, the research that had depended on my finding the Ndebele village in the pictures. But my reminiscences also move beyond that moment to the interviews I conducted, to the opinions and perspectives the women provided and how they now help shape this analysis. And although I was in no way a participant in the original *SI* photo shoots, I am connected now in a way other readers of the issue are not. I have a personal story to tell about some of the places and people depicted in the images. The photographs taken

during my visit to South Africa, as well as those of Ireland and Robertson, evoke that story for me. In this sense, the photos in *SI* function in a similar manner to tourist photographs; they help to personalize an experience of events and places in much the same way that souvenirs do.[104] The images with the models can substitute for my own travel photos or for readers' fantasies of travel. Here the photographs are not necessarily mnemonic for the place depicted—though that may come into play—but are, rather, synechdochal for the experience of travel in general. Viewers of the swimsuit issue are virtual travelers to South Africa in 1996, and to other places in other years. These images, I propose, also personalize the experience for the Ndebele women who participated in the photographic shoot.

Mediating Identity: Traditional, Modern, Democratic

As the above discussion demonstrates, the images in the swimsuit issue do not require physical travel for the reader to partake in their fantasies or discourses of desires. Although many readers of the magazine travel for leisure, one must consider also those who do not. Consumers derive pleasure from looking and imagining, and not actually possessing.[105] The consumption of the *SI* swimsuit issue or a fashion magazine takes the place of literal consumption (of travel or clothing). Reading the swimsuit issue engenders desires. They might be for travel, or they might be more sexual in nature. At the same time, it could produce a fantasy of and desire for control over a world that seems to be increasingly in flux. But in all cases, the swimsuit issues offer fantasies of retreat, proffering relief from the anxieties of the modern world.

Such retreats may have serious social implications, however. The fantasies of the swimsuit issue inscribe a masculine hegemony on the pages of the magazine.[106] Here the changing roles of men and women and the anxieties over the increasing social power that women have (had) in American society necessitate(d) a means by which to reestablish masculine/patriarchal power and positioning in U.S. society. The minimal coverage afforded women athletes in *SI*, the structure of the swimsuit issues, and the fact that the swimsuit issues came into being in 1964, a time of heightened women's liberation, attest to this fact. On one level, the swimsuit issues confirm a man is a man, and still has power as such.

In fact, each of the popular culture forms I explore in this study conceptualizes for consumers their place in this world. The peoples and places

of Africa (and other areas of the nonindustrialized world) are particularly useful in this process, and representations reflect this. In seeking out experiences of the exotic, the tourist reestablishes solid notions of self and reasserts her or his own position in the world.[107] Historically, these cultures were presented in both scholarly and popular literature as static and unchanging. Different, distant, and containable, such people were seen to have fixed and stable identities; these identities are then contrasted to and set in opposition to the multifaceted identities (real and/or desired) of the tourist. If the tourist represents the modern, the people visited represent the nonmodern. In tourist photographs of Africa, for instance, the land, people, and animals are presented in similar ways; as objects of tourist gazes, they are constructed as both timeless and unchanging.[108]

An image of a Maasai woman published in *NG* in 1954 looks very similar to a photograph of a Maasai woman published in the book *Africa Adorned* by Angela Fisher in 1984.[109] In the former, the woman stands, looking off into the distance to the right of the photographer/viewer. While her body faces the camera almost straight-on, the turn of her head to a three-quarter view grants the viewer greater visual access to the large earring she wears. Because she almost fills the pictorial frame, the viewer is directed to focus on the woman's dress. The background is indistinct, save for another Maasai figure in the middle ground. Likewise, in the Fisher photograph two Maasai women, presented in three-quarter view, fill the pictorial space (a third is visible in the background on the viewer's right); the background is even less discernible. Again, the jewelry adorning the women is emphasized. In neither of these photographs do the subjects make eye contact with the photographer/viewer; they are presented as objects for contemplation rather than as individuals with whom to engage. Similarly, neither photographer identified the names of the individuals presented. They remain anonymous, representing Maasai women in general. The similarity in photographic treatment of Maasai women in two photographs that were taken thirty years apart indicates not only the conventionalization with which non-Westerners are represented but also suggests timelessness; 1954 can be 1984 or vice versa.

Similar evocations are evident on the pages of the 1996 *SI* swimsuit issue. The lack of information that allows the viewer to easily identify the locale creates a sense of timelessness. So, too, does the depiction of Ndebele women in full, formal attire. There are no signs of modernity for the Ndebele people despite the fact that the majority of the women and men at the museum the day that I was there were dressed in nontraditional,

Western clothing—skirts, blouses, trousers, shirts.[110] I have no reason to believe my experience of the museum was different than an average tourist's would be. Here this issue presents the unchanging "native." The ethnic clothing suggests a fixed and reductive identity that counters and ultimately alleviates the fragmented modern identity of the tourist/reader. The juxtaposition of traditional and modern as in *NG* representations of non-Western peoples and worlds is evident here. In both magazines non-Westerners function in the same way: to reinforce readers'/viewers' senses of self, their cultural identity, and their modernity.[111]

But, as I suggested at the start of this chapter, it is not only the Western self whose identity is mediated in such representations. For hundreds of years Ndebele peoples have used their visual culture to construct and celebrate a very specific identity against those of the neighboring Sotho peoples and the Afrikaner and British settlers, as well as, more recently, for the tourists who visit them. This Ndebele identity has been played out against the backdrop of colonialism and in the face of forced migrations and the dehumanizing effects of the apartheid system. Their current cultural representations are thus responding to a long sociopolitical and economic history in which the insistence on an Ndebele identity was crucial.[112] The Kgodwana museum, and thus to a certain extent the individuals who work there, chooses to present Ndebele culture in the form of painted buildings, jewelry, dress, and performance. This context positions the women at the museum in a slightly different relationship to this visual culture than that employed by Mahlangu. Though Mahlangu offers tourists an experience of Ndebele culture, her predominant artistic context is the international art world, where her canvases are purchased by museums and where she is commissioned with other famous artists to create one-of-a-kind works of art. Yet both offer Ndebele-ness to their audiences.

In the context of a *SI* swimsuit issue, those visual markers of Ndebeleness that are deployed both by the museum and by Mahlangu lose their specificity. They instead signal Africa, Otherness, exoticism, and the economic power of the West. But as scholarship on Ndebele visual culture and my discussion with the Ndebele women themselves reveal, other meanings are relevant. In South Africa, the mural paintings, clothing, and jewelry mean, among other things, Ndebele, not Africa.[113] Rather than exotic spectacle, the brightly painted walls of a home may indicate pride in family, community, culture, heritage, and/or aesthetic sensibilities. The marketing of jewelry, souvenirs, and a museum experience of Ndebele culture brings money into local communities, thereby empowering Ndebele

peoples themselves as cultural brokers. This speaks to their economic power in the local context—they own and run the museum—not the economic power of their visitors in the global context. Moreover, supporting themselves through the production and presentation of their visual culture allows these women autonomy from the larger economic system that offered them subservient employment. The way the Ndebele women spoke about their participation and their reactions to the images revealed that such possibility is crucial to understanding their presence on the pages of the swimsuit issue. Recall that Nomvula commented on the Robertson photograph: "Because of democracy, this one liked it but I wouldn't like it to happen in my daughter. Taking democracy into consideration it's her right, but I just don't like it for my daughter." That democracy was the framework through which Nomvula was engaging these images is significant, for it suggests that democracy was, in some way, a conceptual component of self-representation at that particular moment.[114] Such representational concerns are part of "the production of locality."[115] This production takes place against an external context, against the nonlocal, such as the nation-state. The moment that these concerns were participating in was 1995–1997, shortly after the official end of apartheid. Hopes for a racially integrated nation ran high, and democracy and the choices it enabled were prominent discourses. The significance of this moment was not lost on the editors of the swimsuit issue, who chose for the cover a photograph depicting a black and white woman together. Nor was the significance of this moment lost on the Ndebele participants, who were engaging with new and different opportunities for presenting their culture, for envisioning and enacting their futures. They were involved in producing a new locality vis-à-vis the newly reformulated South African nation, and participation in the *SI* swimsuit shoot facilitated that.

The self-representation that is part of this process allows viewers to understand the participation of the Ndebele women in more nuanced ways. Photographs are sites around which multiple gazes coalesce: the viewers' and that of the person photographed, among others.[116] Moreover, it is the intersections of these gazes "by which the photograph threatens to break frame and reveal its social context."[117] This happens especially, I suggest, with the Ireland photograph. As I discussed in relation to the photograph of Banks in the previous chapter, the viewer is acknowledged by the model's returned gaze. Its nonconfrontational nature seems to invite, or at least not fight, the voyeurism that is occurring. Moreover, the smile on Nomvula's face is actively inviting that looking. This smile is different

than that of Banks, which along with the tilt of her head and prone body position suggests a seduction of the viewer. And it is different than that of Ireland, whose smile appears practiced. Nomvula's smile is broad, unrestrained, and inviting in a friendly, nonseductive way. One can imagine one might speak to her, not just look at her. The dignity with which Martha and Rose hold themselves, the confidence in their comportment, the nonsubmissive acknowledgment of being looked at, all speak to their role in actively presenting Ndebele visual culture to a larger audience. I am tempted even to suggest that they use *SI* as a vehicle with which to achieve this self-presentation. Such appropriation of representational space is not unprecedented. For example, as I mentioned in the introduction, at the Africa Immigrant Folklife Program held in Washington, D.C., in 1997, local Africans were invited to serve as presenters for the various performances that were taking place. They used this space to comment on and assert their own interests and concerns.[118] One organizer even commented that he had been turned "into a prop in their [the presenter's] performance."[119] I am not suggesting that the Ndebele women went so far as to turn the models into their props, or transform the *SI* photo shoot into an event of their own making. I am proposing, however, that careful attention to their presence in the swimsuit issue can reveal a more nuanced story than the photographs convey visually at first glance.

Of course, the agency of the Ndebele peoples in presenting their culture as they see fit, in constructing a visual identity for themselves and for the world, does not guarantee that their self-representations will be understood in the way they intend; such representations circulate in many contexts and are part of the larger discourses in which they partake. Ndebele and non-Ndebele will read the *SI* images differently even though they are looking at the exact same photograph. That several Ndebele women chose to participate in a situation (the *SI* photo shoot) through which *their* ideas of their cultural selves could be conveyed to larger audiences speaks to their desire to self-represent, and to have others understand them through their visual culture. It speaks to the complexities of representational practices. In providing access to Ndebele visual culture, these women open up and counter, albeit imperfectly, the dominant discourses and photographic conventions that position those with black bodies in subordinate positions. Their presence on the pages of the swimsuit issue reminds both that no discourse is totalizing and that photographs are always multivalent.

In the epigraph with which I began this chapter, Lutz and Collins note that "the photograph and the non-Western person share two fundamental

attributes in the culturally tutored experience of most Americans; they are objects at which we look."[120] In making this analogy, they highlight the fact that on a very basic level, photographs are a noninteractive medium. A photograph sits in front of a viewer and is gazed upon; it does not look back. They see Western encounters with non-Western peoples (in the context of the *NG* photographs) as similarly lacking interaction because the exoticism and foreignness of the non-Western individual invite looking and at the same time create a distance that prevents meaningful engagement. Throughout most of this chapter I have been offering a similar critique of the swimsuit issue photo essay. Such representations on the pages of these popular magazines may seem harmless encounters with another culture, but they have implications that are not so neutral. They are part of larger discourses where the group identity, rather than the individuality of Africans, is important; where Africans are at the service of Westerners; where travel is a right, not a privilege; and where culture is bought and sold. *SI* gives the reader the "right" to possess Africa—visually and/or experientially.

And yet the act of looking disrupts this narrative, even if only slightly. The presence of Ndebele visual culture on the pages of the *SI* swimsuit issue asks responsible readers to note the presence of these women and engage with them. It asks consumers to interact with the photographs—and all that went into their making—and not to merely look, distance, exoticize, and objectify. It asks that viewers seek knowledge about these Ndebele women and their lives. Despite the reductive and problematic presentation of Ndebele culture as nonmodern on the pages of the swimsuit issue, Ndebele visual culture ultimately opens up possibilities of meaning, and of meaningful engagement. And it works to counter stereotypical representations in a way that evocations of Africa as wild, natural, and sexual could not. Indeed, the presence of Ndebele visual culture opens the door to alternative ways of perceiving the world, to expanded understandings. It offers the opportunity to think critically about how you position yourself (as an individual and/or as an American) in the contemporary world. Such reflective opportunities are provided not only by a popular magazine but by other forms of popular culture as well. The use of visual culture as it relates to identity, and for positioning oneself in the world, occurs in the world of Barbie, the subject of the next chapter. I focus there on the interaction of cultural heritage with nostalgic longing.

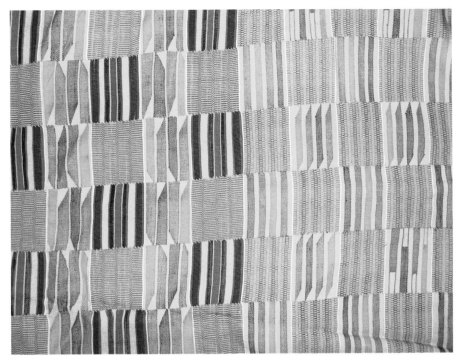

Plate 1. Detail of kente (n.d.)
Photograph: Carol Magee

Plate 2. Togbe Kwaku Dake and Togbe Daku III. These two chiefs illustrate how kente is worn wrapped around the body. The men behind them are wearing cloths whose colors are similar to those of Asha and Ghanaian Barbie's clothing.
Photograph: Carol Magee, Ghana, January 2004

Plate 3. Scene under which one passes when moving from Africa to Latin America in the "it's a small world" ride, Magic Kingdom Park, Walt Disney World Resort
Photograph: Jeff Sekelsky, 2006
Used by permission from Disney Enterprises, Inc.

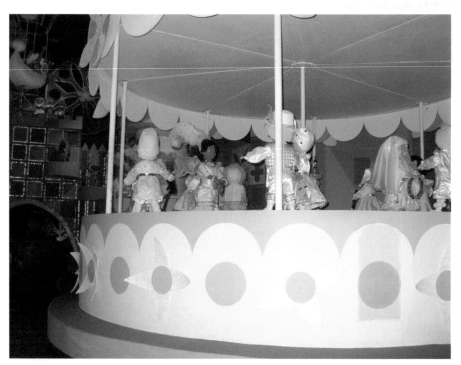

Plate 4. Carousel scene with children from around the world in the "it's a small world" ride, Magic Kingdom Park, Walt Disney World Resort
Photograph: Jeff Sekelsky, 2006
Used by permission from Disney Enterprises, Inc.

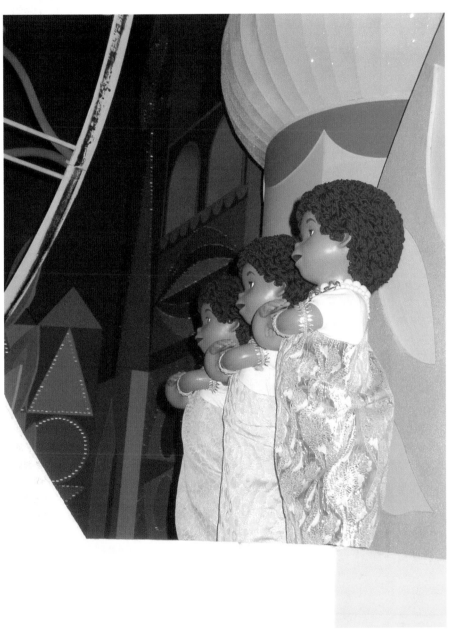

Plate 5. African girls on carousel in the "it's a small world" ride, Magic Kingdom Park, Walt Disney World Resort
Photograph: Jeff Sekelsky, 2006
Used by permission from Disney Enterprises, Inc.

Plate 6. Loading dock for the "it's a small world" ride, Magic Kingdom Park, Walt Disney World Resort
Photograph: Jeff Sekelsky, 2006
Used by permission from Disney Enterprises, Inc.

4.

Fashioning Identities

Kente, Nostalgia, and the World of Barbie

> The problem with prefabricated nostalgia is
> that it does not help us to deal with the future.
> —SVETLANA BOYM, *The Future of Nostalgia*

Mattel's Princess of South Africa (2003) is dressed as Martha Nomvula was dressed in the *Sports Illustrated* (*SI*) photograph with Kathy Ireland. Meticulously researched, this Barbie's costuming pays homage to Ndebele culture. In keeping with Ndebele styles and traditions, this Barbie's hair is short-cropped; she is dressed in colorful, plastic bands (representing the beaded bands Ndebele women wear) around the head, neck, and wrists; yellow plastic to evoke brass bands around the legs and neck; and a multi-color, striped Middleburg blanket around her shoulders (these latter two indicate she is married). Like *SI* before it, Mattel chose Ndebele culture to represent all South African indigenous cultures, and, more generally, to represent South Africa as a whole.[1] Whereas I contend that Ndebele dress in the context of the *SI* swimsuit issue could be read as both reductive *and* as empowering, in the context of Mattel's world of Barbie its empowering capacities largely diminish. The intent of dolls such as the Princess of South Africa is positive, as were the swimsuit representations employing African visual culture. Certainly the presence of Ndebele visual culture in the *SI* and Barbie worlds exposes large audiences to Ndebele culture. But as I assert in this chapter more generally, this exposure does not adequately balance the problematic issues this Barbie and its companion dolls manifest. The Princess of South Africa was the most recent addition to the line of African Barbie dolls offered by Mattel: Nigerian Barbie (1990),

Kenyan Barbie (1994), Ghanaian Barbie (1996),[2] Moroccan Barbie (1999), and the Princess of Nile (2002). And although analysis of this Princess of South Africa could reveal a great deal about racialized identities, the analysis of Ghanaian Barbie offers even richer insights. I focus this story, therefore, around this latter Barbie, though I return briefly to the Princess of South Africa in the concluding chapter.

I came across Ghanaian Barbie in December 1996, five months after returning from Ghana, my first trip to Africa. Five months had been long enough for me to forget the culture shock I had experienced, and I was, in fact, feeling nostalgic for Ghana. But bringing Mattel's Ghanaian Barbie home from the store turned out to be more than an act of individual nostalgic reverie. Indeed, examining the cultural information on the back of the box, and all the various elements of her costuming, I became aware of a larger, cultural nostalgia at work.[3] Studying Ghanaian Barbie (and subsequently her other African counterparts) suggests that clothing is critical to any analysis of her. Barbie is, after all, a fashion doll. Ghanaian Barbie's clothing is based on the Asante textile kente and evokes a cultural/national heritage that promotes a reductive, essentialist notion of identity.[4] Mattel also presents kente in an outfit marketed for Asha, the African American friend of Barbie; here kente is not reductive or restrictive. In both instances, kente embodies notions of identity, yet the possibilities these dolls present for understanding the world are very different. This chapter considers the nature and implications of these identities. Not only does the costuming of these dolls address identity, it also helps fashion a nostalgic worldview and reveals promotion of U.S. domination in the world. While I discuss the costuming in detail, Mattel, unfortunately, would not give me permission to reproduce my own photographs of the Barbie dolls in my collection. Therefore I cannot offer the visuals here as part of my analysis as I do with the other popular culture forms in this book. Interested readers can find photographs of Ghanaian Barbie and Asha in the exhibition catalog *Wrapped in Pride: Ghanaian Kente and African American Identity*; the Princess of South Africa is reproduced on its designer's Web site.[5]

Ghanaian Barbie is part of the "Dolls of the World" series. Begun in 1980, and changing to the "Princess Collection" in 2001, this series' dolls represent over fifty countries from Europe, Asia, Africa, North America, and South America.[6] Yet the "Dolls of the World" is just one in a series of Collector Edition Barbies offered by Mattel. For instance, along with representations of many of the world's cultures, one also has access to doll versions of Marilyn Monroe, Cruella De Vil, and Mulder and Scully of the

X-Files. These dolls speak of nostalgia for childhood memories of Barbie dolls once owned, of favorite fictional worlds, and/or of bygone eras. Unlike other Barbie dolls, Mattel aims its Collector Edition dolls at adult audiences. These dolls are generally higher priced ($75–$300) than regular Barbie dolls ($25). Significantly, the "Dolls of the World" are priced lower than other Collector Edition dolls. In the late 1990s and early 2000s they were being sold for the same $25 as regular Barbie, though more recently for $20. My Ghanaian Barbie cost $12.99, half the price of regular Barbie. I have since found it to be the case that the dolls of color in the "Dolls of the World" series are, after their initial release, readily available at half-price in toy stores.[7] Nonetheless, these dolls are *not* intended for play. Instead, they are to be placed on a shelf, where a relationship is imagined, rather than acted out with them.[8] Ghanaian Barbie, for example, rests on her stand in my office, a reminder of my time in Ghana. More significant, she is an object around which to sort out, in thought and not through physical play, the issues highlighted in this essay: nostalgia, imperialism, cultural interchanges, and identity.

I will clarify terms first, therefore, and present the conceptual framework that informs my analysis before proceeding to the particularities of the dolls. *Imperialism*, as used here, is the processes and policies by which a nation dominates (for its own benefit) the resources—land, labor, markets, people—of another.[9] Historically, this domination has been considered primarily in economic or political terms. Realistically, one cannot separate these two components, even though either one may predominate in any given situation. They are intricately entwined, as a history of U.S. imperialism demonstrates through its worldwide promotion of democracy in the service of capitalism. As such, it is not unreasonable to consider the world of Barbie as an economic empire for Mattel; Barbie is sold in over 150 countries around the world, at a rate of two dolls per second.[10] The 2003 worldwide sales for Barbie totaled $3.6 billion.[11]

But there has been a shift in what imperialism is seen to be. Recent conceptualizations of it focus on notions of civilization and culture as the terms through which power dynamics are expressed.[12] Indeed, what often seems lacking in past discussions of imperialism is an understanding of culture. *Culture* encompasses both material production, the physical objects that make up our environment—from coffee mugs and novels to paintings and Barbie—and the symbolic systems that provide explicit and implicit meaning for those products.[13] An understanding of the role culture plays in the processes of imperialism seems crucial today in a world

where communities are often separated (by choice or by force) based on language, ethnicity, gender, or religion. Elements other than one's economic position or political leanings add to the complex nature of global interactions. Given this, I am concerned with how cultural products convey, reinforce, or subvert imperial values.

One indication of the role culture plays in the processes of imperialism is the spreading of a cultural gender ideal. The social naturalization of Barbie's body-type as an ideal can be seen to have "colonized" the world.[14] Ideals for women's bodies in many of the world's cultures are moving toward a slender, "Westernized" body type.[15] At the same time, these "Dolls of the World" have been seen as exporting U.S. culture and values, responding to and creating a market that makes Barbie and her consumerism the ideal, though tailored to the local environment, whether Ghanaian, Australian, or Indian, for example.[16] Mattel's marketing of Barbie with a sari or other regionally marked ethnic costumes targets the middle and upper classes in India, for instance, as they have the economic ability to partake in a consumer lifestyle.[17]

While many scholars have commented on the ideals that Barbie exemplifies and promotes, few give attention to the "Dolls of the World." Although some studies focus on how these dolls promote American-like consumption in other parts of the world, the largest market for them is in the United States. At stake is more than how these Barbie dolls represent America to the world. It is vital to consider American consumption and to analyze the complexity of the issues of ethnicity, race, identity, and nationhood that these dolls raise in an American context. Indeed, because these Barbie dolls represent the world, and because the United States is the biggest market for them, these dolls beg analysis for how they re-present the world to America and how America perceives the world in relation to itself. And it is here, in this self-representation, where nostalgia comes into play.

The ways nostalgia has been understood historically changed from a diagnosis of homesickness to a more general yearning. It now suggests desire for something that is lost: an object, childhood, the past.[18] Today's society demonstrates a yearning for a sense of community and a sense of continuity prompted by a lack of these due to the sociohistorical conditions in which we live. Faced with the major global, historical events of the twentieth century, many people long for simpler, more concrete times. These conditions include an ever-increasing pace of life from continued industrial and technological inventions and improvements. (As one colleague commented to me, Africa appeals "as a place untainted by Western

cynicism.") Given this, nostalgia is more than just personal mediations of the present with the past and the present with the possible futures. Rather, it also involves the relationship of the individual with the past, present, and future of her or his society. This "global epidemic of nostalgia" is another way of characterizing the postcolonial melancholia I discussed in the introduction.[19] Ghanaian Barbie evidences this desire for a clear relationship with the world. She is a site through which an individual can counteract the stress and anxiety of contemporary culture. She offers a way of remembering a romanticized and an idealized past (clearly defined and meaningful national boundaries, homogenous nationalism, and U.S. superiority in the world). And she offers a way of forgetting that which disrupts it (identity politics, postcoloniality, and globalization). With Ghanaian Barbie, an individual can mediate the past, present, and future of U.S. society, especially as it relates to foreign cultures.

Ghanaian Barbie, however, is more than just one doll in the "Dolls of the World" series. She is also a Barbie and as such is a palimpsest evidencing the traces of regular Barbie. Barbie has been celebrated as a figure that allows girls to live rich fantasy lives, to develop motor skills through the almost constant changing of her clothes, and to develop strong senses of self-esteem. Barbie has also been derided for her unrealistic and anatomically incorrect proportions and her constant promotion of consumerism. Indeed, in 1959 Barbie came into our world a fully developed teenager, born to shop. Not only did Mattel provide Barbie with a middle name (Millicent), parents (George and Margaret Roberts), and an astrological sign (Leo), they also provided her with a life of leisure.[20] She has had through the years a multitude of pets, including five dogs, four cats, and twelve horses. When not riding these horses, she travels extensively, figure skates, skis, and drives her sports cars: a Corvette, a Porsche, and a Ferrari. And, of course, she shops. These are not inexpensive activities. Although Barbie has had several career opportunities—astronaut, nurse, teacher, surgeon—her leisure outfits sell the best.[21] Even her clothing for her latest career, news anchor, can be read in terms of leisure, for they present Barbie as "more equipped for 'Extra' than the nightly News."[22] Barbie's promotion of and participation in consumer activities has led anthropologists to comment that in the context of the Cold War, "Barbie was a reassuring symbol of solidly middle-class values."[23] But those middle-class values are particularly American values and extend beyond the reach of consumerism. Barbie, and all the dolls that inhabit the Barbie world, also promote other Cold War values, including a strong sense of nationalism and attitudes of U.S.

superiority in comparison to the rest of the planet. What, then, can be made of Ghanaian Barbie in the post–Cold War and postcolonial world? What values does she assure? And how do clothes help fashion, reinforce, and convey those assurances?

The Social Life of Kente

Before one can understand the nuances of the worldview conveyed by Mattel's use of kente, it will help to know a bit of the history of this textile. It is woven by men on narrow looms; the resulting strips, about three to four inches wide, are then sewn together to form large cloths. These strips are visible in the detail of kente shown in Plate 1. Ranging from ten to twelve feet in length and five to six feet in width, these cloths are worn wrapped around men's bodies (Plate 2). Women wear smaller wrappers as skirts and/ or around the shoulders. The aesthetic sensibilities of these cloths are playful, with bright colors and dynamic juxtapositions of patterning. Asante aesthetics, however, are more than visual; they are verbal as well.

The Asante value eloquent speech, especially the use of proverbs. Many of their objects are visual depictions of these proverbs, and knowledge of the appropriate object to display or proverb to invoke is highly valued. Kente works within this system as well, in that a cloth can send a specific message to an audience through the weft designs or the alignment of colors in the warp threads. From at least the seventeenth century, the colors and motifs of the textiles have been named for proverbs, historical events, social classes, or even their commissioners.[24]

Kente was originally worn by Asante royalty on ceremonial occasions. However, rules restricting this cloth to royal personages changed throughout the twentieth century, and kente is now a prestige item for southern Ghanaians.[25] Kwame Nkrumah (1909–1972), who served as Ghana's first president (1960–1966), appropriated kente as a national costume and as a means of asserting an African-Ghanaian, rather than a British colonial, identity for the new nation.[26] Moreover, he drew upon the communicative power of kente symbolism, choosing specific cloths for specific contexts. When publicly announcing the achievement of independence, for instance, he wore a cloth whose associated proverb is "My ideas are finished"; this is also understood as "I have done my best." The media showed Nkrumah and his advisers in kente and other ethnic clothes. In 1960 Nkrumah presented the United Nations with a kente cloth whose pattern invoked the

appropriate proverb, "One head cannot go into council." Forty-six years later, then president Jerry Rawlings (1981–2000) presented Bill and Hillary Clinton with kente cloths during their state visit. Kente is obviously still a source of national and cultural pride. Thus kente has both symbolic meaning (via verbal-visual interactions) and contextual meaning (demarcating a portion of the population). It conveys messages specifically through proverbs and generally in terms of national/cultural identity.

Dress, after all, is a communicative system in which meanings are understood by both the wearer and the viewer.[27] As I discussed in relation to the Ndebele women in the preceding chapter, dress can communicate social position, gender, and ethnicity. It may also convey nationality, age, and even emotional states. It signals membership in a group—a group comprised of those who share interests, tastes, values, concerns, or positions.[28] It includes those who understand the symbols and, simultaneously, excludes those who do not. Dress, therefore, also functions to establish boundaries; those who dress differently are outsiders, are Other. The communicative systems of dress are not necessarily simple. This is particularly so for ethnic dress, which is "a past oriented form of identity"; it focuses on those forms that are drawn from the heritage of the group.[29] Such a heritage is not necessarily a stagnant one. Change is quite often incorporated in ideas of what a group's past is or was. But drawing on the past provides that dress, and therefore the cultural identity it marks, with legitimacy and validation in ways that new forms cannot. This was evident in the use of traditional clothing at the Kgodwana Ndebele Village and Museum.

Kwame Nkrumah appropriated kente, a cloth associated with a specific cultural group (the Asante), as national dress. In doing so, he asserted a cohesive postindependence identity to the rest of the world. Yet viewed by outsiders, the same dress is defined not as national, but as ethnic.[30] Such an association, too, was reinforced by Nkrumah's support of Pan-Africanism, emphasizing an individual's African-ness more than her or his Ghanaian-ness or Asante-ness. Combined with the Afro-centrism promoted earlier by the likes of W. E. B. DuBois and Marcus Garvey, kente made a powerful visual symbol for African Americans. This led to kente's incorporation into African American culture in myriad ways, clothing being one of the most visible.[31] In the United States, then, kente is used by those promoting an Afro-centric worldview. African Americans wearing kente-inspired items communicate their pride in an African heritage and their solidarity as a group within American society. Thus kente has shifted from identifying a social class (royalty) of an ethnic group (the Asante) to also identifying a

modern nation-state (Ghana), a continent (Africa), and a diasporic popu-
lation (African Americans). In these instances dress quite literally fashions
an identity. It does so in the context of Barbie as well.

Forever in Kente

Playing with dolls socializes a child to enact certain roles and implicitly
transmits important cultural values. Given this, child psychologists rea-
son that having dolls with skin the same color as the child gives that child a
stronger sense of self-esteem than playing with dolls that seemingly value
other characteristics.[32] Mattel throughout the years has responded to this
logic. Although it first introduced Christie, an African American friend for
Barbie, in 1968, it was not until the 1980s that African American, Asian,
and Hispanic versions of Barbie regularly appeared.[33] It took twenty-five
years, but girls finally had Barbie dolls that looked like them—at least in
terms of skin color. While African American dolls, in general, affirm that
black is beautiful, Mattel's Asha provides more than just the skin for the
celebration of an Afro-centric self. Her clothes are not the trademark pink
marketed with most Barbie dolls, but are instead based on the bright col-
ors and intricate patterns of kente (see Plate 1).

 With this kente outfit, Mattel acknowledges an African American con-
nection with Africa and an African heritage. Mattel's competitors, who offer
African American fashion dolls, also have marketed kente clothes for them.
Imani, the African American Princess made by Olmec Toys, had at least
three different outfits that incorporated kente-based designs. Tyco's Simone
had a kente-inspired top. Mattel's evocations of kente, however, are more
closely aligned to the actual patterning of the textile than either Olmec's
or Tyco's. The importance of clothing in fashioning a sense of self should
not be underestimated in the context of these dolls, for it is through cloth-
ing (and not variations in skin color) that racial and cultural differences are
marked.[34] The same brown plastic has been used for Nigerian, Jamaican,
and African American manifestations of Barbie.[35] Kente in the context of an
African American doll emphasizes a unique and important aspect of iden-
tity—the heritage of the African continent. But it is just *one* aspect of an
African American Barbie's identity. Children can change Asha's clothes and
thus have access to additional Barbie roles, allowing for identities that are
multifaceted. Asha can scuba dive, in-line skate, or ride in a rodeo. She can
be a doctor, a rock star, a lifeguard, or, more recently, a pilot.

But what happens with kente as a marker of identity for Ghanaian Barbie? Does this open up similar possibilities? I suggest not. Like Asha, Ghanaian Barbie is meant to be celebratory. Mattel provides information on the back of the box about Ghana and Ghanaians. Although mostly text, three hand-drawn illustrations are included: a map showing Ghana on the African continent, a woman wearing kente at a market stall, and a mask. The text describes the animals that live in Ghana, the food that Ghanaians eat, and the importance of kente. These are meant to educate owners about Ghanaian culture and establish authenticity for this doll. Mattel does want consumers to assume a level of authenticity in this presentation of Ghanaians, hence its choice of the kente-based dress. She was also given gold jewelry, another important part of royal Asante costuming. While Ghanaian Barbie has her share of gold ornamentation—a ring, pendant, bracelet, earrings, and sandals—she lacks the intentional repetition and overload with which the Asante ceremonially decorate themselves. Thus, despite this presentation and celebration of Ghanaian culture, this Barbie conveys subtler, less positive messages. It is, therefore, necessary to look beyond Mattel's intentions at other possible meanings for how this doll can be read.

Mattel's ideals are not necessarily the same as those who buy and use Barbie.[36] Rather, one of the most appealing things about her, and I would argue this is true for all who play with Barbie, is that she is so easy and inviting to manipulate. Barbie can be whatever the owner wants her to be. She offers, ostensibly, so many choices. Nonetheless, Erica Rand notes, the choices Barbie offers "camouflage what is actually being promoted: a very limited set of products, ideas, and actions."[37] The sexism, racism, heterosexuality, and consumer culture of Mattel's Barbie world are masked in discourses of universal appeal and the fun of fashion. Complicating this masking is the fact that the choices girls/owners can make are unnecessarily restricted when it comes to Ghanaian Barbie and the other "Dolls of the World."

Unlike Barbie or Asha, Ghanaian Barbie's clothes and jewelry are sewn in such a way as to discourage and/or prevent her from being undressed and her outfit changed.[38] This is true for almost every "Doll of the World" I have examined. The one exception is Kenyan Barbie, and the reason for this, I suspect, is that her costume is quite simple in comparison with all the other "Dolls of the World"; it consists of a dress, cape, and necklace. Ghanaian Barbie's costuming is more complex. Her gold and shell necklace is sewn to her kente wrap and yellow under-dress. Her kente head-wrap is

sewn to her head. This Barbie must remain forever in kente. Ghanaian Barbie, then, does not have access to the multiplicity of costuming and hence identities and experiences that American or African American Barbie dolls have. This is not insignificant, even though she is meant more for display than play. She must always be in her "native" outfit, her "native" role. This suggests an essential identity defined by her national costume. Rather than promoting national or cultural pride as *one* aspect of an identity, it is the *only* identity this Barbie has. Kente is, in this context, restrictive.

Other elements of costuming indicate this restrictive nature as well. Along with the kente wrap, the sandals with which Ghanaian Barbie is provided underscore the fact that she is not intended for play; they are flat and do not have high heels. Because Barbie's feet are molded to wear high-heeled shoes, Ghanaian Barbie could only walk on her tiptoes, if she were to walk at all. On the back of the box, Mattel suggests the sandals' flatness facilitates Barbie's walking through "lush forests." Nonetheless, she is meant to be stationary—displayed on her accompanying stand. Indeed, because these dolls are designed for collectors, their clothes do not need to be taken on and off. They are not expected to be played with. On the surface this presents a reasonable explanation as to why the clothes are sewn on.[39] While this could be used to argue against my reading of an essentialized identity and the restrictive nature of this costuming, to stop here would undervalue the role that objects play in our lives.

The style of dress designed for Ghanaian Barbie does not reflect the way a kente wrapper is worn in Ghana, even as it evidences the red, yellow, and green that are dominant in Asante versions of this cloth (see Plates 1 and 2). This discrepancy does not necessarily interfere with the authenticity of this costuming, however. After extensive research, time spent making sure accessories are correct and the clothes sit well on a doll in the "Dolls of the World" collection, and after receiving final management approval, a picture of the newly designed doll is sent to its respective embassy for feedback.[40] Mattel is cautious not to offend anyone, especially the particular culture that is being represented.

Knowing Mattel's procedures, the final kente outfit for Ghanaian Barbie is a bit surprising. Unlike Asha's outfit, which is much closer to the elaborateness of kente in its maintenance of the narrow strip as the basic unit of the cloth and the smaller and highly varied areas of design, Ghanaian Barbie's clothing seems to be a simplified version of the patterning. While this might indicate the amount of care that went into the design, Ghanaian Barbie's kente is not a miniaturized version of the cloth, but rather

one strip of it.[41] The pattern is not scaled to the doll, but rather scaled to humans. One could fold a strip from which a kente cloth is comprised (see Plate 1) over a Barbie—with a slit for the head—and get a costume much like that of Ghanaian Barbie. (This doll's designer, Sharon Zuckerman, did not respond to my queries about her design choices.) On reflection, it is not so surprising that this "problem" in design was approved by the embassy. Why should anyone at an embassy necessarily think about scale for a doll? The doll may simply have been looked at to make sure the kente was accurately evoked, which, essentially, it was.

Though based on many existing kente cloths, legalities require that all designs be original with Mattel.[42] The kente pattern of Ghanaian Barbie is the creation of Zuckerman, rather than a reproduction of a well-established design or motif. That Mattel requires designers to produce original designs can be read in a positive light; it indicates Mattel's respect for informal copyright. And in many ways it demonstrates attentiveness to kente's origins and use that other corporate appropriations have lacked.[43] Nevertheless, as with most other manifestations of this cloth in the United States, the proverbial and verbal associations of the textile are ignored. Kente, in the context of this Barbie, does not symbolize specific meanings or social status within Asante or Ghanaian culture. Rather, it is a sign of Ghana generally. Despite the careful research that Mattel put into the creation of this doll's costuming, it is nonetheless more the idea of Africa than its realities that is played out around Ghanaian Barbie. That Africa functions as an idea within the world of Barbie is especially evident in the 1999 Collector's Edition Fantasy Goddess of Africa Barbie. Here a number of African costumes are combined in a truly bizarre, yet totally fascinating, Las Vegas-esque creation.[44] It is also evident when one looks at the back of the Ghanaian Barbie box where there is a non-Asante mask illustrated. This suggests Mattel views masks as the quintessentially authentic African cultural product, as do most people. The particularities of the mask apparently do not matter. The peoples of Africa are interchangeable or at least easily intermixed; their African-ness takes precedence to the specificities of their cultures.

That ideas rather than realities are represented may well be due to Mattel's target audiences. Mattel claims to sell each of the "Dolls of the World" in the country that the doll represents, yet the vast majority of the dolls are sold in the United States.[45] Indeed, the "Dolls of the World" appeal to people with ideas about the places they represent. Heather Fonseca, designer at Mattel, commented that descent groups within the United States have

a particular interest in these dolls; for instance, the "Dolls of the World" Irish Barbie sold particularly well in the United States due to the large number of Irish descendants in this country.[46] Nevertheless, it does not seem unreasonable to assume that Americans who identify as both Irish and American might want to have a doll that could reflect multiple subjectivities. An Irish American girl may want her doll to reflect not only her (Irish) heritage but her present (American) life as well. Forever in their costumes, the "Dolls of the World" cannot do this. Moreover, the "Dolls of the World" say more about American perceptions and definitions of the Other's identity than about how other peoples fashion themselves.[47]

It seems, then, that with the "Dolls of the World," Mattel does not sell the world's cultures images of themselves to the same degree as they sell Americans an image of the world. In doing so, they subtly sell Americans an image of themselves. While these dolls seemingly present consumers with representations of other cultures, the details of these representations combine to present a nostalgic picture of America's place within and relationship to the world. To elaborate on this, I examine ideas about souvenirs as well as objects in a collection, and, most important, the ways these work toward remembrance and forgetting.

Remembering and Longing

Ghanaian Barbie's box states that "Ghana is a wonderful country to include in your travels," and travel is important to understanding the meanings of the dolls in this series. In his book celebrating four decades of Barbie fashion and fun, Marco Tosa places the "Dolls of the World" series in the tradition of souvenir dolls, collected by people in their travels around the world.[48] The souvenir doll tradition reinforces the consumption and possession of an exotic Other via the travel experience, as was the case with the *SI* swimsuit issue. Souvenier dolls speak of consumption, for travel is a form of consuming, one in which the consumer/traveler is temporarily and often superficially connected with the place being visited. The traveler arrives, takes in the sights, eats, sleeps, and leaves, usually taking along a reminder of the voyage. At the same time, as my Ghanaian Barbie indicates, this reminder, this "souvenir," may also be purchased after the fact. At a symbolic level, these "Dolls of the World" may recall places one has been, or speak to a place that one's family is from, or signify places one desires to visit. The souvenir, then, serves as the object of longings.

It is the thing that is focused on in re-presenting the past or in imagining the future. Here it is important to recall the origins of the word *souvenir*. Meaning "memory" or "recollection" in French, it derives from the Latin *subvenire* (to come up; call to mind). Its reflexive form, *se souvenir*, offers an understanding of the *act* of remembering, thereby encompassing more than an object around which that remembering occurs. With these Barbie dolls, the object and the act of calling to mind are at play.

Susan Stewart's insights into the souvenir and how it can be understood in the context of nostalgia and narratives of desire are particularly useful here.[49] Because the souvenir is metonymic, standing in for a more complete whole, it can never completely fulfill the desire one has for the place, for childhood, or for the object/experience lost. And in its partiality, narratives are developed around it. These narratives reveal more about the possessor of the souvenir than about the object itself. They are about the imagined relationships one creates with the object. As such, the souvenir must remain psychologically and emotionally distant. To achieve closeness would mean that desire would be fulfilled, and the need for the object would be eliminated. The desire of nostalgia thus needs distance, and the souvenir provides that distance—through its foreignness, its exteriority, its idealization of the past. Furthermore, "to have a souvenir of the exotic is to possess both a specimen and a trophy . . . the object must be marked as exterior and foreign."[50] Ghanaian Barbie can be read in this light, for even though, or perhaps especially because, she is American made, she is meant to call to mind the foreign and to evoke difference.

As a souvenir-like doll, Ghanaian Barbie's kente outfit and detailed accessories mark her as different, as foreign. That she is to stay in her outfit ensures her difference is maintained. Displayed on her stand, she is a trophy (something to be shown off) and a specimen (something to be looked at and studied). In this, I see a parallel with the historical display of material culture from Africa in Europe and America in both art and natural history museums. The history of how many of those objects came to be in Western museums and collections includes tales of trophy and specimen. In this light, and when displayed with other "Dolls of the World," Ghanaian Barbie can be read as part of a microcosmic representation of the world. In this case it is a world one does not have to leave one's home, or shopping mall, to engage. I cannot help but be reminded of armchair anthropologists who earlier in the twentieth century relied on other people's accounts of foreign lands in the formulation of their knowledge of other peoples and in the service of empire.

Indeed, the "Dolls of the World" articulate a longing for the seemingly ordered world of the early Cold War era, an imperial era of U.S. dominance in the world. They also reveal the mediation of relationships between individuals and nations. They promote engagement with other cultures but only insofar as it remains superficial and/or beneficial. Thus, in the cultural realm, they parallel U.S. political and economic interactions with the world. In the remembering of nostalgia, Ghanaian Barbie, as souvenir-like, indicates a desire for ordered social positions and essentialized identities. Ghanaian Barbie makes evident a longing for a world of homogeneous nationalism rather than the seemingly more chaotic world posed by the heterogeneity of multiculturalism. That she remains forever in kente places this Barbie in a time that harkens back to an era prior to anticolonial upheavals, widespread civil rights activism, and increased discussion of the multiethnic nature of American culture. She speaks to a time when, as an American, one seemingly understood one's place vis-à-vis the rest of the world.

Given this, it is quite understandable that the "Dolls of the World" series came into existence in the 1980s when the discourses of feminism, pluralism, and multiculturalism challenged U.S. cultural understandings of its own citizens. With the "Dolls of the World," and Barbie's nonwhite friends, Mattel acknowledges, even sells to, the contemporary interest in other cultures (both within and without the geopolitical boundaries of the United States): interests that came to the fore with multiculturalist, civil rights, and postcolonial movements. Yet Mattel does so in such a way as to actually reinforce, reestablish, and reimagine this Barbie world based on a past where such fluctuations and upheavals in identity were not seen to be the norm. People had and knew their places, thus the essentializing nature of the costuming. Furthermore, the accuracy of details and the seemingly authentic cultural data provide the subject (collector) with knowledge. And knowledge about something can easily translate into power over it. This knowledge, therefore, and the ability to possess these dolls place the collector in a position of control.

Control is a characteristic fundamental to understanding collecting as a social activity.[51] Part of that control comes through the physical handling of the collection, and part comes through the closure that a miniature world can provide. In creating a microcosmic collection, a community of objects, the collector can control what may seem in the real world daunting, disorderly, or beyond him or her. Toys especially, as miniature representations of the world, exist in a realm where there are none of the

constant changes of the material world; stability can be created.[52] With a miniature collection such as the "Dolls of the World," collectors can create their own intimate world.[53] They can control what is a part of it, and control how the objects in that world interact (literally in play, or metaphorically in the categorization and arrangement of the collection). They also, then, can control how they interact with the world. Any anxiety collectors' may feel about their place in the contemporary world can be alleviated. (A similar creation of a world and the nostalgic control it provides will be evident in the discussion of the Walt Disney World Resort in the next two chapters.) Ghanaian Barbie, then, should be understood as part of a collection in addition to being souvenir-like. It is where the souvenir interacts with the collection that the subtext of Ghanaian Barbie, as a doll, becomes the most critical in terms of socialization and the transmission of values.

Forgetting

When considered in relation to souvenirs, the "Dolls of the World" are about remembering. When framed as a collection, they engage forgetting: forgetting history, anxiety, contemporary historical and political conditions, and individuality within other cultures. To understand the meanings a collection may have, one has to figure out how that collection is organized.[54] The guiding principles of organization for the "Dolls of the World" series can be seen as definition, display, stereotyping, and a past-orientation. Each doll, a representative of its culture, comes in costuming designed to signal that cultural identity. The basis on which those identifications are made varies from doll to doll. While some are based on the nation (Ghana, Russia, Italy), others are more localized (Paris, Hawaii). Still others, such as Arctic Barbie, suggest identities based on vast geographic regions. But when displayed with one another in the collection, these differences are minimalized; they are all part of the Barbie community.

Moreover, these identities are all based on a time-locked view of ethnicity because ethnic dress references cultural heritage. Such costumes are based on and reference past times and traditions. This is true even if similar dress is worn on occasion today. In the Barbie world, this past-orientation is further underscored, for not only are the clothes of the "Dolls of the World" based on some real or imagined cultural past, they relegate the rest of the world to that past. Where American Barbie has all the trappings of contemporary culture, the rest of this Barbie world does not. The dolls

in this collection are presented as existing in, as coming from, both places and times that are distant from that of the collector. They are similarly distant from the people of that present-day culture.[55]

This is not to claim that such a denial of contemporaneity is intentional on the part of Mattel. Indeed, that is why it is so important to point out; those things one takes for granted, and those ideas that have been naturalized, often bear serious ideological messages. Even so, a past-orientation in the costumes of the "Dolls of the World" is at times intentional. In commenting on the changes that occurred when the Barbie Collectibles moved from "folk costumes" of the original "Dolls of the World" to their current manifestations in the "Princess Collection," Fonseca stated, "Because I am designing princesses, I tend to create a more traditional outfit for each doll. My personal preference is to go back in time to recreate a historical costume, which I find to be more romantic than modern clothing."[56] It is telling that Fonseca acknowledges the past-orientation of her costume designs. Yet there is little in this series of collectible dolls that conveys such knowledge to the consuming public. Here, then, is another example of how tensions arise between coding and decoding, between intent and affect, in representations of Africa in popular culture forms.

Furthermore, with these dolls, as in other instances of nostalgic remembering, the past is romanticized. The beauty of the costumes is remembered even if the actual lived conditions of the historical period are forgotten. The past is invoked in the service of the present.[57] The past-orientation of the costumes creates a sense of continuity with the past and suggests that other areas of the past (identities, social roles, feelings of stability) might be more accessible as well. Yet this past is not necessarily an accurate one; rather, it is an imagined past, with imagined and ideal relationships. This imagined past takes two interrelated forms. The first is a past where national identity was seen to be cohesive, the values of the nation were understood, and individual social roles and positions were seemingly defined. This is the past that the world of Barbie evokes. The second presents those national identities as cultural and as unchanging; this is the past that the tradition-oriented costuming of the "Dolls of the World" evokes.

When asked to elaborate on the differences between the historicalness of folk costumes versus the Princess costumes, Fonseca stated:

> European folk costumes are based on historical clothing. Usually they're based on the styles of clothing worn by the peasants and the middle classes in the 16th to 18th century. From what I've read, folk costumes

were first created in the early 19th century. These "traditional" costumes were handed down through generations, remade and reinterpreted for whatever the present situation. The dolls in the original "Dolls of the World" line were often wearing these kinds of costumes.

The dolls in the Princess collection, however, are being portrayed as an actual princesses from a particular time period. So the Princess of the Danish Court is wearing my interpretation of what an aristocratic woman of the 17th century would have worn. The Princess of the Nile is wearing the kind of clothing a princess would have worn in Ancient Egypt.[58]

Whether historical costuming is implicit, as in the original "Dolls of the World" line, or explicit, as in the "Princess Collection," it relegates these dolls to the past. This removes them from the contemporary world that the original Barbie inhabits. Although the costumes are based on past traditions, a majority of these dolls exist ahistorically. While it may be clear that the Princess of the Danish court is based in the seventeenth century, it is less clear to consumers what historic periods the Princess of South Africa and Ghanaian Barbie reference. This suggests they are timeless, existing as they are in the past, present, and future. This ahistoricity is a common condition for a collection that "replaces history with *classification*, with order beyond the realm of temporality."[59] Similarly, in collections "national traditions and historical pasts are increasingly deprived of their geographic and political groundings."[60] These "Dolls of the World" offer traditional forms of cultural identity that are not adequately grounded in present-day sociopolitics. This has serious implications for understanding the world at both an individual and cultural/national level, as well as for envisioning the future.

One of the messages that Barbie sends relates to success, which is often measured differently for men (money, position) and for women (attention to the body).[61] Given this, Barbie is an icon of feminine success.[62] Barbie is successful, because her clothes and her accessories are signs of economic and social position. How, then, does one understand success with the "Dolls of the World"? Does their clothing convey that same level of socioeconomic success? Again, my analysis suggests not. Rather, because they are limited in the roles they might play, limited to an identity based on culture or nation, and limited to clothing that relegates them to the past, they cannot possibly have the same success. They cannot have the high-powered positions or the range of careers that Barbie has, because they cannot have the sartorial markers of those positions. Even if the clothing they

wear signals success within their respective cultures, many U.S. under-standings of that status are insufficient to translate into something mean-ingful. There is little to mark them visibly as something other than Other. This implicitly posits them as inferior. In the context of a doll, such reduc-tiveness is problematic because play, whether literal or imagined, is about possibilities. Mattel's "Dolls of the World" offer few possibilities for those outside the world of American Barbie, or for the relationships one might have with that world.

Other Barbie scholars comment on the possible effects that Barbie has on children's ideas of relationships. Wendy Singer Jones observes the way Barbie highlights individuals over relationships, while Elizabeth Chin is concerned that Barbie promotes relationships with things (consumable goods) rather than with people.[63] Thus, while ethnically correct dolls may build self-esteem for their owners through similar skin tones or heritages, they do nothing to address the actual lived conditions of those owners. They do nothing to address the lived conditions of the people represented by the dolls. Conditions such as the neighborhood in which one lives, one's economic stability, and/or the support one receives in one's home life may have more to do with creating senses of self-worth than the color of one's skin or the ethnic nature of one's clothing. These are the potential uncer-tainties in contemporary lives that these dolls help us to forget.

What, then, are the implications of distancing, homogenization, notions of superiority, and issues of relationships? Barbie's friends and family, who are meant to have their own identities, separate from that of Barbie, are given their own names: Skipper, Francie, Christie, Midge, Miko, Teresa, Shani, Asha, Nichelle, and Becky, to name a few. They have their own lives, even as they share her car, houses, horses, and clothes. Yet Mattel inten-tionally marks their difference in their names. This gives girls dolls in their own image. Yet the "Dolls of the World" are all Barbie: Chinese *Barbie*, German *Barbie*, Jamaican *Barbie*, Kenyan *Barbie*. As such, they share the same identity with her, and this ultimately diminishes any differences sug-gested physically (through skin color, hair, and facial features) or culturally (with costuming). They are, in the end, the ever-familiar Barbie. Mattel chose not to market these "Dolls of the World" with their own names. They could just as easily have created Barbie's Indian friend Anjali, Bar-bie's Dutch friend Mieke, Barbie's South African friend Thandi, or Barbie's Ghanaian friend Ama. But giving them identities above and beyond those suggested with their clothing, and/or marking them as friends, would have suggested levels of engagement and interaction that run counter to those

imperialist values promoted through Barbie. Ghanaian Ama complicates an imagined relationship to her culture in a way that Ghanaian Barbie does not. With the former, one might not as easily play at being part of the culture, possessing it, leaving it, shelving it, and moving on to something else, somewhere else, someone else. Naming these dolls would not allow them to remain nonspecific cultural Others. Without personalized identities, one can more easily forget the individuality of the people of the countries these Barbie dolls represent. If one can forget this, one does not have to be concerned about the materiality of their lived conditions. One does not have to think about what opportunities they have access to and what things they are denied.

Remembering and Forgetting

As Barbie, though more specifically as part of a collection, Ghanaian Barbie and the other "Dolls of the World" are about forgetting. They are about forgetting the historic and lived conditions of peoples they represent, in the same way the idyllic presentation of Ndebele culture on the pages of the *SI* swimsuit issue allows readers to forget about the tumultuous history and racial oppression suffered by the Ndebele and other indigenous peoples under the apartheid regime. They are about forgetting contentious cultural differences in a world community. They are about forgetting the instability of modern identity and modern lives. And, as with all memory, they enable forgetting through remembering. In this remembering, the "Dolls of the World" share qualities with souvenir dolls. They are the focus of reverie that re-creates, re-presents, and reimagines the past, and thus the present. The traditional outfits in which these dolls are marketed and must remain recall a time (whether it existed or not) when national borders and identities were clearly defined. These clothes speak of cultural differences that are safe and bounded, and that do not force more than a superficial engagement.

In emphasizing difference, the "Dolls of the World" collection functions also in a manner similar to the photographs of the *SI* swimsuit issue. Ghanaian Barbie, the Princess of South Africa, and the Ndebele women posed with Kathy Ireland mark the African world as different from the American world of Barbie, Ireland, the readers of the swimsuit issue, and the collectors of Barbie dolls. But the message these popular culture forms convey is not just that America and Africa are different. Through the possibilities offered

via armchair travel, the changing of clothes and personas, and the juxtaposition of modern with tradition, they posit the American world as better.

One important difference between these two popular culture forms deserves mention, and that is the way in which Africa and racialized identities are deployed to convey the message of difference. The *SI* swimsuit issue conflated the black bodies of Africans with those of the African diaspora. Tyra Banks and, to an even greater extent, Georgianna Robertson were Africanized through the use of African visual culture and stereotypical notions about Africa and Africans. In this way they were distanced from the overwhelmingly white world of the readers of *SI*, and racialized difference is reinforced. In Mattel's world of Barbie, such racialized difference is not as divisive, as the analysis of the use of kente for Asha's clothing demonstrates. Here Asha, the African American friend of Barbie, is aligned with the larger world of Barbie's America, not Africa. Such alignment offers possibilities for an America with reduced tension around racialized identities. My discussion of Ghanaian Barbie indicates it does not, however, offer the same possibility for America's relation to Africa or the rest of the world. The celebratory possibilities for the cultures presented by the dolls are undermined by the way they ideologically position those cultures.

Finally, because the designers at Mattel intentionally look to and draw inspiration from the past with their costumes for the "Dolls of the World," they can be seen to engage with the nostalgia and "postcolonial melancholia" that characterize this moment in history. I am not suggesting that Mattel's designers are explicitly creating dolls to engage in discourses of memory. Rather, they respond to cultural conditions, and when examined, those responses reveal a complex interplay of remembering and forgetting. Because Mattel prepackages the world in an image of past-oriented costuming that reduces identity to nation or culture, the past they invoke is limited. It is therefore not as helpful as it might be for envisioning possible futures. The identity that Ghanaian Barbie suggests with her costuming does not allow easily for the imagining of a future where cultural differences are not feared and are fully embraced. It does not allow easily for the imagining of a future where the United States is not seen as superior to, separate from, or in possession of the world. An analogous vision of U.S. superiority is offered at the Walt Disney World Resort, the subject of the next chapter. There, costuming and Africa are also integral components in such imaginings.

5.

It's a Small, White World

Whiteness claims a universal entitlement that entitles
it to—well—the universe. All the world's its stage and,
unlike blackness, it can play any part.
—ANN DUCILLE, "The Colour of Class"

In the preceding chapter, I discussed Mattel's "Dolls of the World" as embodying nostalgic longing for Cold War–era American life, whereby the ability to collect the world in the guise of Barbie allows metaphoric and symbolic control of that world. In this chapter, I engage with the ways a similar occurrence is evident in the world of Disney, focusing on the Walt Disney World Resort theme parks near Orlando, Florida. As with Mattel, the idea of Africa plays a part in this construction. One encounters "Africa" in many places in the Walt Disney World Resort: at Disney's Animal Kingdom Park and its associated lodge, at the Moroccan Pavilion in the World Showcase section of Epcot, on the Jungle Cruise and "it's a small world" rides in the Magic Kingdom.[1] Each presents a somewhat different perspective of Africa, yet they share some basic elements that work to create implicit messages about Africa as natural, inferior, and subservient to America. Like Barbie, costuming is often central to constructing these messages. This is very evident with the "it's a small world" ride, which presents visitors with small sculptural figures of children from around the globe, each wearing "folk" costumes that connect them to their geographic and cultural locale.

Representing the world through children reaches back to the ride's origins at the New York World's Fair of 1964–1965. Designed by Disney and sponsored by Pepsi, proceeds from this attraction went to the United Nations Children's Fund (UNICEF).[2] It was so popular that it was later

transferred to Disneyland (1966). It is still popular. The relatively sedate, slow-moving (ten-minute) boat ride attracts young and old alike. Each boat has five rows of seats that can accommodate between three to five people, depending on age and size. In October 2006, when I went on this ride in Florida, there were *only* adults on our boat. Nostalgia is one reason for this. On YouTube, where one can view numerous vacation videos of the "it's a small world" ride, people post comments. One noted this ride appealed because he or she had been on the ride at the New York World's Fair; another reported having been on the ride fifty-eight times, with another visit planned that year.[3]

At the Walt Disney World Resort's Magic Kingdom, the "it's a small world" ride begins at a loading dock with a backdrop of tall white buildings whose various architectural features are highlighted in gold, silver, and bright white lights. Leaving this area, one passes beneath a welcoming sign and into Europe; from there one moves through five other rooms: Asia, Africa, Latin America (with Antarctica), the South Pacific (Hawaii, Papua New Guinea, and Australia are all represented), and a final "World's Fair" room.[4] I had been on this ride once before during my first trip to Disneyland at the age of eighteen. On that trip I dutifully and somewhat reluctantly went on all the classics: the Haunted Mansion, Pirates of the Caribbean, Mr. Toad's Wild Ride, and "it's a small world." How could I not? These are the stuff from which the Disneyland legend is made. I admit I was underwhelmed. Perhaps because their renown had so preceded them, I expected more. Or perhaps my lack of enthusiasm, and appreciation, was because I did not have childhood memories of these rides so could not imbue them with nostalgia of bygone days. No matter what the reason, I had no great desire to ride on "it's a small world" again in 2006, but in the interest of academic inquiry, I boarded the boat for my world cruise. Much to my surprise, and admittedly delight, this was not the "small world" of my "childhood" memories. It had been redone, revised, and updated.

Despite the slow physical pace of the ride, visually it is quite (over)stimulating. It is impossible to take in everything, to notice every detail. The costumed figures of children line both sides of the river. There is color everywhere. In France, girls dance the cancan in blue, white, and red dresses and petticoats (the colors of the French flag) on a red, fleur-de-lis-lined stage. They are accompanied by a pink, dancing (French) poodle.[5] Above them towers a blue, white, and red Eiffel Tower. Following its lines upward one sees more figures, dangling from balloons. Later, bright, multicolor flying carpets and box kites soar overhead. Scotland is directly

in line of sight from France. One sees a purple castle with a plaid (green, red, and blue) tower with a bagpipe player standing atop it. In India, girls in pinks, greens, whites, and gold line the reflecting pool in front of the Taj Mahal. A snake charmer sits wearing a vivid pink turban and pale pink loincloth, charming a bright green cobra from a blue vessel. In Egypt, a rider on a bright pink camel stands atop a brown pyramid, surrounded by tall green palm trees and next to a sparkling pink, purple, and blue sphinx. This new version was, for me, in some small way, magical.

Perhaps this magical quality overtook me because I had been at Disney for four days already and my critical defenses were weakening.[6] Perhaps it had more to do with the fact that the war in Iraq still raged, and everyday accounts of violence, destruction, and death filled the newspapers, and I was ready for the message of hope promised by the annoying little song that plays ubiquitously and incessantly throughout the ride. I want to believe *and live* in a world of laughter and smiles, where people from all over can recognize the humanity of each other and act on that, rather than their differences from other people. I was willingly seduced sitting on the boat, listening to the song of unity in myriad languages. (I later heard in an aside by our "guide" on the Jungle Cruise that there are thirty-seven different languages represented in the "it's a small world" ride, while the official Disney Web site states that the song is sung in five.) This ride, it turned out, was for me a guilty pleasure; I was even willing to somewhat overlook the stereotypical treatment of Africa. But as I entered the last room, disillusionment set in. This *revamped* ride was racist and imperialist. Back in critical mode, I immediately and eagerly got right back in line for a second go-round. But this time the happiest cruise held no magic. And the small world was distressing, not comforting.

I return to this ride at the end of this chapter, but to fully appreciate the messages about American culture and racialized identities that it conveys, it is necessary to situate it in the larger world of Disney. To characterize the Disney message and its nearly ubiquitous presence, many appropriate the name of the Disney ride, "it's a small world"; I suggest that a more precise designation is needed.[7] Through my analysis of Africa at the Walt Disney World Resort theme parks, and through careful consideration of the "it's a small world" ride itself, I argue that representations of Africa at the theme parks help construct a Disney ideal of a small, *white, American* world. Because this message is implicit, it is important to remember two things. First, as I have been arguing throughout this book, the conveyance of this message in the form of entertainment means that many consumers

are not critically engaging with that message. The message, rather, is consumed passively; it is absorbed into the psyche. Second, the message is not meant as a commentary on Africa(ns), though its effect is often that. That is to say I am not arguing that Disney is intentionally positioning Africa as natural rather than cultural and/or inferior. Because the producers of Disney experiences are largely part of the same society as the consumers, they frequently share the same subconscious attitudes and biases toward Africa. In fact, like the other examples covered so far, these popular culture producers' attention to and engagement with Africa are intended to be positive and celebratory. At the Walt Disney World Resort, however, as elsewhere, Africa serves to reinforce ideas about what Americans are and what they can/should be. Multiple and contradictory messages coexist.

Disney's treatment of Africa is not much different than its treatment of other non-American cultures. Given this, the analysis that I apply to these attractions could be read, to a certain extent, through the lens of other cultures as well (Native American, Latin American, Arab, and so forth). Many scholars' insights and conclusions about Disney's treatments of other groups will overlap and resonate with those I present here. This is especially true for those scholars who have looked critically at Disney films and who address the treatment of specific groups: Native Americans in *Pocahontas*, Arabs in *Aladdin*, Chinese in *Mulan*. Nevertheless, in using Africa as the lens, certain by now familiar discourses come into focus. And a reading of Africa complements and builds on scholarly analysis of other cultures at the theme parks, which tends to focus on a more general engagement with Otherness than a culturally specific one. Moreover, as I argued in the introduction, Africa holds a special significance in America, and it has a resonance that most other places do not. Africa is the primary site associated with safari and the adventure it offers. The fact that Disney devoted over 100 acres of park and dedicated a lodge to Africa testifies to its importance in the American imagination (at least as Disney constructs it).

Although movies and theme parks are, on the one hand, very different, the Disney message is so consistent throughout its product world that I draw occasionally from analysis of the films, highlighting the commonalities with the parks' attractions. For instance, narrative is central both to a viewer's movie experience and to a visitor's experience of one of Disney's theme parks. It is important, therefore, to interrogate both the various ways that stories are told at the Walt Disney World Resort and the narratives themselves. Specifically, I explore the role Africa plays in these

stories, but here I consider the idea of Africa and Africans as Other, and not as culturally and geographically locatable groups (as with the Ndebele of South Africa or the Asante of Ghana). In presenting Africa, these parks suggest that visitors can experience and thus know other cultures. But closer examination reveals that little knowledge is in fact gained via these encounters. Indeed, at face value this "knowledge" simply perpetuates naturalized ideas. Morocco at the World Showcase and Africa at Disney's Animal Kingdom Park, for example, primarily reinforce previously constructed understandings of the world rather than introducing park-goers to new understandings of the people or places they represent. Moreover, close examination reveals this knowledge's biases and assumptions. Before turning to a discussion of specific narratives, it is necessary to spend some time with narrative construction of subjects, that is, with issues of representation.

Representing Others

One of the main observations about Disney's representations of Others is that those representations are reductive and stereotypical. In the "it's a small world" ride, for instance, the world's children are dressed in "traditional" clothing: kimonos (Japan), sombreros (Mexico), wax-print wraps (Africa). A similar representation is evident at the World Showcase at Epcot, where the world is reductively presented through "costume, language, and diet."[8] This is much like Mattel's "Dolls of the World" and Princess series, discussed in chapter 4, where each Barbie is dressed in geographically appropriate costume, and the information on the back of the box focuses on those three cultural elements.[9] Such reductiveness not only indicates how Americans see these other cultures but also how they *want* them to be, especially in relation to ideas about the self. Epcot's World Showcase similarly presents cultures in such a way as to obscure conflicts, negative images, or notions that might distress park-goers.[10] This fits with the overall Disney project. Walt Disney designed elements of Disneyland in opposition to the (problems of the) contemporary urban world, and he envisioned Epcot as a self-contained and utopic community.[11] The "happy" experience of other cultures at Epcot does not differ from many other tourist experiences, as I discussed in chapter 3 with regard to the *Sports Illustrated* (*SI*) swimsuit issue. Few, understandably, want to see suffering or poverty while on vacation. The costuming at Epcot's World Showcase

and in the "it's a small world" ride therefore provides a safe, happy, surface engagement with other cultures, enabling one to ignore the material conditions of the lives of people and places they represent.

Yet on one level material conditions slip in, especially as they are perceived through common sense. In representations of Africa, an implied poverty is visible, reinforcing media images of starving Africans specifically, and of life in developing countries more generally. At Epcot, for instance, the Moroccan pavilion—the only area dedicated to Africa there— has buildings that are created to look as if they are decaying. Buildings in other areas of the World Showcase are not like this, even those representing pre-Hispanic America and centuries-old Europe.[12] Such decay is evident, too, in Disney's Animal Kingdom Park; it begins immediately as one crosses over a bridge to "arrive" in Africa. The plaster on the bridge wall is cracked and chipped in several areas, revealing the adobe bricks beneath it. On the other side of the bridge is the town Harambe, from which one engages all the attractions that this Africa offers.[13] The tower for the Tusker House Restaurant and the facade of the Tamu Tamu ice-cream shop, with exposed bricks, are in a similar state of ruin. On the latter, the decay is more extensive; the top edge of the building has crumbled, and there are plants growing on top of it and vines climbing the walls. The paint on the columns of the Tusker patio is faded and chipped, revealing previous colors beneath.

Decay, in these instances, serves several purposes. It calls to mind the economic disparity between America and its Others (reassuring parkgoers that they are doing okay economically and can afford to spend their money there). It positions these other cultures in the past (their buildings are old; therefore their cultures must be old—ancient and outdated— too). And it positions them as inferior (they cannot even take care of their buildings). Decay, and the neglect it evokes, bolsters the resort's message promoting Western middle-class lifestyles and ways of being in the world as the ideal.[14] The use of a decaying Africa at Disney as a foil to situate an American ideal is not a unique occurrence, either in relation to Africa or as a general strategy for positioning the West. The West has a long history of using Others to define itself.

Orientalism, as just one example, is a body of knowledge created by the West about the Orient (referring to the Middle East). This knowledge posits those who create/control that knowledge as superior, reinforcing hegemonic ideologies. More important, as Edward Said argues, it is a lens through which future knowledge about the Orient is created, thereby

naturalizing that knowledge, hiding its construction, and presenting it as if essential truths.[15] There are several ways to reveal that knowledge as constructed: "style, figures of speech, setting, narrative devices, historical and social circumstances, *not* the correctness of the representation nor its fidelity to some great original."[16] Representations are about the power to evoke something, to create meaning, not merely to re-present an existing thing. Thus, although Disney designers took six trips to Africa in planning the safari experience for Disney's Animal Kingdom Park, no one-to-one correspondence with a specific African site exists.[17]

As important, cultural objects can manifest certain ideologies and politics implicitly, even when they are not part of the intentional knowledge-producing apparatus for a given topic.[18] Nineteenth-century literature and painting provide insights into this. Jane Austen's *Mansfield Park* offers one example. Although not explicitly a story about the importance of empire, the characters' interactions and musings, the context and narrative of the story, lead Said to observe: "According to Austen we are to conclude that no matter how isolated and insulated the English place (e.g., Mansfield Park), it requires overseas sustenance"; it requires the resources of the colonies.[19] Cultural products are inflected by and inflect the social-political-economic-historical context within which they are produced. Indeed, this premise greatly informs my interpretations of American popular culture forms.

Art historian Linda Nochlin identifies such inflections as key absences in nineteenth-century paintings of the Orient. These absences—which include history, work, the presence of Westerners, and art—reveal European construction of knowledge and its attendant power structures.[20] These absences allowed for projections of the fantasies, desires, and meanings of the Western painters and their patrons onto the paintings, and thus into Western consciousness in general. These same absences are evident in Disney's worlds as well, and are integral to imaginings of Africa there. What is more, these absences reveal as much about contemporary America in this context as they did about European culture over a century earlier. They also speak to the pervasiveness of imperial ideas in the imaginings of cross-cultural relations and the extent to which they can be found throughout Western culture.

The Absence of History

At the World Showcase in Epcot, colonial America exists alongside pre-Hispanic America and tenth-century Viking Norway. Visitors stroll from

one to another in present time. Here history exists, not as some under-standing of past events and places in particular relations to one another, or in relation to a specific present. Rather, it exists as equal moments and sites for the sole purpose of entertainment.[21] Epcot in no way challenges visitors to engage with the world or ideas around them, to relate past events to cur-rent events, or to think critically about their contexts.[22] Similarly, Epcot's Spaceship Earth ride has been seen as identifying America (through its achievements), at the same time neglecting achievements and events that occur outside American history.[23] This message, as I argue throughout this chapter, is central to the Disney enterprise in general.

At Disney's Animal Kingdom Park, Harambe's buildings are inspired by a range of structures that span the colonial era in eastern Africa, from a fifteenth-century fortress to a signpost with the date of 1961—a date just prior to the independence of Kenya in December 1963.[24] While Disney claims Harambe is designed to tell the history of the town, it is significant that that history stops just prior to the British departure. It is as if no his-tory has occurred in the thirty-five years since Kenyan independence and the opening of the park in 1998.[25] Africa without Europeans is, seemingly, an Africa without history. In a world that still privileges ideas and atti-tudes instituted in the colonial moment, Africa exists as it did when con-tact was both first and, from a colonial perspective, last made. Moreover, the sole raison d'être for Harambe is the launching site for various interac-tions with animals that seemingly transcend history and politics, existing outside of them.[26]

The Absence of Work

Orientalist paintings elide the labor and industry of the people they depict. Rather, the inhabitants of the exotic locales are seen as idle and slovenly. Likewise, almost all labor at Disney parks is hidden from view. This is especially true for service, technical, and managerial work, where vast net-works of tunnels underneath the park allow for movement and prevent the labor from being visible.[27] In Epcot's World Showcase, labor is encoun-tered in the guise of guides and shop merchants. Cast members (as all park employees are called) who are meant to be from that locale populate each of these cultural realms. (Calling them cast members underscores the nar-rative structure as vital to a Disney experience.) Yet their labor is not seen to be in the service of themselves (or their cultures); rather, they serve the visitor, creating a leisure experience for Disney vacationers. Similarly,

at Disney's Animal Kingdom Park, the visible labor comes in the form of entertainment. At the Tusker restaurant in Harambe, a musical group, Ngoma, performs several times a day. They play drums and other percussive instruments, sing, and dance. When I saw them in October 2006, they were a real crowd-pleaser, enticing audience members to get up and dance with them.[28] But the fruits of their labors are the smiles and laughs of the park's visitors.

The Absence of Westerners

Europeans are not depicted in Orientalist paintings. They are nonetheless a presence in them, for they are both the producer and consumer of the worlds such paintings portray.[29] At Epcot, cast members fit stereotypical ideas about what people from those countries look like. These individuals are meant to stay within their specific realm so as not to break the illusion; it would be incongruent to see a Mexican in Canada or a Norseman in Japan in the Disney world, where everyone and everything has its place.[30] That is part of the reason for the vast underground tunnels that keep the day-to-day functioning (the *work* of Disney) from view. Yet one cannot experience these country's pavilions without Westerners being part of the scene. This is true also of Harambe at Disney's Animal Kingdom Park. However, it is important to remember that Westerners are only part of the scene in the same way that every visitor is a part of that scene, that is, as a visitor. And, as with Orientalist paintings, the visitor's gaze at Disney brings the Disney world into view. The visitor is meant to look (and make purchases) in the shops, to see the entertainers. These cast members are not there for themselves; they are there for the visitor. And because of their costuming, their names, and maybe even their skin coloring, they fit superficial expectations of other cultures.[31]

The Absence of Art

Nochlin observes that a realist painter such as Jean-Leon Gêrome "tries to make us forget that his art is really art, both by concealing the evidence of his touch, and at the same time, by insisting on a plethora of authenticating details."[32] This is, in fact, the same modus operandi of the Imagineers, as the Disney designers are all called, who painstakingly craft the theme park worlds, creating an illusion of the "real" in such a way that the artifice is denied. A large example of this is the Tree of Life in the

center of Disney's Animal Kingdom Park; the branches are made of flexible fiberglass and the leaves of plastic, but they look quite natural and wood-like.[33] In many ways one could choose any example from the Walt Disney World Resort and make the same point. In fact, the illusions there are so convincing that the questions that are asked within the park—questions such as "Is that tree real?"—are wholly inappropriate outside it; one would be assessed as crazy, as philosopher H. Peter Steeves notes.[34] At the same time, at Disney's Animal Kingdom Park or in the respective pavilions at Epcot, the presence of African, French, or Mexican (among others) workers provides the authenticity necessary to convince visitors of the realness of their cross-cultural experiences.

One of the effects of this blurring of the real and artifice is the suspension of critical thought. We respond with awe. Indeed, adult visitors respond as though children when processing their experiences through enjoyment and wonder.[35] Processing experiences in this manner prevents understandings and insights that critical analysis would bring. Such processing allows for an understanding of Disney's overall message as "fun" and "fantasy."[36] It can result in responses like that provided by R2, a respondent in the Global Disney Audience Project who thought that "visits to Disneyland provided a chance to 'escape into a fantasy world' *without* the stereotypes and ideology typical of Disney films."[37]

Understandings that lack critical engagement re-present, re-create, and reinforce attitudes that are already in play.[38] These representations are based on the viewers' desires and expectations. They help maintain a view of the world as manageable and controllable, all in the guise of fun and fantasy. The exotic does not threaten in such instances; it simply is. One can even have fun with the exotic, play with difference (as with Barbie), but leave it in its place (on the shelf or in the park), where it cannot or does not intrude on one's everyday world. With the above-mentioned absences, and their attendant associations, Disney reinscribes a familiar story. While the minor stories are of Africa (Harambe or a Moroccan bazaar) or France or England, it is, ultimately, the larger stories that these minor stories serve that interest me here.

Storytelling

Many scholars frame their interpretation of the Disney parks' narratives through the phases of life. Folk and fairy tales correspond with childhood,

for instance, and westerns and adventure stories with adolescence.[39] These, in turn, correspond to the layout of Disneyland and its derivative parks.[40] Disney's Animal Kingdom Park, too, was conceived in terms of phases of life, with childhood relating to the fantasy elements of the park, the adventure of the safari coinciding with adolescence, and an adult's "love for animals" going into the creation of the various pavilions.[41]

Although one can associate these genres and areas with different ages, what is most pertinent for my analysis is that in all cases the stories told can be seen, as Deborah Philips argues, as stories of colonization and conquest.[42] Guests of all ages are therefore socialized into this approach to the world: there is the conquering of the supernatural (through rides such as the Haunted Mansion in Fantasyland) and the conquest of America's and space's frontiers (Frontierland and Tomorrowland, respectively); the conquest of nature allows humans to live in harmony with it and/or to dominate it to our will (Fantasyland); and the conquest and colonization of other geographies (the third world) take place in Adventureland via rides such as the Jungle Cruise, which presents a boat ride down the Nile, Amazon, Congo, and Irrawady rivers all at once.[43] The Jungle Cruise (loosely based on the 1951 film *The African Queen*) tells the story both of the wildness of nature and of colonial conquest of new and different lands.[44] But it is not just through the attractions at the Magic Kingdom that the tales of conquest are evident. The rides in Epcot tell of the progress of humanity and its conquering challenges via technology.[45] And a look at the spatial layout of the Magic Kingdom reveals that one moves through technological advancements, from the wooden wagons of Frontierland, to the spaceships of Tomorrowland.[46] Technology conquers the ills of society, providing a harmonious life for all.[47] Relations of power are at the heart of conquest and colonization, whereby those conquering are able to dominate those people or that region being conquered/colonized. Conquest is also an idea that resonates with Africa through its history of interactions with Europe. While this is hinted at in the Jungle Cruise, it becomes more explicit at Disneyland Paris. There Adventureland was changed to better appeal to the local audiences; it presents the desert of Morocco (a former French colony) rather than the jungles of the larger third world.[48]

In fact, it is often through the lens of conquest that Africa has come to be known in America. This is not to say that all understandings of Africa are generated through references to it. Rather, it is to suggest that, as with Orientalism, where the majority of European knowledge about the Middle East (Orient) was produced by Europeans, the knowledge about Africa

that has been most easily accessible and valued in Europe and America has been produced by the West. This is due in part to the Western privileging of written over oral forms of history. Conquest (in a variety of manifestations) was a primary context for initial contact with, and therefore understandings of, Africa and Africans. These understandings are frequently the basis on and framework through which new knowledge is produced: knowledge that often implies superiority and inferiority.

The parks reinforce knowledge with which visitors arrive even when claiming to produce deeper understandings of new places and peoples.[49] The parks do not challenge what we "know" about Africa. It is poor and run down, and, by implication, Africans are incapable of caring for their environment and themselves. Africa is an adventure site. This message is particularly strong in the Africa section of Disney's Animal Kingdom Park. On the safari ride, visitors "delay" their tour to go in search of poachers who are killing the animals. This is the type of adventure story visitors expect and experience here. As a whole, these representations have serious repercussions. These repercussions are not just related to how one sees Africa, or America's Others. They are also highly relevant for how Americans see themselves. Because these narratives position the park-goers in specific ways, they locate them in positions of power vis-à-vis Africa and all it represents.

It might seem I am suggesting a homogeneous audience that engages with Disney attractions and experiences, though this is certainly not the case. Disney experiences are structured in such a way as to position specific identifications (white, middle class, and upper class), and to generate particular meanings (of socioeconomic power). Because of this, audiences respond in a way that suggests more homogeneity than there actually is. The Global Disney Audience Project's study of Disney audiences demonstrates a frightening consistency with how Disney messages (in all Disney products) are read across cultures.

> Respondents agreed not only on the abstract core values but also on the details of narrative structure and character types. . . . These results raise questions about claims that audiences freely negotiate meanings or engage the texts regardless of the semiotics of the text. Our respondents suggest that they are constrained by the text and their expectations of the Disney brand. To follow Stuart Hall's model, our respondents clearly decode the overt message encoded in Disney's products. In fact, our respondents expect to find those messages—

an expectation that, when met, reinforces either their affirmation of or their resistance to Disney.[50]

Whether one is reading against or with the Disney grain, the base story is pretty much the same, in that one starts from the same point when celebrating or critiquing Disney, so ubiquitous are its meanings.[51] Furthermore visitors play roles and take on identities through participation in the narratives that Disney provides.[52] Those narratives create us as consumers of experiences—Disney vacation—and of products—movies, stuffed animals, comics, videos, T-shirts, souvenir mugs, and so forth.[53] In addition, these narratives construct park-goers as consumers of a specific political ideology that positions America's Others as inferior. Africa is an integral component in this construction because of the various imaginings of it that Americans bring with them to their Disney experiences, and because of the way Disney reinforces these imaginings.

Yet even when Disney is telling stories about other places, it is also telling stories about America.[54] Various features of the amusement park indicate desires to return to both "an earlier state of mind" and "the childhood of the nation."[55] The former suggests a return to childhood and is evoked in the various rides, Main Street, and so forth. In this, these rides promote "the material, the excessive, the irrational, the irresponsible and the selfish."[56] By appealing to the child within, the Disney project undermines the social responsibility of one individual to others—to society. "I" and my desires are the only things that matter. The childhood of the nation is the colonial period through the early twentieth century.[57] Most important, however, understandings of this childhood of the nation are "rooted in the outlook of the 1950s."[58] And although not precisely the same, "the childhood of the nation" is not entirely unconnected with conceptions about the childhood of the individual. Both, for instance, are often perceived as having been happier, more stable times. The past offered (an imagined) surety about one's place in the world. Walt Disney's creation of Disneyland engages with this; for him, "to make a model of an ideal past was to reject an imperfect present."[59] The idealized past is a world without the complexity of adult responsibility, the nuances of decision making, the tenuous and changing position of one's social group within the world.

As many scholars have argued, the way the past is imagined is critical to understanding Disney. Common understanding of the 1950s, "the childhood of the nation," suggests other cultures knew their place in the world,

and America's relation to them was clearly defined: ally, foe, economic, military interest, and so forth. Economics were strong. That this is valued by Disney is evident in the World Showcase at Epcot, for example, where the American pavilion is central, flanked on both sides by America's trading partners.[60] Additionally, at mid-twentieth century, American technological power was growing, and Americans were increasingly traveling for leisure. The quaint architecture and costuming of the World Showcase (as past) contrast with the technological advances (of American companies—the future) of Future World.[61] Going on safari in Disney's Animal Kingdom Park evokes international travel and underscores the role of Africa and Africans in the service of American pleasure (a theme I touched on in relation to the *SI* swimsuit issue, and return to again with Disney's Animal Kingdom Lodge in the next chapter). Disney takes the past (via various stories and traditions) and retells it in such a way as to reinforce its particular values and practices.

This nostalgic longing for bygone eras and the environments that support it are critical to the processes of socialization. Walt Disney World Resort consumers are set in relation to this idealized past and at the same time the present and future it offers.[62] This past is presented endlessly for each new generation of Disney theme park attendees, thereby inscribing and reinscribing the values and images of America's imperialistic cultural practices, its world power.[63] Disney becomes the common culture shared by Americans, and Disney's versions of history become the original version.[64] The Disney worldview can thus dominate: an ordered world, where one's place in it is known, as is the place of others. The comfort that results from this imagined stability holds particular sway in times of sociopolitical crises. Like Barbie, Disneyland was born in the Cold War era and can be seen as a celebration of the strength of American capital and its imperial power in the world, though each takes a different approach to this celebration. At the same time, the Disney park empire evidences negotiations with the changing social landscape in which multiculturalism challenged mainstream (white, male) U.S. society.

The perpetuation of ideals of America that are grounded in an earlier time prevent the culture as a whole from engaging with current issues that disrupt these ideals. The phenomenon of postcolonial melancholia in England marks the cultural inability of the English to reconcile their ideal of themselves—as an enduring heroic power (stemming from the colonial era and their participation in World War II)—to the realities of changes

brought about by the influx of immigrants from the former colonies. In the same way, one can read a similar failure to reconcile America's changing place and role in the current global context. What is promoted instead at the Walt Disney World Resort is a vision of America as it existed prior to any change in status. As so many scholars before me have noted, the Disney worldview dominates not just in America but abroad as well. This occurs through the sale of Disney movies and their associated products as well as through the creation of Disney theme parks in Paris and Tokyo. As a result audiences worldwide understand Disney's message in remarkably similar ways despite their quite varied social-political-economic conditions.[65]

That Disney socializes generation after generation with much the same message puts it in a similar category as Barbie and *National Geographic* (*NG*), to name but two enduring popular culture forms. During the time that Disney was planning Epcot and the Walt Disney World Resort, *NG* was steadily increasing its circulation; both the magazine and Disney were working toward reaching larger audiences.[66] Both share similar agendas in creating a vision of the world. It is worthwhile, therefore, to spend time considering these similarities and how they frame (re)presentations and thus imaginings of Africa.

Constructing Ideal Worlds

Catherine Lutz and Jane Collins, in analyzing *NG*, demonstrate how the magazine presents the world as nonthreatening, controllable, and subservient. Editor Gilbert Hovey Grosvenor held a guiding principle for the magazine: "Only what is of a kindly nature is printed about any country or people, everything unpleasant or unduly critical being avoided."[67] A similar approach exists at Disney, where conflict is absent. As one Disney Imagineer related, "What we create is 'Disney Realism,' sort of Utopian in nature, where we carefully program out all the negative, unwanted elements and program in the positive elements."[68] But the link between Disney and *NG* goes beyond the conceptual approach. *NG* was a literal source of inspiration at Disney; copies of it were kept at the studio.[69] This is not to say that Disney was looking to *NG* as a structural model, even if Disney looked to it for information. Certainly there is enough written on Walt Disney and his personal vision to demonstrate otherwise. Rather, it is to point out

that these highly influential cultural products, with similar broad-reaching societal recognition, shared strategies for presenting the world as they wanted it to be perceived.

For instance, both Disney and *NG* link science and enjoyment.[70] The Future World rides of Epcot promote corporate technological advances in the format of a ride for which one queues, boards, and disembarks, like all the other amusements at the Walt Disney World Resort. This link is also quite explicit with all the movie magic one can experience at Disney's Hollywood Studio.[71] Africa is part of the science-enjoyment interaction as well. Disney's Animal Kingdom Park's Conservation Station teaches about environmental protection. Displays address what Disney does for its animals in the park and elsewhere, and what the visitor can do to help. Viewing stations allow visitors to observe the veterinary care of animals. But more than scientific orientation is at play here. *NG*, Disney's Animal Kingdom Park, and now the Discovery Channel mediate what Americans expect nature to look like.[72] This is similar to the way that tourists' experiences have been mediated with photographs prior to their visits (chapter 3). Both cases result in a replication of particular views and approaches to subjects.

Animals at Disney do highlight the natural world. They, in fact, more than people, are the primary markers of Africa at Disney. Nowhere is this more apparent than at Disney's Animal Kingdom Park (and its associated Animal Kingdom Lodge). The entire park focuses on animals: real (in the Africa and Asia sections), imagined (Camp Minnie-Mickey; the Yeti of Mount Everest), contemporary (again Africa and Asia), and historic (Dinosaurland, U.S.A.). A full quarter of the park is given over to Africa; this area is larger than the entire Magic Kingdom. Additionally, as I discussed in chapter 2, Africa is presented as wild and natural in contrast to cultural. This can be found in several places in the Walt Disney World Resort, not just at Disney's Animal Kingdom Park. At the Magic Kingdom, for instance, the wildness of the environment is mapped onto the bodies of the "natives" in the Jungle Cruise ride who have been described, variously, as "savages" or "panicky."[73] Wild animals and nature depict Africa in the "it's a small world" ride, too, as I discuss in detail below. Constructing this as the principal view of Africa also posits its human occupants as natural. This is especially true in the absence of representations that offer another perspective and provide alternate interpretations. Associating (nonwhite) humans with the animal world is a familiar trope of racism. And yet race, and the societal effects of the racism that results from the use of racial categories, is an issue that is little dealt with in either Disney's or *NG*'s worlds.

Historically, *NG* presented American society as "raceless and class-less."[74] It denied the very real domestic crisis around race that was coming to a head in the late 1950s and early 1960s as well as ignored how similar relations of power were being negotiated throughout the world in anti-colonial struggles. By not depicting Westerners in non-Western locales, the magazine avoided publishing images that might suggest the colonial context and any tensions that were part of it.[75] At Disney, park-goers visit Africa without having to deal with the postcolonial reality of the continent (this is especially underscored with the dating of Harambe buildings). In other ways, too, at the parks, race relations are not explicitly dealt with in the narratives of the attractions. Morocco is North African, not Africa south of the Sahara. It is therefore, in most instances, thought of as Arab Africa, not black Africa, if it is thought of as Africa at all.[76] This suggests, again, the hierarchical valuing of various races I discussed in chapters 2 and 3. Great Moments with Mr. Lincoln at Disneyland, another example, did not, in its original form, refer to African Americans or emancipation.[77] As with *NG*, Disney's lack of explicit engagement with the material conditions of the world, historic or contemporary, and the results of these representations, creates and reinforces the view of the "best" parts of the world as (ideally) white.[78]

Yet when asked if they thought Disney promoted racism through its products, only 19 percent of respondents in the Global Disney Audience Project responded affirmatively.[79] While 19 percent may seem relatively low, it should be noted that it is markedly higher than the 2 percent of respondents who viewed the *SI* swimsuit issues as racist.[80] In interviews with Laurel Davis, most consumers of the swimsuit issue equated people of color with African Americans, not Latinos, Native Americans, or Asians, whose presence on the pages of the swimsuit issue remains low.[81] Similar absences were part of the Disney world, where Native Americans did not appear until *Peter Pan* (1953).[82] When it opened, Los Angeles's Disneyland employees were largely white, and these employees sold (unknowingly, implicitly) this image along with all the other commodities they were selling.[83] In fact, it was 1968 (thirteen years after Disneyland first opened) before a black person worked in "a 'people contact' position" despite the fact that as early as 1963, the Congress of Racial Equality (CORE) was demanding that more blacks be hired at Disneyland.[84]

Nowhere is this construction of a white habitus more explicit than in the Magic Kingdom's "it's a small world" ride. Here in this microcosm, as in Mattel's "Dolls of the World" and "Princess" collections, human figures in

varieties of ethnic dress present a seemingly innocent and inclusive vision of the world. Indeed, the sign that one sees as one enters the ride states: "Embark on the 'happiest cruise that ever sailed' serenaded by costumed children from around the world." Riders encounter London Guardsmen in their red uniform coats and large, black helmets; Africans have on brightly colored cloths that wrap, togalike, around their bodies; Hawaiians sport grass hula skirts; and Egyptians wear turbans.[85] While all of this suggests the opposite of a white world, in what follows I demonstrate the way this multicultural world in fact reinforces a construction of it.

"it's a small world"

In the "it's a small world" ride, as in other parts of Disney's parks, Africa's nature is emphasized in contrast to culture (in the guise of costuming and architecture). Throughout the ride, architectural elements situate visitors in this small world. Big Ben lets riders know they are in London, while windmills signal they have moved to Holland. The Taj Mahal marks India, ceramic tiles define sloping Asian temple roofs, and a pyramid places riders in Egypt. In Africa south of the Sahara, however, architecture ceases to be the contextual signifier. A few small, thatched-roof homes are placed here and there, but it is the lush green vegetation and myriad animals that really let riders know their context. As one visitor commented, "i loooooooooove the hippo in the african scene!"[86] Even in the case of the pyramids, nature dominates, as these monumental structures are surrounded by palm trees that tower over them. The majority of the space opposite Egypt is devoted to oversized flowers and leaves. Beyond them a band accompanies a group of women dancing on a colorful platform; the women wear bright pink feathers on their heads as if Las Vegas showgirls. The drum, harp, and flute are inspired by African versions of these instruments.[87] The flute player, sitting atop the head of a lion, suggests humans and nature in harmony or, less generously, equates African humans and animals. Between this group and riders, however, are a large blue hippopotamus with three orange birds sitting on its back, two laughing hyenas, along with a green zebra and purple rhinoceros that look like they are playing drums. On the other side of the river three frogs on lily pads comprise the foreground of a small village scene (two houses and two girls).

But it is really the gateway through which riders pass on their way to Latin America that emphasizes the jungle in a major way (Plate 3). Looking

straight ahead of the boat, a profusion of colorful plants and animals confronts riders. Tall giraffes frame the archway, mixed in among a plethora of multicolored and multishaped flora. Plain, monkey-laden vines hang down from the ceiling, while vines with large flowers drape across the scene. Over the archway through which the boat will pass is a large pink elephant.[88] Three children are perched on its tusks and trunk; they play instruments as well—two horns and a drum. The impression one is left with is that of a natural environment where animals are predominant and humans are incidental. This impression is underscored by the fact that in Latin America, the next room, architecture again dominates the space. Leaving Latin America, one again moves through a more nature-oriented environment (Antarctica and much of the South Pacific).

As one leaves the visual heat and warmth of the South Pacific (evoked both through color and literal representations of the sun and fires), one passes beneath the facade of (and thus into) a *Haus Tamberan* (a ceremonial house of the Abelam people of Papua New Guinea). This architectural choice is not accidental. In Papua New Guinea, the Abelam store their ritual objects in the *Haus Tamberan*. During initiation rites, the male initiates crawl (it has a low opening that prevents one from walking upright) into the house—a symbolic belly or womb. There they undergo a period of cultural gestation, learning a variety of things (both spiritual and practical). At the close of the initiatory period, these men reemerge into the general population, knowing their new position within it. Again crawling, they are symbolically reborn into society. In a similar manner, the "it's a small world" ride visitor is initiated into Disney's vision of the world. As the ride comes to an end, visitors, like the Abelam initiates, pass through the opening of the *Haus Tamberan* and into the final "World's Fair" room, both to complete the initiatory training and to be reborn, fully socialized. That final room articulates the Disney message; it tells visitors how the world is to be and how they are to be in it.[89]

This room (Plates 4 and 5) is dominated by cool colors (icy whites, pale blues and purples, shimmering golds and silvers). Someone on a YouTube video (mis)identifies this as Iceland, so cold is the effect.[90] In part, this final room is so striking because there is so much color everywhere else and relatively none here. There is no longer any architecture; rather, most figures are placed on merry-go-round-like structures, though ones without the horses or other animals. The children of the world go round and round, endlessly repeating the same small circles. While each child is still dressed in the costume of his or her country or region, those clothes are now all the

exact same colors: differing combinations of whites, golds, and silvers. The overall effect of the room is one of sameness, of whiteness, on which I say more momentarily. Leaving the room, the boat glides through a narrow passage where signs saying "Good-bye" in myriad languages are posted;[91] following this, one arrives back at the white and gold, lighted loading dock and disembarks.

One the one hand, this ride might suggest Disney's forward-thinking nature and insight into the multicultural society that would develop some twenty years after the ride was designed.[92] As part of this, the last room can be seen to posit "a sentimental internationalism."[93] Both perspectives align with the denotative message of both the ride and its song. In so doing, they deny the sameness, the whiteness that this vision of the world promotes. Moreover, they seemingly ignore the Disney context within which this ride is experienced. Laudan Nooshin, who rode this at Disneyland Paris, on the other hand, is not so accepting of the benign nature of the message this ride conveys. Focusing as much on the song as anything else, she posits this attraction as colonialist in nature, with the visitor as colonizer on "a voyage of discovery."[94] This voyage of discovery is explicitly depicted in the opening sequence of the Disneyland version of that ride, a scene absent in the Walt Disney World Resort version.[95] The Euro-American compositional basis of the song supports this view.[96] Its tonal and rhythmic structure, along with the "march-like chorus [that] has something of the character of a national anthem," suggests that "*Small World* is less a celebration of diversity and more about the domestication and control of Others."[97] But I propose it is not just the musical structure of the song that suggests this reading. The way it is sung, and experienced, also conveys this message of American domination.

As I mentioned previously, the song is sung in multiple languages throughout the ride. The changes in audio reinforce the visual changes one experiences on this world cruise. However, in this last room the song is sung in English.[98] Therefore not only are all the different cultures of the world subsumed under whiteness, losing the color and patterning that sets their clothing apart from those of others, they must now sing in another language, the language of the dominant culture, the language of the colonizer. Though, as it is American English that dominates here, the language of the imperialist is perhaps a more appropriate characterization.

Interestingly, Stephen Fjellman, whose detailed description of this ride makes some insightful observations about the treatment of other cultures, only mentions the aural outcome in a footnote. He says:

The theme song here, sung in other languages during the ride, returns to English. One reading of the sameness of physiognomy, the eventual sameness of costume colors, and the return to English is that the world would be a better place if children all looked like American Anglos. One wonders what the message would be if all the children in the "white" room were dressed in rust and had brown skins. Another reading is that the designers of this attraction have unconsciously presented an argument for miscegenation. I like that interpretation.[99]

There is much to say in response to this comment, buried in the back of his book, a noteworthy observation, but not important enough to make a part of the main body of the text. He interestingly reads clothes, facial features, *and* language as *looking* like something. It seems to me a much more compelling argument that the insistence on the English language here is more about *performing* than looking. It is about being made *to be* Anglo-American, at least on one level. That is the vision that this world presents—a world in which the conquest of other countries and peoples is complete and successful when "they" *become* like "us." Moreover, to move around the problematic of this representation by wondering "what if" seems a slippery maneuver of avoidance. Of course the room would send a different message if it had a different presentational configuration. The fact is, it does not. Rather than wonder what might have been said in a different context, it seems much more relevant, and pertinent, to explore what *is* being said through this room: that the ideal world is a white world where Anglo-American culture dominates and where racial and cultural differences are given acknowledgment, but ultimately subsumed or undermined. This is particularly relevant when one considers, too, that this ride was created at the height of the civil rights movement and of African decolonization movements. People's positions in the world were changing quickly, and Disney offers, through this ride, a vision for controlling (and perhaps denying) these changes.

Finally, Fjellman suggests this room and thus the story of the ride could be read, not as a way for everyone to "look" like Anglo-Americans, but instead to promote an idea of miscegenation, an interpretation he admittedly favors. I am assuming that he favors this because it does in fact posit a world "with so much that we share." It posits a world in which differences do not matter. But, in the end, the different skin color of the children in the "white" room and their maintenance of national costumes undermine such a reading of blending. The children remain culturally as they were,

but they are made to perform as American. Similarly, colonized peoples
were made to perform as their colonizers.[100] In the end, the children of this
small world all become the same, but the markers of sameness are based
on American ideals and standards: musical, visual, lingual. These markers
are literally, conceptually, and ideologically *white*.

In this final room, Disney suggests that all have a voice, and that all
voices are equal, even if they must all be in English.[101] Yet colonial and
postcolonial studies question whether the voice of the oppressed is ever
really present, given the power (symbolic or otherwise) of those who dom-
inate.[102] The Disney picture is not so rosy when one considers that not
all the peoples presented in this small world had voices to begin with;
some (colonized people) are spoken for. There are places where the song
is instrumental. In the Africa section at the Walt Disney World Resort, for
instance, one does not hear children singing the song in Yoruba (or any
one of the other thousands of languages from the African continent) as
one hears children singing in Italian, Swedish, or Japanese, among other
languages.[103] Rather, as one enters the Africa room one is met first with
silence, then drumming, and finally animal calls fill the air. There is a simi-
lar vocal silence in the South Pacific section. There riders are serenaded by
ukulele(?) music that does not reproduce the "it's a small world" tune, but
rather suggests "island" music. It is perhaps not surprising that the instru-
mental realms of this ride are placed where there are few or no people
depicted: Antarctica, the rain forest, or the lands of peoples who, histori-
cally, were seen to be at the bottom of the social evolutionary ladder. Non-
Western tongues, it seems, are not equal to Western tongues, to American
tongues. The message ultimately conveys that to have a voice and be heard,
speech must be in English. And although one exits the ride past color-
ful signs saying "Good-bye" in many languages, the last of these is, and I
would say not accidentally, in English.

There are other elements that suggest the last, white room can be read
as the Disney ideal of America. This ride does not present an American
scene.[104] There may be several reasons for this. One is that Americans are
present "as passive observers of the scene" in much the same way that
Europeans were positioned in relation to Orientalist paintings a century
ago.[105] Another is that it might be more difficult to create a reductive rep-
resentation of American culture that all Americans could buy into, and
in which they would thereby feel included. Or, in another permutation of
this scenario, Americans might more easily resist the explicit stereotyp-
ing of themselves. They might then be less willing to accept as "real" the

presentation of other cultures, thereby destroying all the "magic" and the power of the message. These provide only partial explanations. Rather, as I have been arguing, a white *America* is the ideal small world for Disney. There are two figures that appear in the "white" room that do not appear earlier. They are a Native American, dressed in the white clothing of a Plains Indian (an animal-skin outfit, large feather headdress, long braids) and a cowboy. These quintessential figures of the American founding myth are above the archway as riders leave this room and head for the docking station to disembark.[106] Americans, therefore, are the last figures one sees as one leaves this small world. But the vision of America as a small white world continues; as one passes the good-bye signs, one sees once again the white, sparkly architectural forms of the loading area (Plate 6). The white of this space makes the visual connection for the rider with the white of the culminating room of the ride. The white of the Disney park ("real" world) space is the same as the white of the last "World's Fair" room. This suggests that room was indeed meant to be an ideal vision of America.

This vision creates a color-blind world, a problem that, as I discussed at length in chapter 2, has serious social consequences. Difference is given passing acknowledgment. But glossing over difference in an escapist environment ultimately reinforces rather than challenges the problems that arise in the real world, problems that result from long histories of antagonism around difference. Scholars have commented on other permutations of this in the Disney empire, arguing that Disney's ideals work to prevent individuals from acting responsibly.[107] Disney films have a similar effect in that that they "position the audience to indulge in their own complicity with such racism and sexism without having to be morally responsible for it."[108] In situating Africa as black and natural (the stereotypical conceptual opposites of white and cultural), Disney's narratives envision American power and values. Here the last room, as a world's fair scene, is not insignificant, for as I relate in the next chapter, it was at world's fairs that European countries often displayed their colonial subjects, the indigenous peoples of the lands that they dominated, further asserting this dominance. Visitors to either the world's fairs or Disney are not to question their role in these processes or the implications of the dominance because these sites are experienced as leisurely entertainment.

Indeed, I began this chapter by suggesting that Africa served a similar purpose at the Walt Disney World Resort as it did in Mattel's world of Barbie. Both position the consumer in a metaphoric place of power over the rest of the world. They do so as a means of creating a sense of stability

in times of social and cultural upheaval, and they do so through the symbolic act of collecting. Like the "Dolls of the World," the "it's a small world" ride presents a collection of the world's peoples at the service of an American vision of itself. Africa, in both contexts, helps to create this vision. There is another significant collection at the Walt Disney World Resort in which Africa plays a part. Disney's Animal Kingdom Lodge, one of the many theme lodges at which visitors to the Walt Disney World Resort stay, is home to over 500 pieces of African visual culture, and it is to this collection that I now turn my attention.

6.

Africa in Florida

Disney's Animal Kingdom Lodge

The "knowledge" that museums facilitate has the quality of
fantasy because it is only possible via an imaginative process.
—LUDMILLA JORDANOVA, "Objects of Knowledge"

The "its a small world" ride presents Africans as just one of many peoples
who are juxtaposed with one another. The Walt Disney World Resort's Dis-
ney's Animal Kingdom Lodge (DAKL), in contrast, focuses solely on Africa
and Africans. More specifically, it presents Africa south of the Sahara, a
geographic divide that distinguishes between Arab Africa to the north and
black Africa to the south.[1] I first became aware of the lodge's existence
when browsing through a copy of *AAA World* that had circulated via post
to homes across America. A photograph of a giraffe, covering half a page,
caught my attention. In her accompanying essay, travel writer Kate Muhl
describes the lodge as "providing a 24-7 total immersion into Sub-Saharan
African wildlife and culture," adding, "You'd have to go to Africa for a more
authentic experience."[2] I had that "authentic experience" of African wild-
life at the Hluhluwe-Umfolozi Park when I was in South Africa in 1997, and
I was skeptical about what Disney could offer, but, intrigued nonetheless,
off I went. Conceived as a safari experience, DAKL re-creates the Afri-
can savanna in Florida. It offers visitors a place to stay that complements
the encounters offered at the Walt Disney World Resort's Disney's Animal
Kingdom Park, thus ensuring a holistic travel experience: Africa within
the park and without. At the lodge, visitors can eat African food, watch
African animals roam past the windows, and learn about African cultures.

As a safari experience, the most obvious story being told is that of the animals. In this, it is in keeping with the park's stories and with representations of Africa in the Jungle Cruise ride at the Magic Kingdom. The Walt Disney World Resort, then, is consistent throughout its representations of Africa, as well as with a vast majority of Americans' imaginings of Africa. Africa at DAKL *is* nature and animals. Additionally, at the Magic Kingdom the associations of Africa as natural operate as stereotypes and thus have negative resonances and problematic implications; the equation of Africa and wild animals in the *Sports Illustrated* (*SI*) swimsuit issue produced a similar effect. At DAKL, positing Africa as nature is more reductive than stereotypical and therefore less problematic. Africa is, after all, home to the many types of animals that wander the grounds of DAKL's savanna, but it is also much more than that, and DAKL provides access to those other stories.

Describing her and her husband's experiences at DAKL, Muhl offers:

Our initial response to the animals was one of surprise and awe, that only deepened over the weekend. We'd developed a sort of relationship with the animals: we waited for them to come and visit, we were transfixed as they did their thing; when they were done, we were sad to see them roam off out of sight.

It was an experience not unlike what one can have with art. In a museum, all you can do is stand there and look at the art for a while. When the art is in your home, the images and artistry become part of your life. Seeing the art at different times of day, from different angles, in different moods, offers something new and rich with each viewing. The Animal Kingdom Lodge experience is similar, if compressed.[3]

Muhl's analogy is particularly interesting and relevant because, in fact, one does live with art in the same way that one lives with animals when staying at DAKL. One cannot walk through the lobby, walk to one's room, eat at one of the restaurants, or shop in the lobby store without seeing African visual culture. This visual culture is presented in two primary ways: as decor and in formal displays. Throughout this chapter, when referring to the visual culture that comprises the decor, I use the term *visual culture*. I also use it in more generalized discussions of objects of African visual expression, as I have been throughout the book. However, when I turn my attention to the formal displays, I will refer to it as *art*, for in these displays DAKL presents African visual culture *as* art.

Muhl's analogy is significant also in that it raises the idea of art museums, for DAKL employs exhibitionary practices of art museums in presenting visual culture as art. Indeed, Disney worked with several specialists in African art (scholars Herbert Cole and Doran Ross, and gallerist Charles Davis) on its plans for the visual culture at the lodge. In addition, the lodge, like a museum, provides both educational and entertaining experiences. An art museum is also important in comparison to DAKL because they are both sites at which American audiences can come into contact with actual African objects. African visual culture is physically presented for the audiences' viewing pleasure and intellectual edification. This is different than the other forms of popular culture in this study, where one encountered only representations of African visual culture and not the real thing. Additionally, both museums and DAKL interact with the tradition of world's fairs and expositions, a point to which I will return.[4] Most important, however, museums are sites around which social relations are mediated, a point revealed in my discussion of the National Museum of African Art in the introduction to this book. Its presentation of visual culture provides objects around which ideas of self and Other are negotiated. DAKL offers guests an opportunity for similar negotiations around African visual culture. In view of this, it is important to note that although DAKL re-creates Africa south of the Sahara in Florida, it is still Disney, and Disney signifies and promotes America. As such, the ways that DAKL locates guests vis-à-vis Africa can be read as positioning America as different from Africa.

Before focusing on African visual culture at DAKL, I want to set the scene by discussing the lodge itself and the understandings of Africa it offers. As the following reveals, the Africa presented at the lodge is colonial Africa, even as the lodge engages with contemporary African manifestations of the safari experience. This is not to say, however, that the extensive team of consultants who designed DAKL set out to intentionally (re)create colonial Africa.[5] Rather, the ideas about and approaches to Africa that are couched in colonial understandings are so prevalent that the perceptions and representations are often reproduced unwittingly. This is especially true in the context of safari.

Travel to Africa in the postcolonial era "exists within scripts drawn from colonial-era representations of Africa and Africans."[6] It is not surprising, then, to find that travel to Africa at Disney is similarly framed, for it is through myriad safari trips in Africa that the Imagineers originated their African designs for both Disney's Animal Kingdom Park and DAKL.[7] And it is a trip to Africa that the lodge itself offers. Nor should it

be surprising that this trip draws on colonial representations of Africa. Among these representations was the idea that African cultures were less evolved and therefore less modern than Western cultures. Africa was possessable (as a colony and in terms of its material goods). And Africa was thought of as black Africa. These imaginings of Africa positioned Westerners in a dominant position, and given this, Africans were seen to be available to provide services for them. Africa was also seen as a realm of wild nature. Traces of these representational conventions run throughout DAKL. In this, DAKL resonates with the other popular culture forms that I have examined in this study. In contrast to America, as the ideal white paradigm for the world that the "its a small world" ride emphasizes, Africa is black and natural, not cultural. The *SI* swimsuit issue, also framed by travel, presents Africa as natural, inferior, nonmodern, and consumable. Barbie suggests Africa is possessable, and through nostalgic longings associates it with earlier historic eras in which America and the West dominated the world order. I argue the evocation of the colonial era at DAKL plays a similar nostalgic role.

And yet even as these meanings are all identifiable in the representations of Africa at DAKL, one can ascertain other meanings as well. As I demonstrated in my discussion of the Ndebele presence on the pages of *SI*, other meanings often counter and subvert the dominant one. With Ndebele participation in the photographic project of the swimsuit issue, the contradictory meanings resulted from the presence of African visual culture as well as Africans themselves; so it is at DAKL. In fact, the interventions offered by both African workers and the formal displays of visual culture at DAKL present some of the most constructive representations of Africa with which this study has engaged. Although in the end the problematic representations predominate, the constructive ones go a long way to providing U.S. audiences with the opportunity to know Africa beyond the stereotypes so often encountered in U.S. contexts.

Colonial Imaginings: Safari at DAKL

The lodge itself is an imposing structure, and as one pulls up on the Disney airport shuttle one immediately sees its thatched roofs.[8] The main portion of the building has an undulating surface and looks as if it is made of mud (as are the homes of the Nankanse peoples of Ghana), and has figurative bas-relief depictions of animals as one might see on buildings of the

Senufo peoples (Côte d'Ivoire).⁹ The parts of the building that house the guest rooms, however, are more standardized hotel structures: a flat roof and rows of balconies, though each trail (as the four guest-room hallways are called) ends with domed, thatched roofs. After visitors de-bus, cast members in khaki uniforms are available to assist them with their luggage. The thatched roofing and khaki uniforms are important; as the first impressions visitors have of the lodge, they set the tone for and mood of subsequent experiences. The thatching signals difference, for it is not a material commonly used in building American homes or hotels, and visually lets visitors know they have arrived in a different world. The thatching's reference to "huts" also signals that this new world is not as "civilized" as the one from which visitors have just come. Huts, generally, have pejorative associations in Western culture. Structurally, they are believed to be inferior to the buildings of the West. Commonsense understandings suggest they are rural, not urban, and do not have electricity, running water, or other amenities, amenities to which most tourists are attached. Despite the fact that the lodge offers luxury accommodations with more than the basic amenities, the architecture subtly anticipates the thrill of the safari experience awaiting the guests, but it does so in a way that offers it safely. Indeed, safety is a common selling point in commentary about a DAKL experience. One Disney visitor notes, "You don't have to think about malaria tablets or any safety issues," concerns that would need to be addressed on an actual safari in Africa.¹⁰

The porters, in addition to providing the practical assistance of luggage handling, serve to reassure visitors that although this new world is perhaps not as developed as the one from which they just came, it is not so underdeveloped as to not have a core group of people to see to their comforts.¹¹ In their khaki uniforms, they evoke colonial-era Africa and signify the civilizing presence of Europeans. Moreover, their khaki outfits are appropriate safari attire, an idea established in the American imagination in the early twentieth century through the photographic depictions of big game hunters (such as former president Theodore Roosevelt) on their African hunting adventures. The photographic safaris of such people as Martin and Osa Johnson were also instrumental in this. They circulated films and photographs of their African experiences, popularizing safaris for American audiences in the early to mid-twentieth century.¹² This style of dress continues today at animal parks throughout the continent. In just the first few moments of one's DAKL experience, then, safari is installed as the primary story, and the colonial era and its legacy, its subtext. This maintains throughout.

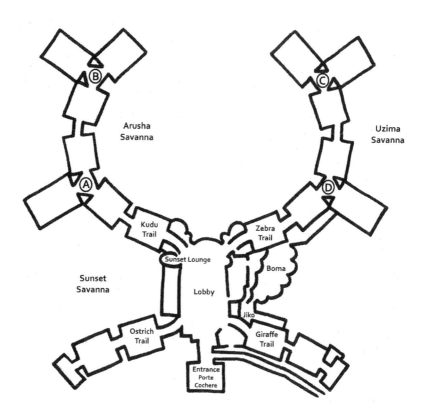

Figure 6.1. Floor plan of Disney's Animal Kingdom Lodge, Walt Disney World Resort
Drawing by Klint Ericson
Used by permission from Disney Enterprises, Inc.

One enters the building into a vast lobby filled with people, chairs, visual culture, art, and more. (Figure 6.1 presents a floor plan of the lodge.) African music fills the air. To the left as one enters is the check-in desk that runs almost the entire length of the lobby. Behind the desk hang appliquéd cloths from Benin with colorful symbols and motifs. Straight ahead, the room is symmetrically divided into six diamond-shaped seating areas arranged end-to-end in two rows. This space offers adults places to meet, relax, and/or people watch, and, through a television on which movies are always showing, offers children an opportunity to see one of their favorite Disney animations. To the right are the bar, the store, and access to the restaurants that are on the lower level. Interspersed throughout the lobby, and helping to shape the separate seating areas, are cases displaying

African art. African visual culture is also present in the form of stools, chairs, tables, and chandeliers (made to look like Maasai shields).[13] These hang from the vaulted ceiling that rises three stories above the lobby floor. This ceiling continues the illusion of the exterior of the lodge, as it is made to look like the interior of a thatched building. To the left rear is the artistic pièce de résistance—in size and guest interest—an Igbo (Nigeria) *Ijele* mask made of brightly colored, appliquéd cloth, and standing fifteen feet in height. At the end of the lobby a glass window stretches from floor to ceiling and provides a view onto Arusha Rock and a "savanna" where one can view the various animals that live on the thirty-acre grounds. The packet DAKL provides guests upon check-in includes the "Wildlife Field Guide," which lists thirteen mammals and eight birds that one might see on the savanna, along with tips to help identify them and information about their behavior. There are also cast members who are available at prime sighting areas to assist with this as well.[14]

To the left, beyond the *Ijele* mask, is the Sunset Lounge. It is an oval room containing cases displaying both African and Western visual culture and artifacts. Historic black-and-white photographs of Africa hang on the walls and sit on shelves in this small, intimate setting. Their presence in DAKL is a physical and conceptual link between the present and the colonial era, for they show scenes (by the Johnsons) from safaris.[15] Weapons, thorn carvings of European figures,[16] an Igbo figure of a colonial man, a pith helmet, binoculars, and china fill the cases and explicitly reference colonial encounters in Africa. Indeed, although the architecture and carpeting of the Sunset Lounge evoke African buildings and textiles, the decor and the furniture, and thus the general atmosphere, evoke a colonial administrator's office and/or home. Guests can sit and relax in this space, and every evening the Cultural Safari is held here.

The Cultural Safari features a representative from an African nation who gives a PowerPoint presentation about his or her country. Each of these individuals has the opportunity to tailor the presentation to his or her own interests and knowledge; all highlight tourism and the Big Five (elephant, lion, leopard, rhinoceros, and cape buffalo). These animals were most sought after in colonial-era hunts, and, incidentally, are not part of DAKL's savanna. These events provide guests the opportunity to learn about a variety of African peoples and places as well as animals. A similar experience is offered in Disney's Animal Kingdom Park, where one can attend educational lessons at various times throughout the day at the Harambe School, a seating area near the entrance to the Kilimanjaro

Safaris ride. Although African culture is ostensibly the subject of those events, that they are called "safaris" exoticizes Africa and Africans, positioning guests as explorers (as is the colonial era) on some great adventure.

I attended two Cultural Safaris at the lodge and one at the Harambe School. The first night my research assistant, Jeff, and I were the only two in attendance for the entire session, which lasted about thirty minutes. Others came and went during this time, but did not stay the full length of the presentation. Our guide on this safari was Baruti from Botswana;[17] dressed in the ubiquitous khaki outfit of the lodge's guides, he spent most of his time talking about animal wildlife and conservation in his home country. As Jeff commented to me afterward, the presentation was not cultural, in that we did not learn much about life in Botswana, about the customs, beliefs, politics, or history of its people. However, the presentation was appropriate for a Disney audience interested in animals, and who is, first and foremost, at the Walt Disney World Resort not for education, but for entertainment. Afterward we stayed and spoke with Baruti about his life and his work at DAKL. When I asked him what he thought about his educational role, he commented that he did not see himself as an educator, rather as an entertainer (a distinction to which I will return).[18]

Baruti told us that he worked at a game reserve in Botswana for seven years before coming to Orlando. Those working in the game parks there need to be licensed, so he first trained and worked as an assistant guide (four years) and then became a full guide. At the time of our conversation, he had been at DAKL for several weeks, but would stay for a year. He was very proud of Botswana and thankful that Disney was providing an opportunity to "put Africa on the map" and make people aware of Africa and African animals. He also talked fondly of Namibia, Zimbabwe, and South Africa, giving us suggestions about where to go and what route to take for a trip: two days at camps starting at the game reserve in the Okavango Delta and then heading east to Victoria Falls, Zimbabwe; from there flying to Johannesburg and then to Cape Town where, he informed us, the nicest beaches could be found. Although not easily included in this itinerary, he recommended Namibia as well because it has amazing deserts. Baruti got the Disney job through the Hotel and Tourism Association of Botswana (HATAB). Interested individuals first applied through HATAB with a letter. If chosen, the individual next had to go through an interview process, and finally, that individual would go to work for Disney. There he or she could learn a different aspect of the tourism industry, and perhaps knowledge or skills to bring to bear on the local situation at the end of his or her

Disney tenure. Indeed, as Jeff noted, Baruti's presentation promoted tourism; he was a good ambassador for tourism in Botswana, the industry to which he will return when his Disney days are over. He did his job well; he readily conveyed his goodwill, enthusiasm, and seemingly genuine desire for us to know and see Africa itself.

The presentations by two other Cultural Safari guides also promoted Africa, and, ultimately, travel there. In the Sunset Lounge, a South African guide, Lisa, spoke about food and drink. This connected well with the restaurants at the lodge, for Jiko, the high-end restaurant, has an extensive and exclusively South African wine list. Jiko and Boma, the more casual restaurant, offer African dishes on their menus. Steve, the guide at the Harambe School in Disney's Animal Kingdom Park, was also South African. He focused on the cities in South Africa, passing around laminated cards of photographs of Johannesburg, Cape Town, Durban, and others, though of course he mentioned the Big Five as well. There were about six other adults in the audience, and they all asked a lot of questions. Perhaps because it started out with cities, the discussion focused primarily on the gold and mining industries, driven largely by questions asked by the audience members. Steve told us that all South African people speak English, and primary education will be in English or Afrikaans. There are, we learned, in addition, nine official indigenous languages, Zulu being the most widespread of these.

Although each of these guides presented different aspects of his or her home country, all took the opportunity to promote that country, and specifically to promote travel to that country, at the same time authenticating the Disney experience. This focus on travel is not surprising, given that the overall context in which they are speaking is one of travel—for all visitors to DAKL travel to get there, even if they are only traveling across town. The entire experience is one of tourism. And, as I have previously stated, a safari is the quintessential African tourist experience. The prevalence of travel as a framing device and as explicit context for this Disney experience is similar to both the *SI* swimsuit issue and Mattel's "Dolls of the World" collection. In each the consumer, the Westerner, is in a position of power vis-à-vis Africa. On a practical level, the power here is economic, for visitors to Disney's parks and hotels have enough income to afford such a trip. It is not cheap. The cost of the trip for me and my research assistant in October 2006 was over $3,000 for a five-day, four-night stay.[19] Indeed, Martin Hall observes that "visitors to installations such as these [Disney's Animal Kingdom Park and DAKL] are already part of privileged elites,

and participation in themed entertainments helps them feel better about themselves."[20] Every time one makes a purchase, for instance, one is given the opportunity to contribute one dollar to the Disney Conservation Fund, an activity countering the consumerism of the park.[21] Visitors to Disney's Animal Kingdom Park and DAKL can make a financial contribution that addresses an issue in the larger world, participating in consumer and charitable acts at the same time. A similar contradiction exists at Disney's Animal Kingdom Park, where concern for the environment runs up against the desire for adventure in that environment.[22] Jeff observed that at Disney, all discussions of animal welfare centered on the problems of poaching; the human environmental impacts (local farming, overpopulation, tourists, global warming) were not addressed explicitly. Visitors were asked to help stop poachers, but not to consider their own ways of acting and being in the world. They are not, nor realistically could they be in this context, asked to consider the impact their own tourism has on any given environment they visit. However, their effect on the environment through the burning of fossil fuels—in a car or on a plane—or the amount of recycling they engage in is something that could be presented for thought.[23]

Power relations in terms of economics and servitude can be seen in Baruti's view of himself as an entertainer. The African, it seems, is there to entertain the tourist and to guide the safari. The African is the insider on whom the successful adventure depends (both logistically and symbolically), just as the Ndebele women helped ensure the success of the *SI* swimsuit shoot. Entertainment is an instrumental and essential part of that success for DAKL visitors. Despite his self-perceived role as entertainer, I found conversation with Baruti to be educational, especially with regard to his role at DAKL. When I asked him what he thought of DAKL, he commented that he thought it was an accurate representation in that lodges in Africa have art and enable visitors to see animals.[24] Overall, he thought, Disney provides a good sense of Africa. Was this his real opinion, or did he feel obligated to say it given the Disney/tourist context? The latter could be seen as speaking to another manifestation of power, one where Africans' thoughts and opinions regarding the tourist experiences they enable are never totally accessible; the African voice may well be silenced—whether in the act of self-censorship or at the behest of Disney.[25] But as with the Ndebele, this silencing or control is not total. The Ndebele women have agency in their presentations of their cultural heritage; such agency is evident in the guides as well. *They* choose what aspect of their country they will present to the Disney-going public. The Harambe

School's South African guide Steve, for example, chose to present cities; this counters the wild, natural depictions of Africa that permeate Disney's Animal Kingdom Park and DAKL experience. Visitors who interact with Steve see that people live in a variety of locales and spaces; they have cities, not just villages with huts, despite the fact that the latter is an image that Disney draws on and perpetuates at the lodge, at Disney's Animal Kingdom Park, and in the "its a small world" ride. In a similar instance, Nancy Muenker, writing about her experience at DAKL, describes her encounter with a guide: "Describing the landscapes of his homeland, he helps dispel the notion that all of Africa is a jungle."[26] Too, Steve and Lisa are white South Africans, countering the idea of Africa as "black," though one white South African worker at Disney's Animal Kingdom Park has had guests refuse to believe he is really African.[27] This is because most people hold an image of Africans as *only* black. A worldview that does not recognize whites as Africans must see them as colonials, imperials, or tourists. Given the service role the guide is playing for the Disney tourist, this latter is not a possibility in the context of the Walt Disney World Resort. Nevertheless, the presence of white Africans at the lodge (and park) is a strong corrective to misperceptions about who is African. And, at the same time, the narratives these guides tell of cities and other aspects of contemporary African life work against the Disney picture of Africa as natural.

Such experiences and interactions counter negative and/or stereotypical messages about Africa as ancient and natural, or Africans as only black. And they bring to light another manifestation of the tensions (productive/ problematic) that exist in representations of Africa. To be sure, despite such interventions and attempts to counter reductive representations by Africans themselves, their presence at the same time can reinforce these representations, and further the colonial subtext. Africans at the Walt Disney World Resort guarantee the experience is authentic, and in this context an authentic African experience is one in which "both 'nature' and the 'native'" are consumed.[28] American visitors to DAKL consume Africa, collecting their African experience without leaving the comfort or convenience of their home (the United States). The majority of hosts, hostesses, waiters, and waitresses, along with some kitchen staff at the two restaurants, are African. That they are there to facilitate the visit (both literally and figuratively) reinforces notions of authenticity and the colonial. The colonial era is perhaps a logical choice for the "ethnographic present" of the lodge because it was during this time period that the safari as a tourist experience became a prevalent activity and focus of American

imaginings.[29] Frequently thirty Africans per one white person would be employed as porters on safaris, leading Curtis Keim to remark that "the safari was about colonialism and the subjugation of nature more than about observing or understanding nature."[30] But the colonial-era safari is more than just a physical model for how the West might relate to Africa and Africans, and thus how a safari experience might be re-created in the wetlands of Florida. It holds symbolic meaning as well.

Several factors combine for a successful safari: "dissatisfaction with the intensity of modern life, yearning for adventure and freedom from the domestic, confidence in the future, wild nature in abundance, and the subservience of other men."[31] Such factors are read at DAKL itself. As I mentioned in the previous chapter, the creation of Disneyland, and subsequently the Walt Disney World Resort and Epcot, was the result of Walt Disney's dissatisfaction with the modern world, a dissatisfaction that was answered by creating ideal environments.[32] The parks offer a variety of adventures for a range of ages and tastes. And the parks offer (the illusion of) freedom in that visitors can decide how they use the parks and what adventures they enact.[33] Wild nature is present in Adventureland at the Magic Kingdom, Disney's Animal Kingdom Park, the Wilderness Lodge, and DAKL. At DAKL, the African staff provides the subservience of other men. The promise of the future exists explicitly in Future World at Epcot and Tomorrowland at the Magic Kingdom. It appears more subtly in the nostalgic return to small town America represented by Main Street and the positing of America as the ideal in the "its a small world" ride.

Indeed, the nostalgia for a bygone era that Main Street and the "its a small world" ride put forward is critical for understanding the significance of the colonial era evoked at DAKL. More relevant for this context, the colonial era harkens back, in the imagination, to a time when Americans knew their places vis-à-vis the rest of the world; America's role as a world power was increasing.[34] Although not itself a colonial power in Africa, the United States certainly partook in the benefits of colonialism—making extensive use (and abuse) of Africa's resources, human and otherwise. For instance, in the late nineteenth and early twentieth centuries, Americans were large consumers and producers of ivory products such as piano keys and billiard balls. Although several ivory-working firms had trade houses in Zanzibar, these firms themselves did not participate in elephant hunts. Rather, they depended on local Africans for their supply of ivory.[35] Africa, then as now, was a support for the commercial enterprises of American business.

In the colonial era, too, there was increased exhibition of things Afri-
can outside of the continent. Colonial powers sponsored collecting expe-
ditions within these territories.[36] But it was not just the colonizing nations
that participated in this; U.S. cultural institutions did so as well. African
flora, fauna, and visual culture were collected and presented to the Ameri-
can public.[37] These items were displayed in the natural history museums
of major cities, and as the colonial era wore on, also in art museums. That
DAKL presents African visual culture to its public therefore can be seen to
be in keeping with the overall colonial subtext of the lodge. It is time now
to look more closely at this visual culture and the meanings it generates.

"Aesthetic Entertainments": African Visual Culture as Decor

As decor, African visual culture is simply part of the environment at DAKL.
Each of the lobby seating areas has an African textile as carpeting (or car-
peting designed to look like an African textile), chairs, couches, tables, and
Cameroonian stools. Glass tops over four Dogon (Mali) granary doors
comprise two of the tables. Maasai-inspired shields form the chandeliers.
A brightly painted, carved shield adorns each guestroom door; the pat-
terning on these shields is obviously inspired by Maasai motifs though
the coloring is not, as they are yellows, greens, and oranges, not the reds
and blacks typical of shields used by the Maasai themselves.[38] Whereas the
furniture references an African domestic setting, the shields invoke the
wildness and savagery of Africa. Both of these, through their difference,
counter the everyday context of the visitor, and align with the imaginings
of a safari experience. Big game hunting is also suggested in the lighting
fixture in the porte cochere, where the ribbing elements evoke elephant
tusks. The spiraling marks that cover these elements also bring to mind
oliphants (ivory horns) carved by the Kongo peoples (Democratic Repub-
lic of the Congo [DRC]). The visual culture, therefore, is vital to creating
the ambience of the overall (colonial) African experience at DAKL, and to
mapping Africa within the space of the lodge.
 Indeed, the vast majority of the visual culture at the lodge is presented
as part of the decor, and as such, it is incidental. For instance, the Ostrich
and Giraffe guestroom trails (hallways), located at the front of the hotel,
are divided into three sections of rooms (see Figure 6.1). Between each
section is a place where one can stand and look out at the surrounding
landscape and the animals that populate it. At various points along the

trail, and at the end of each hall, one can find African visual culture (ladders, masks, clothing, and so forth) or color photographs depicting Africans. Each is marked with a label that identifies the object, cultural group/peoples that made it, and the country of origin: "Ladder," "Lobi peoples," "Burkina Faso," for example. Along with the subject matter, the labels for the photographs identify the photographers, Carol Beckwith and Angela Fisher. The exceptions to these incidentals (though not the labels) are the glass cases in the lobby and the objects presented in didactic displays along the two rear guestroom trails; I address these displays in the next section.

The lights along the trails are sconces that are made to look like carved calabashes and the heads of drums. The rooms continue with African-inspired motifs and objects, though as with the lobby decor, African references are not explicitly named here for the guests. There were no labels in my room; Africa is atmospheric. The carpeting is based on Kuba (DRC) cut-pile cloth and the bedspread on west-African appliquéd cloth. Faux mosquito netting drapes the wall behind the headboard that is carved in the shape of a Bwa (Burkina Faso) butterfly or hawk mask. There are plenty of other animal motifs to remind visitors of their safari context: the wood frame of the mirror is shaped as a lizard, and the wood cabinet that houses the television has turtles incised among geometric patterns. The picture on the wall, based on a Fante (Ghana) *Asafo* flag, depicts three monkeys in red hats, each in front of a blue tree with ovoid green leaves. And, of course, there are the real animals seen out of one's window that remind as well.

The wallpaper in the bathroom was also a potent reminder of both the safari context and the colonial subtext.[39] A faded brown map of eastern Africa, it depicts a repeating grouping of Lake Victoria, the Rift Valley, and Mt. Kilimanjaro, surrounded by (disproportionately sized) animals, people, and modes of transportation (a railroad—with a coal-burning steam engine—and a car). The animals (elephant, crocodile, hippopotamus, sable antelope, rhinoceros, eland, ostrich, lion, situtunga, and water buffalo) reference the natural side of Africa and remind visitors of the purpose of visiting DAKL and Disney's Animal Kingdom Park. The people depicted on the paper recall the colonial era and underscore white civilization: a white man fishes in a lake; another is on a tractor—cultivating the land (though seen only in silhouette, one can assume this figure is white because his hat is similar to that of the man fishing); two black men are shown wearing loincloths and holding spears and shields (like those that decorate the doors and form the chandeliers). Here the perceived wildness/savagery of Africa and its peoples is again referenced, and it is

juxtaposed with the technology, cultivation, and lifestyles of Europeans. Also identified are various place-names. While places such as Nairobi and Entebbe may be familiar to Americans visiting DAKL, the others (Arusha, Biharamulo, Dodoma, Kibando, Kondoa, Konga, Lengal, Lira, Mbeya, Mhenge, Moroto, Mwaaui, Mwanza, Naivasha, Ngorongo, Nzega, Suswa, Tagora, Tsavo, Lakes Rudolph and Natron, and the Selous Game Preserve) are probably less so. This wallpaper, as a map and as a representation of Africa, symbolically orients visitors in their new environment, while the unfamiliarity of these names reinforces the exotic nature of both the Africa of the map and the Africa of Disney. By including Arusha on the map, Disney serves to authenticate the visitor's experience of DAKL's own Arusha savanna (see Figure 6.1). Similarly, with the reference to the Selous Game Preserve, Disney reminds its visitors of one of its explicitly acknowledged missions—the protection and care of animals.

African visual culture decorates the restaurants and marketplace as well. Jiko presents a chic environment with a few well-placed objects in stylishly lit niches. Boma, the larger restaurant, has a more thoroughly African decor. Columns are designed to look like stacked ceramic vessels, and west-African strip-woven cloths, such as kente, drape from the ceiling. The fixtures at Zawadi Marketplace, located just to the right of the main entrance in the lobby, also reference African visual culture: the wall shelves are separated by wooden pieces carved to look like the tree-trunk ladders used by Dogon (Mali) and Lobi (Burkina Faso) peoples, among others; the freestanding shelves reference Asante (Ghana) stools; and the columns are covered in the blue and white patterning of west-African indigo-dyed cloths. This shop offers kitschy Disney African safari tourist items: a T-shirt with the head shape of Mickey Mouse in-filled with silver and black shiny studs in the pattern of zebra stripes, or snow globes and key chains with Mickey and Minnie in khaki outfits and sitting in a jeeplike vehicle, for instance. (Mattel even released an Animal Kingdom Barbie— in both white and black versions—in 1998, coinciding with the opening of Disney's Animal Kingdom Park; they wear the ubiquitous khaki outfits.[40]) These items are mixed with African crafts and art. One can, for example, buy a print or watercolor of an African scene for $200. An African artist often gives demonstrations of the painting process, assuring the authenticity of both the artwork and the experience.

While being able to see the artist at work can be educational, the entertainment value of this, along with the Cultural Safaris, brings to mind exhibitionary practices where African peoples were put on displays in

re-created villages at world's fairs, colonial expositions, and botanical and zoological gardens. This latter context is especially intriguing in relation to DAKL, where the Africans and animals are juxtaposed once again, for it implicitly posits Africans as part of the natural world.[41] World's fairs shared two display strategies. One focused on the industry of the nation, and the other presented objects and peoples from colonized territories.[42] Steve Nelson refers to these, respectively, as "technological presentations" and "aesthetic entertainments."[43] The division reinforces the idea that Westerners are modern (industrial, technological) and Africans (among others) are not. At the lodge, the African painter, greeters, guides, and others can be seen as "aesthetic entertainments." And the association of Africa as non-modern ensures the success of the experience at DAKL, for safaris provided an escape from the demands of the modern (Western) world.

Furthermore fairs and expositions are a critical part of what Tony Bennett calls the "exhibitionary complex." Department stores; art, natural science, and history museums; exhibitions (both national and international); and disciplines such as anthropology, art history, biology, and history comprise this complex and work together toward establishing social order.[44] This complex established an order that positions white middle-class (and male) society on top of all others. Through their broad appeal and far reach, fairs and museums served as ideological apparatuses through which the public could be taught to think in a manner that reinforced mainstream ideals and values.[45] Through the display of non-Euro-American cultures, Western audiences were given knowledge of them and, with that knowledge, power over them. Audiences' passive consumption of these implicit messages socialized them into this point of view; they unconsciously accepted it as a viable perspective. This in turn kept exposition-goers complacent in their own domination or position of powerlessness in other (primarily economic) realms.

Disney can be seen in a similar manner. Disney demonstrates its power over Africa in the display of African visual culture, animals, and peoples at DAKL, for in re-creating Africa in Florida—in America—Disney exerts control over that world. In visiting DAKL, guests partake of that power and at the same time forget about the ultimate economic power that Disney exerts over them. A DAKL experience offers symbolic control of the world through its (neo)colonial adventure. It provides consumers with a means to make sense of their world, and to assure and maintain their privileged places within it. Moreover, these effects construct Africa as *black* even when there are white Africans to counter this message. This is not to

say that Africa should not be thought of as black at all, for the vast majority of its population is indeed black. The problem, rather, is with the associations that imagining entails, associations I have been exploring throughout this book.

As the foregoing discussion indicates, the presence of African peoples and visual culture as "aesthetic entertainments" is vital to the socialization occurring in the spaces of the exhibitionary complex. Visitors are positioned in such a way that they are not consciously aware of this. Indeed, as I have reiterated throughout this study, the producers of these cultural forms are not necessarily aware that their products align with particular ideologies. But the positioning occurs nonetheless. This mediation may occur through symbolic juxtapositions (industry of the West versus the "primitiveness" of other places) or through the subtle messages of decor (such as at DAKL). It may also occur via encounters with a formalized and planned experience of African visual culture.

Counternarratives: African Visual Culture in Formal Displays

The formal displays of African visual culture as art, by which I mean those places where the visual culture is presented in Plexiglas cases or with extensive didactic information, can be found in two main areas of DAKL: the guestroom trails, which form a horseshoe shape (based on cattle kraals) at the rear of the hotel, and the main lobby.[46] The Kudu and Zebra Trails wrap around the Arusha savanna and provide views of Arusha Rock. These trails are longer than the two at the front of the hotel and are divided into five sections of rooms. Two points along each trail (A and B, and C and D; see Figure 6.1) house large displays of African art and photomurals, each providing information about a particular theme. When displayed as art, visual culture generates meanings differently than when the visual culture is simply part of the decor. As decor, visual culture is meant to *create* Africa for visitors; its meanings are grounded in a safari atmosphere. But when presented as art with educational material, African visual culture's meanings shift back, in part, to the meanings of its local context. Guests are meant to *know* Africa. African visual culture, treated here as art in didactic displays, invokes engagements with objects that stem directly from museum practices. It is clear that members of the design team were aware of museum studies literature that focuses on how display strategies influence meanings of objects.[47] But it is not only the display strategies that facilitate

"knowing" Africa. The context of DAKL—the environment in which these pieces are ultimately seen—also frames understandings of them. The display cases at DAKL are not in the pristine white rooms of museum galleries, where hushed voices discuss the works. They are in a space of leisure through which people with luggage, strollers, or children—barely able to contain their excitement—move, and outside of which animals roam.

Nonetheless, as Martin Hall suggests, African art at DAKL is vital to the experience there. Authentic objects, he proposes, are increasingly inserted into simulated experiential environments as a way of grounding those experiences as authentic, and positioning them as unique against other simulated contexts. This experience focuses on the individual, offering "the fantasy of a customized world."[48] Disney offers guests at the lodge a customized fantasy of an African safari. Hall sees such offerings as a move from the exhibitionary complex to an experiential complex. This latter has four components:

> entertainment, education, escape and aestheticism. Education requires the active participation of the individual. Escapism requires immersion in the experience (in contrast to the passive observation of entertainment). The aesthetic requires quality of place: "the sweet spot for any compelling experience—incorporating entertainment, educational, escapist, and esthetic elements into otherwise generic space—is similarly a mnemonic place, a tool aiding in the creation of memories, distinct from the normally uneventful world of goods and services."[49]

These four realms together create the experiential complex in which contemporary museums and Disney's Animal Kingdom Park, though also DAKL, participate. Certainly, the entertainment aspect of the lodge is self-evident; it is fun to watch animals most often seen in zoos grazing trees or grass beneath one's window. It can be awe inspiring to gaze through night vision binoculars and see ankole, zebras, and impala in activities that are usually hidden by the dark from our eyes. The Cultural Safaris and other activities, along with the didactic displays of African art, provide the educational component of that experience. In staying at the lodge guests essentially live with the animals and visual culture, thereby partaking in the escapist element; they are not at home. Disney's attention to detail and the authenticity of the art in the displays contribute to the aesthetic. These, then, combine to create that "sweet spot," the place set apart from the ordinary world, and that place in which memories are created. Yet while DAKL

clearly fits within the experiential complex as elaborated above, it is still strongly grounded in the exhibitionary complex. This is in part due to the disciplinary knowledge that is at play in the presentation of information and the creation of experiences at the lodge.[50] Biology teaches about the animals that are the primary focus of the lodge experience. Art history and anthropology provide specific information about the African cultures that are represented by the works of art.

The art in the lobby is, in fact, the first thing all visitors see as they enter the lodge. It is also the last, for hanging between the two main doors to the building is a large carved Nupe (Nigeria) door. As with the visual culture and photographs on the Ostrich and Giraffe Trails, Disney provides labels with the same identifying information (object, culture, country) for the art in display cases in the lobby, Kudu, and Zebra Trails. As one enters the building, two display cases stand facing the viewer—the left one holds two Lobi (Burkina Faso, Ghana, Côte d'Ivoire) figures and the right a Bamana (Mali) *tjiwara* (antelope-inspired figure). On the exterior sides of the seating areas are cases in which African art and artifacts are displayed. Most of these objects are smaller pieces such as iron currency, jewelry, decorated gourds, beaded bags, hats, flywhisks, and gold weights—basically objects for personal use from both west- and central-African peoples.[51] To the left, and in between the left side of the seating area and the front desk, are three cases with larger objects: an Ewe (Togo) equestrian figure, a Bamileke (Cameroon) beaded hat, a Yoruba (Nigeria) beaded sword sheath, a Ejagham (Nigeria) beaded crest, a Guro (Côte d'Ivoire) mask, and a Kotoko (Chad) fertility amulet. Beyond these, and near the opening to the Sunset Lounge, is the *Ijele* mask. The lobby therefore presents a broad range of cultures, objects, and beliefs. Charles Davis, the gallerist hired by Disney to procure the African pieces, notes that this breadth was one of the goals in gathering the visual culture for both the decor and the displays.[52]

Rarely are the individuals, the artists, who made the objects identified; instead, a label might read: *Asafo* flag, Fante peoples, Ghana. This is not simply a problem with Disney's documentation, but with documentation of objects from Africa in most museum collections. It stems from the fact that the majority of African visual culture in museums was collected during the colonial era; these objects were seen as representative of the style of the cultural group, and not the work of an individual craftsperson or artist, so those collecting did not think to ask about that information. It was, after all, not until the early twentieth century that African visual culture came to be considered art (and therefore worthy of display in art museums) and

not artifact (presented in natural history museums), so it is not surprising that determining the maker's name was not a priority in the colonial era.[53] Moreover, in associating styles with cultures and not individual artists, African art came to be seen in terms of object-types; in a grossly simplified (and decidedly nonconnoisseur-oriented) perspective, one Yoruba *ibeji* (twin figure) is the "same" as another. This history of collection has implications for the objects on display at DAKL, where they are the primary means by which visitors learn about cultural aspects of African peoples. First and foremost, as they were historically, these objects are seen to be synecdochical stand-ins for the cultural group. This focus on the cultural group evokes associations of African "tribes," which references black Africans and thereby reinforces a vision of Africa as black.[54]

This history of collecting also established ideas of authenticity for African objects, and authenticity was an important animating concept in DAKL's creation.[55] As many scholars writing about Africa have addressed and problematized, those objects most generally considered authentic are those made for use by the culture that produced them; those objects made for external audiences are not authentic.[56] Davis works according to this principle, and thus the objects on display in the cases are all authentic pieces of African art.[57] Another aspect of ideas about authenticity and African art is relevant here. Authentic objects are those object-types whose forms first came to be known in the initial period (loosely defined) of European contact, and these forms are believed to derive from a period prior to that contact. These object-types are often referred to as traditional African art. Objects that were made after European contact *and* that reflect ideas, media, or techniques that are seen to be Western are, in some circles, considered less authentic. For a long time, for instance, museums would not collect, and scholars did not seriously consider, the art produced by contemporary African artists whose artistic expression was considered in any way nontraditional, and thus inauthentic. Eliding a whole body of artistic production presents a skewed vision of African visual culture and positions Africa in an ethnographic present of the colonial era. This contributes to ideas that African cultural development (and, by extension, its economic and political development) is stagnant. In this view, it is inferior to Western culture, which is seen to be constantly evolving and progressing. The vast majority of African art presented in DAKL displays is considered authentic in this latter sense as well; these pieces represent object-types made in age-old styles. At the same time, having most of the African objects at the lodge reflect styles associated with the

precolonial and colonial eras implicitly positions Africans as nonmodern. And it keeps African art within the colonial subtext of the lodge.

While overwhelmingly dominant, these messages (colonial, stagnant, premodern) are not totalizing. Presenting authentic African art, for instance, is a respectful decision, for it acknowledges and celebrates the creativity of the cultures that made the visual culture on display. That Disney chose to use the word *peoples* rather than to designate the ethnic/language/culture groups of the objects' makers in some ways counters the colonial subtext. Unfortunately, it does not go far enough, because even though *tribe* is not used, that Africa should be imagined through that lens is implicitly communicated. Nevertheless, it is important that the effort was made, for this careful consideration of terminology works toward breaking stereotypes about Africans and the ways in which they live. *Tribe* generally implies a small-scale society and, since the eighteenth century, has been applied to groups of people who were seen to be less socially evolved than the Westerners using the term.[58] This occurred despite the fact that many African societies historically were large, complex kingdoms that incorporated multiple ethnic groups. *Tribe* is not only inaccurate and inappropriate when applied to these contexts, but it is a classificatory word imposed on Africans by colonizers and has negative associations. Scholars of Africa avoid its use. It is therefore commendable that Disney avoids replicating this problematic language, a move that may be the result of Disney's consultation with experts in African art in the process of designing the lodge. Doran Ross, who was involved with the project only very early on, remarked that sensitivity to terminology was one of his main concerns.[59] Disney also presents some contemporary works of art, thereby updating for visitors understandings of what African arts, and therefore African cultures, are. The Zulu (South Africa) telephone-wire baskets that adorn the walls in the waiting area outside the restaurants are one example of this, as are the guitars (Côte d'Ivoire) made from recycled tin cans that decorate the walls on the fifth-floor Giraffe Trail, the Tingatinga (Tanzania) paintings that decorate guestrooms, and Baba Wague Diakite's (Mali) mural in the Boma restaurant.[60] Ross suggested the purchase of Tingatinga paintings for the lodge because they are colorful, secular, and frequently depict animals, but perhaps, most important, they were "useful for bringing up-to-date representations of African peoples."[61]

Furthermore, the didacticism of the labels on the Kudu and Zebra Trail display areas enables viewers to learn more about a particular object, culture, practice, or belief. From one perspective, this information, along with

the authenticity of the objects on display, gives guests, as armchair collectors, power over the collection and all it represents. At the same time, this additional information works to counter misconceptions about Africa and its peoples, even those that are subtly reproduced by one's experience of and in the lodge. Each trail has two main, thematically organized exhibition spaces that are located at the intersections of hallways that lead to the rooms. As indicated in Figure 6.1, I refer to the breaks along Kudu Trail as A and B, and along Zebra Trail as C and D. The spaces on the fourth and fifth floors have the same themes, as do the ones on the second and third floors. On the third and fifth floors, there are photomurals that address the theme, but there are no objects because of the way these spaces open up to the floor below. Standing, looking over the railing on the third or fifth floor, one can see the object display cases and photomurals of the second or fourth floors, respectively, thereby linking the two spaces visually as well as thematically. For example, in Figure 6.2, one can see the display of objects on the second floor (Kudu Trail, location B), and the bottom portion of the third floor railing that encircles the open space. Figure 6.3 shows the same display, looking down on it from the third floor above. In what follows, I analyze a few of these displays with an eye toward the possible meanings about Africa they generate.

On the fifth-floor Kudu Trail (B), the display area farthest from the lobby highlights African Households. One photomural discusses childhood while the other focuses on the homes themselves. Below, on the fourth floor, the African Households theme continues with one photomural addressing Vessels and the other addressing Work. On the fourth floor, there are cases with objects that relate to this theme: a Kuba (DRC) box, bowl, knife; a Dan (Liberia) ladle; a Bamileke (Cameroon) palm oil container; and others. Each of the photomurals has three to five Beckwith/Fisher photographs. The majority of these photos also appear in their two-volume book, *African Ceremonies* (1999), a fact noted at the bottom of the photomural. Whereas a few photographs depict one or more individuals from the culture that made one of the objects on display or a similar object in use, the majority introduce a new group of peoples or objects that relate to the theme. The images are framed in bright colors, setting them off from the background, which is yet another desaturated photograph. Mary Hannah, one of the designers hired to decorate the lodge and the individual who was responsible for choosing the photographs, commented: "I chose the Beckwith/Fisher photographs based on the images I felt would best help to illustrate how the objects on display were used. We wanted to bring

Figure 6.2. Mysterious Africa display, Kudu Trail second floor, Disney's Animal Kingdom
Lodge, Walt Disney World Resort
Photograph: Yahaira Lorenzo, 2008
Used by permission from Disney Enterprises, Inc.

Figure 6.3. Mysterious Africa display, Kudu Trail view from third floor
Disney's Animal Kingdom Lodge, Walt Disney World Resort
Photograph: Jeff Sekelsky, 2006
Used by permission from Disney Enterprises, Inc.

the objects to life and show their functions, illustrating that not only are they beautiful objects, but they also had a very important function and purpose in African life."⁶² Making connections visually between an object in a case and a photograph of a similar object in use helps visitors have a more holistic sense of that object. A photograph of a person using an object also humanizes the viewer's experience of that object, which exists at a remove (physically and culturally) from the viewer. But it is not just visual connections that help DAKL guests understand the objects and photographs before them; text also serves that purpose.

Explanations of the theme and elaborations on information are provided as well. For instance, the text for Vessels states: "Of all African household objects, the most highly valued is the container. Whether a woven basket or a vegetable gourd, this essential article is normally light weight and used daily to store food and to carry possessions. Expertly balanced on the head, large gourds called calabashes are used to carry grain and liquids and often represent the personal wealth of the owner." Five photographs accompany this. Reading left to right, the first depicts two Fulani (Mali) women carrying calabashes on their heads. The next three photographs are from Ethiopia: one of a Harari woman preparing ritual coffee, one of a Harari woman with an *Agelgil* basket on her head, and the third of a seated Falasha woman with bread baskets. The final photograph is of a Kassena (Ghana) woman climbing a ladder with a basket on her head. (Similar ladders are visible on the Giraffe Trail, fourth floor; and, as I mentioned, they are evoked in the Zawadi Marketplace.) The photograph over which these are laid shows a line of women walking with vessels on their heads. A map of the continent is placed in the upper right corner of the photomural, and each of the countries in which the photographs were taken is highlighted in the same color that frames that photograph, visually connecting people and place. Additionally, countries are marked with a letter: A, B, C, and so forth; these correspond to the display cases that are in the space in front of the photomurals.

African Royalty is the subject of the fourth- and fifth-floor displays on Zebra Trail (C). The fourth floor deals with The King's Court and Regalia, focusing on the Asante peoples. In this display, the art on view corresponds most completely with that depicted in the photomurals. Here there is just one display case, but it is assembled in such a way as to give people a sense of how various pieces work together. A chair in which a chief would sit is presented, along with his regalia. The chair is draped with kente; in front is a pair of sandals with gold-leaf-covered decorative and protective

motifs. Both items are worn by chiefs. Behind, a pole rises to head height (if someone were sitting in the chair), and a black hat with gold ornaments is attached atop it. Next to the chair another pole supports a flywhisk. Two other pieces are included in this assemblage, though these would not be worn or carried by the chief himself, but rather by important members of his court: a state sword (borne by sword-bearers) leans against the chair, while a linguist staff, carried by the spokesman for the chief, stands next to the chair. Upstairs, on the fifth floor, the photomurals present Kings, Queens and Brides.

The third-floor Zebra Trail display (D) deals with domestication of animals and the second floor with masks that depict animals. On the second floor, a Bekom (Cameroon) buffalo mask, covered in cowrie shells, is displayed with a porcupine quill cape. While in the United States *mask* most often refers to only the face/head covering, in Africa it includes the costuming. Museum displays historically have presented only the piece of the mask associated with the head, though increasingly museums are choosing to present entire masking ensembles.[63] Displaying the costume with the headpiece—that is, presenting the entire mask—is important for conveying fuller meanings about the mask and giving audiences an idea of the way one would experience it in an African context. It reminds viewers that these objects were intended to be more than pieces created for aesthetic contemplation and display in a vitrine. It is commendable that Disney made an effort to display one mask in this manner.

Each of these sections engages visitors as a museum might, presenting objects for visual contemplation, offering labels and panels that provide further information about the objects' uses and/or producing cultures; here Disney's education and entertainment drives come together. The themes (African Households, Music, Puppetry, Royalty, Hats, Masks, and Animals) counter the presentation of "Africa as animals" that surrounds these displays. This is true even when the topic is Animals, as the photomurals present the ways in which the human world interacts with the animal world, foregrounding human activity and not the animals themselves. This distancing from the idea of animals was intentional.[64] Because these displays elaborate on the cultural aspects of African life, reductive ideas of Africa as nature/natural are also countered. The themes also work together to give a limited but holistic view of life. Daily life activities are touched on in African Households, Music, and Animals, and spiritual life is touched on in Masks, Music, Animals, and Hats. Special occasions are noted in Music, Masks, Hats, Animals, Royalty, and Puppets, and special persons and social

positions are referenced in Royalty, Puppets, Masks, Hats, and Music. The photomurals touch on ideas of identity, be it for the individual, community, or culture, and present means by which Africans learn about themselves and their world. The objects in the displays give concrete form to the abstract, reinforcing ideas presented in the photomurals. Moreover, the themes that are chosen to represent African life, while not necessarily the same ones someone might choose to represent American life, work to create connections between Americans and Africans, since the themes point to shared human characteristics. All human societies have distinctions between secular and sacred life. All have forms of entertainment to break up mundane routine and celebrate special occasions or individuals. All have political hierarchies and systems of governance (even though it might not take the form of royalty). And all have collective senses of identity and ways to express this visually or to mark visually one's position within that society. In this way, Disney helps to make the unfamiliar familiar. And while not arguing that we are all African, as the Keep A Child Alive organization's advertising campaign did, it goes quite a way to make connections and highlight commonalities. African visual culture, presented as art, is a key component in conveying this understanding of similarity.

In fact, the final display areas (B) on the second and third floors of Kudu Trail seek to demystify Africa, identifying this section's theme as Mysterious Africa. For example, the photomural on the second floor has four images on it. In the color area that frames the photographs, a question is posed. Below each image is the answer. One photo's question is: "Why are the Tuareg called the 'Blue men of the desert'?" The answer: "Tuareg nomads from Niger are called 'blue men of the desert' because their robes are dyed with a plant pigment called indigo. The indigo comes off on the skin with wear, giving Tuareg complexion a dark blue sheen." Another asks: "Why are these men painting their heads red?" and is answered with "These Masai men from Kenya are painting their newly-shaven heads with a mixture of red-ochre pigment and animal fat to beautify themselves, and protect their tender scalps from the harsh rays of the sun." In both instances an appearance or practice that may look or seem strange is given an explanation that dispenses with the strangeness of it.

The other photomural on the second floor turns from African people to ask questions explicitly about African visual culture. Below the Mysterious Africa heading the mural asks, "Can you identify these objects?" It, too, presents four photographs with questions. "What is this woman wearing on her legs?" is the question above a photograph of the decorated legs of an

Ndebele woman. The answer informs viewers: "Beaded rings are proudly worn by Ndebele women of South Africa to imitate the voluptuous rolls of body-fat found so attractive by Ndebele men." Next to this photo, one depicting a close-up of pots, plates, spoons, and other items asks, "What are these vessels used for?" Readers then learn that "Received at the time of marriage, a Wodaabe woman's bridal calabashes are made out of decorated vegetable gourds, and represent her wealth. Unlike other calabashes, they are not used to carry anything, but are put on display at important ceremonies." Again, these questions and answers are meant to place an object or practice that first might look unfamiliar into a context in which it is made more familiar—marriage or personal attraction in these instances. Additionally, calabashes are not prominently depicted in the photograph of the Wodaabe display; rather, enamel pots and plates are. These speak to the realities of Wodaabe life, where practices of display stay the same even as the medium of those objects on display changes to reflect contemporary markers of social status and change in the material goods used by the Wodaabe peoples. This question's focus on aesthetic display presents a picture of African cultures as nonstagnant and Africans as modern.

In asking questions to engage visitors, and to help dispel the aura of mystery that often surrounds ideas of Africa, Disney is using a strategy that many museums use. In their displays, museums often ask visitors to become active rather than passive learners. Disney takes this approach with the objects in this thematic section as well as with the photomurals. Here the labels identifying the objects in the cases are not placed in the case as they are in other sections. Rather, the identifying information is listed on the photomural next to the four photographs. Visitors are challenged to identify the objects in the room and in the photos. Again, the unfamiliar is made familiar. Viewers might think initially that the object in the central case of Figures 6.2 and 6.3 is quite exotic and strange, but when they learn it is simply a blacksmith's bellows used by the Ejagham peoples of Nigeria, it will seem less so. It would perhaps be better to have labeled these thematic photomurals Mysterious Africa? rather than just Mysterious Africa so that the question mark could reiterate that these displays are challenging the idea of mysteriousness. Without the question mark, one could see a statement of fact, or a category such as Masks or Animals. Indeed, that is how I initially read it, bristling upon noticing it from across the exhibition space. Only after spending time with the display and the photomurals did I understand that DAKL was trying to question, not reproduce, representations of Africa as mysterious.

There are other instances as well when the choice of words could have been more sensitively made, given the educational mission of the display areas. The fifth-floor panel (Zebra Trail, C) on Royalty, Kings reads: "Lavishly adorned with gold jewelry, an African king sits with his court to receive loyal subjects. Before him are the golden swords of state symbolizing his power, while around him the most important chiefs of his kingdom advise and protect their monarch." Yet all three photographs are of Asante kings, and the objects displayed on the floor below are all Asante objects. It would have been just as easy to state "an Asante king sits," thereby providing visitors with the culturally specific knowledge for the objects on display as well as for similar objects visible in the photomurals.

Perhaps the most problematic of these texts is on the photomural for African Royalty, Queens and Brides, also on the fifth floor. The text offers: "Women play an important role in political life in Africa as Queens, chiefs and advisors. And every woman is queen for a day when she becomes a bride! The elaborate jewelry and body decoration worn at weddings reflect the importance of the occasion and the extraordinary diversity of African artistic traditions." Instead of focusing on royal brides, as one might expect given the category, the text evokes an American—and perhaps even a Disney—notion of bridehood/womanhood. Disney is the realm of princesses: Cinderella, Jasmine, Ariel, Aurora, Mulan, Snow White, Belle, Pocahontas, and Tiana. There is even an official Disney Princesses Web site. Disney is also the realm for brides, offering an official Disney wedding Web site. Brides (or brides-to-be) with Minnie Mouse ears and a wedding veil are not uncommon sights at the Magic Kingdom. More recently, Disney has made this connection between brides and princesses even more explicit in hiring designer Kirstie Kelly to create a line of wedding dresses based on the Disney princesses.[65] But what does any of this have to do with Africa? Disney could have elaborated on the various important roles women play in governing their peoples. It could have continued the emphasis on the Asante peoples by highlighting the position of Queen Mother, a position that has its own advisers who carry their own badges of office, as the state sword-bearers do for the Asante kings. This neglect seems especially problematic as Disney included a photograph of Queen Mother Nana Afua Kobi on the photomural for African Royalty, The King's Court. It could have related, as Beckwith and Fisher do in the text that accompanies that photograph in their book, that the Queen Mother is regarded as the mother of the nation, or spoken about her role in selecting the heir apparent.[66] But Disney did not.

As the preceding discussion indicates, the didactic displays convey conflicting messages about how Africa and Africans might be understood. Art is intended by the designers to counter the predominant association at DAKL of Africa with nature, and it does so successfully, giving guests insights into various aspects of myriad African cultures. But this does not mean that the displays are without problems. These are evident in the phrasing of the textual information on the photomurals as well as in the types of objects displayed. In presenting authentic, traditional objects, DAKL subtly reinforces the idea of Africa as black Africa, an idea whose presence is manifest in other ways throughout the lodge. So, too, does the choice of these types of objects offer the idea of African cultures as non-modern, for as I described above, they reference object-types that were seemingly made and used during the colonial era, an era when social views posited Africans as less developed than their European colonizers. Nor are any examples of contemporary African fine art offered within the didactic displays; it appears only as a means of decorating the lodge. Guests, therefore, do not have the opportunity to learn about the ways African art has changed over time, or to learn how artists working in nontraditional mediums or styles are also engaging with some of the universal themes highlighted in the displays. Indeed, tension also arises between visual culture deployed as art and visual culture deployed as decor, undermining the positive messages the educational displays convey.

Mediations and Imaginations of Africa

Jeff and I spent much of our time in the lodge documenting the art. We took photographs of the displays, marked cases on our drawings of the floor plans, and read the texts on the photomurals. We were virtually alone in engaging with these displays. In spite, or perhaps because, of its predominance in the hallways and location near elevators, only once or twice did we notice people actually stopping to look at the art itself or to read the text on the photomurals. This does not mean that it did not occur, simply that it was not a primary activity at the lodge. Moreover, that the displays did not seemingly receive much attention suggests that *all* of the visual culture functioned primarily as decor for the vast majority of DAKL visitors, not just those objects intended to be such by Disney. This is one of the reasons why the predominant messages of the lodge prevail, despite the counternarratives the displays present.

The *Ijele* specifically, but to some extent the art in the lobby as well, is the exception to the general lack of attention guests pay to the formal displays. Almost every visitor stopped to look at the *Ijele*. They would read the multiple and detailed labels provided for it and take pictures, both of the mask by itself and of their group members with the mask. Children would run around it, climb underneath it, and hide beneath its long, hanging cloth panels despite railings meant to keep visitors at a slight distance. This happened whether guests were taking the "Spirit of Africa Art Tour" (which begins at the Nupe door at the entrance to the lodge and ends with the *Ijele*) or simply spending time in the lobby.[67] The tour is led by one of the African "greeters," who were given training, much as a museum docent would be, so that they could competently mediate guests' experiences of African art at the lodge. When the lodge first opened, for example, art historian Herbert Cole, whose specialty is Igbo art, was brought in to provide training about the *Ijele*.[68] It was, in fact, through talking with a greeter that Jeff and I came to know Africa in a way we had not by simply living with or looking at the African animals and visual culture at the lodge. Indeed, the opportunity to have conversations with African people is one of the most important elements that DAKL's representation of Africa has that the other popular culture forms I analyze do not.

While we were working on the documentation of the visual culture throughout the lodge, a greeter saw us and asked if he could assist us with something. We told him we were looking at all the visual culture, and he offered to take us around. His name is Mosegi, and he, like Baruti, is from Botswana. His mother is South African, and so even though he grew up in Botswana, he received his university training in Cape Town, studying hospitality and tourism. He had been at Disney for seven months and had another seven months to go. He told us he wants to tell people about tourism in Botswana and South Africa because he can make sure they have good contacts and will have good experiences when they visit. Because both he and Baruti shared information about their personal lives, we got a sense (albeit small) of them as more than just tour guides. We got a sense of them as people, too. At the same time, that both men promoted travel in their home country specifically, and Africa more generally, is a reminder that African individuals who are involved in representations of Africa have their own agendas and agency in the processes. Promotion of tourism in Africa, after all, undermines the Disney agenda that wants guests to experience Africa (repeatedly), but in Florida, not on the continent itself.[69]

Mosegi told us there were over 500 pieces of visual culture in the lodge. He started us at the Animals, Domesticated mural on the third-floor Zebra Trail (D); here he told us about how his people kept goats (throwing a small puppy into the kraal to grow up with the kids so that the puppy would bond with them and would grow to protect them as it got bigger). He was quite loquacious and elaborated on almost every aspect he talked about (to the point where he was late to his next activity). Mosegi also talked about dress and hairstyles and how they are both particular to culture and event; for instance, one's hair might be done to fit a certain outfit, and then specific jewelry would be worn with it. At Disney, however, the specificity of cultures is not always maintained. He commented, for example, that although he was from Botswana, he was wearing a Nigerian outfit, but that he liked it because it was versatile (though dry clean only!). All of this information, and more, is readily available to any visitor, simply by starting a conversation.

At the section on Royalty, he explained that Botswana has a House of Chiefs responsible for caring for each chief's particular region (there are eight in Botswana), as well as parliamentary and judicial branches of the government. He provided information that chieftaincies were inherited, and about who might have access to the palace and why. He was very skilled in talking about the objects; for instance, he commented that bows, arrows, and certain masks were used by people in the past. He did not talk about them in an ethnographic present, as if their use today was the same as it had been 100 years earlier. Mosegi noted, for instance, that in present-day DRC, one would most frequently see the masks and other ceremonial attire at soccer matches. When I asked if other guests were interested in learning about Africa, he hesitated and then suggested that it was not as much as he would like. For me, this reality is unfortunate, for it is in conversation with the greeters and guides, whether about animals or visual culture, that I best got to *know* Africa during my stay at the lodge.

Mosegi's presentation of the art on display at DAKL speaks to museological understandings of how objects function in that "objects are triggers of chains of ideas and images that go far beyond their initial starting-point."[70] The African art at DAKL was not from Botswana, and yet many of the objects on display triggered associations for Mosegi, and he was able to make connections, through them, to Botswana life and culture. The regalia of an Asante king is ultimately just that: the regalia of an Asante king. But at the same time it makes present, for Mosegi, and thus for those with whom he speaks, the chiefs of Botswana. On the third floor, the photographs of

the headdresses specific women wear led to a broader conversation about customs of dress. Photographs of Fulani and Wodaabe women dressed for special occasions, for instance, prompted comments about the coordination of clothing and hairstyle for particular occasions, and led to a discussion of weddings and the marriage practices of people in Botswana. It even led to a brief conversation about Mosegi's own marriage plans. Here it is clear that art links to and prompts reflections on larger social relations. Those social relations are not just the various practices of a given African culture. They extend across cultures: African to African, African to American. Moreover, these relations take any number of forms: cultural, political, economic.

The presence of Africans at the lodge enables cross-cultural dialogue to take place. Economic exchanges between Africa and America take place as well in terms of the provision of jobs—at the lodge itself—or through the creation of the art work that is placed throughout. For instance, the Bamenda Cooperative in Cameroon was commissioned to make the stools that are found throughout the lobby and in other sites in the lodge.[71] At the time of this writing, Disney is nearing completion of another African-themed lodge. The Kidani Village will give even more attention to visual culture as decor and as display. Kuba (DRC) and Fon (Benin) artisan cooperatives will provide textiles for the guestrooms, and a Maasai collective will provide beadwork. This last group, the Women's-Project-Kenya, is, Davis notes, "a group of women that are HIV-AIDS infected and affected, single mothers, deaf women, refugees and women without a source of income."[72] The influx of money from such large-scale commissions as those offered by Disney can help many people in that local Kenyan community.

But the visual culture at DAKL can impact lives in other ways as well. Davis relates the following story: "I was told by a greeter (host) from South Africa that an Ibo guest staying at the hotel burst into tears upon seeing the Ibo Ijele headdress and said proudly 'finally someone is seeing Ibo culture.' To me that was a great surprise. We wanted to bring Africa to non-Africans but it had not occurred to me that we might also bring it to Africans."[73] The Disney visitor of whom Davis speaks recognized the exciting possibilities for cross-cultural exchange that the presence of the *Ijele* mask represents. This perspective echoes that of those who worked to incorporate the National Museum of African Art (NMAfA) into the Smithsonian complex as well as those of the Ndebele women who were excited that millions of people were going to see their culture on the pages of the *SI* swimsuit issue.

Indeed, like NMAfA and other museums, DAKL offers visitors an experience of actual African objects, rather than representations of them. Yet the way Africa is imagined at DAKL is quite different from the way Africa is imagined at NMAfA. At both institutions, African visual culture is imagined to be an important element for American understandings of themselves. At NMAfA, the cultural heritage of Africa is important to know and understand in part because African Americans can trace their heritage to the continent, and because African culture permeates American culture in myriad ways (as these case studies have indicated). Moreover, at its founding, African visual culture at NMAfA was seen to offer a possibility for healing a nation torn by racial strife. It offered the possibility of unifying across racial divides. In this perspective, Africa, though different from America, is also part of it. In contrast, at DAKL, Africa's difference is what is significant: America vis-à-vis Africa, white vis-à-vis black. In short, Africa is black, Disney (read as America) is white.[74] Given this, racialized identities remain formulated with broad, dualistic conceptualizations. That this occurs around art is not surprising, for, as the historian Daniel Sherman notes, museums are produced by and produce difference; this is a continuous process in any institution for which a purpose (explicit or not) is to make sense of the world.[75] Making sense of the world is one thing the Disney parks do (see chapter 5), so it is not unexpected that the production of difference has relevance at DAKL, for, like museums, DAKL is part of the exhibitionary complex. In the end, the difference that DAKL produces is Africa itself. Although DAKL's didactic displays work well to make the unfamiliar familiar and to allow guests to make connections between African and American ways of life, Africa is not presented as part of America. The success of the DAKL's fantasy experience relies on the imagined distance between Africa and America being maintained; guests are socialized into this perspective on the world.

This brings me to the epigraph that opened this chapter, and which underscores the imaginative process by which one comes to understand the objects on displays in a museum, or, in this instance, at DAKL. In suggesting the quality of fantasy in which this process participates, and in placing "knowledge" in quotes, Jordanova acknowledges that all production of knowledge is partial, and that there will be other ways in which one might imagine one's subject.[76] African visual culture at the lodge is central to multiple imaginings of Africa, offering both constructive and problematic ones. It often reinforces the dominant message of Africa as black, natural, culturally premodern, and therefore "less" than America. At the same

time, the conditions of the visual cultures' procurement, the presence of Africans, and even, at times, the stories the visual culture tells intervene in and offer possibilities for additional narratives to come to prominence, or at least to assert an influence. They offer other possibilities for imagining Africa, possibilities not based in difference or distance.

7·

Refrain

Africa in the American Imagination

Throughout this book I have explored the ways that Disney, Mattel, and *Sports Illustrated* (*SI*) (three major American popular culture icons) incorporate African visual culture into their own culture products (Disney's Animal Kingdom Lodge [DAKL] and the "it's a small world" ride, the "Dolls of the World" Barbie collection, and the 1996 *SI* swimsuit issue), repackaging and re-presenting this visual culture to American consumers. I have, in general, been arguing that the meanings generated by the appearance of African visual culture in American popular culture speak to the complexities of social relations—in particular, drawing attention to the juncture of racialized identities: Euro-American, African American, and African. More specifically, American popular culture, African visual culture, and racialized identities interact in varied and convoluted ways, as issues of nationalism, imperialism, nostalgia, and multiculturalism are negotiated within networks of travel, the circulation of mass media images, globalized corporations, and social institutions such as museums. In fact, I began the analysis of these interactions arguing not only for the significance of Africa to America but also by emphasizing that African visual culture in American popular culture produces understandings and imaginings about *both* Africa and America. These two threads of meaning are interwoven, moving over and under one another. Accordingly, to draw this study to a close, I ruminate upon these interweavings with an eye toward the places they entwine smoothly as well as where they tangle. In doing so, I reflect upon the insights offered by the preceding analyses and their implications for the world today.

Each of the American popular culture forms comprising this study incorporates African visual culture, though each does so via distinct means

and to differing ends. Mattel transforms the visual culture, while Disney and *SI* present the visual culture in its original African form, though positioned in new (American) contexts. Mattel, in transforming kente for its African American and Ghanaian Barbie dolls, looked primarily to the form and visuals of kente, rather than to its indigenous meanings. *SI*, like Mattel, focused on form (though without transforming it) rather than on meaning in presenting Ndebele visual culture on the pages of the swimsuit issue. But *SI*'s engagement with the visual culture, as a focus in and of itself, was less explicit than Mattel's or Disney's. Disney engaged African visual culture explicitly and directly by purchasing it for display in DAKL, and in doing so employed the meanings of the visual culture as they are understood in their African contexts. At the same time, the presence of African visual culture in these popular culture forms creates new meanings for and understandings of it in these American contexts.

These new meanings and understandings convey values and messages to their consuming publics, socializing them into the explicit and implicit ideas and ideologies that the cultural products (re)present. Both the "Dolls of the World" collection and the "it's a small world" ride offer microcosmic representations of the world, depicting children from myriad cultures. Within these worlds, cultures are defined primarily through the use of costume. These costumes establish difference (here read as "Africa") and help to define America in opposition to the differences. In my discussion of Barbie, I argued that the authenticity of the cultural data—in the form of clothes, accessories, and information provided on the back of the box— provides knowledge that situates the owner/collector in a position of control over the world represented by these Barbie dolls, a world that speaks to a time when people's places in the world in relation to one another were seemingly more well defined. They imagine a world untroubled by the upheavals of the civil rights and feminist movements, a world prior to contemporary American society. Both Mattel's world of Barbie and Disney's "it's a small world" ride evidence nostalgia for the America that (seemingly) existed prior to the rise of multiculturalism and increased global migration, and they do so through representations that, at first glance, seem to embrace the pluralist vision that is the overt message of these products. The *presence* of Africa within these worlds helps establish the progressive pluralism, though Africa's *treatment* speaks to their regressive messages. In this, one can see how popular culture products can be both productive and problematic at the same time, a point illustrated also with the "I am African" advertising campaign with which I began this book.

The authenticity of, and cultural knowledge provided about, the African visual culture objects at DAKL serves a similar nostalgic purpose. At DAKL, difference is created through an all-encompassing experience of Africa, specifically of colonial-era Africa. This, like Mattel's world of Barbie, evokes a time when the social position of America and Americans was seemingly clearer in relation to Africa and Africans than it has been in the last twenty years, the time frame of this study. DAKL's microcosmic world is smaller, too, than that presented by either the "it's a small world" ride or the "Dolls of the World" collection, for where the latter two profess to encompass the globe, DAKL focuses exclusively on Africa south of the Sahara. DAKL is distinctive, too, in that it exposes American consumers to Africa in ways that the other cultural products cannot. It provides access to actual African objects and African peoples. Thus, while the lodge subtly conveys a message, in evocations of the colonial era, of dominance and control over Africa, DAKL also offers the opportunity to learn about and actually know Africa—its culture, people, and physical environments—more strongly than any of the other popular culture forms I consider here. Indeed, the opportunity to engage with and reflect on African perspectives helps to nuance imaginings of Africa at DAKL.

The 1996 *SI* swimsuit issue offers a similar opportunity, though those alternative perspectives are less easily accessed by the general public. People can speak more easily to an African individual at the Walt Disney World Resort than they can to the Ndebele women who were integral to the production of the swimsuit issue. The swimsuit issue, too, embodies an even smaller world than DAKL does, for it spotlights one country, South Africa, rather than most of the continent. The narrower center of attention allows for the imaginings it engenders to emphasize not the past (through nostalgia for bygone eras), but possible futures. On the pages of this swimsuit issue, Ndebele people and visual culture suggest problematically a peaceful, postapartheid South Africa, where the stresses of racist policies and their continuing consequences are seemingly nonexistent. At the same time, they speak to the historic conditions and social position of indigenous populations in South Africa, offering a glimpse of agency and cultural self-determination in the face of the still-lingering effects of the apartheid system. The opportunity for cross-cultural understanding this provides is echoed at DAKL by the availability of Africans with which park-goers can converse about Africa.

The ahistorical view of South Africa found on the pages of the *SI* swimsuit issue is, as I have said, part of a larger convention for presenting Africa

as nonmodern, a convention that implies and reinforces the modernity of the Western world that consumes these representations of Africa. In the swimsuit issue, the nonmodern is established in two primary ways: invoking nature and wildness, and drawing on tradition. The emphasis on nature to help differentiate Africa from America is evident also in the "it's a small world" ride's lack (relative to the other areas represented) of architecture in the African section, and its large inclusion of flora and fauna in the scene. Nature is the primary means of distinguishing Africa in the context of DAKL, which, like the swimsuit issue, makes use of African arts in relation to the notion of tradition as well. There the vast majority of the objects displayed present the "traditional" arts of Africa, those object-types produced by cultures at the time of European contact. Their association with ideas of stasis, and a lack of attention to individual producers, creates images of cultures that do not change or progress, as Western cultures (supposedly) do, thereby positioning, conceptually, Africans as inferior to Americans.

It is also the visual culture of Africa, largely that of personal decoration, that suggests ideas of tradition in the swimsuit issue, "Dolls of the World" collection, and "it's a small world" ride. In each, Africans are bound by ideas of cultural dress, dress that seemingly does not suggest or offer participation in the modern world, as it is imagined in the West, for it stands in stark contrast to the clothing with which Americans associate themselves. African visual culture therefore assists in constructing Africa and Africans as nonmodern, underscoring their differences from the Americans that collect, re-present, and/or consume them. This elides the present social-historical-political conditions, something that, I stress, can have serious consequences in the ways people's lives are lived, for representations both reflect and inform (explicitly and implicitly) the way people act in the world. This is particularly so with regard to racialized identities, especially when they are formed through, or articulated around, ideas about national and/or cultural identity.

To be sure, Mattel, Disney, and SI engage and employ racialized identities to various ends. All imagine Africa as black Africa. This, as I have argued, is problematic in that these imaginings often have negative connotations associated with them, even in contexts where there are people or cultural elements that counter such meanings. This contrasts sharply with the "white habitus" that is the American imaginative landscape. The "Dolls of the World" collection and "it's a small world" ride reinforce racialized identities, underscoring the dominance of America and suggesting the

inferiority of Africa and Africans. The black, African bodies in the "Dolls of the World" collection are treated differently than the black, non-African bodies that populate the larger world of Barbie. These latter, who are marketed with their own names, are aligned with the white body of Barbie when juxtaposed with the culturally defined Barbie dolls of the "Dolls of the World." In this, the identities constructed around racialized bodies work more to support the power of America, and the American way of life, than to circulate ideas around racialized bodies per se. Indeed, as in the "it's a small world" ride, racialized bodies are put to the service of constructing culturally and/or nationally defined differences. This is the case, too, with DAKL, where Africa is constructed as black Africa through evocations of the colonial era, ideas about traditional society and visual culture production, and the roles Africans might play in the context of the lodge, especially as Africa is set against Disney, which, as I argued with the "it's a small world" ride, creates an ideal of white America. This is not the case, however, with the *SI* swimsuit issue, where the nonblack models are aligned with and reinforce ideas about black African bodies. There presentation of diasporic black bodies underscores that the conventions for representation that were so prevalent in the colonial era persist today, though they are viewed through different lenses; the conflation of black bodies speaks directly to and about racialized identities within America, but not necessarily those linked with ideas about national/cultural identity. Yet only in exploring these constructions can the inequalities that arise in the racist construction of racial identities begin to be addressed and undone. I return to Barbie for one brief moment to offer a glimpse of what a challenge to such constructions might look like.

Recall the Princess of South Africa from chapter 4. This is Mattel's version of Ndebele culture; it puts forward key sartorial elements that mark it as such. Compare it now to another Barbie (Figure 7.1).[1] Here is a Ndebele version of Barbie. She is dressed with real beaded bands around her head, neck, wrists, arms, legs, and waist, rather than the plastic suggestion of bands found on the Princess of South Africa. She is also dressed in a beaded apron (referred to variously as a *liphotu* or *mapotu*), which indicates she is married. Here the size and overload of beadwork are more typical of Ndebele beaded styling than the smaller suggestions of beadwork worn by the Princess of South Africa. In addition to the differences in costuming, these two Barbie dolls also differ in their skin color. While Mattel's Princess of South Africa is black, the "Ndebele" Barbie is white. This complicates issues of identity, for while American consumers recognize

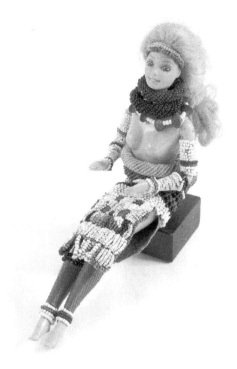

Figure 7.1. Artist unrecorded. *Ndebele Umndwana/child figure*. Mid-twentieth century
Medium: doll (Barbie), glass beads, thread, string, wooden beads, hide, telephone wire, textile; 20 x 20 x 9 cm (includes base)
Image courtesy of the Johannesburg Art Gallery
Collection of the Johannesburg Art Gallery

this latter doll as the ever-familiar Barbie, the costuming clearly marks her as Ndebele, as Other. The clothes, not skin color (around which racialized identities are organized), establish the identity. This doll seems to suggest that identities based in race are not important, and it offers another small example of how the intersections of African visual culture and popular culture might work to disrupt and undo age-old conventions of representation and ways of thinking. In some ways, then, it aligns with the message of the Keep A Child Alive advertising campaign with which I began this book, for it asks viewers to consider what it might mean to say "I am African" and how that might be visualized in a way where skin color is not

a significant marker of that identity. Given this, I submit that this Nde-bele Barbie offers one type of argument "against race."[2] It offers, instead, an affirmation of the vital role that visual and popular culture have in express-ing ideas about one's identity and one's place in the world.

Indeed, I have maintained throughout this book that Africa and its visual culture provide a key entry into considering issues of race in the United States. In this, the use of African visual culture in American pop-ular culture is productive and constructive. At the same time, and often in the same cultural product, it can be reductive and restrictive. In fact, as my analysis of the Disney, Mattel, and *SI* products has shown, this lat-ter effect is more frequent. This speaks to the tenacity with which atti-tudes and biases persist in imaginings of Africa. Yet this study also shows, critically, that despite the predominance of problematic representations, they are not totalizing. Some imaginings push against the edges of socially institutionalized categories and ways of thinking, like the Ndebele women in the swimsuit issue or African guides at DAKL who present their cul-ture in ways they see fit; like the African artisans who help their com-munities through sales of art to Disney; like the Ndebele woman who dispensed with Mattel's intentions and remade a white American Barbie in her image. In this, they ask the audiences of these popular culture forms to rethink what they know and/or what they think they know. As such, I am not suggesting that people stop buying Barbie dolls, or going to the Walt Disney World Resort, or browsing a *SI* swimsuit issue. In fact, the pres-ence of African visual culture in American popular culture offers an ideal opportunity for consumers to engage critically in their pleasures, and to get to know Africa, for one of the many things that imaginings of Africa offer to America is an opportunity to think not just about Africa, but about America as well.

Notes

1. Introduction

1. Somalian supermodel Iman is the exception, though the musician Seal is closely associated with his Nigerian heritage.

2. As recently as September 2010, this could be seen at http://gawker.com/news/photoshop/gwyneths-african-ad-inspires-imitators-193729.php.

3. These advertisements appeared in magazines as varied as *Glamour* and *Condé Nast Traveler* in the winter of 2006 and could be seen in 2008 at http://keepachildalive.org/media/index.php?p=IamAfrican, though in September 2010 they were no longer available.

4. The majority of men who appear in the ad are clothed; Tyson Beckford and Seal are the exceptions. Both of these men are black, which adds the additional association of skin to the mix. Lenny Kravitz is the only other black male included in this campaign, but he wears clothes. Although their appearances may reflect self-marketing choices, I posit this is not the case, as the women in the ads appear different than they do in other popular images. Rather, it suggests that the campaign designers have made this choice in appearances.

5. While the Keep A Child Alive Foundation was willing to let me reproduce the image of Lucy Liu here, the photographer, Michael Thompson, was not.

6. Su Holmes and Sean Redmond, eds., *Framing Celebrity: New Directions in Celebrity Culture* (London: Routledge, 2006); Jessica Evans and David Hesmondhalgh, eds., *Understanding Media: Inside Celebrity* (Berkshire: Open University Press, 2005).

7. These studies come out of the disciplines of anthropology, history, literary studies, and sociology. Curtis Keim's study is closest to mine in terms of his focus on popular media and American imaginings, though he presents a survey of these ideas without in-depth analysis of his many examples. Originally published in 1999, a second edition of this text was published in 2009, and I use that edition when citing specific passages. Curtis A. Keim, *Mistaking Africa: Curiosities and Inventions of the American Mind*, 2nd ed. (Boulder, Colo.: Westview Press, 2009). Cornelia Sears examines the construction of these images of Africa in America from 1870 to 1955. Cornelia Sears, "Africa in the American Mind, 1870–1955: A Study in Mythology, Ideology and the Reconstruction of Race" (Ph.D. diss., University of California, Berkeley 1997). V. Y. Mudimbe investigates philosophical and literary representations of Africa. V. Y. Mudimbe, *The Invention of Africa: Gnosis, Philosophy, and the Order*

of Knowledge (Bloomington: Indiana University Press, 1988); V. Y. Mudimbe, *The Idea of Africa* (Bloomington: Indiana University Press, and London: James Currey, 1994). He also touches on African visual culture, though his treatment of it isolates it in a museum context rather than looking at its broader circulation, and his treatment of European imagery is not nearly as extensive as that offered by Jan Nederveen Pieterse, who explores the visual side of representations of blacks in the West. Nederveen Pieterse focuses more on representations of people within art and popular culture. Jan Nederveen Pieterse, *White on Black* (New Haven, Conn.: Yale University Press, 1992). Most recently, James Ferguson has examined the implications for considering "Africa" as a concept in relation to and against the traditions of the specificity of anthropological studies that look at particular African locales and peoples. James Ferguson, *Global Shadows: Africa in the Neoliberal World Order* (Durham, N.C.: Duke University Press, 2006).

 8. Ferguson, *Global Shadows*, 1–23.

 9. The Exploris Museum merged with Playspace in 2007 and is now the Marbles Kids Museum.

 10. Arjun Appadurai, ed., *The Social Life of Things: Commodities in Cultural Perspective* (Cambridge: Cambridge University Press, 1986).

 11. In one account, for example, traditional art "emphasizes its connection to received forms more than the invention of the individual artist. . . . Traditional art is village based, and is made by artists who work mainly for members of their own ethnic groups." Susan Vogel, *Africa Explores: 20th Century African Art* (New York: Center for African Art, and Munich: Prestel Verlag, 1991), 10. Too, in asserting a particular characterization of traditional, I am drawing from Eric Hobsbawm's definition. He offers: "'Invented tradition' is taken to mean a set of practices, normally governed by overtly or tacitly accepted rules and of a ritual or symbolic nature, which seek to inculcate certain values and norms of behavior by repetition, which automatically implies continuity with the past." Eric Hobsbawm, "Introduction: Inventing Traditions," in *The Invention of Tradition*, ed. Eric Hobsbawm and Terence Ranger (Cambridge: Cambridge University Press, 1992), 1. He uses "invented" here to allow for a historical analysis and grounding of practices that "appear or claim to be old [but] are often quite recent in origin and sometimes invented." Ibid.

 12. Such commonsense understandings of modern/traditional are the result of a long history stemming from, among other things, the Enlightenment; European social, political, and economic development; and the Industrial Age. Many scholars have addressed the problematics of this dichotomy. James Clifford considers the relations of tribal and modern cultures in relation to exhibitions. James Clifford, *The Predicament of Culture* (Cambridge, Mass.: Harvard University Press, 1988), chapter 9; especially germane to this discussion are pages 200–202. Catherine Lutz and Jane Collins discuss these ideas in the context of the *National Geographic* magazine. Catherine A. Lutz and Jane L. Collins, *Reading National Geographic* (Chicago: University of Chicago Press, 1993), 90–91, 110–115. Hobsbawm addresses this dichotomy as well, stating, "It is the contrast between

the constant change and innovation of the modern world, and the attempt to structure
at least some parts of social life within it as unchanging and invariant, that makes 'the
invention of tradition' so interesting for historians of the past two centuries." Hobsbawm,
"Introduction," 2. He goes on to distinguish between tradition and custom and custom's
relevance for so-called traditional societies and understandings, but, I would argue,
tradition in common parlance serves the same descriptive purpose.

13. Edward Said, *Orientalism* (New York: Vintage, 1978).

14. Lata Mani and Ruth Frankenberg, "The Challenge of Orientalism," *Economy and
Society* 14, no. 2 (1985); Aijaz Ahmad, "*Orientalism* and After," in *Colonial Discourse
and Post-Colonial Theory: A Reader*, ed. Patrick Williams and Laura Chrisman (New
York: Columbia University Press, 1993); Reina Lewis, *Gendering Orientalism* (New
York: Routledge, 1996); Ania Loomba, *Colonialism/Postcolonialism*, 2nd ed. (London:
Routledge, 2005).

15. Ferguson, *Global Shadows*, 3; Keim, *Mistaking Africa*, 18–21. Even where
specific countries are covered in a discussion, the titles of the essays refer only to
Africa. For example: Jendayi Frazer "Current Themes in U.S.–African Policy," U.S.
Department of State, http://www.state.gov/p/af/rls/rm/2006/69321.htm, accessed
December 27, 2006. See also Chris Alden, "From Neglect to 'Virtual Engagement': The
United States and Its New Paradigm for Africa," *African Affairs* 99 (2000); Edmond
J. Keller, "Africa in Transition: Facing the Challenges of Globalization," *Harvard
International Review* 29, no. 2 (2007); Gayle Smith, "US Aid to Africa," *Review of
African Political Economy* 31, no. 102 (2004).

16. Anna Triandafyllidou, "National Identity and the 'Other,'" *Ethnic and Racial
Studies* 21, no. 4 (1998).

17. I recognize that there has been a shift in scholarship to move away from
conceptualizing the world in terms of the West and its Others because it privileges
the West as the term through which analysis ultimately occurs. Terms such as the
Global South have been offered very usefully as an alternative for conceptualizing the
relationships that were encompassed in ideas about the West and the rest of the world.
In contrast, the Global South positions in the dominant term the majority peoples in
the world, emphasizing those peoples and places that used to be the West's Others.

18. Svetlana Alpers, Emily Apter, Carol Armstrong, Susan Buck-Morss, Tom
Conley, Jonathan Crary, Thomas Crow, et al., "Visual Culture Questionnaire," *October*
77 (1996): 26. A similar characterization of this term states that "visual culture is
concerned with visual events in which information, meaning, or pleasure is sought
by the consumer in an interface with visual technology. By visual technology, I mean
any form of apparatus designed either to be looked at or to enhance natural vision,
from oil painting to television and the Internet." Nicholas Mirzoeff, *An Introduction to
Visual Culture* (London: Routledge, 1999), 3.

19. Marquand Smith, ed., *Visual Culture Studies* (Los Angeles: Sage, 2008), 11.

20. W. J. T. Mitchell, "Showing Seeing: A Critique of Visual Culture," *Journal of
Visual Culture* 1, no. 2 (2002): 170.

21. Kris L. Hardin and Mary Jo Arnoldi, "Introduction: Efficacy and Objects," in *African Material Culture*, ed. Mary Jo Arnoldi, Christraud M. Geary, and Kris L. Hardin (Bloomington: Indiana University Press, 1996), 1.

22. Christopher D. Geist and Jack Nachbar, eds., *The Popular Culture Reader* (Bowling Green, Ohio: Bowling Green University Popular Press, 1983), 4–11.

23. In the same way, the American popular culture forms I investigate here might be considered American visual culture. They are, however, more familiarly thought of as popular culture, and so I retain that descriptive term. I refer to the African objects discussed here as visual culture to emphasize the visual and aesthetic components that are being drawn on in the appropriation of them by American popular culture producers. For a discussion of African visual culture as popular culture, see African Studies Association, ed., Special issue, *African Studies Review* 30, no. 3 (1987); Mary Jo Arnoldi, Christraud M. Geary, and Kris L. Hardin, eds., *African Material Culture* (Bloomington: Indiana University Press, 1996); Karin Barber, *Readings in African Popular Culture* (Bloomington: International African Institute in association with Indiana University Press, and Oxford: James Currey, 1997). Since the late 1990s, when these latter two anthologies were published, there have been an increasing number of articles published in *African Arts* that take African popular culture as their subjects.

24. Henry A. Giroux, *Disturbing Pleasures* (New York: Routledge, 1994), x.

25. Ibid.

26. John Parham, "Teaching Pleasures: Experiments in Cultural Studies and Pedagogy," *International Journal of Cultural Studies* 5, no. 4 (2002): 467.

27. Although I do not know the specific sociopolitical context of Parham's students, their acknowledgment of racial identity in these terms suggests to me the significance of race as an organizing concept for their lives.

28. Bono, ed. Special issue, *Vanity Fair* 563 (2007); "The Black Issue," Special issue, *Vogue Italia* 695 (2008). On this issue of *Vogue*, see Cathy Horyn, "Conspicuous by Their Presence," *New York Times*, June 18, 2008; Cathy Horyn, "Beauty and Soul," *New York Times*, June 18, 2008. Moreover, the treatment of black bodies in this issue of *Vogue* is very similar to that of Africans in the *Vanity Fair* issue. In both issues the black bodies are relegated primarily to the back half of the issue. For a discussion of this in regard to *Vanity Fair*, see Carol Magee, "Representing Africa? Celebrities, Photography and *Vanity Fair*," in *Celebrity Colonialism: Fame, Power and Representation in Colonial and Postcolonial Cultures*, ed. Robert Clarke (Cambridge: Cambridge Scholars Press, 2009). This is not the only time when the presence of black models in fashion magazines has been addressed; for two other recent examples, see Sala Elise Patterson, "Yo, Adrienne," *New York Times*, February 25, 2007; Guy Trebay, "Ignoring Diversity, Runways Fade to White," *New York Times*, October 14, 2007. Outrage over a fashion spread in *Vogue* (India) also points to a desire among consumers for socially responsible media. Heather Timmons, "Vogue's Fashion Photos Spark Debate in India," *New York Times*, September 1, 2008.

29. The following scholars offer insightful analysis of issues of race with relation to the various culture forms considered in this study. For Barbie, see Ann duCille, *Skin Trade: Essays on Race, Gender, and the Merchandising of Difference* (Cambridge, Mass.: Harvard University Press, 1996), chapter 1. For the *SI* swimsuit issue, see Laurel R. Davis, *The Swimsuit Issue and Sport: Hegemonic Masculinity in "Sports Illustrated"* (Albany: State University of New York Press, 1997), chapter 8. For Disney, see Monika Kin Gagnon, "Race-ing Disney: Race and Culture in the Disney Universe" (Ph.D. diss., Simon Fraser University, 1998); Eleanor Byrne and Martin McQuillan, *Deconstructing Disney* (London: Pluto Press, 1999), chapter 5.

30. Paul Gilroy, *Postcolonial Melancholia* (New York: Columbia University Press, 2005).

31. In articulating this theory, Paul Gilroy draws on the work of social psychologists Alexander Mitscherlich and Margarete Mitscherlich, who further "suggest that the racial and national fantasies that imperial and colonial power required were . . . predominantly narcissistic." Ibid., 99.

32. Ibid., 106. Gilroy elaborates: "The consolidation of postcolonial melancholia suggests an even more disturbing possibility, namely that people in Britain have actually come to need 'race' and perhaps to welcome its certainties as one sure way to keep their bearings in a world they experience as increasingly confusing." Ibid.

33. The ideas presented in this paragraph summarize Gilroy's arguments around this issue. Paul Gilroy, *Against Race: Imagining Political Culture Beyond the Color Line* (Cambridge, Mass.: Belknap/Harvard University Press, 2000), 12–14.

34. Gilroy, *Postcolonial Melancholia*, 14.

35. Paul Gilroy, *The Black Atlantic: Modernity and Double Consciousness* (Cambridge, Mass.: Harvard University Press, 1993), chapter 1.

36. Errol Lawrence, "Just Plain Common Sense: The 'Roots' of Racism," in *The Empire Strikes Back: Race and Racism in 70s Britain*, ed. Centre for Contemporary Cultural Studies (London: Hutchinson, 1982), 47–48, 64–65.

37. Andrew Ross, *No Respect: Intellectuals & Popular Culture* (New York: Routledge, 1989), 9.

38. Regarding racial imagery, Lawrence notes that "although such images, whatever their source, are cross-cut by other contradictory images about the essential equality of all people, for example, they nevertheless tend to pull popular opinion towards racist interpretations and understandings." Lawrence, "Just Plain," 65.

39. Ibid., 74.

40. Gilroy, *Against Race*, 15.

41. Ibid., especially chapter 1.

42. Stuart Hall, "Encoding, Decoding," in *The Cultural Studies Reader*, ed. Simon During (London: Routledge, 1999).

43. Ibid., 512, 516–517.

44. Janet Wasko and Eileen R. Meehan, "Dazzled by Disney? Ambiguity in Ubiquity," in *Dazzled by Disney? The Global Disney Audiences Project*, ed. Janet

Wasko, Mark Phillips, and Eileen R. Meehan (London: Leicester University Press, 2001).

45. Ibid., 334.

46. Ibid., 334–340.

47. Norma Pecora and Eileen R. Meehan, "United States: A Disney Dialectic: A Tale of Two American Cities," in Wasko, Phillips, and Meehan, *Dazzled by Disney?* 306–318.

48. See Sears, "Africa."

49. National Museum of African Art, "National Museum of African Art" (Washington, D.C.: National Museum of African Art, Smithsonian Institution, n.d.). This brochure has no precise publication date, though it was produced sometime between 1993 and 1997. Janet Stanley, e-mail message to author, November 10, 2008. I obtained it in 1999 when I was doing dissertation research at NMAfA. The population statistic it provides is out of date. There are approximately 38.6 million black people in the United States, or 12.85 percent of the general population. Central Intelligence Agency, "North America: United States: People," https://www.cia.gov/library/publications/the-world-factbook/geos/us.html, updated biweekly, accessed September 25, 2010.

50. NMAfA's brochure implies that Americans negotiate myriad social positions and identities around African objects. Donna Haraway has also demonstrated their interconnectedness. Donna Haraway, "Teddy Bear Patriarchy: Taxidermy in the Garden of Eden, New York City, 1908–1936," *Social Text* 11 (Winter 1984–1985). In her study of the dioramas in the African Hall at the American Museum of Natural History, New York City, Haraway concludes that the displays are "mute about Africa," manifesting rather an experience of "race, sex and class in New York City that reached to Nairobi." Ibid., 21. Her analysis suggests the ways in which the discourse of eugenics, the management of capital, and science intersect in a re-presentation of African mammals. Her insightful study demonstrates that in the various phases of organization and display in the African Hall, "different forms of capitalist patriarchy and racism would emerge, embodied as retooled nature." Ibid., 57.

51. Senate Committee on Rules and Regulations, Acquisition of the Museum of African Art by the Smithsonian Institution, S.2507 (1978), 6.

52. These visitor statements were made about the Museum of African Art (NMAfA before it joined the Smithsonian). Ibid., 20–22. Popular press also spoke to the importance of this institution. See, for example, Carolyne S. Blount and Ted Jones, "National Museum of African Art," *about . . . time* (February 1988); Racine S. Winborne, "African Art for All People," *Afro-American* (1984); Frederick M. Winship, "U.S. Is Center of Black African Art and Culture," *Parkersburg (W.Va.) News,* June 14, 1981.

53. Eduardo Bonilla-Silva, "The New Racism: Racial Structure in the United States, 1960s–1990s," in *Race, Ethnicity, and Nationality in the United States: Towards the Twenty-first Century,* ed. Paul Wong (Boulder, Colo.: Westview Press, 1999), 84; John

Brenkman, "Race Publics," *Transition* 66 (1995): 17; Patricia Hill Collins, *Black Sexual Politics: African Americans, Gender and the New Racism* (New York: Routledge, 2004), 132; Susan Searls Giroux, "Reconstructing the Future: Du Bois, Racial Pedagogy and the Post–Civil Rights Era," *Social Identities* 9, no. 4 (2003): 577.

54. Barack Obama, *The Audacity of Hope: Thoughts on Reclaiming the American Dream* (New York: Three Rivers Press, 2006), 232.

55. Carmen DeNavas-Walt, Bernadette D. Proctor, Jessica C. Smith, and U.S. Census Bureau, "Income, Poverty, and Health Insurance Coverage in the United States: 2007" (Washington, D.C.: U.S. Government Printing Office, 2008), 7.

56. David Leonhardt, "For Blacks, Progress in Happiness," *New York Times*, September 15, 2010.

57. Avery F. Gordon and Christopher Newfield, *Mapping Multiculturalism* (Minneapolis: University of Minnesota Press, 1996); David Bennett, *Multicultural States: Rethinking Difference and Identity* (London: Routledge, 1998); Slavoj Žižek, "Multiculturalism, or, the Cultural Logic of Multinational Capitalism," *New Left Review*, no. 225 (September/October 1997).

58. Ferguson, *Global Shadows*, 23.

59. Kwame Anthony Appiah, "Why Africa? Why Art?" in *Africa: Art of a Continent*, ed. Tom Phillips (Munich: Prestel, 1995).

60. Nils Bhinda and FONDAD, *Private Capital Flows to Africa: Perception and Reality* (The Hague: FONDAD [Forum on Debt and Development], 1999), 52; David F. Gordon, David C. Miller Jr., and Howard Wolpe, *The United States and Africa: A Post–Cold War Perspective* (New York: W. W. Norton, 1998), 17.

61. Curt Tarnoff and Larry Nowels, "Foreign Aid: An Introductory Overview of U.S. Programs and Policy" (Washington, D.C.: Congressional Research Service, 2005), 19, 24.

62. Gerald J. Bender, "Ideology and Ignorance: American Attitudes toward Africa," *African Studies Review* 31, no. 1 (1988); Emmanuel Onyedike, "Repositioning Africa: The Role of African-American Leaders in Changing Media Treatment of Africa," *Journal of Third World Studies* 13, no. 2 (1996); Sophie Wilmot, "Caring About Africa," *Washington Post*, July 23, 2007.

63. Bhinda and FONDAD, *Private Capital*, 49. They also note that most direct investment comes from former colonizers, especially the United Kingdom and France. Ibid., 51.

64. Gordon, Miller, and Wolpe, *United States*, 17.

65. Bhinda and FONDAD, *Private Capital*, 51; Gordon, Miller, and Wolpe, *United States*, 17; Jim Cason, "The US: Backing Out of Africa," *Review of African Political Economy* 24, no. 71 (1997): 153.

66. This danger takes many forms. For some, the lack of infrastructure in a country makes it backward and potentially dangerous. Others fear the crime of urban areas, or the political instability of a particular government. Bhinda and FONDAD, *Private Capital*, 61–62.

67. Ibid., 55.

68. For a discussion of this in the context of *Vanity Fair*, see Magee, "Representing Africa?"

69. Gordon, Miller, and Wolpe, *United States*, 80.

70. Charles P. Henry, ed., *Foreign Policy and the Black (Inter)National Interest* (Albany: State University of New York Press, 2000); Gordon, Miller, and Wolpe, *United States*, 79.

71. Cason, "US," 153.

72. Krista Thompson, "Beyond Tarzan and *National Geographic*: The Politics and Poetics of Presenting African Diasporic Cultures on the Mall," *Journal of American Folklore* 121, no. 479 (2008): 105.

73. See Said, *Orientalism*; Edward Said, *Culture and Imperialism* (New York: Vintage, 1993).

74. The literature in these areas is too vast to cite in its entirety. Key texts for my thinking have been Tony Bennett, "Exhibitionary Complexes," *New Formations* 4 (1988); James Clifford, "Of Other Peoples: Beyond the 'Salvage Paradigm,'" in *Discussions in Contemporary Culture 1*, ed. Hal Foster (Seattle: Bay Press, 1987); Clifford, *Predicament*; James Clifford, *Routes: Travel and Translation in the Late Twentieth Century* (Cambridge, Mass.: Harvard University Press, 1997); Annie E. Coombes, "The Recalcitrant Object: Culture Contact and the Question of Hybridity," in *Colonial Discourse, Postcolonial Theory*, ed. Francis Barker, Peter Hulme, and Margaret Iversen (Manchester: Manchester University Press, 1994); Annie E. Coombes, *Reinventing Africa: Museums, Material Culture and Popular Imagination in Late Victorian and Edwardian England* (New Haven, Conn.: Yale University Press, 1994); Annie E. Coombes, *History after Apartheid: Visual Culture and Public Memory in a Democratic South Africa* (Durham, N.C.: Duke University Press, 2003); Carol Duncan, *Civilizing Rituals: Inside Public Art Museums* (London: Routledge, 1995); Haraway, "Teddy Bear"; Eilean Hooper-Greenhill, *Museums and the Shaping of Knowledge* (London: Routledge, 1992); Ivan Karp, "How Museums Define Other Cultures," *American Art* 5, nos. 1–2 (1991); Ivan Karp and Steven D. Lavine, eds., *Exhibiting Cultures: The Poetics and Politics of Museum Display* (Washington, D.C.: Smithsonian Institution Press, 1991); Harrie Leyten, foreword to *Art, Anthropology and the Modes of Re-presentation*, ed. Harrie Leyten and Bibi Damen (Amsterdam: Royal Tropical Institute, Tropenmuseum, 1993); Barbara Pollack, "The Newest Avant-Garde," *ARTnews* 100, no. 4 (2001); Mary Nooter Roberts and Susan Vogel, *Exhibition-ism: Museums and African Art* (New York: Museum for African Art, 1994); Daniel J. Sherman, ed., *Museums and Difference* (Bloomington: Indiana University Press, 2008); Susan Vogel, ed., *Art/artifact: African Art in Anthropology Collections* (New York: Center for African Art, and Munich: Prestal Verlag, 1988).

75. Ferguson, *Global Shadows*, vii, 1–23.

2. Race-ing Fantasy

1. A 1991 study indicates that 96 percent of *Sports Illustrated* readers live in the United States, and the majority of the remaining 4 percent are in Canada. This study is cited in Davis, *Swimsuit Issue*, 105–106. By 2007 Canada's share had fallen to under 2.5 percent, with the rest of international readership representing less than 1 percent. Audit Bureau of Circulation, "Paid and Verified Magazine Publisher's Statement: Sports Illustrated," Audit Bureau of Circulation, http://sportsillustrated.cnn.com/adinfo/si/ABC-SI2007June.pdf, accessed July 9, 2009.

2. Daddario provides the statistics on women athletes. Gina Daddario, "Swimming against the Tide: *Sports Illustrated's* Imagery of Female Athletes in a Swimsuit World," *Women's Studies in Communication* 15, no. 1 (1992): 50. Several models comment on the desire for the cover photo in the 1996 edition of the making-of-the-swimsuit-issue video. Sports Illustrated Television and Stacey Williams, *"Sports Illustrated" Swimsuit 1996 Out of Africa* (New York: Sports Illustrated Television, Distributed by Image Entertainment, 1996), VHS, 1 videocassette (45 min.).

3. Davis, *Swimsuit Issue*, 90–91.

4. This is true also for *Essence*, where models have similar characteristics. Susan Bordo, "'Material Girl': The Effacements of Postmodern Culture," in *Turning It On: A Reader in Women and Media*, ed. Helen Baehr and Ann Gray (London: Arnold, 1996), 47. For related discussions of African Americans and ideals of beauty and issues of hair, see also Margo Okazawa-Ray, Tracy Robinson, and Janie Victoria Ward, "Black Women and the Politics of Skin Color and Hair," *Women & Therapy* 6, nos. 1/2 (1987); Pearl Cleage, "Hairpiece," *African American Review* 27, no. 1 (1993); Lisa Jones, *Bulletproof Diva: Tales of Race, Sex, and Hair* (New York: Doubleday, 1994). Kobena Mercer offers a recuperative semiotic reading of the practice of hair straightening, arguing against a reading of it as simply buying into a low self-image of the black self. His argument does not, however, address the combination of physical characteristics that privilege white standards of beauty in mainstream popular culture. Kobena Mercer, "Black Hair/ Style Politics," in *Out There: Marginalization and Contemporary Cultures*, ed. Russell Ferguson, Martha Gever, T. Minh-ha Trinh, and Cornel West (New York: New Museum of Contemporary Art, and Cambridge, Mass.: MIT Press, 1990).

5. Davis, *Swimsuit Issue*, 90.

6. Michael Omi and Howard Winant, *Racial Formation in the United States: From the 1960s to the 1990s* (New York: Routledge, 1994), 66.

7. Ibid.

8. Banks has had her own television talk show, created and produced the television show *America's Next Top Supermodel*, and started the TZONE foundation, an organization dedicated to funding nonprofit groups that service low-income and underprivileged women and girls.

9. Eduardo Bonilla-Silva, *Racism without Racists: Color-blind Racism and the Persistence of Racial Inequality in the United States* (Lanham, Md.: Rowman and Littlefield, 2003), chapter 5.

10. Ibid., 104.

11. Ibid., 124.

12. It is important to note here that scholars, myself included, are not talking about whites as individuals. Rather, we are talking about the racialized social structure of American society and therefore about white as a social category of people. Individuals in any racialized group may act against the conventionalized behaviors and attitudes of that group.

13. Omi and Winant, *Racial Formation*, 3; Bonilla-Silva, "New Racism."

14. Davis, *Swimsuit Issue*, 95. There are too many sources to list regarding income disparity. For a summary of major figures and findings, see Associated Press, "Study Finds Higher Income for Lighter-Skinned Immigrants," *New York Times*, January 28, 2007; Leonhardt, "For Blacks, Progress in Happiness."

15. See, for example, Jenifer B. McKim, "Fed Report Shows Loan Inequities," *Boston Globe*, January 13, 2009; Patricia Cohen, "Mapping a Bird's-Eye View of Foreclosure Misery," *New York Times*, July 8, 2009; Erin Dukin, "Minorities Hit Hard in Mortgage Crunch," *New York Daily News*, October 28, 2008; Darryl Fears and Carol D. Leonnig, "Activists Angered by Blame for Crisis," *Washington Post*, October 3, 2008; Charles Steele Jr., "The Color Of Credit," *Washington Post*, June 23, 2008; Ovetta Wiggins, "NAACP Urges Homeowners to Join Suit Over Unfair Lending," *Washington Post*, July 10, 2008.

16. The 1990s case of Denny's restaurant and its refusal to serve black patrons is just one example of this. See, among others, Jim Adamson, Robert McNatt, and Rosemary Bray McNatt, *The Denny's Story: How a Company in Crisis Resurrected Its Good Name* (New York: John Wiley & Sons, 2000); Lynne Duke, "More Denny's Patrons Allege Racial Bias," *Washington Post*, June 17, 1993; Lynne Duke, "Service Agents Allege Racial Bias at Denny's," *Washington Post*, May 24, 1993; Stephen Labaton, "Denny's Gets a Bill for the Side Orders of Bigotry," *New York Times*, May 29, 1994; Stephen Labaton, "Denny's Restaurants to Pay $54 million in Race Bias Suits," *New York Times*, May 25, 1994; "Another Discrimination Suit for Denny's," *Washington Post*, April 1, 1995; Howard Pankratz, "4 Black Students Suing Denny's," *Denver Post*, July 8, 1995. One regularly can find reports on racial discrimination in the *New York Times*. Jodi Kantor, in just one instance, describes the difficulties many middle-class blacks have in hiring nannies to care for their children. She notes that many nannies (of all races) and agencies were interviewed, and the reasons for not wanting to nanny for a black family "included accusations of low pay and extra work, fears that employers would look down at them, and suspicion that any neighborhood inhabited by blacks had to be unsafe." Jodi Kantor, "Nanny Hunt Can Be a 'Slap in the Face' for Blacks," *New York Times*, December 26, 2006.

17. Bonilla-Silva, *Racism without Racists*, 178.

18. Discussing television (*The Cosby Show*) and real life (the writings of scholar Cornel West), Ann duCille asserts that skin color, as a phenotypical marker of race, positions a person in terms of class as well as race. Black skin allows individuals to be "mis-cast(e)" as "low-Other" and necessitates intentional attempts to counter popular discourses by presenting blacks as middle or upper class. Ann duCille, "The Colour of Class: Classifying Race in the Popular Imagination," *Social Identities* 7, no. 3 (2001): 413. Patricia Hill Collins echoes this observation when she writes that "poor and working-class Black culture was routinely depicted as being authentically Black whereas middle- and upper-middle class Black culture was seen as less so." Collins, *Black Sexual Politics*, 122.

19. Ann duCille, "The Shirley Temple of My Familiar," *Transition*, no. 73 (1997): 25.

20. This is not to say that some of the stereotypes evoked and reproduced are not changing, especially in the years following the production of this swimsuit issue. For a look at some of the ways ideas around black female bodies have been challenged recently in the realm of art, see the catalog for the exhibition *Black Womanhood*. Barbara Thompson, ed., *Black Womanhood: Images, Icons, and Ideologies of the African Body* (Hanover, N.H.: Hood Museum of Art, Dartmouth College, and Seattle: University of Washington Press, 2008). That an exhibition of this topic and engaging issues of representation was relevant in 2008 demonstrates the prevalence and tenacity with which many of these ideas are maintained in society.

21. Bonilla-Silva, *Racism without Racists*, 178.

22. Ibid., chapter 5.

23. Margaret Wetherell and Jonathan Potter, *Mapping the Language of Racism: Discourse and the Legitimation of Exploitation* (New York: Columbia University Press, 1992), 28.

24. Davis, *Swimsuit Issue*, 91–92.

25. Ibid., 89.

26. Bonilla-Silva, *Racism without Racists*; Howard Winant, "Racism Today: Continuity and Change in the Post–Civil Rights Era," in Wong, *Race, Ethnicity, and Nationality*; Susan Searls Giroux, "Reconstructing the Future: Du Bois, Racial Pedagogy and the Post–Civil Rights Era," *Social Identities* 9, no. 4 (2003).

27. The controversy that arose around the University of Michigan's admission policies is just one example of this. Ellis Cose, "Affirmative Action Slips, but Will Fairness Stand?" *Baltimore Sun*, November 21, 2006; Shikha Dalmia, "Blacks and Hispanics Don't Need Racial Preference Laws," *Chicago Sun Times*, November 26, 2006; Jonathan D. Glater, "At Berkeley Law, a Challenge to Overcome All Barriers," *New York Times*, January 17, 2007; Tamar Lewin, "Campaign to End Race Preferences Splits Michigan," *New York Times*, October 25, 2006; Tamar Lewin, "Michigan Rejects Affirmative Action, and Backers Sue," *New York Times*, November 9, 2006; Tamar Lewin, "Colleges Regroup After Voters Ban Race Preferences," *New York Times*, January 26, 2007; Cathy Young, "A Well-Meaning End to Discrimination," *Boston Globe*, December 11, 2006. Bonilla-Silva, Omi and Winant, and other scholars of race

assert, however, that while equal opportunity may exist, equality in results does not. Equality of results is a much more crucial thing to achieve. Complicating this issue is the fact that colorblindness uses the rhetoric of individualism, leaving little room for discussing group rights. Bonilla-Silva, "New Racism," 71; Omi and Winant, *Racial Formation*, 70.

28. Omi and Winant, *Racial Formation*, especially chapter 7.

29. Ibid., 122.

30. Bonilla-Silva, *Racism without Racists*, 28.

31. Davis treats the subject of brown-skinned models in chapter 8 of her study on the swimsuit issues. Davis, *Swimsuit Issue*. Though the treatment of women of color in general has resonance with the racialized identities that are the subject of this book, I do not address them more fully here as they are not focused through ideas of Africa and therefore fall outside the purview of this study.

32. Anandi Ramamurthy, "Construction of Illusion," in *Photography: A Critical Introduction*, ed. Liz Wells (New York: Routledge, 1997), 50–57. Women are presented also as childlike, though this is not manifest in the *SI* swimsuit issue photographs.

33. Erving Goffman, *Gender Advertisements* (Cambridge, Mass.: Harvard University Press, 1979), 41.

34. Margaret Carlisle Duncan, "Beyond Analyses of Sport Media Texts: An Argument for Formal Analyses of Institutional Structures," *Sociology of Sport Journal* 10 (1993): 48; John Pultz, *The Body and the Lens: Photography 1839 to the Present* (New York: Harry N. Abrams, 1995), 26; Frank Rich, "The Girl Next Door," *New York Times*, February 20, 1994.

35. Goffman, *Gender*, 46.

36. Interestingly, *SI* provided fashion coverage into the 1970s. Davis, *Swimsuit Issue*, 11–12.

37. Ibid., 77.

38. Martin Harrison, *Appearances: Fashion Photography since 1945* (New York: Rizzoli, 1991), 17.

39. Nancy Hall-Duncan, *The History of Fashion Photography* (New York: Alpine Book, 1979), 68.

40. Davis, *Swimsuit Issue*, 90–91; Ramamurthy, "Construction," 175–177; Hall-Duncan, *History of Fashion*, 158; "Advertising and Fashion Photography: A Short Survey," *British Journal of Photography* 128 (March 20, 1981): 305.

41. Goffman, *Gender*, 84; Anthony J. Cortese, *Provocateur: Images of Women and Minorities in Advertising* (Lanham, Md.: Rowman and Littlefield, 1999), 5, 124; Elizabeth Wilson, *Adorned in Dreams: Fashion and Modernity* (Berkeley: University of California Press, 1985), 246–247.

42. Jennifer Craik, *The Face of Fashion: Cultural Studies in Fashion* (London: Routledge, 1994), 101.

43. Goffman, *Gender*, 84.

44. Ramamurthy, "Construction," 158.

45. Hall, "Encoding, Decoding."

46. Statistics for the early 1990s readership indicate that 89 percent of the readers were male. Duncan, "Beyond Analyses," 362. In spring 1995 males made up 75.6 percent of the readership, and it rose to 79.6 percent in spring 2009. The 1995 and 2009 statistics were provided by Time, Inc. via its customer service. Chris Mahr, e-mail message to author, July 20, 2009. In 2007 the median age of readers was thirty-nine years. Sports Illustrated, "MRI National Spring 2007 Fact Sheet," *Sports Illustrated*, http://sportsillustrated.cnn.com/adinfo/si/mri2007.html, accessed July 9, 2009. Blacks comprised 14 percent of the readership in 2006. Sports Illustrated, "MRI National Spring 2006 Male Base Fact Sheet," *Sports Illustrated*, http://sportsillustrated.cnn.com/adinfo/si/mriNationalSpring2006.html, accessed January 24, 2007. When I asked for racial demographics for the mid-1990s and for 2009, I was told that that information was not tracked. Mahr, e-mail. However, as the 2006 statistics indicate, it was tracked at one time. It may be that it is in fact tracked, but is no longer made public. Additionally, *SI* "targets affluent men" specifically. Davis, *Swimsuit Issue*, 61. In 2007 the median income for subscribers was $65,464. Sports Illustrated, "MRI National Spring 2007 Fact Sheet." Even though readership is comprised of men from different economic backgrounds, and of varying ages, who will have differing relationships to ideas about Africa depending on a number of factors such as when or where they were schooled, or even their racial background, a white hegemonic message prevails in the magazine as a strong subtext. Readers, of course, may reject or intervene in those messages, but they engage them in some way.

47. Kathy Myers, "Fashion 'n' Passion," in *Looking On: Images of Femininity in the Visual Arts and Media*, ed. Rosemary Betterton (London: Pandora, 1989), 59; Clive Scott, *The Spoken Image: Photography and Language* (London: Reaktion Books, 1999), 153.

48. There are people who feel the swimsuit issues tend toward pornography in their sexualized objectification of women. See, for instance, Lee Quarnstrom, "The Swimsuit Issue Is Here," www.salon.com/mwt/feature/2000/02/25/swimsuit, accessed March 3, 2000; Linnea Smith, "Dear 1997 *SI* Swimsuit Issue Advertiser," *Talking Trash* (blog) http://www.talkintrash.com/sportsillustrated/SIADVER.html, accessed June 2003 (this page is no longer available); and Joel Stein, "Brown-bagging It," *Time*, February 28, 2000. I am not in agreement. I do, however, understand how these images can be read, and used, erotically. Certainly this is suggested by the nervous laughter of the men in my classroom when I discuss the possibilities for fantasy the swimsuit issues offer, and the several offers I have had from male students to help me interview these models should my research go that route.

49. Myers, "Fashion," 59.

50. Judith Williamson, *Decoding Advertisements: Ideology and Meaning in Advertising* (London: Marion Boyars, 1978), 74.

51. Rich, "Girl"; Myers, "Fashion," 62; Davis, *Swimsuit Issue*, 35.

52. Davis, *Swimsuit Issue*, especially chapter 6; Duncan, "Beyond Analyses"; Rich, "Girl."

53. The models for the 1996 issue and the number of photographs in which they appear (shown in parentheses) are: Tyra Banks (2), Angie Everhart (3), Kathy Ireland (2), Valeria Mazza (2), Georgianna Robertson (3), Rebecca Romijn (7), Ingrid Seynhaeve (2), Manon von Gerkan (4), and Stacey Williams (6). Two years previous, only one black model appeared in the swimsuit issue. Rich, "Girl."

54. Davis, *Swimsuit Issue*, chapter 9.

55. In relation to examining fashion photographs that depict people of color, Ramamurthy suggests that the viewer's "consumption of . . . 'Other' worlds is domesticated through the familiar context of the fashion magazine and the more-often-than-not white model." Ramamurthy, "Construction," 177. Davis notes that the tanned bodies of the white models reinforce this as well; in this perspective, all the models bodies can be read as "dark," further subordinating them to their white male readers. She notes, "In the West, due to the racist stereotype that people of color are licentious, dark skin signifies unrestrained sexuality; therefore the tanned skin of the white models increases the perception that they are sexy." Davis, *Swimsuit Issue*, 28.

56. Williamson, *Decoding*, 25.

57. Phalana Tiller, "Swimsuit Issue *Sports Illustrated* (Review)," *Siecus Report*, April/ May 1996, 25. The use of Ndebele and Zulu jewelry for the models throughout the issue helps to create this sense of the exotic.

58. There are exceptions to this in both the swimsuit video and weekly desk calendar that were released that year. These included photos of the models that did not make it into the swimsuit issue itself. The video shows Ireland crawling around acting *as* a lion. Sports Illustrated Television and Williams, *"Sports Illustrated" Swimsuit 1996 Out of Africa*. Similarly, the 1997 *SI* swimsuit desk calendar, featuring the South African shoot, has Rebecca Romijn in a leopard-print one-piece, posed on a leopard-print blanket, and Tyra Banks in a one-piece depicting zebras on the savanna. I focus on the images in the swimsuit issue itself given the fact that the swimsuit issue reaches over six million readers.

59. The shot of Georgianna Robertson that closes this photo essay is an exception to this, but in it she appears in an equally exoticized and problematic manner. I discuss this at length in the following chapter.

60. E. M. Swift, "Wild Things," *Sports Illustrated*, January 29, 1996, 60.

61. Interestingly, Carl Hiaasen chose to parody Joseph Conrad's *Heart of Darkness* in his 2003 fictional contribution to the swimsuit issue, though Africa was not a location for the shoot in that year. Carl Hiaasen, "Tart of Darkness," *Sports Illustrated*, Winter 2003.

62. Davis, *Swimsuit Issue*, 90.

63. Stephen Jay Gould, *The Mismeasure of Man* (New York: W. W. Norton, 1981).

64. Cortese, *Provocateur*, 80; Anthony W. Marx, *Making Race and Nation: A Comparison of South Africa, the United States, and Brazil* (Cambridge: Cambridge University Press, 1998), 550.

65. Sears, "Africa," 1, 3.

66. Anne McClintock, "Soft-Soaping Empire: Commodity Racism and Imperial Advertising," in *The Gender and Consumer Culture Reader*, ed. Jennifer Scanlon (New York: Routledge, 2000), 145–146.

67. Africa is still imagined largely as a place of danger. While cannibals have been replaced by war as a fear-inducing condition, disease and animals still loom large. Several educational events at Walt Disney World Resort's Disney's Animal Kingdom Park and DAKL highlighted the Big Five: elephant, lion, leopard, rhinoceros, and cape buffalo; all are animals that pose potential threats to humans. I discuss this and Disney's Africa in detail in chapter 6.

68. Sears, "Africa," 30.

69. Patrick Brantlinger, "Victorians and Africans: The Genealogy of the Myth of the Dark Continent," in *"Race," Writing and Difference*, ed. Henry Louis Gates Jr. (Chicago: University of Chicago Press, 1986); Raymond Corby, "Alterity: The Colonial Nude," *Critique of Anthropology* 8, no. 3 (1988); Rebecca Scott, "The Dark Continent: Africa as Female Body in Haggard's Adventure Fiction," *Feminist Review* 32 (1989).

70. Helen Carr, "Woman/Indian: 'The American' and His Others," in *Europe and Its Others*, ed. Francis Barker, Peter Hulme, Margaret Iversen, and Diana Loxley (Colchester: University of Essex, 1985), 50.

71. Ibid.

72. The poses the models (black or white) appear in, their connection with natural settings, their youthfulness, and their subordination "encourage the consumer to associate the models with femininity." Davis, *Swimsuit Issue*, 27–28. I am arguing the African locale nuances this reading in particularly racialized ways.

73. Scott, "Dark Continent," 76.

74. Sander Gilman, *Difference and Pathology: Stereotypes of Sexuality, Race, and Madness* (Ithaca, N.Y.: Cornell University Press, 1985).

75. Sander Gilman, "Black Bodies, White Bodies: Toward an Iconography of Female Sexuality in Late Nineteenth-Century Art, Medicine and Literature," in Gates, *"Race," Writing and Difference*, 230.

76. Indeed, as Deborah Willis and Carla Williams note, "The combination of sexuality and public display was a function of Baartman's blackness." Deborah Willis and Carla Williams, *The Black Female Body: A Photographic History* (Philadelphia: Temple University Press, 2002), 61.

77. Gilman, "Black Bodies," 257.

78. Ayo Abiétou Coly, "Housing and Homing the Black Female Body in France: Calixthe Beyala and the Legacy of Sarah Baartman and Josephine Baker," in Thompson, *Black Womanhood*, 261. Postcards, a significant medium by which images of African women circulated during the colonial era, largely positioned women as sexual and savage. See Christraud M. Geary, "The Black Female Body, the Postcard, and the Archives," in Thompson, *Black Womanhood*.

79. Coly, "Housing," 261, emphasis mine.

80. The meanings of the connections between the prostitute and the black female are not fixed and vary according to context. For example, Patricia Leighten reads Picasso's use of African mask shapes to create the faces of the prostitutes in *Les Demoiselles d'Avignon* as an important anticolonial commentary. Patricia Leighten, "The White Peril and L'art Negre: Picasso, Primitivism, and Anticolonialism," *Art Bulletin* 72, no. 4 (1990). In another context, much anthropological writing located the prostitute in an intermediary position between "proper" European women and the black female colonial subject. Scott, "Dark Continent," 76.

81. Davis, *Swimsuit Issue*; Rich, "Girl"; Duncan, "Beyond Analyses."

82. Kimberly Wallace-Sanders, "The Body of a Myth: Embodying the Black Mammy Figure in Visual Culture," in Thompson, *Black Womanhood*, 168. She offers that the implication of this "corporeal fragmentation" is that these women are not treated as "whole," "normal" human beings.

83. I am indebted to Lyneise Williams and Gina Sully for their keen visual insights in our discussions of this image of Banks and Mazza. Additionally, the photograph of the Khoisan woman (Figure 2.4) was taken at the *Exposition Universelle* in Paris, 1889. It shows the same background as photographs of other African women by the same photographer and of other Khoisan women who were photographed by other photographers. See Willis and Williams, *Black Female*, 68, Figure 3; Albert Friedenthal, *Das Weib im Leben der Völker* (Berlin-Grunewald: Verlagsanstalt Hermann Klemm A.G., 1910), 291, Figure 491. In chapters 3 and 6, I consider the topic of Africans who are displayed as entertainment, as these women, part of a group of South Africans displayed at the exposition, were.

84. Many of the ethnographic photographic conventions within which photographers today still work were developed during the colonial period. Ramamurthy, "Construction," 171.

85. Brantlinger, "Victorians," 176–178. There are many people who have written on this topic; see, for instance, Virginia-Lee Webb, "Fact and Fiction: Nineteenth-Century Photographs of the Zulu," *African Arts* 25, no. 1 (1992); Christraud Geary, "Missionary Photography: Private and Public Readings," *African Arts* 24, no. 4 (1991); Elizabeth Edwards, ed., *Anthropology and Photography 1860–1920* (New Haven, Conn.: Yale University Press, 1992). Moreover, the documentation of local "specimens" does not begin with the advent of photography but has a history dating back to drawing and painting in the sixteenth and seventeenth centuries.

86. Pultz, *Body and Lens*, 20; Geary, "Black Female," 150–156.

87. David Green, "Classified Subjects, Photography and Anthropology: The Technology of Power," *Ten–8* 14 (1984): 31.

88. Friedenthal, *Das Weib*, 275. All translations from German to English in this chapter were provided by Bettina Meier.

89. For more on this type of representation, see Geary, "Black Female."

90. Carolee Kennedy, "Art, Architecture and Material Culture of the Zulu Kingdom" (Ph.D. diss., University of California, Los Angeles, 1993). Kennedy

confirmed this outfit was not standard costuming for Zulu women (personal communication to author, October 2003).

91. C. H. Stratz, *Die Rassenschönheit des Weibes* (Stuttgart: Verlag von Ferdinand Enke, 1903), 118–122. Stratz also comments that "the girl knew to mask her only blemish [sagging breasts evident in the full-length image]" with clothing. Ibid., 121.

92. Lutz and Collins, *Reading National Geographic*, 197–203.

93. Ibid.

94. John Picton, "Undressing Ethnicity," *African Arts* 34, no. 3 (2001): 73, emphasis mine.

95. Ima Ebong, ed., *Black Hair: Art, Style and Culture* (New York: Universe Publishing, 2001); Jones, *Bulletproof*. In this collection of her essays, Jones devotes an entire section of her book to the significance of hair to African Americans, and specifically discusses the connection to Africa in the piece "Hair Trade"; see especially pages 280 and 296.

96. Bill Gaskins, *Good and Bad Hair: Photographs by Bill Gaskins* (New Brunswick, N.J.: Rutgers University Press, 1997), preface.

97. Mercer, "Black Hair," 253–255.

98. Ibid., 255–256. My own mother is an example of the way such items were incorporated into mainstream fashion during the 1960s and early 1970s. A white middle-class homemaker, she always paid attention to what she wore, though she was not overly concerned with the latest fashions. Nevertheless, she had a caftan that she wore when entertaining guests.

99. Sears, "Africa."

100. Ibid.

101. See Carol Magee, "*400 Men of African Descent*: Negotiating Racialised Identities at the Seattle Art Museum," *Third Text* 18, no. 5 (2004).

102. In her discussion of the placement of Tyra Banks on the cover of this swimsuit issue, Davis comments that readers generally accept token representation of women of color in the swimsuit issues as indicative of the absence of racism. Davis, *Swimsuit Issue*, 92. This attitude can be read to some extent in the celebrations of Banks's cover photo.

103. Africa is largely neglected in U.S. foreign policy, receiving only 18 percent of the foreign aid budget in 2004; that this was so "large" was due mostly to the AIDS pandemic. Curt Tarnoff and Larry Nowels, "Foreign Aid: An Introductory Overview of U.S. Programs and Policy" (Washington, D.C.: Congressional Research Service, 2004), 13.

3. "It's Sort of Like *National Geographic* Meets *Sports Illustrated*"

The quote that I am using as the title of this chapter is taken from Rebecca Romijn as she comments on her photo shoot among the Maasai peoples of Kenya for the 1998

swimsuit issue. Sports Illustrated Television and Rob Schneider, *"Sports Illustrated" Swimsuit 1998* (New York: Sports Illustrated Television, 1998), VHS.

1. Here I am using *locality* as it is articulated by Arjun Appadurai, highlighting that it is "primarily relational and contextual rather than scalar or spatial." He continues: "I see it as a complex phenomenological quality, constituted by a series of links between the sense of social immediacy, the technologies of interactivity, and the relativity of contexts. This phenomenological quality, which expresses itself in certain kinds of agency, sociality, and reproducibility, is the main predicate of locality as a category." Arjun Appadurai, *Modernity at Large: Cultural Dimensions of Globalization* (Minneapolis: University of Minnesota Press, 1996), 178.

2. Although Ireland had her own line of swimsuits at the time of this shoot, conflict of interest prevented her from wearing any. Sports Illustrated Television and Williams, *"Sports Illustrated" Swimsuit 1996 Out of Africa*. Moreover, none of the other models in the issue wears an Ireland-designed suit.

3. I was accompanied on this trip by Herbert Cole and Michael Hamson, though for conciseness of phrasing I write as if traveling alone. They both documented this research photographically.

4. Ivor Powell, *Ndebele: A People & Their Art* (New York: Cross River Press, 1995); Giovanni Fontana Antonelli, "Donne Ndebele. Le Case Dipinte. Ndebele Women. Painted Houses," *Lotus International* 114 (September 2002); Elizabeth Ann Schneider, "Paint, Pride and Politics: Aesthetic and Meaning in Transvaal Ndebele Wall Art" (Ph.D. diss., University of the Witwatersrand, 1986); Lindsay Hooper, "The Art of Ndebele Beadwork," *Sagittarius: Magazine of the South African Museum*, December 1988; Margaret Courtney-Clarke, *Ndebele: The Art of an African Tribe* (New York: Rizzoli, 1986); Peter Rich, "The Hybrid 'Palaces' of the Mapogga," *Spazio e Società* 7, no. 26 (1984).

5. Courtney-Clarke, *Ndebele*, 21–22; Powell, *Ndebele*, 39.

6. Powell, *Ndebele*, 46.

7. Schneider, "Paint," 173.

8. There has been a decrease in youth participation in learning these traditions; as with people everywhere, younger generations do not necessarily value cultural practices as older generations have. A result of the decrease in women who are learning or practicing mural painting is that some men are taking up the practice. This is the case with Esther Mahlangu's son Elias. Lynne Duke, "The Living Art of Esther Mahlangu," *Washington Post*, September 4, 1994.

9. Schneider, "Paint," 222.

10. Powell, *Ndebele*, 39, 45, 52, 56; Elizabeth Rankin, "Black Artists, White Patrons: The Cross-Cultural Art Market in Rural South Africa," *Africa Insight* 20, no. 1 (1990): 33; Schneider, "Paint," 29–30, 42.

11. Muriel Horrell, *South Africa: Basic Facts and Figures* (Johannesburg: South African Institute of Race Relations, 1973), 37; Jeffrey Butler, Robert I. Rotberg, and John Adams, *The Black Homelands of South Africa: The Political and Economic*

Development of Bophuthatswana and KwaZulu (Berkeley: University of California Press, 1977), 35–37; Muriel Horrell, *Race Relations as Regulated by Law in South Africa 1948–1979* (Johannesburg: South African Institute of Race Relations, 1982), 17–19.

12. Schneider, "Paint," 30.

13. It was not a village in the sense of it being a community in which people lived: the buildings were not arranged according to Ndebele compound conventions, and all were empty. Nevertheless, that a museum has been established and dedicated solely to this cultural practice demonstrates its importance to an understanding of Ndebele culture.

14. As I mentioned in the previous chapter, I was unable to talk to anyone at *SI* who could answer my questions about specific details of this trip. Additionally, I left the color copy with Nomvula.

15. All my interviews with the Ndebele women were conducted on September 3, 1997. They were transcribed and translated by Jako Olivier Language Services in South Africa.

16. This misperception of Americans indicates that superficial understandings flow both ways across cultural boundaries. The Ndebele women's perceptions of American dress come from the mass exportation of American popular culture around the globe. For example, when people asked me where I was at school, I would answer the University of California; in both America and Ghana, people would then ask "UCLA?" or "UC Berkeley?" depending on their own knowledge. I would counter, saying, "No, Santa Barbara," and then often have to explain where that was in relation to those other campuses. In southern Africa, however, people knew Santa Barbara right away because they watched the U.S.-produced daytime television drama by that name.

17. Powell, *Ndebele*, 52.

18. Ibid., 120; Anna-Marie Trollip, "Meaning of Blankets, Towels, and T-shirts in the Context of Acculturation," *South African Journal of Ethnology* 18, no. 4 (1995): 153.

19. Sandra Klopper and Peter Magubane, *Dress and Adornment* (Cape Town: Struik, 2001), 13, 88.

20. Powell, *Ndebele*, 95.

21. Rose, whose surname was not provided, was in Indonesia at the time, so I was unable to speak with her about her participation; she was conducting a beaded jewelry workshop. Given this, I refer to these women as Martha and Rose when referencing them together (it seems less awkward than Nomvula and Rose). When speaking of Nomvula alone, I use her last name, as I do with all the other individuals I discuss.

22. Trollip, "Meaning."

23. Ibid., 152–153.

24. Even recently there have been published photographs that depict Ndebele girls with bare breasts, though as with other traditions, this style of dress is also becoming less frequent. See Powell, *Ndebele*; Klopper and Magubane, *Dress*.

25. A primary income source for Ndebele women has been to serve as domestic labor in the homes of white South Africans. A variety of economic and political

circumstances resulted in the domestic labor force in South Africa being primarily black. Jacklyn Cock, *Maids & Madams: A Study in the Politics of Exploitation* (Johannesburg: Ravan Press, 1980), especially 197–228; Bridget Kenny, "Servicing Modernity: White Women Shop Workers on the Rand and Changing Gendered Respectabilities, 1940s–1970s," *African Studies* 67, no. 3 (2008). These positions often require women to travel great distances from their homes to the suburban neighborhoods of their employers. Some women travel as many as four hours each way, leaving their homes in the early hours of the morning and returning well after dark. See, for instance, Brenda Goldblatt, "My Children Know What Is Going On in KwaNdebele," in *amaNdebele: Farbsignale aus Sudafrika—Signals of Color from South Africa*, ed. Wolfger Pohlmann and Haus der Kulturen der Welt (Tubingen: Ernst Wasmuth, 1991). In 1984 as many as three-quarters of white homes in South Africa employed domestic servants, positions that held little stability for the black women workers as they had no formal labor protection and were often paid low wages. Joyce Hickson and Martin Strous, "The Plight of Black South African Women Domestics," *Journal of Black Studies* 24, no. 1 (1993): 109–110. Moreover, even after the end of the apartheid regime, "most recent labour demographics demonstrate that domestic work remains the largest sector of employment of African women in South Africa." Jennifer N. Fish, "Engendering Democracy: Domestic Labour and Coalition-Building in South Africa," *Journal of Southern African Studies* 32, no. 1 (2006): 109.

26. M. F. Kennedy, "Visions of Ndebele," *Town & Country* 146 (January 1992). The *Town & Country* piece is informative and meant to convey actual information to its audience, an audience who may well travel to South Africa. Similarly, *Paris Vogue* offered a look at Ndebele culture and fashion in the December 1993/January 1994 issue. As in the *Town & Country* piece, didactic text was included, educating readers about the types of beaded skirts worn at various stages of an Ndebele female's life, and even providing indigenous names for the skirts. "Femmes de coleur," *Paris Vogue* (December 1993/January 1994). Although both articles appeared earlier than this swimsuit issue, and may well have been known by *SI*'s editors, including local peoples from the various sites at which they shoot is an approach used by the *SI* team since the 1970s. Davis, *Swimsuit Issue*, chapter 9. Moreover, in 1985 *SI* presented another instance of body painting; Elle Macpherson appeared in a photograph with Paulina Porizkova; like Robertson, Macpherson appeared only in the bottom of a bikini with designs (this time Australian Aboriginal) painted on her breasts but also on the rest of her body. Porizkova, in contrast, wears a full suit. While exoticizing, it does not have the same effect of associating Macpherson with the indigenous people of Australia, as does the paint on Robertson's breasts and black skin. The Macpherson photograph was not printed in the swimsuit issue itself, though it does appear in Sports Illustrated, *Around the World with the Swimsuit Supermodels* (New York: Sports Illustrated, 1997).

27. Esther Mahlangu, for instance, is represented in the following museums and corporate collections: Museum Bochum (Bochum, Germany); National Gallery (Cape Town, South Africa); Musée des Arts d'Afrique et Océanie (Paris); Botshabelo

Museum (Middleburg, South Africa); BMW Art Cars, BMW Museum (Munich); World Bank Collection; Pretoria Art Museum (South Africa); among others. Francina Ndimande, also a famous painter, is represented in the Musée des Arts d'Afrique et Océanie and the Botshabelo Museum.

28. Both Mahlangu and Nelson Tjakamarra were participants in the 1989 exhibition *Magiciens de la terre* held at the Centre George Pompidou in Paris; this exhibition was controversial and received quite a lot of press, but also brought notoriety to many non-European and non-Euro-American artists.

29. Kathy Ireland, "Dear Diary," *Sports Illustrated*, http://sportsillustrated.cnn.com/features/1996/swimsuit/diary/index.html, accessed August 5, 2004. In 2005 I found that it is no longer posted.

30. Powell, *Ndebele*, 49, 52.

31. Deborah James, "A Question of Ethnicity: Ndzundza Ndebele in a Lebowa Village," *Journal of Southern African Studies* 16, no. 1 (1990).

32. World Tourism Organization, "Tourism Highlights 2007" (Madrid: United Nations World Tourism Organization, 2007), 10.

33. Sidney Littlefield Kasfir, "Samburu Souvenirs," in *Unpacking Culture: Art and Commodity in Colonial and Postcolonial Worlds*, ed. Ruth B. Phillips and Christopher B. Steiner (Berkeley: University of California Press, 1999); Davis, *Swimsuit Issue*, chapter 9; David Nicholson-Lord, "The Politics of Travel: Is Tourism Just Colonialism in Another Guise?" *Nation*, October 6, 1997; Edward M. Bruner and Barbara Kirshenblatt-Gimblett, "Maasai on the Lawn: Tourist Realism in East Africa," *Cultural Anthropology* 9, no. 4 (1994).

34. Nicholson-Lord, "Politics," 16.

35. Swift, "Wild Things," 65.

36. Nicholson-Lord, "Politics."

37. Ibid., 14.

38. Ibid., 17.

39. See Kenneth Little, "On Safari: The Visual Politics of a Tourist Representation," in *The Varieties of Sensory Experience: A Sourcebook in the Anthropology of the Senses*, ed. Davis Howes (Toronto: University of Toronto Press, 1991); Dean MacCannell, *The Tourist: A New Theory of the Leisure Class* (1976; repr., New York: Schocken Books, 1989); Dean MacCannell, "Reconstructed Ethnicity: Tourism and Cultural Identity in Third World Communities," *Annals of Tourism Research* 11 (1984); Patricia C. Albers and William R. James, "Travel Photography: A Methodological Approach," *Annals of Tourism Research* 15 (1988).

40. Davis, *Swimsuit Issue*, 112.

41. Ibid., 97.

42. Ibid., 103.

43. This promotion is part of what Laurel Davis identifies in her study as a key element in the construction of a masculine hegemony.

44. Ibid., 98–99.

45. Ibid., 100.

46. Quoted in ibid.

47. Ibid., 101.

48. Ibid., 103.

49. Albers and James, "Travel Photography."

50. Ibid., 153; Kathleen M. Adams, "Cultural Displays and Tourism in Africa and the Americas," *Ethnohistory* 50, no. 3 (2003): 569; Davis, *Swimsuit Issue*, 115; Gerhard Schutte, "Tourists and Tribes in the 'New' South Africa," *Ethnohistory* 50, no. 3 (2003): 473.

51. I experienced this most acutely myself in Ghana the first time I went, though it is never something that goes away. I was a graduate student doing preliminary research for my dissertation and living, paycheck to paycheck, mostly on student loans. Yet most of the Ghanaians I encountered viewed me as rich. Some would ask for money. I did not feel rich, even as I knew I was not poor. I had flown thousands of miles to live there for six weeks. I was not visibly working when I was there, and I could buy food, and souvenirs, and pay rent on my room. Compared to many Ghanaians, I was rich!

52. Ireland's online diary entry for September 20, 1995; see note 29.

53. Albers and James, "Travel Photography," 153. Albers and James argue this point about travel photography in the context of Native Americans.

54. Davis, *Swimsuit Issue*, 104–105.

55. The roles that indigenous men and women play on the pages of the swimsuit issue are in keeping with many representations of non-Western peoples where women are the keepers and presenters of "tradition" and men more actively and visually serve as liaisons between cultures.

56. Davis, *Swimsuit Issue*, 104–105.

57. Ibid., 109.

58. Ibid., 106.

59. Quoted in ibid., 103. Here seems an opportunity to discuss more fully the implications of engaging with other cultures, but Davis does not explore this further.

60. *Bogolanfini*, mudcloth from Mali in west Africa, uses mud to stimulate a chemical reaction with the dyes used to create the designs, thereby permanently staining the cotton cloth with intricate geometric patterns. For a description of this process, see Victoria Rovine, "Bogolanfini in Bamako: The Biography of a Malian Textile," *African Arts* 30, no. 1 (1997).

61. This suggests an agency in self-presentation that these Ndebele women have in their work environment, but that the models do not.

62. Davis, *Swimsuit Issue*, 108.

63. I would like to thank Gary van Wyk for confirming this for me. Gary van Wyk, e-mail message to the author, June 23, 2005. Interestingly, Iman also wears a *pepetu* in the photograph in which Mahlangu is painting her body; there, however, she wears it around her waist. See Kennedy, "Visions," 68–69.

64. MacCannell, "Reconstructed," 385.

65. MacCannell, *Tourist*, xv.

66. Little, "On Safari," 157; Peter Osborne, *Traveling Light: Photography, Travel, and Visual Culture* (Manchester: Manchester University Press, 2000), 74, 88.

67. *Baywatch* is shown in 148 countries, and it is estimated that close to one billion people have seen it. Thomas L. McPhail, *Global Communications: Theories, Stakeholders, and Trends*, 2nd ed. (Malden, Mass.: Blackwell, 2006), 122. I do not know specifically if it is shown in South Africa, though many American-produced television shows are, including the soap opera *Santa Barbara*.

68. Kasfir, "Samburu," 73.

69. For a full discussion of this relationship to tourism, see Powell, *Ndebele*.

70. Francina did not provide her surname.

71. This possibility was suggested by Herbert Cole, as he, Michael Hamson, and I were leaving her compound (see note 3, this chapter). I thank them for the insights this conversation produced.

72. Bruner and Kirshenblatt-Gimblett, "Maasai on the Lawn," 457.

73. Ibid., 466.

74. Little, "On Safari," 153.

75. Ibid., 150.

76. Bruner and Kirshenblatt-Gimblett, "Maasai on the Lawn."

77. Citing Laura Mulvey's work on scopophilia, Bruner and Kirshenblatt-Gimblett argue that further work needs to be done on the visual nature of control in tourist settings. Ibid., 448.

78. Both Rebecca Romijn and Laetitia Casta comment on how wonderful their job is, in part because it allows them to travel to myriad places. Sports Illustrated Television and Schneider, *"Sports Illustrated" Swimsuit 1998*.

79. Allan Sekula, "The Body and the Archive," *October* 39 (Winter 1986).

80. Brian Wallis, "Black Bodies, White Science: Louis Agassiz's Slave Daguerreotypes," *American Art* 9, no. 2 (1995).

81. Lutz and Collins, *Reading National Geographic*, 192.

82. This photograph is reproduced in Willis and Williams, *Black Female Body*, 19.

83. Charnay identified indigenous people with their names when it was important to him, as in the case of his portrait of Princess Juliette Fiche (1863).

84. Keith Davis, *Desire Charnay, Expeditionary Photographer* (Albuquerque: University of New Mexico Press, 1981), 17–21.

85. The prominence of the wholesome, girl-next-door image is evident when one looks at the relationship of the swimsuit issue to fashion photography, for where fashion photography became more risqué and pushed at boundaries in the 1980s and 1990s, ushering in "heroin chic," for instance, the swimsuit issues stayed relatively true to the conventions of fashion photography from the late 1960s and 1970s. This was also the time when the swimsuit issue was becoming the cultural product/icon it is today. For a discussion of the development of the swimsuit issue, see Davis, *Swimsuit Issue*, chapter 2.

86. Wallis, "Black Bodies," 54. Similarly, "power comes to be defined as the procedures through which this mute body is shaped into forms of subjectivity, categories of people, types of population and given voice." Wetherell and Potter, *Mapping the Language of Racism*, 84.

87. Kasfir, "Samburu," 72.

88. Little, "On Safari," 156.

89. Gayatri C. Spivak, "Can the Subaltern Speak? Speculations on Widow-Sacrifice," *Wedge* 7/8 (1985).

90. As I discussed in the previous chapter, the captions name the models (along with the designer of the swimsuit, its price, and the location of the photograph). As supermodels, these women are also known by sight.

91. Albers and James, "Travel Photography," 136; Little, "On Safari," 156; Keim, *Mistaking Africa*, 69–73; Osborne, *Traveling*, 81.

92. I have found that among my students, *NG* continues to be a source of information about Africa as well as representations of it, though certainly they obtain imagery from other popular sources as well: movies, comics, advertising, television shows, video games, and the Internet, among others.

93. Lutz and Collins, *Reading National Geographic*, 89.

94. Ibid., chapter 4.

95. John Berger, *Ways of Seeing* (London: British Broadcasting Corporation, and New York: Penguin Group, 1977), 141.

96. Lutz and Collins, *Reading National Geographic*, 110–111.

97. Little, "On Safari," 155.

98. Osborne, *Traveling*, 78.

99. Ibid., 24.

100. This belief in the medium as true exists on a commonsense level even though digital technologies allow, more easily, for the manipulation, and in some instances complete invention, of a photograph's subject matter.

101. Albers and James, "Travel Photography," 141. They draw on the work of Roland Barthes in making this analysis.

102. I did have a student once who thought Robertson to be Native American, which speaks to how non-Euro-Americans are imagined as exotic more generally.

103. Kasfir, "Samburu," 67–68.

104. Little, "On Safari," 156.

105. Osborne, *Traveling*, 89.

106. This is described by Laurel R. Davis, "Critical Analysis of the Popular Media and the Concept of the Ideal Subject Position: *Sports Illustrated* as Case Study," *Quest* 45, no. 2 (1993); Davis, *Swimsuit Issue*; Daddario, "Swimming against the Tide"; Duncan, "Beyond Analyses of Sport Media Texts."

107. MacCannell, *Tourist*, xv, 15; Little, "On Safari," 157; Osborne, *Traveling*, 72–74.

108. Little, "On Safari," 50.

109. Lutz and Collins, *Reading National Geographic*, 92; Angela Fisher, *Africa Adorned* (New York: Abrams, 1984), 26.

110. It has always struck me as absurd that such clothing is still referred to as Western clothing, even though many indigenous groups have been wearing these clothes for over 100 years now.

111. Lutz and Collins, *Reading National Geographic*, 192.

112. For a discussion of the necessity of Ndebele identity historically, see Powell, *Ndebele*; James, "Question"; Courtney-Clarke, *Ndebele*; David Jeffrey, "Pioneers in Their Own Land," *National Geographic*, February 1986; Schneider, "Paint."

113. Beyond identifying individuals as Ndebele, the wall-paintings also specify "under which chieftainship they live, [and] what geographical region they are from." Schneider, "Paint," 182. Schneider also suggests such alignment could be read as political statements on the part of the Ndebele. Ibid., 221. Indeed, she goes on to briefly discuss the change in painting style that occurred in the 1970s, describing it as unimaginative, "as if done with a stencil." Ibid., 222. This uninspired style, she offers, was a result of enforced decoration, done for the benefit of visiting government officials: "a Zulu girl living in the area, who, when asked why she had painted her house in such a decorative manner when it was not her custom said, seriously, 'It is now the law of the land.' It would seem this display of identity can also be a useful device for the people in power." Ibid., 223.

114. Indeed, Gwen Allen argues that interviews "participate in the representational concerns of the moment." Gwen Allen, "Against Criticism: The Artist Interview in *Avalanche* Magazine, 1970–76," *Art Journal* 64, no. 3 (2005): 54. As such, they, like image production, are grounded in their social-historical-political context.

115. Appadurai, *Modernity*, chapter 9.

116. Lutz and Collins, *Reading National Geographic*, 187.

117. Ibid.

118. Thompson, "Beyond Tarzan," 102.

119. Richard Kurin, quoted in ibid.

120. Lutz and Collins, *Reading National Geographic*, 188.

4. Fashioning Identities

An earlier version of this chapter appears as Carol Magee, "Forever in Kente: Ghanian Barbie and the Fashioning of Identity," *Social Identities* 11, no. 6 (2005).

1. Mattel and *SI* are not the only ones to be making use of Ndebele culture in this manner. As a colleague noted, in South Africa in the late 1990s and early 2000s, tourist agencies, Coca-Cola, and the National Gallery, among others, were making use of Ndebele visual culture to promote their products, and a new South African identity. William Dewey, e-mail message to author, November 18, 2008. A similar appropriation

of indigenous culture took place in Australia in the 1980s, where Australian Aboriginal objects such as the boomerang and "dot" paintings of the central dessert Aborigines were appropriated as symbols of national identity. This is an interesting and important phenomenon to consider; however, it is beyond the purview of this study to engage it in an in-depth manner.

2. When I purchased this doll in the year of its release, Mattel marketed it as Ghanian Barbie. On its Barbie Web site in 2008, however, it has updated the spelling to the common form: *Ghanaian.*

3. See Gilroy, *Postcolonial Melancholia.*

4. Both the Asante and Ewe peoples of Ghana produce kente (though interestingly, neither called it by that name originally). The kente that Mattel presents is more closely aligned (both in its use of reds, gold, and green and in its patterning) with that produced by the Asante peoples, and therefore throughout this essay I refer to kente as an Asante textile. Ewe versions of this strip-woven cloth differ in that they often have figurative elements added to it and exhibit a wider range of color use than do Asante versions. For a more detailed history of this cloth and its circulation internationally, see Venice Lamb, *West African Weaving* (London: Duckworth, 1975), especially chapters 3 and 4; Doran Ross, ed., *Wrapped in Pride: Ghanaian Kente and African American Identity* (Los Angeles: Fowler Museum of Cultural History, University of California, 1998). That Mattel drew inspiration from Asante versions is not surprising, for as Ross notes, this is the version that is most widely drawn on in the United States in general. Doran Ross, "Introduction: Fine Weaves and Tangled Webs," in Ross, *Wrapped in Pride,* 21.

5. Ross, *Wrapped in Pride,* 221, Figures 12.44 and 12.45. Heather Fonseca worked for Mattel when she designed the Princess of South Africa and other Barbie dolls. She is now a freelance toy designer; http//heatherfonseca.com/, accessed November 2010.

6. I am tempted to speculate that the name change helps Mattel capitalize on the growing popularity of Disney's princesses.

7. As designer Heather Fonseca notes, although they are aimed at adult audiences, the "Dolls of the World" are also very popular gifts for children. Heather Fonseca, e-mail message to the author, December 3, 2002. This varied audience may explain, at least in part, the difference in pricing between the "Dolls of the World" and other Collector Edition dolls.

8. Thanks to Rick Curtis for the many discussions about how adults relate to Barbie.

9. Michael Parenti, *Against Empire* (San Francisco: City Lights Books, 1995); Raymond Williams, *Keywords: A Vocabulary of Culture and Society,* rev. ed. (New York: Oxford University Press, 1983), 159–160.

10. Jane Leavy, "Is There a Barbie Doll in Your Past? At 20, Barbie and Ken Have Learned to Kiss. What Next?" *Ms.,* September 1979, 102 (considers Barbie in terms of empire); Wendy Varney, "Barbie Australis: The Commercial Reinvention of National Culture," *Social Identities* 4, no. 2 (1998): 163–164 (provides the sales statistic). See also

Rone Tempest, "Barbie and the World Economy," *Los Angeles Times*, September 22, 1996.

11. This figure for Barbie sales is the most recent I was able to obtain. Mattel Inc., "Annual Report 2003" (El Segundo, Calif.: Mattel, 2004), 5. In Mattel's annual reports, the sales figures for Barbie are usually included in the figures for the Girls and Boys Brands, of which Barbie is just one line. That there are specific figures available for 2003 is a result of the fact that they are mentioned specifically by Chairman Robert A. Eckert in his letter that begins the annual report. The 2007 annual report mentions that worldwide sales of Barbie increased 1 percent, though domestic sales of Barbie decreased 15 percent. Mattel Inc., "Annual Report 2007" (El Segundo, Calif.: Mattel, 2008), 41. Within this domestic decrease, however, there is an increase in the sale of Collector Edition Barbie dolls.

12. Mohammed A. Bamyeh, "The New Imperialism: Six Theses," *Social Text 62* 18, no. 1 (2000): 21.

13. Williams, *Keywords*, 90–91.

14. Carol Ockman, "Barbie Meets Bouguereau: Constructing an Ideal Body for the Late Twentieth Century," in *Barbie Chronicles*, ed. Yona Zeldis McDonough (New York: Simon & Schuster, 1999), 85.

15. Julia Savacool, "Women's Ideal Bodies Then & Now," *Marie Claire (US)*, April 2004.

16. Varney, "Barbie Australis"; Inderpal Grewal, "Traveling Barbie: Indian Transnationalities and the Global Consumer," *Positions: East Asia Cultures Critique* 7, no. 3 (1999).

17. Grewal, "Traveling Barbie," 812. Imma Arroya, a Puerto Rican woman that I met at a conference, confirmed the upper-class orientation implicit in Barbie. She told me that her mother had made all her dolls when she was growing up because she had wanted her children to have dolls that looked like them, and none were available on the market. When Mattel released Puerto Rican Barbie in 1997, many did not like her because she represented, through her dress, only one class of Puerto Ricans, a class with which many did not identify. Imma Arroya, conversation with the author, February 9, 1999.

18. Boym, *Future*.

19. Ibid., xiv.

20. Marco Tosa, *Barbie: Four Decades of Fashion, Fantasy, and Fun* (New York: Harry N. Abrams, 1998), 1; Erica Rand, *Barbie's Queer Accessories* (Durham, N.C.: Duke University Press, 1995), 49; Jacqueline Urla and Alan C. Swedlund, "The Anthropometry of Barbie: Unsettling Ideals of the Feminine Body in Popular Culture," in *Deviant Bodies: Critical Perspectives on Difference in Science and Popular Culture*, ed. Jennifer Terry and Jacqueline Urla (Bloomington: Indiana University Press, 1995), 284.

21. Leavy, "Is There?" 102. This is testified to by the sheer number of leisure outfits available in comparison to career outfits. Moreover, as Leavy reports, a Mattel

marketing manager freely admits the doctor outfit was kept on the market despite its lack of sales so that Mattel would look "progressive" in the face of feminist criticism.

22. Piper Weiss, "She Works Hard for Her Money: Barbie's Career Timeline," *Shine*, October 5, 2010, http://shine.yahoo.com/channel/parenting/she-works-hard-for-the-money-Barbie dolls-career-timeline-2397224/;_ylt=AmB7CtVOguR4ZmgLFUU8po9a bqU5#photoViewer=1, accessed October 5, 2010.

23. Urla and Swedlund, "Anthropometry," 280.

24. Doran Ross, "Asante Cloth Names and Motifs," in Ross, *Wrapped in Pride*, 107–119.

25. The Asante and related Akan peoples make up close to 50 percent of the Ghanaian population and inhabit the southern portion of Ghana. Kente is generally not worn in the north where non-Akan and non-Ewe peoples live.

26. Ross, "Asante Cloth Names," 160–170.

27. Joanne B. Eicher and Mary Ellen Roach-Higgins, "Definition and Classification of Dress: Implications for Analysis of Gender Roles," in *Dress and Gender: Making and Meaning in Cultural Contexts*, ed. Ruth Barnes and Joanne B. Eicher (Providence, R.I.: Berg, 1992), 15.

28. Deborah Durham, "Lady in the Logo: Tribal Dress and Western Culture in a Southern African Community," in *Dress and Ethnicity: Change Across Space and Time*, ed. Joanne B. Eicher (Oxford: Berg, 1995), 190.

29. George de Vos and Lola Romanucci-Ross, "Ethnicity: Vessel of Meaning and Emblem of Contrast," in *Ethnic Identity: Cultural Continuities and Change*, ed. George de Vos and Lola Romanucci-Ross (Palo Alto, Calif.: Mayfield, 1975), 363.

30. Joanne B. Eicher and Barbara Sumberg, "World Fashion, Ethnic, and National Dress," in Eicher, *Dress and Ethnicity*, 302.

31. Ross, "Introduction," 19–30. Kente production undergoes major changes as it moves from the local context of Ghana to the United States. In the United States, the patterns and colors are primarily printed rather than being woven on a loom. Even in Ghana changes in production are evident as cheaper, printed versions of the cloth are available, as are machine, rather than handwoven, versions.

32. Darlene Powell Hopson and Derek S. Hopson, *Different and Wonderful: Raising Black Children in a Race-Conscious Society* (New York: Prentice Hall Press, 1990), 127.

33. For examples of popular reactions to these dolls of color, see "Finally, Barbie Doll Ads Go Ethnic," *Newsweek*, August 13, 1990; Jenee Osterheldt, "When Girls Want Dolls Just Like Them," *Durham (N.C.) Herald-Sun*, January 5, 2003; Cheryl Lu-Lien Tan, "After Mattel's Snub of Asian-Americans, It's Time to Show It's White House or Bust," *Baltimore Sun*, July 23, 2000.

34. As exceptions to this rule, Asha, Shani, and Nichelle all had different skin tones. The "Dolls of the World" have varying skin tones as well. The latest in the line, Princess of South Africa, has considerably darker skin coloring, for instance, than Ghanaian Barbie or Kenyan Barbie.

35. Ann duCille, "Dyes and Dolls: Multicultural Barbie and the Merchandising of Difference," *Differences* 6, no. 1 (1994): 52.

36. See, for example, Erica Rand's study of the "queering" of Barbie through play by adult lesbians and play against the roles Mattel proscribes for Barbie. Rand, *Barbie's Queer Accessories*. J. Paige MacDougall's study of Barbies in Mexico also demonstrates counter uses of Barbie dolls by consumers. J. Paige MacDougall, "Transnational Commodities as Local Cultural Icons: Barbie Dolls in Mexico," *Journal of Popular Culture* 37, no. 2 (2003).

37. Rand, *Barbie's Queer Accessories*, 87.

38. Fonseca, e-mail. She confirmed that Mattel did not intend for these dolls to have their clothing removed or changed.

39. Ibid. According to Fonseca, the clothes are sewn on because the doll must arrive at the store in the same condition in which it left the factory. This does not ring true, however, because regular Barbie is not packaged with her clothes sewn on.

40. Ibid.

41. Thanks to Doran Ross for pointing this out to me.

42. Fonseca, e-mail.

43. I would like to thank an anonymous reviewer for the insight on informal copyright. For more on the problematic appropriation of kente, see Nii Q. Quarcoopome, "Pride and Avarice: Kente and Advertising," in Ross, *Wrapped in Pride*.

44. Byron Lars's five Treasures of Africa dolls continue along this line; the costuming for Moja (2001), Mbili (2002), and Tanu (2005) evidence the same theatrical pastiche. Tatu, from 2003, looks simply like a haute couture fashion model. The absurdity continues with 2004's Nne, though it takes a different direction; rather than a pastiche, this African Barbie comes complete with fur hood and boots—dressed for a climb few continental Africans really experience. I do not discuss these Barbie dolls because they are meant to be fantastic representations, whereas the "Dolls of the World" are meant to represent "reality."

45. When I asked for sales figures for this collection, Fonseca responded: "Because this is part of our Collector line, we do not release sales information related to the dolls. The African Barbie dolls are sold in Africa but because it is still a developing market, the quantities are small. Obviously each doll's sales tend to get a boost if it is based on the local country, but the primary driver of sales is how developed the Barbie brand is." Fonseca, e-mail.

46. Ibid.

47. Varney, "Barbie Australis," 170.

48. Tosa, *Barbie*, 136–143.

49. Susan Stewart, *On Longing: Narratives of the Miniature, the Gigantic, the Souvenir, the Collection* (Baltimore: Johns Hopkins University Press, 1984; repr., Durham, N.C.: Duke University Press, 1993), 133–151.

50. Ibid., 147.

51. Brenda Danet and Tamar Katriel, "No Two Alike: Play and Aesthetics in Collecting," *Play & Culture* 2, no. 3 (1989): 263.

52. Stewart, *On Longing*, 65.

53. Boym suggests that the object of nostalgic longing is no longer simply "home," but rather a "sense of intimacy with the world." Boym, *Future*, 251.

54. Stewart, *On Longing*, 154.

55. There is, in the words of Johannes Fabian, a "denial of coevalness." Johannes Fabian, *Time and the Other: How Anthropology Makes Its Object* (New York: Columbia University Press, 1983).

56. Fonseca, e-mail.

57. Stewart, *On Longing*, 145; Boym, *Future*, 27.

58. Fonseca, e-mail.

59. Stewart, *On Longing*, 151.

60. Andreas Huyssen, *Present Pasts: Urban Palimpsests and the Politics of Memory* (Stanford, Calif.: Stanford University Press, 2003), 4.

61. Mary F. Rogers, *Barbie Culture* (London: Sage, 1999).

62. Ibid., 116.

63. Wendy Singer Jones, "Barbie's Body Project," in McDonough, *Barbie Chronicles*; Elizabeth Chin, "Ethnically Correct Dolls: Toying with the Race Industry," *American Anthropologist* 101, no. 2 (1999).

5. It's a Small, White World

1. The Magic Kingdom is the name of the park at the Walt Disney World Resort that is the equivalent of Disneyland, Tokyo Disneyland, and Disneyland Paris. While each of these parks has its unique attractions, I consider these parks interchangeably because the attractions and the overall park structure and layout are similar enough for the arguments I am making here. I will thus use Disneyland and the Magic Kingdom interchangeably throughout, noting differences when relevant.

2. Robert Feder, "'It's a Small World' Broadens Its Horizons," *Chicago Sun-Times*, April 8, 2001.

3. Nightowlky, "'it's a small world' Ride at Magic Kingdom," YouTube, October 7, 2006, http://www.youtube.com/watch?v=W83dDW1PYXY&mode=related&search, accessed July 29, 2007. See werdxxupxSON comment, posted four months prior to the date I accessed this site, and photografr7 comment, posted one month prior to my access.

4. Stephen Fjellman is one of the only scholars to give this ride critical attention by doing more than evoking the name of the ride as a metaphor for the impact of Disney's overall project. He attends to the specifics of this ride with more than passing attention, and suggests that this last room is "a fantasy World's Fair scene with hot air balloons, a roller coaster, a river boat, and a carousel." Stephen M. Fjellman, *Vinyl Leaves: Walt Disney World and America* (Boulder, Colo.: Westview Press, 1992), 275.

He also comments: "As the ride progresses, we glide through Europe before heading for more exotic parts of the globe. Rooms that depict the latter seem put together as textbook examples of what Edward W. Said has described as 'Orientalism.' They are presented as undifferentiated symbols of Southern Hemisphere locales." Ibid., 274. While the point of his comment is accurate—reductive "typing" of other cultures—the comment itself is not. The cultures are in no way undifferentiated, though perhaps most riders lack the appropriate knowledge with which to identify them. Nevertheless, his point that it is the idea of Otherness that is at work here, more than the specificity of the cultures themselves, is well taken.

5. It is somewhat amusing that even though these figures are meant to represent the children of the world, they are often presented in adult activities (dancing the cancan, or acting as palace guards, for instance). This slippage is also notable with Barbie, who, though a teenager, has various careers.

6. Knowing that the majority of people who are at the Walt Disney World Resort would not be critically analyzing their Disney experience, I wanted to have someone along who could balance my (perhaps) overly critical perspective. I wanted also to have someone with me who is not trained in cultural analysis and critique and could provide a thoughtful assessment of the experience. Jeff Sekelsky served as photographer and research assistant on this trip. I chose Jeff both because he is an academic, trained as a geneticist and therefore not in the same analytical methods as an art historian or other cultural analyst (historian, anthropologist, sociologist, and so forth) might be, and because he is a much better photographer than I am.

7. Kevin Flynn, "It's a Small Jungle, After All," *New York Times*, June 10, 2001; Jane Kuenz, "It's a Small World After All: Disney and the Pleasures of Identification," *South Atlantic Quarterly* 92, nos. 1–2 (1993); Kathy Rodeghier, "Disney's Small World Gets Bigger," *Chicago Daily Herald*, May 17, 1998; Janet Wasko, "Is It a Small World, After All?" in Wasko, Phillips, and Meehan, *Dazzled by Disney?*

8. Steve Nelson, "Walt Disney's EPCOT and the World's Fair Performance Tradition," *Drama Review: TDR* 30, no. 4 (1986): 141.

9. Of the eight dolls in my collection, only one box, that for the Princess of the Nile, mentions neither food nor language. The Princess of India and the Princess of South Africa do not mention specific foods, though the South African box talks about feasting. This lack of attention to local cuisine may be a decision made around the "Princess Collection" in general. The Ghanaian and Kenyan Barbie dolls do not offer local words, but they do mention that although English is the official language, other languages are commonly used. All the other boxes provide at least "hello" and "good-bye" in an indigenous language and often other local words as well. Most common are local words for the costume elements that the dolls are wearing.

10. Adelaide H. Villmoare and Peter G. Stillman, "Pleasure and Politics in Disney's Utopia," *Canadian Review of American Studies* 32, no. 1 (2002).

11. See John M. Findlay, *Magic Lands: Western Cityscapes and American Culture after 1940* (Berkeley: University of California Press, 1992); Karal Ann Marling,

"Disneyland, 1955: Just Take the Santa Ana Freeway to the American Dream,"
American Art 5, nos. 1/2 (1991); Karal Ann Marling, *Designing Disney's Theme Parks:
The Architecture of Reassurance* (New York: Flammarion, 1997); Karal Ann Marling
and Donna R. Braden, *Behind the Magic: 50 Years of Disneyland* (Dearborn, Mich.:
Henry Ford Museum, 2005); Michael Sorkin, "See You in Disneyland," in *Variations
on a Theme Park: The New American City and the End of Public Space*, ed. Michael
Sorkin (New York: Hill and Wang, 1992); Villmoare and Stillman, "Pleasure"; Mike
Wallace, "Mickey Mouse History: Portraying the Past at Disney World," *Radical
History Review* 32 (1985); Alexander Wilson, "The Betrayal of the Future: Walt
Disney's EPCOT Center," in *Disney Discourse: Producing the Magic Kingdom*, ed. Eric
Smooden (New York: Routledge, 1994); Alexander Wilson, *The Culture of Nature:
North American Landscape from Disney to the Exxon Valdez* (Cambridge, Mass.:
Blackwell, 1992).

12. Other amusement parks, such as Busch Gardens in Williamsburg, Virginia,
whose entire theme is Europe, do show chipped walls and other signs of age on
buildings to help establish the "old country" and the authenticity of the experience for
park visitors.

13. *Harambee* (come together as one; pulling together) is the word that appears on
the Kenyan coat of arms.

14. Various authors make this argument about the class message of Disney; see
Margaret J. King, "Disneyland and Walt Disney World: Traditional Values in Futuristic
Form," *Journal of Popular Culture* 15, no. 1 (1981); Nelson, "Walt Disney's EPCOT";
Findlay, *Magic Lands*; Giroux, *Disturbing Pleasures*; Mark Phillips, "The Global Disney
Audiences Project: Disney Across Cultures," in Wasko, Phillips, and Meehan, *Dazzled
by Disney?*; Smooden, *Disney Discourse*.

15. Said, *Orientalism*.

16. Ibid., 21.

17. Melody Malmberg, *The Making of Disney's Animal Kingdom Theme Park* (New
York: Hyperion, 1998), 20. This is similar to Mattel's carefully researched, but totally
original, costumes for the "Dolls of the World" collection.

18. Said, *Culture and Imperialism*.

19. Ibid., 89.

20. Linda Nochlin, "The Imaginary Orient," *Art in America* 71, no. 5 (1983).

21. There are elements that interfere with this as a blanket reading—the museums
that are present in some of these countries' pavilions, for example, at times offer more
grounded looks at history. Corinne A. Kratz and Ivan Karp, "Wonder and Worth:
Disney Museums in World Showcase," *Museum Anthropology* 17, no. 3 (1993). But I
would argue that they are exceptions that perhaps prove the rule.

22. Wallace, "Mickey Mouse."

23. William F. Van Wert, "Disney World and Posthistory," *Cultural Critique* 32
(1995–1996): 201.

24. Martin Hall, "The Reappearance of the Authentic," in *Museum Frictions: Public Cultures/Global Transformations*, ed. Ivan Karp, Corinne A. Kratz, Lynn Szwaja, and Tomas Ybarra-Frausto (Durham, N.C.: Duke University Press, 2006), 87.

25. Ibid.

26. Gagnon, "Race-ing Disney," 132–133.

27. David M. Johnson, "Disney World as Structure and Symbol: Re-creation of the American Experience," *Journal of Popular Culture* 15, no. 1 (1981): 159.

28. Of course, this was a superficial exposure to African musical culture because there was no information provided about the group or the songs and dances they performed; unless they ask, visitors do not learn that *ngoma* is a Bantu word meaning drum. In this way, however, Ngoma's performance is very much like that of the Ndebele at the heritage museum (chapter 3). I did find out, in speaking to the lead member of Ngoma afterward, that they are from the Democratic Republic of Congo, that they had been playing together prior to coming to Disney six years earlier, and that they had performed elsewhere in the United States. They appreciated the steady work that performing at Disney provides.

29. Nochlin, "Imaginary Orient," 122.

30. Johnson, "Disney World," 159.

31. Van Wert, "Posthistory," 205–206. Van Wert comments that real names are changed.

32. Nochlin, "Imaginary Orient," 122.

33. Malmberg, *Making of Disney's Animal Kingdom*, 38, 40.

34. H. Peter Steeves, "Becoming Disney: Perception and Being at the Happiest Place on Earth," *Midwest Quarterly* 44, no. 2 (2003): 185.

35. Donald Britton, "The Dark Side of Disneyland," *Art Issues* (1989): 16.

36. Phillips, "Global Disney," 46.

37. Pecora and Meehan, "United States," 322, emphasis mine.

38. Alexander Moore talks about the Walt Disney World Resort as a ritual space of pilgrimage, whereby in the ritual performance of the pilgrimage, the Disney vacationer enacts a transformation. This transformation does not necessarily change the pilgrim in a major way, but might simply reaffirm what is already known and believed. Alexander Moore, "Walt Disney World: Bounded Ritual Space and the Playful Pilgrimage Center," *Anthropological Quarterly* 53, no. 4 (1980): 210. A reaffirmation of what is already known can in some ways be seen as a tool for managing the world. For a discussion of Disney as reinforcing the world as manageable, see also John Van Maanen, "Displacing Disney: Some Notes on the Flow of Culture," *Qualitative Sociology* 15, no. 1 (1992): 15.

39. Deborah Philips, "Narrativised Spaces: The Functions of Story in the Theme Park," in *Leisure/Tourism Geographies: Practices and Geographical Knowledge*, ed. David Crouch (London: Routledge, 1999).

40. Van Maanen, "Displacing Disney"; Moore, "Walt Disney World."

41. Malmberg, *Making of Disney's Animal Kingdom*, 12.

42. Philips, "Narrativised Spaces," 97.

43. Ibid. Schaffer suggests that this conflation of world rivers occurs because geography does not matter; the Other is simply non-European or non-American. Scott Schaffer, "Disney and the Imagineering of Histories," *Postmodern Culture* 6, no. 3 (1996): 25.

44. Marling, "Disneyland," 173, 200.

45. Villmoare and Stillman, "Pleasure," 89–90; see also King, "Disneyland"; Wallace, "Mickey Mouse," 42.

46. Van Wert, "Posthistory," 195.

47. In this way Marling and Braden are correct when they posit Fantasyland as the essence, or heart, of the Disney vision. Marling and Braden, *Behind the Magic*, 51.

48. Smooden, *Disney Discourse*, 15.

49. Philips, "Narrativised Spaces," 106.

50. Wasko and Meehan, "Dazzled," 334–335.

51. This does not mean, as I mentioned in the introduction, that audiences read connotative messages in the same way; some may see affirmation of the denotative message, others find resistance. Monika Gagnon addresses the process of identification and the possibilities of resistance in terms of "raced" viewers of Disney films, arguing for the need for more theorization of how ethnic viewers engage them. Such theorization would take into account the processes by which individuals come to understand themselves as racial beings, and such an understanding frames viewing. Gagnon, "Race-ing Disney," chapter 3.

52. Steeves, "Becoming," 193; Nikhilesh Dholakia and Jonathan Schroeder, "Disney: Delights and Doubts," *Journal of Research for Consumers*, no. 2 (2005), http://www.jrconsumers.com/academic_articles/issue_2.

53. Steeves, "Becoming"; see also Wallace, "Mickey Mouse," 44.

54. Jack C. Wolf, "Disney World: America's Vision of Utopia," *Alternative Futures* 2 (1979); King, "Disneyland"; Louis Marin, *Utopics: The Semiological Play of Textual Spaces*, trans. Robert A. Vollrath (New York: Humanity Books, 1984); Findlay, *Magic Lands*; Smooden, *Disney Discourse*; Richard Francaviglia, "History after Disney: The Significance of 'Imagineered' Historical Places," *Public Historian* 17, no. 4 (1995); Nelson, "Walt Disney's EPCOT"; Schaffer, "Disney."

55. King, "Disneyland," 131.

56. Wolf, "Disney World," 76.

57. King, "Disneyland," 131.

58. Ibid., 31.

59. Marling, "Disneyland," 193.

60. Wilson, "Betrayal," 122–123; Wallace, "Mickey Mouse," 43. Lutz and Collins also discuss America in the postwar period, noting increased trade with Africa, Latin America, and Asia, as well as a shift in imperial power from Europe to the United States. Lutz and Collins, *Reading National Geographic*, 35.

61. See Nelson, "Walt Disney's EPCOT," 128–130; Kratz and Karp, "Wonder and Worth," 34–35.

62. Francaviglia, "History," 72. This past never really existed. Dholakia and Schroeder, "Disney," 12. This is similar to what I argued about the romanticized past evoked with the Barbie dolls; it did not necessarily have to exist. An imagined past can hold as much sway as the actual past—especially given that the past is always interpreted and therefore always imagined on some level.

63. Schaffer, "Disney."

64. Johnson, "Disney World," 164.

65. Wasko and Meehan, "Dazzled."

66. Lutz and Collins, *Reading National Geographic*, 37.

67. Ibid., 27, citing C. D. B. Bryan, *The National Geographic Society: 100 Years of Adventure and Discovery* (Washington, D.C.: National Geographic Society, 1987), 90.

68. Quoted in Wallace, "Mickey Mouse," 35.

69. Robert De Roos describes his visits to the Disney Studios. He comments that he saw many issues of *NG* in the studios; he then goes on to quote Disney's then chief of research as saying, "The *Geographic* is one of our basic research sources," while Disney himself offered, "We couldn't be in business without it." Quoted in Robert De Roos, "The Magic Worlds of Walt Disney," in Smoodin, *Disney Discourse*, 61. De Roos's piece was originally published in the August 1963 issue of *NG*.

70. Lutz and Collins, *Reading National Geographic*, 24–26.

71. At the time I was there, this park was the MGM Studios Park.

72. Scott Hermanson, "Truer Than Life: Disney's Animal Kingdom," in *Rethinking Disney: Private Control, Public Dimensions*, ed. Mike Budd and Max H. Kirsch (Middletown, Conn.: Wesleyan University Press, 2005), 206.

73. Respectively, Van Maanen, "Displacing Disney," 14; and Findlay, *Magic Lands*, 95.

74. Lutz and Collins, *Reading National Geographic*, 38–40.

75. Ibid., 39.

76. I have been unable to determine why Morocco was chosen as the representative of Africa at Epcot, but it may have something to do with the fact that the United States and Morocco have a long history of diplomatic relations, and that these ties were formalized and strengthened following Morocco's independence from France in 1956.

77. Findlay, *Magic Lands*, 94.

78. In relation to Disney, see, for instance, Giroux, *Disturbing*, 31; Smoodin, *Disney Discourse*, 19; Schaffer, "Disney," 6; Wilson, *Culture*, 11. This, as I discussed in chapter 2 around the *SI* swimsuit issue images of black models, is problematic and has effects on the real world conditions of a great many people.

79. Phillips, "Global Disney," 52.

80. Davis, *Swimsuit Issue*, 33. Davis's sample group was split between men and women whose ages ranged from fifteen to seventy-three years. Eighty-two percent of the group was white, with the remaining 18 percent was made up of various people of color; 10 percent of them were African American.

81. Ibid., 92.

82. Wilson, *Culture*, 181. No African American male has been portrayed in a Disney movie—in human form—since *The Song of the South* (1946). Rather, African American actors are given roles where they are the voices for animal characters. Similarly, African American women did not appear in human form until *Hercules* (1997). Byrne and McQuillan, *Deconstructing Disney*, 94. Through their analysis of *The Lion King* (1994), Byrne and McQuillan demonstrate not only an inability (or unwillingness) on Disney's part to represent blacks but, through an analysis of the voices of the various characters—who was chosen to play what animal, and what message that animal/role conveys—a clear distinction in how Africa(ns) and African America(ns) are portrayed. They offer, "the lion/hyena divide coincides with an African/African American divide, with African American criminals menacing an endearing African culture." Ibid. 102–103. Given this, it is interesting that one of the criticisms leveled against the Disney film *The Princess and the Frog* (2009), in which Disney introduced the first African American princess, is that Tiana spends the majority of the film as a frog, and not in human form. Brooke Barnes, "Her Prince Has Come. Critics, Too," *New York Times*, May 31, 2009.

83. Findlay, *Magic Lands*, 74–75. Van Maanen comments on the absence of blacks both in terms of "the productions and the work force" when noting a similar absence of Koreans in Tokyo Disneyland. Van Maanen, "Displacing Disney," 23.

84. Findlay, *Magic Lands*, 94.

85. A Hawaiian man is depicted in a boat wearing a feathered cloak and helmet, clothing that marked elite status through the nineteenth century. Here, as with the "Dolls of the World," the costuming is connected to past times.

86. laurenlovesmark, comment posted one month prior to the day I accessed this video clip: July 29, 2007; see note 3, this chapter, for the URL.

87. The harp is anthropomorphized and looks much like a Mangbetu *kundi* (Democratic Republic of Congo), though the sound table on Disney's harp is rounder than a Mangbetu one. Similarly, the flute looks more like a recorder, extending parallel to the head-to-toe line of a body, than the European version of this instrument, which extends perpendicular to the head-to-toe line. The majority of figures in this room are girls (15), not boys (7), which replicates the fact that women are frequently the bearers of culture/tradition in colonized societies. Too, "showgirl" costuming on some of the figures recalls the fantasy Barbie dolls of Mattel that I mention in chapter 4, and reinforces ideas about Africa as entertainment.

88. The elephant's ears are oversized, evoking the well-known Disney character Dumbo, as does the color pink. One of the musical numbers in the film *Dumbo* (1941) depicts a parade of pink elephants. Moreover, the film has been criticized for its racist overtones. I am, therefore, tempted to read a bit of subversion into the placement of this elephant in this Africa room, for the phrase "an elephant in the room" refers to something being ignored. I would love to think that this designer is commenting on the racist nature of the display and the denial of that fact. Even if the designer was

making such a comment, however, it may only resonate with those who take home images from their ride around the world. It was only in studying my own photographs that I was able to realize the richness of the possible subversion here.

89. While I present a reading of this as initiatory, it has another potential reading as well. I have not been able to determine if this passage through the entrance to the *Haus Tamberan* was in the ride's original design at the New York World's Fair, but if it was, it may have been a reference, a memorial of sorts, to Michael Rockefeller's disappearance in New Guinea in 1961. The son of New York governor Nelson Rockefeller, Michael was officially declared dead in 1964, the year of the fair. Although Michael Rockefeller disappeared in the Asmat region on the western part of the island (Irian Jaya) and not the eastern part (Papua New Guinea, in which the Abelam live), such cultural and geographic distinctions are not essential elements at Disney or in other popular culture forms.

90. See note 3, this chapter.

91. Fifteen are visible to the right side of the boat, and while there are more on the left, I did not have time to count them on either of my trips through this world.

92. Douglas Brode, *Multiculturalism and the Mouse: Race and Sex in Disney Entertainment* (Austin: University of Texas Press, 2005), 1–3.

93. Fjellman, *Vinyl Leaves*, 267.

94. Laudan Nooshin, "Circumnavigation with a Difference? Music, Representation and the Disney Experience: *It's a Small, Small World*," *Ethnomusicology Forum* 13, no. 2 (2004): 245.

95. ru42, "it's a small world" Disneyland Fantasyland California," YouTube, August 5, 2006, http://www.youtube.com/watch?v=APmHR2bmQgw&mode=related&search. The absence of the opening voyage scene was one of the first differences I noticed when I went on the Magic Kingdom version.

96. Nooshin, "Circumnavigation," 244.

97. Ibid.

98. This is at least true in the American manifestations of the ride.

99. Fjellman, *Vinyl Leaves*, 443 note 14.

100. On this idea, see Homi K. Bhabha, "The Other Question: Difference, Discrimination and the Discourse of Colonialism," in Ferguson et al., *Out There*.

101. In a similar maneuver, workers at Epcot (and presumably other parks as well) who speak a language other than English cannot speak that language with visitors— only among themselves. Van Wert, "Posthistory," 205–206. Van Wert further notes: "I suddenly realize that they have anticipated our every move again. They expect the visitor to choose a clockwise path, going around the lake from left to right, and the entire right side of the lake reinforces what the false Betsy told me. This side of the lake is occupied by Great Britain, the United States, and Canada: the *prototype* of an English-speaking world of tomorrow. Together, they embody the consolidation of all the world's languages into a single language." Ibid. 206. On my two visits to Epcot, I

happened to walk counterclockwise; this, I suppose, could suggest some subversion of the Disney vision is possible.

102. Spivak, "Can the Subaltern Speak?"; Said, *Orientalism*; Loomba, *Colonialism/ Postcolonialism*, 45–46, 194–204, 308.

103. Of course, it may be that in the Disneyland and Disneyland Paris versions there is song in this section. On Nightowlky's YouTube video (see note 3) there are drums and animals sounds in Africa, but also the English version of the song can be heard—seemingly as bleed-through from another room.

104. Van Maanen, "Displacing Disney," 13. At the Magic Kingdom, there is a noticeable absence of North Americans in the "it's a small world" ride, though they sneak in as individual figures in the white room, where one can find an Eskimo on a carousel. A video posted to YouTube of this ride at Disneyland displays Canadians in the guise of Eskimos and a Mountie. More explicitly, Disneyland Paris begins in Europe and ends in America. Nooshin, "Circumnavigation," 237. I do not know if that America is the same world's fair room that is presented here. I also do not know if America is present in the Tokyo version of this ride.

105. Van Maanen, "Displacing Disney," 13.

106. For a powerful discussion of the impact of this founding myth, see Jimmie Durham, "Cowboys and . . . Notes on Art, Literature, and American Indians in the Modern American Mind," in *The State of Native America: Genocide, Colonization, and Resistance*, ed. M. Annette Jaimes (Boston: South End Press, 1992).

107. In relation to ideas of utopia, see Wolf, "Disney World." In relation to history, see Wallace, "Mickey Mouse," 48–49.

108. Giroux, *Disturbing*, 37.

6. Africa in Florida

1. For a brief discussion of this division and its implications for imaginings of Africa and African art, see Appiah, "Why Africa?"

2. Kate Muhl, "Serious Fun," *AAA World*, July/August 2001, 20.

3. Ibid., 24.

4. See Bennett, "Exhibitionary Complexes"; Tony Bennett, *The Birth of the Museum* (London: Routledge, 1995).

5. Peter Dominick was the architect for the lodge. The Brandston Partnership and the Urban Design Group were also involved in the design of the lodge. Ellen Lampert-Graux, "From Africa to Anaheim," *Lighting Dimensions*, February 2002. Avery Brooks and Associates consulted on interior design. Staff, "Out of Africa," *Interior Design Magazine*, June 1, 2001. Kay/Hannah was the art consulting firm, and it brought in African gallerist Charles Davis to oversee and facilitate the purchasing of the African visual culture.

6. Kevin C. Dunn, "Fear of a Black Planet: Anarchy Anxieties and Postcolonial Travel to Africa," *Third World Quarterly* 25, no. 3 (2004): 484.

7. Malmberg, *Making of Disney's Animal Kingdom*, chapter 1; Kathryn Brockman, "A Journey to Darkest Africa," *Globe and Mail*, April 21, 2001; Lampert-Graux, "From Africa to Anaheim," 2.

8. The roofs are designed to look thatched, though, through typical Disney design and magic, they are most likely made of concrete or some other permanent material.

9. For an image of a Senufo building, see Anita J. Glaze, *Art and Death in a Senufo Village* (Bloomington: Indiana University Press, 1981), 78, Plate 39. For Nankese architecture, see Herbert M. Cole and Doran H. Ross, *The Arts of Ghana* (Los Angeles: Museum of Cultural History, University of California, 1977), 87, Figure 189. Examples of these Sudanic-style compounds are depicted for the lodge's visitors in photographs on the photomural "African Households, Homes," which picture a Kassena (Ghana) compound along with a Somba (Benin) household.

10. "No . . . Florida Wins Out/Yes . . . Opt for Africa," *Travel Weekly (UK)*, no. 62 (2007). See also Brockman, "Journey."

11. Willis makes a similar comment about Disney's Animal Kingdom Park, noting, "a visitor to the Animal Kingdom is enveloped in a Third World Never Never Land amenable to American sensibilities. It's exotic, but comfortable; different, but recognizable." Susan Willis, "Disney's Bestiary," in Budd and Kirsch, *Rethinking Disney*, 59–60.

12. As Byron Caminero-Santangelo and Garth Andrew Myers note: "Through their 27 wildlife films (most about Africa), 18 books and Osa's television series in the 1950s, *Big game hunt* (which ran for 26 episodes), the Johnsons introduced their ideas of a wild Africa to a broad American audience. The Osa and Martin Johnson Museum's guide sheets claims, probably with some truth, that the Johnsons made 'safari' and 'simba' household words and Kenya's Nairobi more familiar to thousands throughout the world than Seattle or New Orleans." Byron Caminero-Santangelo and Garth Andrew Myers, "Cultural Geographies in Practice," *Ecumene* 8, no. 4 (2001): 493.

13. Charles Davis, e-mail message to author, September 2, 2008. The shields were in fact made in America to look like Maasai shields, one of the rare instances of the African visual culture being inspired by an African object rather than being that object itself.

14. They are ankole cattle, bongo, blesbok, eland, Grant's gazelle, Grant's zebra, greater kudu, impala, nyala, reticulated giraffe, Thompson's gazelle, waterbuck, white-bearded wildebeest, Abyssinian ground hornbill, African spoonbill, East African crown crane, greater flamingo, marabou stork, ostrich, eastern white pelican, and Ruppel's griffon vulture.

15. Mary Hannah, e-mail message to author, September 24, 2008. These photographs were procured by art consultant Mary Hannah, who noted that she learned about the Osa and Martin Johnson Museum in Chanute, Kansas, through the

architect of the lodge who had visited it. Caminero-Santangelo and Myers provide
an insightful reading of this museum as it constructs a relationship with Africa for
Americans. Caminero-Santangelo and Myers, "Cultural Geographies."

16. These are carvings made from the thorn of a wild cotton tree.

17. The Disney Corporation has a reputation for being very controlling of what
its employees say and how they (re)present both Disney and themselves. Van Wert
notes that cast members do not go by their real names. Van Wert, "Disney World
and Posthistory," 205–206. Several former students who have worked for Disney
throughout the years commented that they would often choose a nametag randomly.
One student did so because her own name was unusual, and she found it easier to deal
with Disney guests with a common "American" name. In light of this, I have chosen
to change the names of the individuals who spoke with me to prevent any possible
negative repercussions for them. There is a distinct probability that I am changing
pseudonyms.

18. Perhaps this perspective accounts for Baruti's choice to speak only about
animals. All the information he provided came from the conversation we had the
evening of October 18, 2006.

19. Our package cost $3,183 and included four nights in a Savannah View room in
the lodge, all meals, and entrance to the parks at the Walt Disney World Resort. Airfare
was not included in that price. In 2009 rooms at DAKL started at $240 per night.

20. Hall, "Reappearance of the Authentic," 89.

21. Ibid., 81.

22. Willis, "Disney's Bestiary," 54. Curtis Keim notes the large animals that are the
draw of safaris (and presumably DAKL and the Animal Kingdom Park) are not the
most critical to maintaining "the web of life." Keim, *Mistaking Africa*, 142–143.

23. In fact, the Oceanarium in Lisbon, Portugal, does just this, making known the
serious effects that lifestyle choices of individuals have on the ocean's ecosystem.

24. Art at African safari lodges serves as decoration, but it is most often visible in
shops (that are formal parts of the lodges, or that exist as street-side stands outside of
the doors of the lodges) at which guests can buy souvenirs.

25. I have found that guides and others who are acting as "ambassadors" for Africa
are hesitant to talk about any problems or disappointments they may have around
Western-African relations. For instance, my guide Moise, in Mali in the fall of 2007,
did not express his own opinion about any of the problems of tourism until after I had
voiced my own observations of them. Once I had opened that door, however, he had
very strong opinions about and insights into this field of experiences.

26. Nancy Muenker, "Wild at Heart: Disney's Animal Kingdom Lodge Captures the
Essence of Africa," *Toronto Sun*, January 13, 2002.

27. Hermanson, "Truer Than Life," 221.

28. Hall discusses issues of authenticity, while Dunn explores the consumption of
other cultures. Hall, "Reappearance," 95; Dunn, "Fear " 487.

29. Fabian, *Time and the Other*, 80. Johannes Fabian discusses the concept "ethnographic present," and notes that "in simple terms, the ethnographic present is the practice of giving accounts of other cultures and societies in the present tense." Ibid. The consequence of this practice is that cultures are seen to be unchanging, existing now as they did in the past and will in the future. Keim provides a succinct picture of the development of safari. Keim, *Mistaking Africa*, 131–136.

30. Keim, *Mistaking Africa*, 134. Similarly Cypher and Higgs argue that Disney's Wilderness Lodge, also at the Walt Disney World Resort, is about the subjugation of nature, and as a result, the colonization of the mind, for it affects the ways in which people think about the world around them. Jennifer Cypher and Eric Higgs, "Colonizing the Imagination: Disney's Wilderness Lodge," *Capital, Nature, Socialism* 8, no. 4 (1997).

31. Keim, *Mistaking Africa*, 137. Keim notes these in his discussion of Bartle Bull's account of the decline of the safari in Kenya.

32. Findlay, *Magic Lands*, 54, 67; Marling, "Disneyland," 176–196.

33. Villmoare and Stillman, "Pleasure and Politics." Philips also comments that "the narrator at Disneyland is always Disney. There is only one valid voice." Philips, "Narrativised Spaces," 98.

34. Monica Gagnon comments on this phenomenon in the context of Disney's Animal Kingdom Park: "If *Pocahontas* represents Disney's version of the birth of America, the Animal Kingdom represents a nostalgia for a feudal order in which everyone knew their place within the patriarchal economy of succeeding kings." Gagnon, "Race-ing Disney," 145.

35. David H. Shayt, "The Material Culture of Ivory Outside Africa," in *Elephant: The Animal and Its Ivory in African Culture*, ed. Doran Ross (Los Angeles: Fowler Museum of Cultural History, University of California, 1992), 375.

36. Enid Schildkrout and Curtis A. Keim, eds., *The Scramble for Art in Central Africa* (Cambridge: Cambridge University Press, 1998), 6.

37. See Steven Conn, *Museums and American Intellectual Life, 1876–1926* (Chicago: University of Chicago Press, 1998); Shelly Errington, *The Death of Authentic Primitive Art and Other Tales of Progress* (Berkeley: University of California Press, 1998), 21–26; Haraway, "Teddy Bear Patriarchy"; Keim, *Mistaking Africa*, chapter 9; Christine Mullen Kreamer, "African Voices," *Museum News* 76, no. 6 (1997); Enid Schildkrout and Curtis A. Keim, *African Reflections: Art from Northeastern Zaire* (Seattle: University of Washington Press, and New York: American Museum of Natural History, 1990); Schildkrout and Keim, *Scramble*.

38. This is a conflation, perhaps, of the colors of kente (Asante) with the material culture of the Maasai; my thanks to Nicki Ridenour for suggesting this. The Maasai are among the best-known African peoples in America, and kente is one of the most widely recognized types of visual culture from Africa. That these forms predominate in American evocations of Africa is therefore not surprising.

39. Mary Hannah, e-mail message to author, November 20, 2008. Mary Hannah, of Kay/Hannah Associates—the company hired to oversee the decoration of the lodge— is fairly certain that this wallpaper was designed exclusively for Disney, though I have been unable to confirm this.

40. My thanks to Amanda Carlson for contributing this Barbie to my collection.

41. Some scholars have even called such exhibitions "human zoos." For discussion of these practices in a variety of locales and across a number of sites, see Pascal Blanchard, Nicolas Bancel, Gilles Boëtsch, Eric Deroo, Sandrine Lemaire, and Charles Forsdick, eds., *Human Zoos: Science and Spectacle in the Age of Colonial Empires* (Liverpool: Liverpool University Press, 2008). Although Africans and their visual culture are presented at DAKL in a manner that shares similarities with these earlier exhibitionary practices, more differences exist, and for this reason I do not go into a more in-depth comparison here. The most relevant difference is that in these earlier spaces, Africans were meant to be looked at. There was not meaningful interaction between the spectators and those being looked at. Here Africans are free to have conversations with visitors to the lodge on any topic of their choice, and thus more meaningful engagements occur.

42. Curtis M. Hinsley, "The World as Marketplace: Commodification of the Exotic at the World's Columbian Exposition, Chicago, 1893," in Karp and Lavine, *Exhibiting Cultures*, 345.

43. Nelson, "Walt Disney's EPCOT," 107.

44. Bennett, "Exhibitionary Complexes," 73–77.

45. Ibid., 92–93, 95–99.

46. Hall, "Reappearance," 72; Flynn, "It's a Small Jungle."

47. It would be impractical to compose a comprehensive list of texts that deal with this topic; I present here some key works. Susan Vogel, founder and former director of the Museum for African Art (MAA) in New York, has been a significant figure in raising and thinking through issues surrounding the presentation of African art in the United States. Numerous exhibitions organized by the MAA dealt explicitly with this topic: Susan Mullin Vogel and Mario Carrieri, *African Aesthetics: The Carlo Monzino Collection* (New York: Center for African Art, 1986); Center for African Art, *Perspectives: Angles on African Art* (New York: Center for African Art, 1987); Vogel, *Art/artifact*; Susan Mullin Vogel and Center for African Art, *The Art of Collecting African Art* (New York City: Center for African Art, 1988); Jerry L. Thompson, Susan Mullin Vogel, Anne D'Alleva, and Center for African Art, *Closeup: Lessons in the Art of Seeing African Sculpture; from an American Collection and the Horstmann Collection* (New York: Center for African Art, 1990); Vogel, *Africa Explores*; Susan Vogel, "Always True to the Object, in Our Fashion," in Karp and Lavine, *Exhibiting Cultures*; Roberts and Vogel, *Exhibition*-ism. See also those texts listed in note 74 of chapter 1.

48. Hall, "Reappearance," 81.

49. Ibid., 78. Here Hall cites Joseph B. Pine and James H. Gilmore, *The Experience Economy: Work Is Theatre and Every Business Is a Stage* (Boston: Harvard Business School Press, 1999).

50. Bennett, "Exhibitionary Complexes," 73.

51. For the cynic, these are object-types that are also the types of souvenirs one might purchase in the lobby store, which sells Disneyfied jewelry, bags, hats, and also some African jewelry.

52. Davis, e-mail.

53. There are exceptions to this practice, and the field of African art scholarship has also changed greatly. For discussions of this problem, correctives, and exceptions, see, for instance, Rowland Abiodun, Henry John Drewal, and John Pemberton III, *The Yoruba Artist: New Theoretical Perspectives on African Art* (Washington, D.C.: Smithsonian Institution Press, 1994); Sidney Littlefield Kasfir, "One Tribe, One Style: Paradigms in the Historiography of African Art," *History in Africa* 11 (1984); Sidney Littlefield Kasfir, "Remembering Ojiji: Portrait of an Idoma Artist," *African Arts* 22, no. 4 (1989); Sandra Klopper, "The Carver in Africa: Individually Acclaimed Artist or an Anonymous Artisan?" *Social Dynamics* 19, no. 1 (1993); Alisa LaGamma, ed., "Authorship in African Art, Part 1," Special issue, *African Arts* 31, no. 4 (1998); Alisa LaGamma, ed., "Authorship in African Art, Part 2," Special issue, *African Arts* 32, no. 1 (1999); Claude-Henri Pirat, "The Buli Master: Isolated Master or Atelier," *Tribal Arts* 3, no. 2 (1996); Vogel, *Art/artifact.*

54. For discussions of the use and problematics of the word *tribe*, see Keim, *Mistaking Africa*, chapter 8.

55. Lisa Stiepock and Pippin Ross, "Disney's Animal Kingdom: Where the Wild Things Are," *Disney Magazine*, Summer 1998, 39; Staff, "Out of Africa," 238–239; Lampert-Graux, "From Africa to Anaheim," 2.

56. It would be too cumbersome to list all the sources on this topic. Readers can start with these texts: Sidney Littlefield Kasfir, "African Art and Authenticity: A Text with a Shadow," *African Arts* 15, no. 2 (1992); Leyten, foreword to *Art, Anthropology and the Modes of Re-presentation*; Phillips and Steiner, *Unpacking Culture*; Christopher B. Steiner, *African Art in Transit* (Cambridge: Cambridge University Press, 1994).

57. Millie Ball, "Authentic Africa," *New Orleans Times-Picayune*, May 20, 2001.

58. Keim, *Mistaking Africa*, 115.

59. Doran Ross, interview with author, August 11, 2008.

60. Hannah, e-mail, September 24, 2008. While Charles Davis procured the "traditional" works, Kay/Hannah Associates procured the contemporary pieces and the photographs, though it was a collaborative effort in designing the visual culture program.

61. Ross, interview.

62. Hannah, e-mail, September 24, 2008.

63. One reason for this focus on the headpiece is that it is frequently made of wood, and thus is the piece that is most easily preserved and displayed. It is the part of the costume that most resembles Western notions of sculpture, and therefore art, and it is often the most visually interesting. Another reason may be that costuming frequently is made of ephemeral materials such as leaves; other times the materials simply do not last as long as wood—textiles or feathers are more fragile and harder to maintain in optimum condition. Still another reason may be the result of misunderstandings across cultures. Because so many early collectors of these pieces were not collecting them with detailed information about their use and meaning, they may not have realized the conceptual significance behind the whole costume.

64. Davis, e-mail.

65. Jeff Gammage and Inquirer Staff Writer, "Brides of Disney," *Philadelphia Inquirer*, June 10, 2007.

66. Carol Beckwith and Angela Fisher, *African Ceremonies*, 2 vols. (New York: Harry Abrams, 1999), 1:356.

67. This tour, like the Cultural Safaris, is one of the many activities offered throughout the day. At the time of my visit, the vast majority of these activities were oriented toward children and included Horticultural Activity (Wednesdays), Arts and Crafts with the Life Guards, Ceramics class, Medallion Rubbings (where children could make rubbings of the medallions depicting animals that are found on the floor of the lobby), African games and crafts, African folktales (this event was not offered during my stay there, so I do not know what it consisted of), Culinary Tour of Africa (a tour of the restaurants and their offerings), Animal Viewing with night vision goggles (This was GREAT!), cookie decorating, and the Primal Parade, which was not offered while I was there.

68. Herbert Cole, e-mail message to author, July 29, 2008.

69. Jay Straker offers an insightful analysis of similar interventions by Tuareg performers at the 2003 Smithsonian Folklife Festival's "From Timbuktu to Washington" program. Jay Straker, "Performing the Predicaments of National Belonging: The Art and Politics of the Tuareg Ensemble Tartit at the 2003 Folklife Festival," *Journal of American Folklore* 121, no. 479 (2008).

70. Ludmilla Jordanova, "Objects of Knowledge: A Historical Perspective on Museums," in *The New Museology*, ed. Peter Vergo (London: Reaktion Books, 1989), 23.

71. Davis, e-mail.

72. Ibid.

73. Ibid.

74. The importance of the message for Americans should not be underestimated because, at least in the past, Americans were the primary audience at the Walt Disney World Resort. The last year for which figures were published, 1986, showed that 94 percent of visitors were from the United States. Dave Smith, Chief Archivist, Walt Disney Company, e-mail message to author, November 19, 2008. I am sure that the audience is more international today, given the ever-increasing numbers of

international tourists. However, the presence of Disney parks in Japan and France may prevent some, who might have traveled to the United States for their Disney experience, from visiting Disney parks here, thereby leaving a large American audience, even today. Disney moreover does not release demographic information about its audiences because it is "proprietary." Smith, e-mail. The cynical side of me reads the fact that Disney will not share demographic data regarding race as suggesting that Disney is not necessarily proud of the figures. This resonates with the change in demographic information made public by Time Inc. in regard to *SI*; see note 46 in chapter 2. Despite the lack of substantiating numbers, I feel confident in suggesting that the world of Disney is an overwhelmingly white world. Even a brief glance around the various parks at the Walt Disney World Resort reveals predominantly white audiences. Disney, too, may recognize this predominance of whiteness in its audiences, as indicated by its creation of an African American princess for its latest princess film, *The Princess and the Frog* (2009). Perhaps more immediately relevant, it is also indicated by the fact that Disney recently invited a group of nine African American mothers to spend a weekend at the Walt Disney World Resort parks. These were not just any mothers, but rather women who blog and therefore have a potential to reach a larger audience than their immediate families and friends, and thus a potential to encourage other African Americans to visit the Walt Disney World Resort. While at Disney, these women met with officials who solicited feedback on their experiences of the Disney parks and other products. In Kimberly Coleman's post to "Mom in the City," the Web site and blog she founded, she comments: "All of us (in varying degrees) took issue with the lack of diversity in Disney films and products. Before going to Disney, I had looked at some of their advertising material (print and online). What stood out to me was that the only black or brown people that I saw were in subservient type roles." October 21, 2008, http://mominthecity.com/wp/2008/10/21/walt-disney-world-the-participants/. Responding to this post, Melanie commented, "I can only hope they took what we said seriously enough to implement some new ideas." http://mominthecity.com/wp/2008/10/21/walt-disney-world-the-discussion/. Nevertheless, and in spite of improvements that have been made in the presence and representations of minorities at the Disney parks and in other Disney products, an overall "whiteness" dominates the Disney world.

75. Sherman, *Museums and Difference*, 4.

76. Jordanova, "Objects," 23.

7. Refrain

1. This Barbie is in the collection of the Johannesburg Art Gallery (JAG), Johannesburg, South Africa. JAG does not have information about the production or collection of this doll, so it is unclear what its original use was or who was its intended audience. It may have been made by a barren woman wanting to have children, or

it may have been created for use in a coming-of-age ceremony. Sheree M. Lissoos, letter to author, March 17, 2003. The latter seems the most likely option given other characteristics of dolls' uses in coming-of-age ceremonies. See Gary van Wyck, "Fertile Flowers of Femininity," in *Evocations of the Child: Fertility Figures of the Southern African Region*, ed. Elizabeth Dell and Rayda Becker (Johannesburg: Johannesburg Art Gallery, and Cape Town: Human & Rousseau, 1998); Hazel Friedman, "Ntwane Gimwane," in Dell and Baker, *Evocations of the Child*; Elizabeth Ann Schneider, "Ndebele Umndwana," in Dell and Becker, *Evocations of the Child*. Schneider reproduces this Barbie in color; see Schneider, "Ndebele Umndwana," Figure 8, page 146. Gary van Wyck suggested that it was made for non-Ndebele consumption; it could, for instance, have been made for sale to a tourist. Gary van Wyck, e-mail message to author, February 2, 2007. Rayda Becker writes about similarly dressed white dolls that ultimately became part of the non-Ndebele market. Rayda Becker, "Observation on Two Dolls," *De arte*, no. 36 (September 1987). In interviewing Poppie Stollie, an Ndebele woman who dressed dolls in traditional Ndebele attire, Becker discovered that, for their Ndebele owners, these dolls originally served as objects around which to focus nostalgic remembrances.

2. Here I reference the (American) title of Paul Gilroy's book, *Against Race: Imagining Political Culture Beyond the Color Line*. It was published in Britain with the name *Between Camps: Race, Identity and Nationalism at the End of the Colour Line* (London: Allen Lane, 2000).

Bibliography

Abiodun, Rowland. "The Future of African Art Studies: An African Perspective." In *African Art Studies: The State of the Discipline*, ed. National Museum of African Art, 63–89. Washington, D.C.: National Museum of African Art, 1990.

Abiodun, Rowland, Henry John Drewal, and John Pemberton III. *The Yoruba Artist: New Theoretical Perspectives on African Art*. Washington, D.C.: Smithsonian Institution Press, 1994.

Adams, Kathleen M. "Cultural Displays and Tourism in Africa and the Americas." *Ethnohistory* 50, no. 3 (2003): 567–573.

Adamson, Jim, Robert McNatt, and Rosemary Bray McNatt. *The Denny's Story: How a Company in Crisis Resurrected Its Good Name*. New York: John Wiley & Sons, 2000.

"Advertising and Fashion Photography: A Short Survey." *British Journal of Photography* 128 (March 20, 1981): 300–305, 313.

African Studies Association, ed. Special issue, *African Studies Review* 30, no. 3 (1987).

Ahmad, Aijaz. "*Orientalism* and After." In *Colonial Discourse and Post-Colonial Theory: A Reader*, ed. Patrick Williams and Laura Chrisman, 162–171. New York: Columbia University Press, 1993.

Albers, Patricia C., and William R. James. "Travel Photography: A Methodological Approach." *Annals of Tourism Research* 15 (1988): 134–158.

Alden, Chris. "From Neglect to 'Virtual Engagement': The United States and Its New Paradigm for Africa." *African Affairs* 99 (2000): 355–371.

Allen, Gwen. "Against Criticism: The Artist Interview in *Avalanche* Magazine, 1970–76." *Art Journal* 64, no. 3 (2005): 50–61.

Alpers, Edward A. "The Ivory Trade in Africa." In *Elephant: The Animal and Its Ivory in African Culture*, ed. Doran Ross, 349–363. Los Angeles: Fowler Museum of Cultural History, University of California, 1992.

Alpers, Svetlana, Emily Apter, Carol Armstrong, Susan Buck-Morss, Tom Conley, Jonathan Crary, Thomas Crow, et al. "Visual Culture Questionnaire." *October* 77 (1996): 25–70.

Amselle, Jean-Loup. "Africa's Repulsive Charm." *Critical Interventions: Journal of African Art History and Visual Culture* 2 (2008): 11–18.

Antonelli, Giovanni Fontana. "Donne Ndebele. Le Case Dipinte. Ndebele Women. Painted Houses." *Lotus International* 114 (September 2002): 106–119.

Anyidoho, Kofi. "Ghanaian Kente: Cloth and Song." In *The Poetics of Cloth: African Textiles/Recent Art*, ed. Lynn Gumpert, 33–47. New York: Grey Art Gallery, New York University, 2008.

Appadurai, Arjun. *Modernity at Large: Cultural Dimensions of Globalization.* Minneapolis: University of Minnesota Press, 1996.

———, ed. *The Social Life of Things: Commodities in Cultural Perspective.* Cambridge: Cambridge University Press, 1986.

Appiah, Kwame Anthony. "Why Africa? Why Art?" In *Africa: Art of a Continent*, ed. Tom Phillips, 21–26. Munich: Prestel, 1995.

Arnoldi, Mary Jo, Christraud M. Geary, and Kris L. Hardin, eds. *African Material Culture*. Bloomington: Indiana University Press, 1996.

Atkinson, Sue. "Photography in Advertising, Part I." *British Journal of Photography* 132 (July 1985): 749–751, 754.

Audit Bureau of Circulation. "Paid and Verified Magazine Publisher's Statement: Sports Illustrated." Audit Bureau of Circulation, http://sportsillustrated.cnn.com/adinfo/si/ABC-SI2007June.pdf.

Back, Les, and Vibeke Quaade. "Dream Utopias, Nightmare Realities: Imaging Race and Culture within the World of Benetton Advertising." *Third Text* 7, no. 22 (1993): 65–80.

Bailey, David A. "Re-Thinking Black Representations: From Positive Images to Cultural Photographic Practices." *Exposure* 27, no. 4 (Fall 1990): 37–46.

Bamyeh, Mohammed A. "The New Imperialism: Six Theses." *Social Text* 62 18, no. 1 (2000): 1–29.

Barber, Karin. *Readings in African Popular Culture*. Bloomington: International African Institute in association with Indiana University Press, and Oxford: James Currey, 1997.

Barnes, Ruth, and Joanne B. Eicher, eds. *Dress and Gender: Making and Meaning in Cultural Contexts*. Providence, R.I.: Berg, 1992.

Bazin, Germain. *The Museum Age*. New York: Universe Books, 1967.

Becker, Rayda. "Observation on Two Dolls." *De arte*, no. 36 (September 1987): 5–10.

Beckwith, Carol, and Angela Fisher. *African Ceremonies*. 2 vols. New York: Harry Abrams, 1999.

Behrens, Leigh. "Barbie Salutes Military Mothers." *Public Culture: Bulletin of the Project for Transnational Cultural Studies* 2, no. 2 (Spring 1990): 138–139.

Bender, Gerald J. "Ideology and Ignorance: American Attitudes toward Africa." *African Studies Review* 31, no. 1 (1988): 1–7.

Bennett, David. *Multicultural States: Rethinking Difference and Identity*. London: Routledge, 1998.

Bennett, Tony. *The Birth of the Museum*. London: Routledge, 1995.

———. "Exhibitionary Complexes." *New Formations* 4 (1988): 73–102.

Benney, Lona, Fran Black, and Marisa Bulzone, eds. *The Color of Fashion*. New York: Stewart, Tabori and Chang, 1992.

Berger, John. *Ways of Seeing*. London: British Broadcasting Corporation, and New York: Penguin Group, 1977.

Bérubé, Michael. "Past Imperfect, Present Tense." *Nation*, May 12, 1997, 38–42.

Betterton, Rosemary, ed. *Looking On: Images of Femininity in the Visual Arts and Media*. London: Pandora, 1989.

Bhabha, Homi K. "The Other Question: Difference, Discrimination and the Discourse of Colonialism." In *Out There: Marginalization and Contemporary Culture*, ed. Russell Ferguson, Martha Gever, T. Minh-ha Trinh, and Cornel West, 71–88. New York: New Museum of Contemporary Art, and Cambridge, Mass.: MIT Press, 1990.

Bharucha, Rustom. "Interculturalism and Its Discriminations: Shifting Agendas of the National, the Multicultural and the Global." *Third Text* 13, no. 46 (1999): 3–24.

Bhinda, Nils, and FONDAD. *Private Capital Flows to Africa: Perception and Reality*. The Hague: FONDAD [Forum on Debt and Development], 1999.

"The Black Issue." Special issue, *Vogue Italia* 695 (2008).

Blanchard, Pascal, Nicolas Bancel, Gilles Boëtsch, Eric Deroo, Sandrine Lemaire, and Charles Forsdick, eds. *Human Zoos: Science and Spectacle in the Age of Colonial Empires*. Liverpool: Liverpool University Press, 2008.

Bloom, Lisa. *With Other Eyes: Looking at Race and Gender in Visual Culture*. Minneapolis: University of Minnesota Press, 1999.

Blount, Carolyne S., and Ted Jones. "National Museum of African Art." *about . . . time* (February 1988): 15–19.

Boje, David M. "Stories of the Storytelling Organization: A Postmodern Analysis of Disney as 'Tamara-Land.'" *Academy of Management Journal* 38, no. 4 (1995): 997–1035.

Bonilla-Silva, Eduardo. "The New Racism: Racial Structure in the United States, 1960s–1990s." In *Race, Ethnicity, and Nationality in the United States: Towards the Twenty-first Century*, ed. Paul Wong, 55–101. Boulder, Colo.: Westview Press, 1999.

———. *Racism without Racists: Color-blind Racism and the Persistence of Racial Inequality in the United States*. Lanham, Md.: Rowman and Littlefield, 2003.

Bono, ed. Special issue, *Vanity Fair* 563 (2007).

Bordo, Susan. "'Material Girl': The Effacements of Postmodern Culture." In *Turning It On: A Reader in Women and Media*, ed. Helen Baehr and Ann Gray, 44–57. London: Arnold, 1996.

Boym, Svetlana. *The Future of Nostalgia*. New York: Basic Books, 2001.

Brantlinger, Patrick. "Victorians and Africans: The Genealogy of the Myth of the Dark Continent." In *"Race," Writing and Difference*, ed. Henry Louis Gates Jr., 185–222. Chicago: University of Chicago Press, 1986.

Brenkman, John. "Race Publics." *Transition* 66 (1995): 4–36.

Britton, Donald. "The Dark Side of Disneyland." *Art Issues* (Summer 1989): 13–16.

Brode, Douglas. *Multiculturalism and the Mouse: Race and Sex in Disney Entertainment*. Austin: University of Texas Press, 2005.

Brown, Claudine K., and Deborah Willis-Braithwaite. "An Authoritative Voice: Establishing a National African American Museum." In *Disrupted Borders: An*

Intervention in Definitions of Boundaries, ed. Sunil Gupta, 186–189. London: Rivers Oram Press, 1993.

Bruner, Edward M. "Tourism in Ghana: The Representation of Slavery and the Return of the Black Diaspora." *American Anthropologist* 98, no. 2 (1996): 290–304.

Bruner, Edward M., and Barbara Kirshenblatt-Gimblett. "Maasai on the Lawn: Tourist Realism in East Africa." *Cultural Anthropology* 9, no. 4 (1994): 435–470.

Budd, Mike, and Max H. Kirsch, eds. *Rethinking Disney: Private Control, Public Dimensions*. Middletown, Conn.: Wesleyan University Press, 2005.

Bukatman, Scott. "There's Always Tomorrowland: Disney and the Hypercinematic Experience." *October* 57 (Summer 1991): 55.

Burton, Johanna, and Lisa Pasquariello. "'Ask Somebody Else Something Else': Analyzing the Artist Interview." *Art Journal* 64, no. 3 (Fall 2005): 46–49.

Burton, Simon. "South Africa: Disney in South Africa: Towards a Common Culture in a Fragmented Society?" In *Dazzled by Disney? The Global Disney Audiences Project*, ed. Janet Wasko, Mark Phillips, and Eileen R. Meehan, 257–268. London: Leicester University Press, 2001.

Butler, Jeffrey, Robert I. Rotberg, and John Adams. *The Black Homelands of South Africa: The Political and Economic Development of Bophuthatswana and KwaZulu*. Berkeley: University of California Press, 1977.

Byrne, Eleanor, and Martin McQuillan. *Deconstructing Disney*. London: Pluto Press, 1999.

Caminero-Santangelo, Byron, and Garth Andrew Myers. "Cultural Geographies in Practice." *Ecumene* 8, no. 4 (2001): 493–496.

Caponi-Tabery, Gena. "Jump for Joy: Jump Blues, Dance and Basketball in 1930s African America." In *Sports Matters: Race, Recreation, and Culture*, ed. John Bloom and Michael Nevin Willard, 39–74. New York: New York University Press, 2002.

Carr, Helen. "Woman/Indian: 'The American' and His Others." In *Europe and Its Others*, ed. Francis Barker, Peter Hulme, Margaret Iversen, and Diana Loxley, 46–60. Colchester: University of Essex, 1985.

Cashmore, Ellis. *Celebrity/Culture*. Abingdon, England: Routledge, 2006.

Cason, Jim. "The US: Backing Out of Africa." *Review of African Political Economy* 24, no. 71 (1997): 147–153.

Center for African Art. *Perspectives: Angles on African Art*. New York: Center for African Art, 1987.

Chennells, Anthony. "Empires and Nations." *Gallery* 17 (September 1998): 16–21.

Chin, Elizabeth. "Ethnically Correct Dolls: Toying with the Race Industry." *American Anthropologist* 101, no. 2 (1999): 305–321.

Chris, Cynthia. "Beyond the Mouse-Ear Gates: The Wonderful World of Disney Studios." *Afterimage* (November/December 1995): 8–12.

Cleage, Pearl. "Hairpiece." *African American Review* 27, no. 1 (1993): 37–42.

Clifford, James. "Of Other Peoples: Beyond the 'Salvage Paradigm.'" In *Discussions in Contemporary Culture 1*, ed. Hal Foster, 121–130. Seattle: Bay Press, 1987.

———. *The Predicament of Culture*. Cambridge, Mass.: Harvard University Press, 1988.

———. *Routes: Travel and Translation in the Late Twentieth Century*. Cambridge, Mass.: Harvard University Press, 1997.

Cock, Jacklyn. *Maids & Madams: A Study in the Politics of Exploitation*. Johannesburg: Ravan Press, 1980.

Cole, Herbert M., and Doran H. Ross. *The Arts of Ghana*. Los Angeles: Museum of Cultural History, University of California, 1977.

Collins, Patricia Hill. *Black Sexual Politics: African Americans, Gender and the New Racism*. New York: Routledge, 2004.

———. "New Commodities, New Consumers: Selling Blackness in a Global Marketplace." *Ethnicities* 6, no. 3 (2006): 297–317.

Colson, Bill. "To Our Readers." *Sports Illustrated*, Winter 1997, 5.

Coly, Ayo Abiétou. "Housing and Homing the Black Female Body in France: Calixthe Beyala and the Legacy of Sarah Baartman and Josephine Baker." In *Black Womanhood: Images, Icons, and Ideologies of the African Body*, ed. Barbara Thompson, 259–277. Hanover, N.H.: Hood Museum of Art, Dartmouth College, and Seattle: University of Washington Press, 2008.

Conn, Steven. *Museums and American Intellectual Life, 1876–1926*. Chicago: University of Chicago Press, 1998.

Connolly, John L., Jr. "Ingres and the Erotic Intellect." In *Woman as Sex Object: Studies in Erotic Art, 1730–1970*, ed. Thomas B. Hess and Linda Nochlin. *Art News Annual*, xxxviii, 16–31. New York: Newsweek, 1972.

Coombes, Annie E. *History after Apartheid: Visual Culture and Public Memory in a Democratic South Africa*. Durham, N.C.: Duke University Press, 2003.

———. "The Recalcitrant Object: Culture Contact and the Question of Hybridity." In *Colonial Discourse, Postcolonial Theory*, ed. Francis Barker, Peter Hulme, and Margaret Iversen, 89–114. Manchester: Manchester University Press, 1994.

———. *Reinventing Africa: Museums, Material Culture and Popular Imagination in Late Victorian and Edwardian England*. New Haven, Conn.: Yale University Press, 1994.

Corbin, Alain. *Women for Hire: Prostitution and Sexuality in France after 1850*. Trans. Alan Sheridan. Cambridge, Mass.: Harvard University Press, 1990.

Corby, Raymond. "Alterity: The Colonial Nude." *Critique of Anthropology* 8, no. 3 (1988): 75–92.

Cortese, Anthony J. *Provocateur: Images of Women and Minorities in Advertising*. Lanham, Md.: Rowman and Littlefield, 1999.

Courtney-Clarke, Margaret. *Ndebele: The Art of an African Tribe*. New York: Rizzoli, 1986.

Craik, Jennifer. *The Face of Fashion: Cultural Studies in Fashion*. London: Routledge, 1994.

Crain, Mary M. "Negotiating Identities in Quito's Cultural Borderlands." In *Cross-Cultural Consumption: Global Markets, Local Realities*, ed. David Howes, 125–137. London: Routledge, 1996.

Cusic, Don, and Gregory K. Faulk. "Popular Culture and the Economy." *Journal of Popular Culture* 42, no. 3 (June 2009): 158–179.

Cypher, Jennifer, and Eric Higgs. "Colonizing the Imagination: Disney's Wilderness Lodge." *Capital, Nature, Socialism* 8, no. 4 (1997): 107–130.

Daddario, Gina. "Swimming against the Tide: *Sports Illustrated's* Imagery of Female Athletes in a Swimsuit World." *Women's Studies in Communication* 15, no. 1 (1992): 49–64.

Danet, Brenda, and Tamar Katriel. "No Two Alike: Play and Aesthetics in Collecting." *Play & Culture* 2, no. 3 (1989): 253–277.

Danzker, Jo-Anne Birnie. "Organizational Apartheid." *Third Text* 5, no. 13 (1991): 85–95.

Davis, Keith. *Desire Charnay, Expeditionary Photographer.* Albuquerque: University of New Mexico Press, 1981.

Davis, Laurel R. "Critical Analysis of the Popular Media and the Concept of the Ideal Subject Position: *Sports Illustrated* as Case Study." *Quest* 45, no. 2 (1993): 165–181.

———. *The Swimsuit Issue and Sport: Hegemonic Masculinity in "Sports Illustrated."* Albany: State University of New York Press, 1997.

Delancey, Virginia. "The Economies of Africa." In *Understanding Contemporary Africa*, ed. April A. Gordon and Donald L. Gordon, 101–142. Boulder, Colo.: Lynne Rienner, 2001.

Dell, Elizabeth, and Rayda Becker, eds. *Evocations of the Child: Fertility Figures of the Southern African Region.* Johannesburg: Johannesburg Art Gallery, and Cape Town: Human & Rousseau, 1998.

Dellums, Ronald V. "Defining National Security: The African American State in U.S. Defense and Foreign Policy Formation." In *Foreign Policy and the Black (Inter) National Interest*, ed. Charles P. Henry, 219–238. Albany: State University of New York Press, 2000.

DeNavas-Walt, Carmen, Bernadette D. Proctor, Jessica C. Smith, and U.S. Census Bureau. "Income, Poverty, and Health Insurance Coverage in the United States: 2007." Washington, D.C.: U.S. Government Printing Office, 2008.

De Roos, Robert. "The Magic Worlds of Walt Disney." In *Disney Discourse: Producing the Magic Kingdom*, ed. Eric Smooden, 48–68. New York: Routledge, 1994.

Desnoes, Edmundo. "The Photographic Image of Underdevelopment." *Jump Cut* 33 (1988): 69–81.

de Vos, George, and Lola Romanucci-Ross. "Ethnicity: Vessel of Meaning and Emblem of Contrast." In *Ethnic Identity: Cultural Continuities and Change*, ed. George de Vos and Lola Romanucci-Ross, 363–390. Palo Alto, Calif.: Mayfield, 1975.

Dholakia, Nikhilesh, and Jonathan Schroeder. "Disney: Delights and Doubts." *Journal of Research for Consumers* no. 2 (2005): 1–18. http://www.jrconsumers.com/academic_articles/issue_2.

Diamond, Heather A., and Ricardo D. Trimillos. "Introduction: Interdisciplinary Perspectives on the Smithsonian Folklife Festival." *Journal of American Folklore* 121, no. 479 (2008): 3–9.

Doris, David T. "'It's the Truth, It's Actual': Kodak Picture Spots at Walt Disney World." *Visual Resources* 14 (1999): 321–338.

Douglas, Ann. "Periodizing the American Century: Modernism, Postmodernism, and Postcolonialism in the Cold War Context." *Modernism/modernity* 5, no. 3 (September 1998): 71–98.

Dubin, Stephen C. "How I Got Screwed by Barbie: A Cautionary Tale." *New Art Examiner*, November 1995, 20–23.

duCille, Ann. "Barbie in Black and White." In *Barbie Chronicles*, ed. Yona Zeldis McDonough, 127–144. New York: Simon & Schuster, 1999.

———. "The Colour of Class: Classifying Race in the Popular Imagination." *Social Identities* 7, no. 3 (2001): 490–519.

———. "Dyes and Dolls: Multicultural Barbie and the Merchandising of Difference." *Differences* 6, no. 1 (1994): 46–68.

———. "The Shirley Temple of My Familiar." *Transition*, no. 73 (1997): 10–32.

———. *Skin Trade: Essays on Race, Gender, and the Merchandising of Difference.* Cambridge, Mass.: Harvard University Press, 1996.

Dudar, Helen. "New Treasures on the Mall." *Smithsonian* 18, no. 6 (September 1987): 44–54.

———. "A Welcoming New Museum for the City on the Sound." *Smithsonian* 23, no. 1 (April 1992): 46–56.

Duncan, Carol. *Civilizing Rituals: Inside Public Art Museums.* London: Routledge, 1995.

Duncan, Margaret Carlisle. "Beyond Analyses of Sport Media Texts: An Argument for Formal Analyses of Institutional Structures." *Sociology of Sport Journal* 10 (1993): 353–372.

Dunn, Kevin C. "Fear of a Black Planet: Anarchy Anxieties and Postcolonial Travel to Africa." *Third World Quarterly* 25, no. 3 (2004): 483–499.

Duquin, Mary E. "Fashion and Fitness: Images in Women's Magazine Advertisements." *Arena Review* 13, no. 2 (1989): 97–109.

Durham, Deborah. "Lady in the Logo: Tribal Dress and Western Culture in a Southern African Community." In *Dress and Ethnicity: Change Across Space and Time*, ed. Joanne B. Eicher, 183–194. Oxford: Berg, 1995.

Durham, Jimmie. "Cowboys and . . . Notes on Art, Literature, and American Indians in the Modern American Mind." In *The State of Native America: Genocide, Colonization, and Resistance*, ed. M. Annette Jaimes, 423–438. Boston: South End Press, 1992.

Ebong, Ima, ed. *Black Hair: Art, Style and Culture.* New York: Universe Publishing, 2001.

Edwards, Elizabeth, ed. *Anthropology and Photography 1860–1920.* New Haven, Conn.: Yale University Press, 1992.

Ehrenreich, Barbara. "The Real Swimsuit Issue." *Time*, July 1, 1996, 68.

Eicher, Joanne B., and Mary Ellen Roach-Higgins. "Definition and Classification of Dress: Implications for Analysis of Gender Roles." In *Dress and Gender: Making*

and Meaning in Cultural Contexts, ed. Ruth Barnes and Joanne B. Eicher, 8–28. Providence, R.I.: Berg, 1992.

Eicher, Joanne B., and Barbara Sumberg. "World Fashion, Ethnic, and National Dress." In *Dress and Ethnicity*, ed. Joanne B. Eicher, 295–306. Oxford: Berg, 1995.

Enwezor, Okwui, and Octavio Zaya. "Colonial Imaginary, Tropes of Disruption: History, Culture, and Representation in the Works of African Photographers." In *In/sight: African Photographers 1940 to the Present*, ed. Clare Bell, Okwui Enwezor, Olu Oguibe, and Octavio Zaya, 17–47. New York: Guggenheim Museum and Harry Abrams, 1996.

Errington, Shelly. *The Death of Authentic Primitive Art and Other Tales of Progress.* Berkeley: University of California Press, 1998.

Evans, Jessica, and David Hesmondhalgh, eds. *Understanding Media: Inside Celebrity.* Berkshire: Open University Press, 2005.

Eze, Emmanuel Chukwudi. "The Color of Reason: The Idea of 'Race' in Kant's Anthropology." In *Postcolonial African Philosophy: A Critical Reader*, ed. Emmanuel Chukwudi Eze, 103–140. Cambridge, Mass.: Blackwell, 1997.

Fabian, Johannes. *Time and the Other: How Anthropology Makes Its Object.* New York: Columbia University Press, 1983.

"Femmes de Coleur." *Paris Vogue*, December 1993/January 1994, 208–211.

Ferguson, James. *Global Shadows: Africa in the Neoliberal World Order.* Durham, N.C.: Duke University Press, 2006.

"Finally, Barbie Doll Ads Go Ethnic." *Newsweek*, August 13, 1990, 40.

Findlay, John M. *Magic Lands: Western Cityscapes and American Culture after 1940.* Berkeley: University of California Press, 1992.

Findlen, Paula. "The Museum: Its Classical Etymology and Renaissance Genealogy." *Journal of the History of Collections* 1, no. 1 (1989): 56–78.

Finn, Geraldine. "Patriarchy and Pleasure: The Pornographic Eye/I." *Canadian Journal of Political and Social Theory* 9, nos. 1/2 (1985): 81–95.

Fish, Jennifer N. "Engendering Democracy: Domestic Labour and Coalition-Building in South Africa." *Journal of Southern African Studies* 32, no. 1 (2006): 107–127.

Fisher, Angela. *Africa Adorned.* New York: Abrams, 1984.

Fjellman, Stephen M. *Vinyl Leaves: Walt Disney World and America.* Boulder, Colo.: Westview Press, 1992.

Foglesong, Richard. *Married to the Mouse: Walt Disney World and Orlando.* New Haven, Conn.: Yale University Press, 2001.

Francaviglia, Richard. "History after Disney: The Significance of 'Imagineered' Historical Places." *Public Historian* 17, no. 4 (1995): 69–74.

Frederickson, George M. *The Comparative Imagination: On the History of Racism, Nationalism, and Social Movements.* Berkeley: University of California Press, 1997.

Friedenthal, Albert. *Das Weib im Leben der Völker.* Berlin-Grunewald: Verlagsanstalt Hermann Klemm A.G., 1910.

Friedman, Hazel. "Ntwane Gimwane." In *Evocations of the Child: Fertility Figures of the Southern African Region*, ed. Elizabeth Dell and Rayda Becker, 131–137. Johannesburg: Johannesburg Art Gallery, and Cape Town: Human & Rousseau, 1998.

Frow, John. "Spectatorship." *Australian Journal of Communications* 5–6 (1984): 21–38.

Fulkerson, Jennifer. "Don't Play with These Barbie Dolls." *American Demographics*, May 1995, 17.

Gagnon, Monika Kin. "Race-ing Disney: Race and Culture in the Disney Universe." Ph.D. diss., Simon Fraser University, 1998.

Galla, Amareswar. "The Tshwane Declaration: Setting Standards for Heritage Tourism in South Africa." *Museum International* 50, no. 4 (1998): 38–42.

Gaskins, Bill. *Good and Bad Hair: Photographs by Bill Gaskins*. New Brunswick, N.J.: Rutgers University Press, 1997.

Geary, Christraud M. "The Black Female Body, the Postcard, and the Archives." In *Black Womanhood: Images, Icons, and Ideologies of the African Body*, ed. Barbara Thompson, 143–161. Hanover, N.H.: Hood Museum of Art, Dartmouth College, and Seattle: University of Washington Press, 2008.

———. "Missionary Photography: Private and Public Readings." *African Arts* 24, no. 4 (1991): 48–59, 98–100.

Geist, Christopher D., and Jack Nachbar, eds. *The Popular Culture Reader*. Bowling Green, Ohio: Bowling Green University Popular Press, 1983.

Gilman, Sander. "Black Bodies, White Bodies: Toward an Iconography of Female Sexuality in Late Nineteenth-Century Art, Medicine and Literature." In *"Race," Writing and Difference*, ed. Henry Louis Gates Jr., 223–261. Chicago: University of Chicago Press, 1986.

———. *Difference and Pathology: Stereotypes of Sexuality, Race, and Madness*. Ithaca, N.Y.: Cornell University Press, 1985.

Gilroy, Paul. *Against Race: Imagining Political Culture Beyond the Color Line*. Cambridge, Mass.: Belknap/Harvard University Press, 2000.

———. *The Black Atlantic: Modernity and Double Consciousness*. Cambridge, Mass.: Harvard University Press, 1993.

———. *Postcolonial Melancholia*. New York: Columbia University Press, 2005.

Giroux, Henry A. *Disturbing Pleasures*. New York: Routledge, 1994.

Giroux, Susan Searls. "Reconstructing the Future: Du Bois, Racial Pedagogy and the Post–Civil Rights Era." *Social Identities* 9, no. 4 (2003): 563–596.

Glaze, Anita J. *Art and Death in a Senufo Village*. Bloomington: Indiana University Press, 1981.

Goffman, Erving. *Gender Advertisements*. Cambridge, Mass.: Harvard University Press, 1979.

Goldblatt, Brenda. "My Children Know What Is Going On in KwaNdebele." In *amaNdebele: Farbsignale aus Sudafrika—Signals of Color from South Africa*,

ed. Wolfger Pohlmann and Haus der Kulturen der Welt, 33–39. Tubingen: Ernst Wasmuth, 1991.

Gordon, Avery F., and Christopher Newfield. *Mapping Multiculturalism*. Minneapolis: University of Minnesota Press, 1996.

Gordon, David F., David C. Miller Jr., and Howard Wolpe. *The United States and Africa: A Post–Cold War Perspective*. New York: W. W. Norton, 1998.

Gould, Stephen Jay. *The Mismeasure of Man*. New York: W. W. Norton, 1981.

Graham, Judith. "Mattel Hopes for Help from Barbie's Friends." *Advertising Age*, March 21, 1988, 1.

Green, David. "Classified Subjects, Photography and Anthropology: The Technology of Power." *Ten–8* 14 (1984): 30–37.

Grewal, Inderpal. "Traveling Barbie: Indian Transnationalities and the Global Consumer." *Positions: East Asia Cultures Critique* 7, no. 3 (1999): 779–826.

Hall, Martin. "The Reappearance of the Authentic." In *Museum Frictions: Public Cultures/Global Transformations*, ed. Ivan Karp, Corinne A. Kratz, Lynn Szwaja, and Tomas Ybarra-Frausto, 70–101. Durham, N.C.: Duke University Press, 2006.

Hall, Stuart. "Encoding, Decoding." In *The Cultural Studies Reader*, ed. Simon During, 507–517. London: Routledge, 1999.

Hall-Duncan, Nancy. *The History of Fashion Photography*. New York: Alpine Book, 1979.

Hamilton, Peter, and Roger Hargreaves. *The Beautiful and the Damned: The Creation of Identity in Nineteenth-Century Photography*. Aldershot, Hampshire: Lund Humphries, and London: National Portrait Gallery, 2001.

Haraway, Donna. "Teddy Bear Patriarchy: Taxidermy in the Garden of Eden, New York City, 1908–1936." *Social Text* 11 (Winter 1984–1985): 20–64.

Hardin, Kris L., and Mary Jo Arnoldi. "Introduction: Efficacy and Objects." In *African Material Culture*, ed. Mary Jo Arnoldi, Christraud M. Geary, and Kris L. Hardin, 1–28. Bloomington: Indiana University Press, 1996.

Harris, Michael. *Colored Pictures: Race and Visual Representation*. Chapel Hill: University of North Carolina Press, 2003.

Harrison, Julia D. "Ideas of Museums in the 1990s." *Museum Management and Curatorship* 13 (1993): 160–176.

Harrison, Martin. *Appearances: Fashion Photography since 1945*. New York: Rizzoli, 1991.

Hebdige, Dick. "Dis-Gnosis: Disney and the Re-tooling of Knowledge, Art, Culture, Life, Etcetera." In *Rethinking Disney: Private Control, Public Dimensions*, ed. Mike Budd and Max H. Kirsch, 37–52. Middletown, Conn.: Wesleyan University Press, 2005.

Henderson, Amy, and Adrienne L. Kaeppler. *Exhibiting Dilemmas: Issues of Representation at the Smithsonian*. Washington, D.C.: Smithsonian Institution, 1997.

Henry, Charles P., ed. *Foreign Policy and the Black (Inter)National Interest*. Albany: State University of New York Press, 2000.

Hermanson, Scott. "Truer Than Life: Disney's Animal Kingdom." In *Rethinking Disney: Private Control, Public Dimensions*, ed. Mike Budd and Max H. Kirsch, 199–227. Middletown, Conn.: Wesleyan University Press, 2005.

Hiaasen, Carl. "Tart of Darkness." *Sports Illustrated*, Winter 2003, 35–48.

Hickson, Joyce, and Martin Strous. "The Plight of Black South African Women Domestics." *Journal of Black Studies* 24, no. 1 (1993): 109–122.

Hinsley, Curtis M. "The World as Marketplace: Commodification of the Exotic at the World's Columbian Exposition, Chicago, 1893." In *Exhibiting Cultures: The Poetics and Politics of Museum Display*, ed. Ivan Karp and Stephen D. Lavine, 344–365. Washington, D.C.: Smithsonian Institution Press, 1991.

Hitchcock, Michael. "Tourism and Ethnicity: Situational Perspectives." *International Journal of Tourism Research* 1, no. 1 (January/February 1999): 17–32.

Hobsbawm, Eric. "Introduction: Inventing Traditions." In *The Invention of Tradition*, ed. Eric Hobsbawm and Terence Ranger, 1–14. Cambridge: Cambridge University Press, 1992.

Hohmann, Delf Maria. "'Jennifer and Her Barbies': A Contextual Analysis of a Child Playing with Barbie Dolls." *Canadian Folklore* 7, nos. 1–2 (1985): 111–120.

Holmes, Su, and Sean Redmond, eds. *Framing Celebrity: New Directions in Celebrity Culture*. London: Routledge, 2006.

Hooper, Lindsay. "The Art of Ndebele Beadwork." *Sagittarius: Magazine of the South African Museum*, December 1988, http://www.museums.org.za/sam/resource/arch/ndebele.htm, accessed December 30, 2002.

Hooper-Greenhill, Eilean. *Museums and the Shaping of Knowledge*. London: Routledge, 1992.

Hopson, Darlene Powell, and Derek S. Hopson. *Different and Wonderful: Raising Black Children in a Race-Conscious Society*. New York: Prentice Hall Press, 1990.

Horrell, Muriel. *Race Relations as Regulated by Law in South Africa 1948–1979*. Johannesburg: South African Institute of Race Relations, 1982.

———. *South Africa: Basic Facts and Figures*. Johannesburg: South African Institute of Race Relations, 1973.

House of Representatives. 97th Cong., 2nd sess. "Authorization of Smithsonian Institution Museum of African Art and a Center for Eastern Art." Washington, D.C.: U.S. Government, 1982.

Howes, David, ed. *Cross-Cultural Consumption: Global Markets, Local Realities*. London: Routledge, 1996.

Huyssen, Andreas. *Present Pasts: Urban Palimpsests and the Politics of Memory*. Stanford, Calif.: Stanford University Press, 2003.

Ibrahim, Abdullahi A. "The Birth of the Interview: The Thin and the Fat of It." In *African Words, African Voices: Critical Practices in Oral History*, ed. Luise White, Stephan F. Miescher, and David William Cohen, 103–124. Bloomington: Indiana University Press, 2001.

Jacobson, Matthew Frye. *Whiteness of a Different Color: European Immigrants and the Alchemy of Race*. Cambridge, Mass.: Harvard University Press, 1998.

James, Deborah. "A Question of Ethnicity: Ndzundza Ndebele in a Lebowa Village." *Journal of Southern African Studies* 16, no. 1 (1990): 33–54.

Janus, Noreene Z. "Research on Sex Roles in the Mass Media: Toward a Critical Approach." In *Turning It On: A Reader in Women and Media*, ed. Helen Baehr and Ann Gray, 5–10. London: Arnold, 1996.

Jeffrey, David. "Pioneers in Their Own Land." *National Geographic*, February 1986, 260–283.

Jennings, James. "The International Convention on the Elimination of All Forms of Racial Discrimination: Implications for Challenging Racial Hierarchy." In *Foreign Policy and the Black (Inter)National Interest*, ed. Charles P. Henry, 75–94. Albany: State University of New York Press, 2000.

Johnson, Claudette. "Issues Surrounding the Representation of the Naked Body of a Woman." *FAN—Feminist Art News* 3, no. 8 (1991): 12–14.

Johnson, David M. "Disney World as Structure and Symbol: Re-creation of the American Experience." *Journal of Popular Culture* 15, no. 1 (1981): 157–164.

Jones, Lisa. *Bulletproof Diva: Tales of Race, Sex, and Hair*. New York: Doubleday, 1994.

Jones, Wendy Singer. "Barbie's Body Project." In *Barbie Chronicles*, ed. Yona Zeldis McDonough, 91–107. New York: Simon & Schuster, 1999.

Jordanova, Ludmilla. "Objects of Knowledge: A Historical Perspective on Museums." In *The New Museology*, ed. Peter Vergo, 22–40. London: Reaktion Books, 1989.

Kaplan, Flora E. S. *Museums and the Making of "Ourselves": The Role of Objects in National Identity*. London: Leicester University Press, 1994.

Kapur, Greta. "A New Inter Nationalism: The Missing Hyphen." In *Global Visions: Towards a New Internationalism in the Visual Arts*, ed. Jean Fisher, 39–49. London: Kala Press and the Institute of International Visual Arts, 1994.

Karp, Ivan. "How Museums Define Other Cultures." *American Art* 5, nos. 1–2 (Winter/Spring 1991): 10–15.

Karp, Ivan, and Stephen D. Lavine. "Communities and Museums: Partners in Crisis." *Museum News* 72, no. 3 (May/June 1993): 44–45, 69, 79–84.

———, eds. *Exhibiting Cultures: The Poetics and Politics of Museum Display*. Washington, D.C.: Smithsonian Institution Press, 1991.

Kasfir, Sidney Littlefield. "African Art and Authenticity: A Text with a Shadow." *African Arts* 15, no. 2 (1992): 40–53, 96–97.

———. "One Tribe, One Style: Paradigms in the Historiography of African Art." *History in Africa* 11 (1984): 163–193.

———. "Remembering Ojiji: Portrait of an Idoma Artist." *African Arts* 22, no. 4 (1989): 44–51.

———. "Samburu Souvenirs." In *Unpacking Culture: Art and Commodity in Colonial and Postcolonial Worlds*, ed. Ruth B. Phillips and Christopher B. Steiner, 67–83. Berkeley: University of California Press, 1999.

Keim, Curtis A. *Mistaking Africa: Curiosities and Inventions of the American Mind.* 2nd ed. Boulder, Colo.: Westview Press, 2009.

Keller, Edmond J. "Africa in Transition: Facing the Challenges of Globalization." *Harvard International Review* 29, no. 2 (Summer 2007): 46–51.

Kennedy, Carolee. "Art, Architecture and Material Culture of the Zulu Kingdom." Ph.D. diss., University of California, Los Angeles, 1993.

Kennedy, M. F. "Visions of Ndebele." *Town & Country,* January 1992, 63–73.

Kenny, Bridget. "Servicing Modernity: White Women Shop Workers on the Rand and Changing Gendered Respectabilities, 1940s–1970s." *African Studies* 67, no. 3 (2008): 365–395.

Kern-Foxworth, Marilyn. *Aunt Jemima, Uncle Ben, and Rastus: Blacks in Advertising, Yesterday, Today, and Tomorrow.* Westport, Conn.: Greenwood, and London: Praeger, 1994.

K.I. "Swimsuit Issue Make Waves." *School Library Journal* (April 2003): 28.

King, Margaret J. "Disneyland and Walt Disney World: Traditional Values in Futuristic Form." *Journal of Popular Culture* 15, no. 1 (1981): 116–140.

Klopper, Sandra. "The Carver in Africa: Individually Acclaimed Artist or an Anonymous Artisan?" *Social Dynamics* 19, no. 1 (1993): 39–51.

Klopper, Sandra, and Peter Magubane. *Dress and Adornment.* Cape Town: Struik, 2001.

Knight, Kimberly. "Black Like Us: Dolls for Our Kids." *Essence,* November 1990, 104.

Kratz, Corinne A., and Ivan Karp. "Wonder and Worth: Disney Museums in World Showcase." *Museum Anthropology* 17, no. 3 (1993): 32–42.

Kreamer, Christine Mullen. *African Vision: The Walt Disney–Tishman African Art Collection.* Washington, D.C.: National Museum of African Art, Smithsonian Institution, and Munich: Prestel Verlag, 2007.

———. "African Voices." *Museum News* 76, no. 6 (1997): 50–55.

Kuenz, Jane. "It's a Small World After All: Disney and the Pleasures of Identification." *South Atlantic Quarterly* 92, nos. 1–2 (1993): 63–88.

Kurin, Richard. *Reflections of a Culture Broker.* Washington, D.C.: Smithsonian Institution Press, 1997.

LaGamma, Alisa, ed. "Authorship in African Art, Part 1." Special issue, *African Arts* 31, no. 4 (1998).

———, ed. "Authorship in African Art, Part 2." Special issue, *African Arts* 32, no. 1 (1999).

Lalioti, Vali, Andries Malan, James Pun, and Juergen Wind. "Ndebele Painting in VR." *IEEE Computer Graphics and Applications* (March/April 2001): 10–13.

Lamb, Venice. *West African Weaving.* London: Duckworth, 1975.

Lampert-Graux, Ellen. "From Africa to Anaheim." *Lighting Dimensions,* February 2002, 2.

Lavine, Steven D. "Museums and Multiculturalism: Who Is in Control?" *Museum News* (March/April 1989): 36–41.

Lawrence, Errol. "Just Plain Common Sense: The 'Roots' of Racism." In *The Empire Strikes Back: Race and Racism in 70s Britain*, ed. Centre for Contemporary Cultural Studies, 47–94. London: Hutchinson, 1982.

Leavy, Jane. "Is There a Barbie Doll in Your Past? At 20, Barbie and Ken Have Learned to Kiss. What Next?" *Ms.*, September 1979, 102.

Leighten, Patricia. "The White Peril and L'art Negre: Picasso, Primitivism, and Anticolonialism." *Art Bulletin* 72, no. 4 (1990): 609–630.

Levinsohn, Rhoda. *Art and Craft of Southern Africa: Treasures in Transition.* Craighall, South Africa: Delta Books, 1984.

Lewis, Reina. *Gendering Orientalism.* New York: Routledge, 1996.

Leyten, Harrie. Foreword to *Art, Anthropology and the Modes of Re-presentation*, ed. Harrie Leyten and Bibi Damen, 7–14. Amsterdam: Royal Tropical Institute, Tropenmuseum, 1993.

Lippard, Lucy R. *On the Beaten Track: Tourism, Art and Place.* New York: New Press, 1999.

Little, Kenneth. "On Safari: The Visual Politics of a Tourist Representation." In *The Varieties of Sensory Experience: A Sourcebook in the Anthropology of the Senses*, ed. Davis Howes, 143–163. Toronto: University of Toronto Press, 1991.

Loomba, Ania. *Colonialism/Postcolonialism.* 2nd ed. London: Routledge, 2005.

Lord, M. G. *Forever Barbie: The Unauthorized Biography of a Real Doll.* New York: Morrow, 1994.

Lowe, Donald M. *The Body in Late Capitalist USA.* Durham, N.C.: Duke University Press, 1995.

———. *History of Bourgeois Perception.* Chicago: University of Chicago Press, 1982.

Lowenthal, David. *The Past Is a Foreign Country.* 1985. Repr., Cambridge: University of Cambridge, 1986.

Lugli, Adalgisa. "Inquiry as Collection." *Res* 12 (Autumn 1986): 110–124.

Lutz, Catherine A., and Jane L. Collins. *Reading National Geographic.* Chicago: University of Chicago Press, 1993.

MacCannell, Dean. "Reconstructed Ethnicity: Tourism and Cultural Identity in Third World Communities." *Annals of Tourism Research* 11 (1984): 375–391.

———. *The Tourist: A New Theory of the Leisure Class.* 1976. Repr., New York: Schocken Books, 1989.

MacDougall, J. Paige. "Transnational Commodities as Local Cultural Icons: Barbie Dolls in Mexico." *Journal of Popular Culture* 37, no. 2 (2003): 257–275.

Maddox, K. B. "Perspectives on Racial Phenotypicality Bias." *Personality & Social Psychology Review* 8, no. 4 (2004): 383–401.

Magee, Carol. "Forever in Kente: Ghanian Barbie and the Fashioning of Identity." *Social Identities* 11, no. 6 (2005): 589–606.

———. "*400 Men of African Descent*: Negotiating Racialised Identities at the Seattle Art Museum." *Third Text* 18, no. 5 (2004): 497–511.

———. "Re-presenting Africa? American Displays of African Visual Culture in the 1990s." Ph.D. diss., University of California, Santa Barbara, 2001.

———. "Representing Africa? Celebrities, Photography and *Vanity Fair*." In *Celebrity Colonialism: Fame, Power and Representation in Colonial and Postcolonial Cultures*, ed. Robert Clarke, 275–289. Cambridge: Cambridge Scholars Press, 2009.

Malmberg, Melody. *The Making of Disney's Animal Kingdom Theme Park*. New York: Hyperion, 1998.

Mandeville, A. Glenn. "Foreign Faces of Barbie." *Barbie Bazaar*, 1996, 32.

Mani, Lata, and Ruth Frankenberg. "The Challenge of Orientalism." *Economy and Society* 14, no. 2 (1985): 174–192.

Manning, Robert D. "Multicultural Washington, D.C.: The Changing Social and Economic Landscape of a Post-Industrial Metropolis." *Ethnic and Racial Studies* 21, no. 2 (March 1998): 328–355.

Marin, Louis. *Utopics: The Semiological Play of Textual Spaces*. Trans. Robert A. Vollrath. New York: Humanity Books, 1984.

Marling, Karal Ann. *Designing Disney's Theme Parks: The Architecture of Reassurance*. New York: Flammarion, 1997.

———. "Disneyland, 1955: Just Take the Santa Ana Freeway to the American Dream." *American Art* 5, nos. 1/2 (1991): 168–207.

Marling, Karal Ann, and Donna R. Braden. *Behind the Magic: 50 Years of Disneyland*. Dearborn, Mich.: Henry Ford Museum, 2005.

Marx, Anthony W. *Making Race and Nation: A Comparison of South Africa, the United States, and Brazil*. Cambridge: Cambridge University Press, 1998.

Mattel Inc. "Annual Report 2003." El Segundo, Calif.: Mattel, 2004.

———. "Annual Report 2007." El Segundo, Calif.: Mattel, 2008.

Mavor, Carol. *Pleasures Taken: Performances of Sexuality and Loss in Victorian Photographs*. Durham, N.C.: Duke University Press, 1995.

McClintock, Anne. "Maid to Order: Commercial Fetishism and Gender Power." *Social Text* 37 (Winter 1993): 87–116.

———. "Soft-Soaping Empire: Commodity Racism and Imperial Advertising." In *The Gender and Consumer Culture Reader*, ed. Jennifer Scanlon, 129–152. New York: Routledge, 2000.

McDonough, Yona Zeldis, ed. *Barbie Chronicles*. New York: Simon & Schuster, 1999.

McElroy, Keith. "Popular Education and Photographs of the Non-Industrialized World." *Exposure* 28, no. 3 (1992): 34–51.

McPhail, Thomas L. *Global Communications: Theories, Stakeholders, and Trends*. 2nd ed. Malden, Mass.: Blackwell, 2006.

Mercer, Kobena. "Black Hair/Style Politics." In *Out There: Marginalization and Contemporary Cultures*, ed. Russell Ferguson, Martha Gever, T. Minh-ha Trinh, and Cornel West, 247–264. New York: New Museum of Contemporary Art, and Cambridge, Mass.: MIT Press, 1990.

Miner, Roy Waldo. *General Guide to the Exhibition Halls of the American Museum of Natural History*. New York: American Museum of Natural History, 1943.

Mirzoeff, Nicholas. *An Introduction to Visual Culture*. London: Routledge, 1999.

Mitchell, W. J. T. "Showing Seeing: A Critique of Visual Culture." *Journal of Visual Culture* 1, no. 2 (2002): 165–181.

Mizinga, Flexon M. "Where Did Africa Come From and Where Is It Heading?" *Quest* 12, no. 1 (1998): 55–60.

Mogelonsky, Marcia. "Butterfly Barbie Effect." *American Demographics*, May 1996, 8.

Moore, Alexander. "Walt Disney World: Bounded Ritual Space and the Playful Pilgrimage Center." *Anthropological Quarterly* 53, no. 4 (1980): 207–217.

Motz, Marilyn Ferris. "'I Want to Be a Barbie Doll When I Grow Up': The Cultural Significance of the Barbie Doll." In *The Popular Culture Reader*, ed. Christopher D. Geist and Jack Nachbar, 122–136. Bowling Green, Ohio: Bowling Green University Popular Press, 1983.

Mudimbe, V. Y. *The Idea of Africa*. Bloomington: Indiana University Press, and London: James Currey, 1994.

———. *The Invention of Africa: Gnosis, Philosophy, and the Order of Knowledge*. Bloomington: Indiana University Press, 1988.

Muhl, Kate. "Serious Fun." *AAA World*, July/August 2001, 20–25.

Myers, Kathy. "Fashion 'n' Passion." In *Looking On: Images of Femininity in the Visual Arts and Media*, ed. Rosemary Betterton, 58–65. London: Pandora, 1989.

"The National Museum of African Art." *African Arts* 17, no. 3 (May 1984): 40–46.

National Museum of African Art. "National Museum of African Art." Washington, D.C.: National Museum of African Art, Smithsonian Institution, n.d.

———. "National Museum of African Art Campaign." Washington, D.C.: Smithsonian Institution, 1988.

Nederveen Pieterse, Jan. *White on Black*. New Haven, Conn.: Yale University Press, 1992.

Nelson, Steve. "Walt Disney's EPCOT and the World's Fair Performance Tradition." *Drama Review: TDR* 30, no. 4 (Winter 1986): 106–146.

"New Boom in Ethnic Toys." *Ebony* 49, no. 1 (1993), 64, 66.

Nicholson-Lord, David. "The Politics of Travel: Is Tourism Just Colonialism in Another Guise?" *Nation*, October 6, 1997, 11–18.

Nochlin, Linda. "The Imaginary Orient." *Art in America* 71, no. 5 (1983): 118–191.

Nooshin, Laudan. "Circumnavigation with a Difference? Music, Representation and the Disney Experience: *It's a Small, Small World*." *Ethnomusicology Forum* 13, no. 2 (2004): 236–251.

Noriega, Chon A. "On Museum Row: Aesthetics and the Politics of Exhibition." *Daedalus: Journal of the American Academy of Arts and Sciences* 128, no. 3 (Summer 1999): 57–81.

Norment, Lynn. "Tyra Banks on Top of the World." *Ebony* 52, no. 1 (May 1997), 110–114.

Obama, Barack. *The Audacity of Hope: Thoughts on Reclaiming the American Dream.* New York: Three Rivers Press, 2006.

O'Barr, William M. *Culture and the Ad: Exploring Otherness in the World of Advertising.* Boulder, Colo.: Westview Press, 1994.

Ockman, Carol. "Barbie Meets Bouguereau: Constructing an Ideal Body for the Late Twentieth Century." In *Barbie Chronicles*, ed. Yona Zeldis McDonough, 75–88. New York: Simon & Schuster, 1999.

Okazawa-Ray, Margo, Tracy Robinson, and Janie Victoria Ward. "Black Women and the Politics of Skin Color and Hair." *Women & Therapy* 6, nos. 1/2 (1987): 89–102.

Omi, Michael. "Racial Identity and the State: Contesting the Federal Standards for Classification." In *Race, Ethnicity, and Nationality in the United States: Towards the Twenty-first Century*, ed. Paul Wong, 25–33. Boulder, Colo.: Westview Press, 1999.

Omi, Michael, and Howard Winant. *Racial Formation in the United States: From the 1960s to the 1990s.* New York: Routledge, 1994.

Onyedike, Emmanuel. "Repositioning Africa: The Role of African-American Leaders in Changing Media Treatment of Africa." *Journal of Third World Studies* 13, no. 2 (1996): 51–60.

"Opening September 1987 the National Museum of African Art." *African Arts* 20, no. 4 (August 1987): 28–37.

Osborne, Peter. *Traveling Light: Photography, Travel, and Visual Culture.* Manchester: Manchester University Press, 2000.

Outlaw, Lucius T. "Racial and Ethnic Complexities in American Life: Implications for African Americans." In *Multiculturalism from the Margins: Non-dominant Voices on Difference and Diversity*, ed. Dean A. Harris, 39–53. Westport, Conn.: Bergin & Garvey, 1995.

Parenti, Michael. *Against Empire.* San Francisco: City Lights Books, 1995.

Parham, John. "Teaching Pleasures: Experiments in Cultural Studies and Pedagogy." *International Journal of Cultural Studies* 5, no. 4 (2002): 461–478.

Parmar, Pratibha. "Hateful Contraries: Media Images of Asian Women." In *Looking On: Image of Femininity in the Visual Arts and Media*, ed. Rosemary Betterton, 93–104. 1987. Repr., London: Pandora, 1989.

Patton, Sharon F. "Disney-Tishman Gift to the Smithsonian Institution." *Tribal Arts* (Autumn/Winter 2005): 62–63.

Pearce, Susan. *Interpreting Objects and Collections.* London: Routledge, 1994.

———. *Museums, Objects, and Collections.* Washington, D.C.: Smithsonian Institution Press, 1992.

Pecora, Norma, and Eileen R. Meehan. "United States: A Disney Dialectic: A Tale of Two American Cities." In *Dazzled by Disney? The Global Disney Audiences Project*, ed. Janet Wasko, Mark Phillips, and Eileen R. Meehan, 297–326. London: Leicester University Press, 2001.

Pekarik, Andrew J. "Understanding Visitor Comments: The Case of Flight Time Barbie." *Curator* 40, no. 1 (March 1997): 56–68.

Philips, Deborah. "Narrativised Spaces: The Functions of Story in the Theme Park." In *Leisure/Tourism Geographies: Practices and Geographical Knowledge*, ed. David Crouch, 91–108. London: Routledge, 1999.

Phillips, Kendall R. "Textual Strategies, Plastic Tactics: Reading Batman and Barbie." *Journal of Material Culture* 7, no. 2 (2002): 123–136.

Phillips, Mark. "The Global Disney Audiences Project: Disney Across Cultures." In *Dazzled by Disney? The Global Disney Audiences Project*, ed. Janet Wasko, Mark Phillips, and Eileen R. Meehan, 31–61. London: Leicester University Press, 2001.

Phillips, Ruth B., and Christopher B. Steiner. *Unpacking Culture: Art and Commodity in Colonial and Postcolonial Worlds*. Berkeley: University of California Press, 1999.

Picton, John. "Undressing Ethnicity." *African Arts* 34, no. 3 (2001): 66–73, 93–95.

Pirat, Claude-Henri. "The Buli Master: Isolated Master or Atelier." *Tribal Arts* 3, no. 2 (1996): 54–77.

Pohlmann, Wolfger, and Haus der Kulturen der Welt, eds. *amaNdebele: Farbsignale Aus Sudafrika—Signals of Color from South Africa*. Tublingen: Ernst Wasmuth, 1991.

Pollack, Barbara. "The Newest Avant-Garde." *ARTnews* 100, no. 4 (April 2001): 124–129.

Powell, Ivor. *Ndebele: A People & Their Art*. New York: Cross River Press, 1995.

Press, Eyal. "Barbie's Betrayal: The Toy Industry's Broken Workers." *Nation*, December 30, 1996, 11.

Preston, Douglas J. *Dinosaurs in the Attic: An Excursion into the American Museum of Natural History*. New York: St. Martin's Press, 1986.

Primm, Eric, Summer DuBois, and Robert Regoli. "Every Picture Tells a Story: Racial Representation on *Sports Illustrated* Covers." *Journal of American Culture* 30, no. 2 (June 2007): 222–230.

Project on Disney. *Inside the Mouse: Work and Play at Disney World*. Durham, N.C.: Duke University Press, 1995.

Proschaska, David. "Fantasia of the *Photothèque*: French Postcard Views of Colonial Senegal." *African Arts* 24, no. 4 (October 1991): 40–47, 98.

Pultz, John. *The Body and the Lens: Photography 1839 to the Present*. New York: Harry N. Abrams, 1995.

Quarcoopome, Nii Q. "Pride and Avarice: Kente and Advertising." In *Wrapped in Pride: Ghanaian Kente and African American Identity*, ed. Doran Ross, 192–200. Los Angeles: Fowler Museum of Cultural History, University of California, 1998.

Quick, Betsy. "Pride and Dignity." In *Wrapped in Pride: Ghanaian Kente and African American Identity*, ed. Doran Ross, 203–265. Los Angeles: Fowler Museum of Cultural History, University of California, 1998.

Ramamurthy, Anandi. "Construction of Illusion." In *Photography: A Critical Introduction*, ed. Liz Wells, 153–198. New York: Routledge, 1997.

Rand, Erica. *Barbie's Queer Accessories*. Durham, N.C.: Duke University Press, 1995.

Rankin, Elizabeth. "Black Artists, White Patrons: The Cross-Cultural Art Market in
 Rural South Africa." *Africa Insight* 20, no. 1 (1990): 33–38.
Rexer, Lyle, and Rachel Klein. *American Museum of Natural History: 125 Years of
 Expedition and Discovery.* New York: Harry Abrams, with the American Museum
 of Natural History, 1995.
Rice, Danielle. "The Cross-Cultural Mediator." *Museum News* (January/February 1993):
 38–41.
Rich, Peter. "The Hybrid 'Palaces' of the Mapogga." *Spazio e Società* 7, no. 26 (1984):
 6–25.
———. "Pride of the Ndebele." *Architectural Review* 197, no. 1177 (March 1995): 73–77.
Robbins, Warren. "African Art." *Museums and Arts Washington*, September 1987, 36.
Roberts, John. "The Museum and the Crisis of Critical Postmodernism." *Third Text* 11,
 no. 41 (1997): 67–74.
Roberts, Lisa. "Museums and Knowledge: The Responsibility to Open Minds." *Journal
 of Museum Education* 14, no. 1 (Winter 1989): 9–12.
Roberts, Mary Nooter, and Susan Vogel. *Exhibition*-ism: *Museums and African Art.*
 New York: Museum for African Art, 1994.
Robinson, Cedric J. "The Inventions of the Negro." *Social Identities* 7, no. 3 (2001):
 329–361.
Rogers, Mary F. *Barbie Culture.* London: Sage, 1999.
Ross, Andrew. *No Respect: Intellectuals & Popular Culture.* New York: Routledge,
 1989.
Ross, Doran. "Asante Cloth Names and Motifs." In *Wrapped in Pride: Ghanaian Kente
 and African American Identity*, ed. Doran Ross, 107–125. Los Angeles: Fowler
 Museum of Cultural History, University of California, 1998.
———. "Introduction: Fine Weaves and Tangled Webs." In *Wrapped in Pride:
 Ghanaian Kente and African American Identity*, ed. Doran Ross, 19–30. Los
 Angeles: Fowler Museum of Cultural History, University of California, 1998.
———. "Kente and Its Image Outside of Ghana." In *Wrapped in Pride: Ghanaian
 Kente and African American Identity*, ed. Doran Ross, 151–187. Los Angeles: Fowler
 Museum of Cultural History, University of California, 1998.
———, ed. *Wrapped in Pride: Ghanaian Kente and African American Identity.* Los
 Angeles: Fowler Museum of Cultural History, University of California, 1998.
Rovine, Victoria. *Bogolan: Shaping Culture through Cloth in Contemporary Mali.*
 Washington, D.C.: Smithsonian Institution Press, 2001.
———. "Bogolanfini in Bamako: The Biography of a Malian Textile." *African Arts* 30,
 no. 1 (1997): 40–51.
Roy, Abhik. *Selling Stereotypes: Images of Women in Indian Television Commercials.*
 New Delhi: New Concept Information Systems, 1998.
Ryan, James R. *Picturing Empire: Photography and the Visualization of the British
 Empire.* Chicago: University of Chicago Press, 1997.

Said, Edward. *Culture and Imperialism*. New York: Vintage, 1993.

———. *Orientalism*. New York: Vintage, 1978.

Salomon, Allyn. *Advertising Photography*. New York: Amphoto Books, 1982.

Savacool, Julia. "Women's Ideal Bodies Then & Now." *Marie Claire (US)*, April 2004,
 102–110.

Schaffer, Scott. "Disney and the Imagineering of Histories." *Postmodern Culture* 6, no.
 3 (1996). http://jhu.edu/journals/postmodern_culture/v006/6.3schafer.html.

Schiappa, Edward. *Beyond Representational Correctness: Rethinking Criticism of
 Popular Media*. Albany: State University of New York Press, 2008.

Schildkrout, Enid, and Curtis A. Keim. *African Reflections: Art from Northeastern
 Zaire*. Seattle: University of Washington Press, and New York: American Museum
 of Natural History, 1990.

———, eds. *The Scramble for Art in Central Africa*. Cambridge: Cambridge University
 Press, 1998.

Schneider, Elizabeth Ann. "Ndebele Umndwana." In *Evocations of the Child: Fertility
 Figures of the Southern African Region*, ed. Elizabeth Dell and Rayda Becker, 138–
 149. Johannesburg: Johannesburg Art Gallery, and Cape Town: Human & Rousseau,
 1998.

———. "Paint, Pride and Politics: Aesthetic and Meaning in Transvaal Ndebele Wall
 Art." Ph.D. diss., University of the Witwatersrand, 1986.

Schouten, Frans. "Psychology and Exhibition Design." *International Journal of
 Museum Management and Curatorship* 6 (1987): 259–262.

Schutte, Gerhard. "Tourists and Tribes in the 'New' South Africa." *Ethnohistory* 50, no.
 3 (2003): 473–487.

Scott, Clive. *The Spoken Image: Photography and Language*. London: Reaktion Books,
 1999.

Scott, Rebecca. "The Dark Continent: Africa as Female Body in Haggard's Adventure
 Fiction." *Feminist Review* 32 (1989): 69–89.

Sears, Cornelia. "Africa in the American Mind, 1870–1955: A Study in Mythology,
 Ideology and the Reconstruction of Race." Ph.D. diss., University of California,
 Berkeley, 1997.

Sekula, Allan. "The Body and the Archive." *October* 39 (Winter 1986): 3–64.

Senate Committee on Rules and Regulations. Acquisition of the Museum of African
 Art by the Smithsonian Institution, S.2507, 1978.

Shapiro, Bruce. "A House Divided: Racism at the State Department." *Nation*, February
 12, 1996, 11–16.

Sharpley-Whiting, T. Denean. *Black Venus: Sexualized Savages, Primal Fears, and
 Primitive Narratives in French*. Durham, N.C.: Duke University Press, 1999.

Shayt, David H. "The Material Culture of Ivory Outside Africa." In *Elephant: The
 Animal and Its Ivory in African Culture*, ed. Doran Ross, 367–381. Los Angeles:
 Fowler Museum of Cultural History, University of California, 1992.

Sherman, Daniel J., ed. *Museums and Difference*. Bloomington: Indiana University Press, 2008.

Sherman, Daniel J., and Irit Rogoff, eds. *Museum Culture: Histories Discourses Spectacles*. Minneapolis: University of Minnesota Press, 1994.

Shohat, Ella, and Robert Stam. "The Politics of Multiculturalism in the Postmodern Age." *Art and Design* 43 (1995): 10–16.

Simpson, Moira G. *Making Representations: Museums in the Post-Colonial Era*. London: Routledge, 1996.

Sit, Elaine C. "From Barbie to the Bar: Thoughts on Asian Americans in Our Toy Stores and in Our Courts." *Federal Lawyer* 47, no. 7 (August, 2000): 26–32.

Sklar, Martin A. "Guardians of an International Treasure: The Walt Disney–Tishman African Art Collection." In *African Vision: The Walt Disney–Tishman African Art Collection*, ed. Christine Mullen Kreamer, 1–5. Washington, D.C.: National Museum of African Art, Smithsonian Institution, and Munich: Prestel Verlag 2007.

Smith, Gayle. "US Aid to Africa." *Review of African Political Economy* 31, no. 102 (December 2004): 698–703.

Smith, Marquand, ed. *Visual Culture Studies*. Los Angeles: Sage, 2008.

Smooden, Eric. *Disney Discourse: Producing the Magic Kingdom*. New York: Routledge, 1994.

Sobieszek, Robert A. *The Art of Persuasion: A History of Advertising Photography*. New York: Harry N. Abrams, 1988.

Solomon-Godeau, Abigail. "Going Native." *Art in America* 77 (July 1989): 118–129+.

———. *Photography at the Dock: Essays on Photographic History, Institutions, and Practices*. Minneapolis: University of Minnesota Press, 1991.

Sontag, Susan. *On Photography*. 1977. Repr., New York: Picador USA/Farrar, Strauss, and Giroux, 2001.

Sorkin, Michael. "See You in Disneyland." In *Variations on a Theme Park: The New American City and the End of Public Space*, ed. Michael Sorkin, 205–232. New York: Hill and Wang, 1992.

Spivak, Gayatri C. "Can the Subaltern Speak? Speculations on Widow-Sacrifice." *Wedge* 7/8 (1985): 120–130.

Sports Illustrated. *Around the World with the Swimsuit Supermodels*. New York: Sports Illustrated, 1997.

Sports Illustrated Television, and Rob Schneider. *"Sports Illustrated" Swimsuit 1998*. New York: Sports Illustrated Television, 1998. VHS.

Sports Illustrated Television, and Stacey Williams. *"Sports Illustrated" Swimsuit 1996 Out of Africa*. New York: Sports Illustrated Television, Distributed by Image Entertainment, 1996. VHS.

Staff. "Out of Africa." *Interior Design Magazine*, June 1, 2001, 236–239.

Steele, Valerie. *Fashion and Eroticism: Ideals of Feminine Beauty from the Victorian Era to the Jazz Age*. New York: Oxford University Press, 1985.

Steeves, H. Peter. "Becoming Disney: Perception and Being at the Happiest Place on Earth." *Midwest Quarterly* 44, no. 2 (2003): 176–194.

Stein, Joel. "Brown-bagging It." *Time*, February 28, 2000, 25.

Steinberg, Stephen. *Race and Ethnicity in the United States: Issues and Debates.* Malden, Mass.: Blackwell, 2000.

Steiner, Christopher B. *African Art in Transit.* Cambridge: Cambridge University Press, 1994.

———, ed. Special issue, *Museum Anthropology* 19, no. 2 (1995).

Stewart, Susan. *On Longing: Narratives of the Miniature, the Gigantic, the Souvenir, the Collection.* Baltimore: Johns Hopkins University Press, 1984. Repr., Durham, N.C.: Duke University Press, 1993.

Stiepock, Lisa, and Pippin Ross. "Disney's Animal Kingdom: Where the Wild Things Are." *Disney Magazine*, Summer 1998, 31–50.

Stocking, George. *Objects and Others: Essays on Museums and Material Cultures.* Madison: University of Wisconsin Press, 1985.

Stoler, Ann L. "Making Empire Respectable: The Politics of Race and Sexual Morality in 20th-Century Colonial Cultures." *American Ethnologist* 16, no. 4 (1989): 634–660.

Straker, Jay. "Performing the Predicaments of National Belonging: The Art and Politics of the Tuareg Ensemble Tartit at the 2003 Folklife Festival." *Journal of American Folklore* 121, no. 479 (2008): 80–96.

Stratz, C. H. *Die Rassenschönheit des Weibes.* Stuttgart: Verlag von Ferdinand Enke, 1903.

Swift, E. M. "Wild Things." *Sports Illustrated*, January 29, 1996, 60–73.

Tagg, John. *The Burden of Representation.* 1988. Repr., Minneapolis: University of Minnesota Press, 1993.

Tarnoff, Curt, and Larry Nowels. "Foreign Aid: An Introductory Overview of U.S. Programs and Policy." Washington, D.C.: Congressional Research Service, 2004.

———. "Foreign Aid: An Introductory Overview of U.S. Programs and Policy." Washington, D.C.: Congressional Research Service, 2005.

Taylor, Joshua C. "The Art Museum in the United States." In *On Understanding Art Museums*, ed. Sherman E. Lee, 34–67. Englewood Cliffs, N.J.: Prentice Hall, 1975.

Thompson, Barbara, ed. *Black Womanhood: Images, Icons, and Ideologies of the African Body.* Hanover, N.H.: Hood Museum of Art, Dartmouth College, and Seattle: University of Washington Press, 2008.

Thompson, Carol. "Decade of 'Trade Not Aid.'" *Review of African Political Economy* 30, no. 96 (June 2003): 321–323.

Thompson, Jerry L., Susan Mullin Vogel, Anne D'Alleva, and Center for African Art. *Closeup: Lessons in the Art of Seeing African Sculpture; from an American Collection and the Horstmann Collection.* New York: Center for African Art, 1990.

Thompson, Krista. "Beyond Tarzan and *National Geographic*: The Politics and Poetics of Presenting African Diasporic Cultures on the Mall." *Journal of American Folklore* 121, no. 479 (2008): 97–111.

Tiller, Phalana. "Swimsuit Issue *Sports Illustrated* (Review)." *Siecus Report*, April/May 1996, 25.

Torres, Sascha. *Black, White, and in Color*. Princeton, N.J.: Princeton University Press, 2003.

Tosa, Marco. *Barbie: Four Decades of Fashion, Fantasy, and Fun*. New York: Harry N. Abrams, 1998.

Triandafyllidou, Anna. "National Identity and the 'Other.'" *Ethnic and Racial Studies* 21, no. 4 (July 1998): 593–612.

Trollip, Anna-Marie. "Meaning of Blankets, Towels, and T-shirts in the Context of Acculturation." *South African Journal of Ethnology* 18, no. 4 (December 1995): 150–154.

Tuchman, Gaye. "Women's Depiction by the Mass Media." In *Turning It On: A Reader in Women and Media*, ed. Helen Baehr and Ann Gray, 11–15. London: Arnold, 1996.

Urla, Jacqueline, and Alan C. Swedlund. "The Anthropometry of Barbie: Unsettling Ideals of the Feminine Body in Popular Culture." In *Deviant Bodies: Critical Perspectives on Difference in Science and Popular Culture*, ed. Jennifer Terry and Jacqueline Urla, 277–313. Bloomington: Indiana University Press, 1995.

Van Maanen, John. "Displacing Disney: Some Notes on the Flow of Culture." *Qualitative Sociology* 15, no. 1 (1992): 5–35.

Van Wert, William F. "Disney World and Posthistory." *Cultural Critique* 32 (Winter 1995–1996): 187–214.

van Wyck, Gary. "Fertile Flowers of Femininity." In *Evocations of the Child: Fertility Figures of the Southern African Region*, ed. Elizabeth Dell and Rayda Becker, 53–67. Johannesburg: Johannesburg Art Gallery, and Cape Town: Human & Rousseau, 1998.

Varney, Wendy. "Barbie Australis: The Commercial Reinvention of National Culture." *Social Identities* 4, no. 2 (1998): 162–176.

Villmoare, Adelaide H., and Peter G. Stillman. "Pleasure and Politics in Disney's Utopia." *Canadian Review of American Studies* 32, no. 1 (2002): 81–104.

Vogel, Susan. *Africa Explores: 20th Century African Art*. New York: Center for African Art, and Munich: Prestel Verlag, 1991.

———. "Always True to the Object, in Our Fashion." In *Exhibiting Cultures: The Poetics and Politics of Museum Display*, ed. Ivan Karp and Stephen D. Lavine, 191–203. Washington, D.C.: Smithsonian Institution Press, 1991.

———, ed. *Art/artifact: African Art in Anthropology Collections*. New York: Center for African Art, and Munich: Prestal Verlag, 1988.

Vogel, Susan Mullin, and Mario Carrieri. *African Aesthetics: The Carlo Monzino Collection*. New York: Center for African Art, 1986.

Vogel, Susan Mullin, and Center for African Art. *The Art of Collecting African Art*. New York: Center for African Art, 1988.

Wall, David. "It Is and It Isn't: Stereotypes, Advertising and Narrative." *Journal of Popular Culture* 41, no. 9 (December 2008): 1033–1050.

Wallace, Mike. "Mickey Mouse History: Portraying the Past at Disney World." *Radical History Review* 32 (1985): 33–57.

Wallace-Sanders, Kimberly. "The Body of a Myth: Embodying the Black Mammy Figure in Visual Culture." In *Black Womanhood: Images, Icons, and Ideologies of the African Body*, ed. Barbara Thompson, 163–179. Hanover, N.H.: Hood Museum of Art, Dartmouth College, and Seattle: University of Washington Press, 2008.

Wallis, Brian. "Black Bodies, White Science: Louis Agassiz's Slave Daguerreotypes." *American Art* 9, no. 2 (1995): 38–61.

Walters, Ronald. "The African Growth and Opportunity Act: Changing Foreign Policy Priorities toward Africa in a Conservative Political Culture." In *Foreign Policy and the Black (Inter)National Interest*, ed. Charles P. Henry, 17–36. Albany: State University of New York Press, 2000.

Walzer, Michael. "The Meaning of American Nationality." In *Race and Ethnicity in the United States: Issues and Debates*, ed. Stephen Steinberg, 186–196. Malden, Mass.: Blackwell, 2000.

Warren, Stacy. "Cultural Contestation at Disneyland Paris." In *Leisure/Tourism Geographies: Practices and Geographical Knowledge*, ed. David Crouch, 109–125. London: Routledge, 1999.

Wasko, Janet. "Is It a Small World, After All?" In *Dazzled by Disney? The Global Disney Audiences Project*, ed. Janet Wasko, Mark Phillips, and Eileen R. Meehan, 3–28. London: Leicester University Press, 2001.

Wasko, Janet, and Eileen R. Meehan. "Dazzled by Disney? Ambiguity in Ubiquity." In *Dazzled by Disney? The Global Disney Audiences Project*, ed. Janet Wasko, Mark Phillips, and Eileen R. Meehan, 329–343. London: Leicester University Press, 2001.

Wasko, Janet, Mark Phillips, and Eileen R. Meehan, eds. *Dazzled by Disney? The Global Disney Audiences Project*. London: Leicester University Press, 2001.

Webb, Virginia-Lee. "Fact and Fiction: Nineteenth-Century Photographs of the Zulu." *African Arts* 25, no. 1 (1992): 50–59.

Weinstock, Jeffrey Andrew, ed. *Taking South Park Seriously*. Albany: State University of New York Press, 2008.

Wetherell, Margaret, and Jonathan Potter. *Mapping the Language of Racism: Discourse and the Legitimation of Exploitation*. New York: Columbia University Press, 1992.

Wilkes, Anastasia. "Smithsonian Okays African American Museum." *Art in America* 79 (October 1991): 39.

Williams, Raymond. "Advertising: The Magic System." In *The Cultural Studies Reader*, ed. Simon During, 410–423. London: Routledge, 1999.

———. *Keywords: A Vocabulary of Culture and Society*. Rev. ed. New York: Oxford University Press, 1983.

Williamson, Judith. *Decoding Advertisements: Ideology and Meaning in Advertising*. London: Marion Boyars, 1978.

——. "Woman Is an Island: Femininity and Colonization." In *Studies in Entertainment: Critical Approaches to Mass Culture*, ed. Tania Modleski, 99–118. Bloomington: Indiana University Press, 1986.

Willis, Deborah. "Picturing the New Negro Woman." In *Black Womanhood: Images, Icons, and Ideologies of the African Body*, ed. Barbara Thompson, 227–245. Hanover, N.H.: Hood Museum of Art, Dartmouth College, and Seattle: University of Washington Press, 2008.

Willis, Deborah, and Carla Williams. *The Black Female Body: A Photographic History*. Philadelphia: Temple University Press, 2002.

Willis, Susan. "Disney's Bestiary." In *Rethinking Disney: Private Control, Public Dimensions*, ed. Mike Budd and Max H. Kirsch, 53–71. Middletown, Conn.: Wesleyan University Press, 2005.

Wilson, Alexander. "The Betrayal of the Future: Walt Disney's EPCOT Center." In *Disney Discourse: Producing the Magic Kingdom*, ed. Eric Smooden, 118–128. New York: Routledge, 1994.

——. *The Culture of Nature: North American Landscape from Disney to the Exxon Valdez*. Cambridge, Mass.: Blackwell, 1992.

Wilson, Elizabeth. *Adorned in Dreams: Fashion and Modernity*. Berkeley: University of California Press, 1985.

Wilson, Robert. *Great Exhibitions: The World Fairs 1851–1937*. Melbourne: Council of Trustees of the National Gallery of Victoria, 2007.

Winant, Howard. *The New Politics of Race: Globalism, Difference, Justice*. Minneapolis: University of Minnesota Press, 2004.

——. "Racism Today: Continuity and Change in the Post–Civil Rights Era." In *Race, Ethnicity, and Nationality in the United States: Towards the Twenty-first Century*, ed. Paul Wong, 14–24. Boulder, Colo.: Westview Press, 1999.

Wolf, Jack C. "Disney World: America's Vision of Utopia." *Alternative Futures* 2 (1979): 72–77.

Wong, Paul. "Race, Ethnicity, and Nationality in the United States: A Comparative, Historical Perspective." In *Race, Ethnicity, and Nationality in the United States: Towards the Twenty-first Century*, ed. Paul Wong, 293–314. Boulder, Colo.: Westview Press, 1999.

——, ed. *Race, Ethnicity, and Nationality in the United States: Towards the Twenty-first Century*. Boulder, Colo.: Westview Press, 1999.

World Tourism Organization. "Tourism Highlights 2007." Madrid: United Nations World Tourism Organization, 2007.

Žižek, Slavoj. "Multiculturalism, or, the Cultural Logic of Multinational Capitalism." *New Left Review*, no. 225 (September/October 1997): 28–51.

Index

locales, 39, 72, 74, 75, 122; and Others, 44, 76, 77, 85, 94

Exploris Museum (Raleigh, N.C.), 7, 182n9

facial painting, 76; use of, in advertising, 5

Fante (people), Asafo flag, 152, 157

feminism, 108, 174

Ferguson, James, and perception of Africa, 28

Fisher, Angela, 8, 152; *Africa Adorned*, 90; *African Ceremonies*, 160

Fjellman, Stephen, 134–36, 210n4

Fon (people), artisan cooperatives, 170

Fonseca, Heather, 105–6, 110–11

Frederick Douglass house (Washington, D.C.), 20

Freud, Sigmund, 44

Friedenthal, Albert, 49–50

Fulani (women), 170

Galton, Francis, 82. *See also* photography: scientific

Garvey, Marcus, 55, 101

Gaskins, Bill, 54

Ghana: empire, 7; nation, 96, 102

Ghanaian Barbie. *See* Barbie: Ghanaian Barbie

Gilroy, Paul: on race and identity, 16–17, 185n29. *See also* "postcolonial melancholia"

Global Disney Audience Project, 124, 126; and racism, 131

Grosvenor, Gilbert Hovey, 129

Guro (people), mask, 157

Haggard, Rider, 44

Hall, Martin, 147–48, 156

Hall, Stuart, 16

Hannah, Mary, 160, 219n15, 223n60

Hans Tamberau. See "it's a small world" ride

Hardin, Kris L., *African Material Culture*, 3, 10

HATAB. *See* Hotel and Tourism Association of Botswana

heritage, 19, 21, 101, 102, 171; cultural, 58, 66, 69, 91, 94, 96, 105, 109, 148

Hluhluwe-Umfolozi Park, 139

Hotel and Tourism Association of Botswana, 146

Hottentot Venus. *See* Baartman, Saartje

Hova (people), 83

Humphrey, Hubert, 20

"I Am African." (Keep a Child Alive 2006 advertising campaign), 181n5; analysis of, 3–4, 5, 6, 7, 10, 13, 21, 25, 76, 174, 178. *See also* Keep a Child Alive

Ibeji. See Yoruba: *ibeji*, twin figures

identity, 90, 94, 127, 164, 179; Afrikaner, 90; Afro-centric, 101, 102; Asante, 101; and Barbie, 102, 104, 109; British, 16, 90, 100; crisis of, 4, 16, 17, 98, 128–29; cultural, 18, 96, 97, 101, 110, 113, 114, 177; ethnic, 66, 78, 83, 98, 109; modern, 113; national, 4, 18, 20–21, 32, 96, 98, 100, 102, 104, 111, 113, 114, 177; Ndebele, 62, 66, 69, 80, 84, 90; racialized, 4, 8, 9, 15–16, 18–19, 20, 23, 24, 26, 28, 96, 114, 117, 131, 171, 173, 176, 177–78; social, 28; social construction of, 12; Western, 91

ideology: definition of, 28; and Disney, 124; dissemination of, 39, 110, 114; dominant social, 12, 17, 33–34, 120, 136; political, 43, 127; racial, 17–19, 35, 38; reinforcement of, 10, 14, 18; socialization into, 4, 38, 39, 57, 114, 121, 154, 155, 174

Ijele, Igbo (people), 145, 157, 168, 170

Imagineers, 123, 129, 141

Iman, 67

imperialism, 107, 117, 121; and culture, 97, 173; discourse of, 14, 16, 24, 27, 97–98, 113, 173; and United States, 97, 128, 134, 150

International Monetary Fund, 24

Iooss, Walter, Jr., 32, 35

Ireland, Kathy, 39–40, 60, *61*, 64, 66, 68–69, 75, 80, 87–88, 92, 95, 113; diary entry of, 68, 73

"it's a small world" ride (Magic Kingdom), 11, 14, 27, 115, 116, 120, 131, 132–38, 139, 150, 174, *plates 3–6*; depiction of Africa, 132, 176, 216n87, *plate 3*, *plate 5*; description of, 116–17, 132–34; *Haus Tamberan* (Papua New Guinea), 133, 217n89; theme song of, 134–35. *See also* Walt Disney World Resort

Jiyani, Lettie, 64, *65*

Johnson, Martin and Osa, 143, 145

Jones, Lisa, 54, 197n95

Jordanova, Ludmilla, "Objects of Knowledge," 139, 171–72

Kalahari Desert, location for swimsuit issue, 39, 72

Kamali, Norma, 36, 60

Keep a Child Alive (organization), 3, 34, 60, 76, 164, 178. *See also* "I Am African."

Keim, Curtis, 150, 181n7

kente (Asante cloth), 27, 56, 100–102, 174, 206n4, 208n25, *plates 1–2*; and dolls, 102, 107; and Ghanaian Barbie, 103–5; and identity, 96, 101–2; and Kwame Nkrumah, 100; production of, 208n31

Kenya, 122; location for swimsuit issue, 41, 42; and tourism, 70

Keys, Alicia, 3, 5

Kgodwana Ndebele Village and

Museum, 39, 62, 64, 65, 67, 70, 74, 76, 77, 78, 79, 81, 91, 101

Khoisan (women), photographs of, 46–47, *47*, 83

King, Rodney, beating of, 15. *See also* America: and racial tension

Kirshenblatt-Gimblett, Barbara, 80

Kongo (people), visual culture of, 151

Kotoko (people), fertility amulet, 157

Kravitz, Lenny, 181n4

Kuba (people), 152; artisan cooperatives, 170; household objects, 160

KwaMsiza, 64, 69

KwaNdebele, 64, 69

Kwanzaa, 56

Lawrence, Errol, 16; and idea of common sense, 17–18

Liu, Lucy, 3, 5, 181n5

liphotu. See Ndebele: *liphotu*

Lobi (people), 153

Locke, Alain, 55

Lutz, Catherine, *Reading National Geographic*, 59, 85, 93–94, 129

Maasai (people), 5, 41–42, 43, 80–81, 90; culture of, 80–81, 145, 164; motifs, 151

MacCannell, Dean, and "reconstructed ethnicity," 77–78

Madagascar, 83

Magic Kingdom (Walt Disney World Resort), 115, 116, 125, 130; Adventureland, 150; Fantasyland, 125; Frontierland, 125; Jungle Cruise, 115, 117, 125, 130, 140; Tomorrowland, 125, 150. *See also* "it's a small world" ride

Mahlangu, Esther, 67–69, 76, 80, 91, 200n27, 200n28; painted BMW, 68

Mala Mala Game reserve, location for swimsuit issue, 39, 41, 53, 76

Malagasy (people), 83

Masombuka, Sarah, 64, *65*, 67

Mattel (corporation), 4, 10, 173; Collector Edition dolls, 96–97, 131; as empire, 97. *See also* Barbie; "Dolls of the World" collection

Mayers, Jane, 80

Mayers Ranch (Kenya), performance at, 80, 81

Mazza, Valeria: description in photograph/analysis of pose, 40, 46, 52; and *Sports Illustrated* (1996 swimsuit issue), 26, 29, *30*, 35, 36, 42, 75

Mbonani, Sarah, 64, *65*

meanings: connotative, 66, 117–18, 152, 174, 214n51; denotative, 56, 87–88, 126, 130, 174, 214n51; indigenous, 7, 23, 101, 174; racialized, 40, 57

Meiring, A. L., 64, 69

Mercer, Kobena, 55

modern: America/the West as, 8, 85, 90, 154; clothing, 110; identity, 91, 113; life, 63, 81, 85, 89, 113, 150, 176, 182n12; modernity, 81, 90, 91, 176; Others as, 81, 165. *See also* tradition

Muhl, Kate, description of Disney's Animal Kingdom Lodge, 139, 140–41

multiculturalism, 18, 22–24, 27, 108, 128, 132, 134, 173, 174

Museum of African Art, 20–21, 186n52

museums, 139; and Africa, Africans, and African art, 7, 19–22, 56, 107, 157, 158, 186n50, 219n12; art, 19, 68, 107, 141, 151, 154, 157; cultural heritage, 64, 70, 77, 80, 199n13, 213n28; educational aspects, 141, 153, 155, 156, 167; ethnographic, 19; exhibitionary complex, 154, 157, 161, 171; exhibitionary practice, 19, 137, 141, 153, 155, 156, 163, 165, 168, 169, 171, 174, 222n41; experiential complex, 156–57; natural history, 19, 56, 107, 151, 154, 158, 168, 186n50; scholarship

of, 28, 155; as social sites, 8, 23–24, 34, 141, 154, 173; socialization in, 7, 19, 22, 23, 34, 77, 78, 139, 141, 154–55, 168, 171, 186n50; and Walt Disney World Resort, 140, 141, 155–67, 171, 212n21, 213n28; and world's fairs, relation to, 115, 116, 121, 122, 133, 137, 141, 154. *See also* Exploris Museum; Kgodwana Ndebele Museum and Village; Museum of African Art; National Museum of African Art

Namibia, 146

Nankanse (people), 142

narrative, 27, 60, 122; of desire, 107; as representation, 118–21; at Walt Disney World Resort, 122, 124–27, 131, 137, 139, 149, 171. *See also* counternarrative

National Geographic, 8, 81, 129, 130, 204n92; and American Society, 131; as visual documentation, 85, 90, 91, 94

National Museum of African Art (Smithsonian Institution), 19–21, 23, 24, 25, 56, 141, 170, 171, 186n49, 186n50. *See also* Museum of African Art

nationalism, 14, 24, 55, 99, 108, 173

Ndebele (people), 27, 39, 43, 58, 59, 60–62, *65*, 69, 72, 79, 88, 113, 164–65, 170; and Afrikaners, 62; Barbie, 177, *178*, 179, 225n1; clothing of, 26, 62, 63, 66, 80, 85, 90–91, 95, 101; culture of, 13, 62–63, 67, 69–70, 78, 83, 91, 93, 95, 113, 177; as domestic labor, 199n25; *dzilla*, 41, 42, *61*, 66, 76; jewelry of, 75–76, 91–92; *liphotu*, 66; location for swimsuit issue (*see* Kgodwana Ndebele Village and Museum); Matabele of Zimbabwe, 62; Northern Transvaal, 62; and Otherness, 81, 84, 87, 119, 178; *pepetu*, 76–77, 202n63; Southern Transvaal, 62; and tourism, 63, 64, 67–69, 70, 74–75; traditions of,